WITHDRAWN

GOTHIC TOMBS OF KINSHIP IN FRANCE,
THE LOW COUNTRIES,
AND ENGLAND

GOTHIC TOMBS OF KINSHIP

IN FRANCE, THE LOW COUNTRIES, AND ENGLAND

Anne McGee Morganstern

With an Appendix on the Heraldry of the Crouchback Tomb in Westminster Abbey by John A. Goodall, FSA, FRNS

THE PENNSYLVANIA STATE UNIVERSITY PRESS

UNIVERSITY PARK, PENNSYLVANIA

Grants from The Ohio State University College of the Arts, the Dean of the College, the Department of History of Art, and the Center for Medieval and Renaissance Studies have assisted in the publication of this book.

Library of Congress Cataloging-in-Publication Data

Morganstern, Anne McGee, 1936–
Gothic tombs of kinship in France, the low countries, and England
/ Anne McGee Morganstern ; with an appendix on the heraldry of the
Crouchback tomb in Westminister Abbey by John A. Goodall.
p. cm.
Includes bibliographical references and index.
ISBN 0-271-01859-3 (cloth : alk. paper)
1. Effigies—France. 2. Sepulchral monuments, Gothic—France.
3. Effigies—Europe, Northern. 4. Sepulchral monuments, Gothic
—Europe, Northern. 5. Kings and rulers—Tombs I. Goodall, John
A. II. Title.
NB1820.M72 2000
731'.76'0940902—dc21 98-41261

It is the policy of The Pennsylvania State University Press to use acid-free paper for
the first printing of all clothbound books. Publications on uncoated stock satisfy
the minimum requirements of American National Standard for Information Sciences—
Permanence of Paper for Printed Library Materials, ANSI Z39.48–1992.

DESIGNED BY LAURY A. EGAN

To my family and friends

Contents

CONTENTS

List of Illustrations

Tomb Charts

To judge from the material collected, by the mid–thirteenth century, the figures representing family members on tomb chests were arranged according to the orientation of the effigy. That is, as a general rule, programs were meant to be read from the head to the foot of the tomb by a viewer approaching the monument from the west, for such a reading yields either a genealogical or an honorific order. The tomb charts have been designed accordingly, so that the reader may follow the order of the programs by reading down, from head to foot. Figures are numbered according to the side of the tomb chest on which they appear (north, south, east, or west) and according to place on a given side. The head and the foot of the chest were generally designed around the central figure on that side, but for the sake of uniformity, these figures are numbered consecutively from left to right. For the head sides, this results in a reversal of the numbers on the charts if read from left to right.

Color Plates

Black and White Figures

Abbreviations Used in Figures and Appendixes

A.	aunt		H.	husband
ag.	agnatic		H.R.Emp.	Holy Roman Emperor, Holy Roman Empress
Arg.	Argent		Hf.	half
Az.	Azure		impal.	impaling
B.	brother		K.	king
B.-in-l.	brother-in-law		Ks.	kings
b.	born		k.	killed
Bp.	bishop		L.	lord, lady
C.	count, countess		Lgr.	landgrave
cog.	cognatic		liv.	living
Cous.	cousin		m.	married
Cs.	counts		M.	mother
D.	duke, duchess		M.-in-l.	mother-in-law
d.	died		marr.	marriage
Da.	daughter		N.	nephew
Da.-in-l.	daughter-in-law		Ne.	niece
de.	deposed		Pr.	prince, princess
dimid.	dimidiating		pts.	points
Dr. of Juris	doctor of jurisprudence		Pur.	Purpure
Ds.	dukes		Q.	queen
E.	earl		qtd.	quartered
Emp.	emperor, empress		qtr.	quarter
ex.	executed		qtring.	quartering
F.	father		qtrly.	quarterly
Fr.	friend		Sa.	Sable
F.-in-l.	father-in-law		Sr.	sister
Gd.	granddaughter		Sr.-in-l.	sister-in-law
Ger. Emp.	German emperor		S.	son
Gf.	grandfather		s.p.	sans progeny
Gr.	great		U.	uncle
Gm.	grandmother		unmarr.	unmarried
Gs.	grandson		W.	wife
Gu.	Gules			

Preface

THIS WORK would not have been possible without the good will and assistance of many people. The manuscript benefited from an unusual number of readers, who helped me to extend the interpretation of the evidence far beyond my original intention. Among them, special thanks are due Willibald Sauerländer, Walter Cahn, and Megan McLaughlin. I owe the idea for the book to the advisory committee of the Center for Medieval and Renaissance Studies at Ohio State University and its director, Joseph Lynch, for it was while preparing a paper for the center's annual conference, on court patronage and the arts, in 1980, that my interest in the prince's tomb of the late Middle Ages was renewed. The continued support of the center and its subsequent directors, Christian K. Zacher, Eve Levin, and Nicholas Howe, was most evident in the award of a research assistant for 1989–90, and in a substantial contribution to the subvention for publication spearheaded by the College of the Arts at Ohio State, its dean, Donald Harris, and the Department of History of Art, led by Christine Verzar and Mark Fullerton. Thanks are due in particular to Judith Koroscik, then associate dean of the college, for her advice on securing this support.

A year as senior fellow at the Center for Advanced Study in the Visual Arts at the National Gallery of Art in 1982–83 provided stimulating contact with other scholars under the benevolent eyes of Henry Millon and his able assistant, Marianna Shreve Simpson, and the chance to explore the rich collection of antiquarian sources at the Library of Congress. There, I began to realize the extent of the English material, and in the summer of 1984, aided by a grant from Ohio State University's College of the Arts, I set out to study and photograph all the tombs of kinship on the island. That I very nearly succeeded I owe in large part to the wise counsel of George Zarnecki and Neil Stratford, to the opportunity to consult the photographic archives of the Courtauld Institute's Conway Library and the National Monuments Record, and to a chance encounter with Bridget Cherry, who put the card file from Nicolaus Pevsner's *Buildings of England* at my disposal. Hopefully, some of the rich human experience of those journeys in the English countryside is distilled in the pages that follow. At any rate, I shall never forget them, nor the hospitality extended everywhere that I went, especially at Bures, Holbeach, Thornhill, Elford, and Clifton Reynes. In England, I also profited from the privilege of working in the library of the London Society of Antiquaries, the Muniment Room and Library of Westminster Abbey, the British Library, and the Bodleian Library. And I am especially grateful to the Dean and Chapter of Westminster Abbey and to the Dean and Chapter of Gloucester Cathedral for special arrangements for photography of monuments within their sanctuaries.

On the Continent, since so few of the monuments have survived, my work was more sedentary, involving research at the Bibliothèque Nationale and the Bureau de Documentation des Objets mobiliers, Monuments historiques, in Paris; at the Archives départementales de l'Yonne

in Auxerre; at the Bibliothèque royale Albert Ier and the Institut royal du Patrimoine Artistique in Brussels; and at the Bibliothèque municipale of Valenciennes. In the museums where fragments of monuments are preserved, I enjoyed the full cooperation of helpful curators: Françoise Baron at the Louvre, Fabienne Joubert at the Musée national du Moyen Age-Thermes de Cluny, J. Fontseré and N. Berthelier at the Musée des Beaux-Arts, now the Musée Anne de Beaujeu, in Moulins, Philippe Beaussart at the Musée des Beaux-Arts in Valenciennes, F. X. Amprimoz at the Musée Crozatier in Le Puy, M. Danzin at the Musée archéologique in Namur, Hans M. J. Nieuwdorp at the Musée Mayer van den Bergh in Antwerp, and Paul Williamson at the Victoria and Albert Museum in London.

Many other colleagues generously responded to my requests for advice, expertise, and support. John A. Goodall guided my heraldic and genealogical research, and checked several appendixes besides those he co-authored; Baron Hervé Pinoteau also responded generously to my queries on heraldic problems; the late Hans Keller, the late Carl Schlam, Frank Coulson and Joseph Lynch helped with onerous problems of paleography and language; Robert Didier paved the way for my field work in Belgium. Others responded with support so varied that an account of it would make an interesting volume in itself. They include Harald Anderson, Charles Atkinson, Nicolas Bennett, the late John Benton, Christiane van den Bergen-Pantens, Bartley Brown, James Brundage, Robin A. Birch, William W. Clark, Dawn Cunningham, Charles Daudon, Ellen Erdreich, Father Aled Gieben, Anne D. Hedeman, Joel Hershman, John Hopkins, Julia King, Lisa Kiser, the late Richard Krautheimer, Charlotte Lacaze, Phillip Lindley, Roseline Maître-Devallon, Paul Meyvaert, the late Nicolas MacMichael, Isabelle Maillard, Thomas F. Mathews, Ursula Pariser, Franklin Pegues, Seymour Phillips, Debra Pincus, Suzanne Reece, William A. Reitwiesner, Lucy Sandler, Gabrielle Spiegel, Malcolm Thurlby, Sean Ulmer, Anne Van Buren, the late Philippe Verdier, Harry Vredeveld, Françoise Weinmann, Canon David Welander, Thomas E. Wilgus, Christopher Wilson, Karen Wilson, William D. Wixom, Anne Zielinski, and Stephen Zwirn.

At Ohio State I have enjoyed the cooperation of the library staff, especially that of Susan Wyngaard in the Fine Arts Library and Deborah Cameron and Clara Goldschlager at Interlibrary Loan. The tomb charts, which I devised from the evidence presented in the appendixes, were programmed for the computer by Jean Ippolyto and executed by Betsy Deady, while Jean Ippolyto and Mark Pompelia executed the family trees under my direction; all were kindly supervised by John Taormina. Mark Pompelia also executed Figure 100. Paul Pepper and Ken Frick printed my negatives for the photographic illustrations not otherwise credited. Amy Case is largely responsible for the index and also helped me with the final editing.

At Penn State Press, I have enjoyed the cooperation and moral support of Philip Winsor, senior editor, the benefit of Ann Donahue's scrutinizing editorial eye, and many helpful suggestions from Janet Dietz and Cherene Holland. Observing Laury Egan design this book has been a pleasure.

But finally, in spite of so much help, the tasks of this book often taxed my patience and strained my intellect, and without the interest, advice, and never-failing encouragement of Jim Morganstern, who accompanied me on many journeys and kept the home fires burning when

he did not, the material in this volume might have wound up long ago in the trash, the fire, or some forgotten corner of my filing cabinet.

PORTIONS of the introduction and Chapters 5 and 6 were presented as papers: "The Tomb as Prompter for the Chantry," at the annual meeting of the College Art Association of America in New York in 1994, "The Bishop, the Lion, and the Two-headed Dragon: The Burghersh Memorial in Lincoln Cathedral," at *Memory and Oblivion,* 29th International Congress of the History of Art, Amsterdam, 1996, and "The Tomb of Edward II at Gloucester: Plantagenet Shrine and Insignia," at the annual meeting of the College Art Association of America in Los Angeles in 1999. Permission to print material to be published in "The Bishop, the Lion, and the Two-headed Dragon: The Burghersh Memorial in Lincoln Cathedral," *Memory and Oblivion: Acts of the 29th Congress of the History of Art,* has been kindly granted by Kluwer Academic Publishers.

GOTHIC TOMBS OF KINSHIP IN FRANCE,
THE LOW COUNTRIES,
AND ENGLAND

Introduction

EARLY IN THE YEAR of the great plague, 1348, the prior and canons of St. Frideswide in Oxford regulated the chantry recently established in their cloister by Elizabeth de Montfort, Lady Montacute. They approved a daily mass to be celebrated in perpetuity by two secular priests in the Chapel of the Virgin Mary for Lady Montacute and her family, jointly with an Office of the Dead. The beneficiaries of the Montacute chantry included the lady's parents, two husbands, ten children by the first husband, and two ecclesiastics from Lincoln Cathedral: a canon, Simon Islip, and the bishop, John Gynwell. The prior and canons also agreed that after Lady Montacute died, her tomb in the same chapel would be the focus of the daily Office of the Dead, accompanied by a special prayer for her soul.[1]

In addition to these services, two annual high masses were to be celebrated by the regular canons of the house and remunerated with a portion for those who participated. One mass was to be held on the anniversary of the death of the lady's first husband, William Montacute; the other on the feast day of Saint Botulph for her health as long as she lived, to be commuted to the solemn celebration of her anniversary after her death.[2]

To support these services, Lady Montacute had already deeded a meadow to the priory, Stockwell Mead, now part of Christ Church Meadow, and to this day a peaceful retreat beyond the bustle of the city center. The tomb of Lady Montacute remains in the church where it was erected, although it has been moved from its original place in the Lady Chapel to a confining space between two piers of the chapel's north arcade.[3] The priory church is now the Cathedral of Oxford and the Chapel of Christ Church College.[4] But the chantry has gone the way of all medieval chantries, except as petrified in the monument containing the lady's remains.

The tomb of Lady Montacute, like hundreds of comparable monuments created in the Gothic period, consists of a rectangular chest on which an effigy of the lady lies with her hands joined in prayer (Plate I).[5] Angels support the pillow on which her head rests and a dog lies at her feet. The long sides of the chest are decorated with arcades framing figures carved in relief that have long been identified as the lady's ten children, for their stations and gender correspond to the family record, and the shields in the spandrels above them, alternately Montfort for their mother and Montacute for their father, seem appropriate for such a program.[6]

The figures representing Lady Montacute's family are generally called "weepers" in the literature on this tomb, a term that is used rather indiscriminately to describe family members represented on English Gothic tombs.[7] I suggest, however, that this term, as applied to Lady Montacute's tomb and many others similar to it, is a misnomer. The figures represented on this tomb chest do not appear to weep, nor are they dressed for the funeral ceremony that the term usually implies.[8] And three of them predeceased their mother.[9] Rather than depicting the family

gathered for her funeral, I suggest that the members of Lady Montacute's family represented on the tomb chest represent those *for* whom prayers were offered, because they constitute an abbreviation of the chantry commendations.

We may surmise that Lady Montacute herself planned the program of her tomb, whether or not she supervised its execution, for the choice of those to be represented from a long list of loved ones suggests a mother's solicitude for the welfare of her children, in the midst of whom she wished to be immortalized.[10] Besides containing her body, the tomb was a visual reminder of the chantry ordinance and the focus of the prayers said daily for her and her loved ones. As we shall see in Chapter 6, the figures represented on the tomb chest probably also served as a mnemonic device for calling up the string of commendations listed in the chantry ordinance.

LADY MONTACUTE'S CHANTRY and tomb represent the late medieval development of a religious practice with broad social ramifications that became prevalent in the early Middle Ages and proliferated on a grand scale thereafter. By the mid-fourteenth century, when the Montacute foundation was created, monastic communities had been commemorating the living and dead members of noble houses in their prayers for centuries, in exchange for confession, provision for almsgiving, and transfer of property.[11] Many monasteries were established for the spiritual benefit of noble founders, whose association with these houses of prayer was expected to help them in life and to provide intercessors for their souls after death.[12] The family was usually involved in the act of donation, and often included in the prayers.[13] An important founder's privilege was burial in the monastery, often in a prominent place in the choir of the conventual church, and burial rights were usually extended to their descendants.[14] In fulfillment of their responsibilities for the bodies and souls of these noble families, some monastic communities thus became the mausoleums of particular dynasties and the focus of family consciousness. Karl Schmid has summarized the historical evolution of the relationship between founding families and monastic foundations in the empire in a famous article with an often-quoted sentence: "The proximity of the dead, and with it, their long-lasting presence obligated the living. It bound the clan together."[15] One has only to cite the bond between the kings of France and the monastery of Saint-Denis,[16] or the identification of the Plantagenets in England with Westminster Abbey,[17] to realize how intercession for the dead became enmeshed with the welfare of the living in a society in which the patronage of a monastery was not only a hereditary right but part of the very fabric of religious and social life.[18]

As demonstrated by Otto Gerhard Oexle, an important by-product of monastic intercession was its perpetuation of the memory of the dead, and by extension, the maintenance of the legal and social bond between monasteries and the relatives and descendants of those interred in their precincts.[19] Invocation for the living and the dead by naming them was an important aspect of this commemoration.[20] Since the early Middle Ages, the names of founders and other benefactors had been entered in the memorial books *(libri memoriales* or *libri vitae)*, which were placed on the altar during the celebration of mass in order to include those inscribed within by implication in the commemoration of the living and the dead.[21] A variation on this practice was

recorded at New Minster Abbey, Winchester, in the early eleventh century, where such a book was used in intercessions for the living and the dead before the celebration of the conventual mass and then placed on the altar during the recitation of the canon.[22] By the ninth century, the practice of celebrating a special mass on the anniversary of the death of founders or great benefactors can be documented,[23] as well as the commendation of the souls of founders and benefactors in the daily office of the chapter, following prime or terce.[24] Concurrent with these practices was the increase in liturgical observances in general, including daily mass and Offices of the Dead.[25]

By the high and late Middle Ages, the celebration of private masses for particular dead multiplied in monasteries, as in other religious settings.[26] But as recently discussed by Megan McLaughlin, the relationships expressed by this liturgy and the circumstances of its observance differed from those of early medieval society in several important respects.[27] In the first place, it often represented an altered relationship between the intercessor and his or her lay patron. Whereas monastic patronage from the ninth through the eleventh centuries had involved a close association between the house and its benefactors, often reflected in formal bonds of brotherhood or sisterhood that resulted in their inclusion in the conventual round of prayers, this was no longer necessarily the case in the new monastic orders that began to appear in the wake of the church reform movements of the late eleventh and early twelfth centuries. The shift from Benedictine preeminence in the early Middle Ages to a wide range of intercessors beginning in the twelfth century, including the new orders—the Carthusians, Cistercians, Canons Regular, Franciscans, and Dominicans—that had sprung up as a result of church reform, was accompanied by changes in the liturgy performed for the dead in the new orders, which would also ultimately affect that in the older establishments. For lay patrons, the most important implication of these new liturgical developments was perhaps the normalization of perpetual private masses and offices, opening the possibility of special foundations of priests to celebrate the liturgy privately on their behalf, following their wishes.[28] In the second place, the gradual change from a gift-giving to a market economy had a lasting effect on the mentality of the noble class along with the rest of society, which resulted in much more specific liturgical expectations in exchange for their gifts to the church.[29] And in the third place, with the development of the concept of purgatory as a place in the twelfth century, prayers were more consistently associated with penance and exact calculations of what amount of prayer might suffice to liberate the dead from an anticipated period of punishment after death.[30]

Lady Montacute's foundation at St. Frideswide's Priory reflects these new developments. The daily masses and Offices of the Dead to be celebrated for her family were no longer part of the conventual liturgy, but private, and to be celebrated by two secular priests, although one of the initial charters of foundation did provide for the substitution of regular canons from the priory for the priests in case the income from Stockwell Mead should prove to be insufficient to maintain them, an eventuality that had materialized by the end of the century.[31] On the other hand, the anniversaries for Lord and Lady Montacute to be celebrated by the regular canons of the house must have strengthened the bond between the priory and its benefactress. Lady

Montacute's foundation may thus be considered conservative in that it combined the new aspects of intercession of the late Middle Ages with the traditional bonds between monastic communities and their patrons.

The chantry had already become an important religious institution in England by the thirteenth century. Essentially it represented a systemization of the intercessory prayer for individuals and families that had been celebrated in religious communities for a very long time. But its fundamental distinction from this earlier prayer was that its endowment provided a living for a chaplain or chaplains specially charged to pray for individuals or their souls.[32] The extent of the prayers and commendations established by chantry ordinances varied considerably, but members of the founder's family were usually included.[33] Not every chantry was focused on a tomb, as Lady Montacute's was intended to be after her death, but we may assume that the imposing monuments to be discussed in this volume served as the setting of prayers for their occupants, although the present state of knowledge rarely permits us to correlate them so cogently with specific observances.[34]

LADY MONTACUTE'S TOMB and chantry provide valuable evidence for understanding the religious origin of the type of Gothic tomb that will be the focus of this study. In all these monuments, an effigy of the deceased is accompanied by figures representing members of his/her family; hence their designation as tombs of kinship. These family members are usually identified more precisely than those on the Montacute tomb, either by inscriptions and/or heraldic shields or dress.[35] In fact, some tomb chests yield a coherent family tree if read from west to east, or from the head side to the foot, for the family programs are subordinate to the effigy, which is invariably oriented facing east, unless it has been disturbed.[36] The lineage of the tomb's occupant is apt to be reflected in the family members represented, with dynastic implications paramount if the subject is male, or family connections, if female.

Like the chantries, the iconographic type represented by the Montacute tomb was a pervasive cultural phenomenon during the late Middle Ages in northern Europe, appearing in various sepulchral conformations in a variety of religious institutions.[37] By far the largest number of these tombs assumes the relatively simple form of the Montacute monument. But in the more elaborate examples, the chest might be inserted in a wall niche or crowned by a canopy and accompanied by additional images that are devotional or eschatological. And as we shall see in Chapters 6 and 7, series of family members were also widely incorporated on tomb slabs and brasses in the fourteenth and fifteenth centuries.

Treatment of tombs expressing kinship has heretofore been largely limited to monographic or regional studies, with little or no awareness of their wide geographical appearance. By crossing territorial and artistic borders, I have been able to identify more than one hundred examples, extending as far north as Durham and as far south as Naples, but only a fraction of those surviving in substance or in reproduction are sufficiently preserved or recorded to allow a complete reconstruction of their original programs. Therefore, to some degree, the monuments to be discussed in detail have been determined by historical accident, but I have tried to select the most representative among them in order to suggest the origin of the type in the Kingdom of France

and its subsequent development in territories subject to French cultural influence during the Gothic period, particularly in England, where the survival of monuments and related chantry documents provides the most copious material for investigation. Extensive investigation has been limited to northern France, Belgium, and England, largely because of personal predilection and competence, but this also appears to be the region where the tombs were most prevalent.[38]

Since only a few kinship tombs survived the French Revolution, it is very difficult to estimate how widespread the type became in France, as compared with England and the Low Countries, where it appears to have been the predominant theme for tombs of the nobility by the fourteenth century.[39] But it can hardly be a coincidence that the Low Countries and England are also richest in surviving written medieval genealogies.[40] Such genealogies define particular families at given moments. As Karl Schmid has made clear, historical genealogies reflect situations involving personal relationships and the historical consciousness of the family members, and were not merely records of biological kinship.[41] Georges Duby has further emphasized the value of genealogies written by contemporaries in conveying family consciousness and even in helping to form family cohesiveness.[42] One of the most important contributions of my study is to draw attention to the important source of historical genealogies that tombs of kinship afford. Although Oexle has cited the genealogical references in a few of the tombs discussed in my text in relation to his extensive work on the medieval cult of *memoria*,[43] only Michel Bur has grasped the full potential of these monuments for historical studies. As suggested by his work on the tomb of Count Thibaud III of Champagne, an investigation of the political circumstances surrounding the erection of many tombs demonstrates that a surprising number conceal dynastic concerns beneath the religious and familial piety that are evident in the Montacute monument.[44] Thus they reflect the complex relationship between religion and politics that is characteristic of the Middle Ages. Occasionally, these tombs also help to resolve long-standing genealogical problems.[45]

That the importance of the kinship tomb has been largely overlooked is due at least in part to its widespread destruction in France and the Low Countries, but also to its confusion with its more celebrated counterpart, the ceremonial tomb, in which the figures represented on the tomb chest represent the last rites for the deceased, subsequent offices on his/her behalf,[46] or a full-fledged funeral procession, as on the tombs of the dukes of Burgundy in Dijon. Emile Mâle first isolated the kinship tomb in 1908, viewing it as a manifestation of the cult of the feudal family, which mixed pride and affection with faith in an exalted destiny.[47] But even Mâle confused this type with the ceremonial tomb, and with few exceptions, the general tendency in the subsequent literature has been to conflate them. This is most obvious in Pierre Quarré's catalogue of the exhibition, *Les Pleurants dans l'art du Moyen Age en Europe,* in which, having failed to notice the presence of identifying shields on tombs previous to the fifteenth century, he misinterpreted the series of kinship tombs commissioned by the Burgundians in the Low Countries as representative of a new tradition rather than, as we shall see in Chapter 8, the survival of an old one.[48] Erwin Panofsky had earlier thought that the Flemish tombs were derived from the tombs of the Burgundian dukes in Dijon, with figures that "abandoned their grief-stricken attitudes as well as their anonymity."[49] Henriette s'Jacob also merged the two themes.[50]

In spite of this confusion, the two traditions were already recognized as separate phenomena by Louise Pillion,[51] by Guiseppe Gerola,[52] and more recently by Françoise Baron.[53] As mentioned earlier, the rich potential for historical studies embodied in the kinship tomb has been admirably demonstrated by Michel Bur in two articles on the tomb of Thibaud III, count of Champagne (d. 1201), which is the first known example of the type,[54] and another on the tomb of Marie de Bourbon.[55] Most recently, Philippe Plagnieux has placed another kinship tomb, for Philippe de Morvilliers (d. 1438) and Jeanne du Drac (d. 1436), within its religious and social context.[56] The most thoughtful and detailed treatment of the tomb of kinship as a type appeared in a few pages of one of Adelin de Valkeneer's articles on Gothic tombs in Belgium.[57] He recognized that this was the main type employed by the nobility in the Low Countries during the Gothic period, but he dealt specifically only with tombs in Belgium, and unfortunately his studies have found little recognition in the general literature. However, his observations on the Belgian tombs are valid for kinship tombs in general, and his work has been an invaluable aid to the present study.

In England, where the largest number of tombs survives, historians have long recognized that family members are represented in the "weepers" decorating the tomb chests.[58] But most twentieth-century historians have considered the English tombs the direct descendants of French ceremonial tombs and hence evocative of funeral rites.[59] They have thus disregarded the correlation between chantry commendations and family members represented on tombs, and the dynastic emphasis in such tombs as those of Philippa of Hainault and Edward III at Westminster Abbey, where a significant number of the personages represented were already dead at the time of the royal funerals.[60] Andrew Martindale has interpreted these tombs as "intrusions of the secular into sacred spaces," a view that accords with my own in recognizing that funerals are not portrayed, although the nuances of his interpretation differ from mine, and his analysis of particular programs is often inexact.[61]

The confusion in the literature between the kinship and the ceremonial tomb is understandable, since family members were present at funerals, and they are sometimes recognizable on ceremonial tombs from either their costumes or their position in the procession, or both. Moreover, the genealogical display on a tomb chest cannot be completely dissociated from the funeral ceremony and certainly not from those paraliturgical aspects of late Gothic funerals that included placing shields of the deceased's ancestors on the wooden canopy erected in the choir to shelter the effigy or the coffin during the funeral service,[62] the offering of family shields, and a recitation of the deceased's genealogy.[63] And the famous tomb of Philippe Pot from Cîteaux, now in the Louvre, may reflect a practice in which shields referring to the lineage of the deceased were carried by pall-bearing mourners.[64] But the main theme of the kinship tomb is not a specific event, but family structure, and beyond the religious and affective associations suggested by Lady Montacute's tomb and chantry, these tombs are often reflections of the political reality of family relations under the feudal system. In contrast to the ceremonial tomb, family members are not bound by time or specific circumstances, although they sometimes do express emotion or pray by the early fourteenth century. Their dress and attributes are not necessarily appropriate for a funeral ceremony, but reflect social standing.

In the chapters to follow, I shall discuss the development of the tomb of kinship as an iconographic type from its inception in the thirteenth century in France through its peak in the fourteenth and its vulgarization and aftermath in the fifteenth. My study will demonstrate that in England, at least, this type reached a climax of opulence and popularity in the tombs commissioned by the Crown, the court, and the knights of the shires in the fourteenth century. Elsewhere the record is more fragmentary, and I have not been able to trace such a clear development. But the material collected is extensive enough to suggest the widespread occurrence of the type, and I hope that it will enable many still unidentified examples to be recognized and placed in their proper historical and liturgical contexts.

Genesis: Early Thirteenth-Century Family Tombs in Champagne and Brabant

THE EARLIEST TOMB of kinship that can be set in a meaningful historical context was erected for a young count of Champagne, Thibaud III, in the collegiate church of Saint-Etienne in Troyes after his death in 1201.[1] Saint-Etienne had been founded in 1157 by the count's father, Henry I, the Liberal, as part of the comital palace complex.[2] Count Henry's own tomb, covered in gilt and enameled bronze, copper, and silver, already stood on the north side of the choir of Saint-Etienne when his son's monument was placed in line with it nearer the altar.[3] Raised on a common plinth, the tombs functioned as a pair, for they sealed the foundation of the church and formed the focus of the anniversary celebrated for the founder until the Revolution.

The tomb of Henry the Liberal is known from a detailed description made by a canon of Saint-Etienne, Jean Hugot, in 1704, and from two engravings based on a pre-Revolutionary drawing (Fig. 1).[4] The count was represented lying within a shrinelike open chest, with his hands folded in prayer and his eyes open, expressing, as will most of the effigies to be discussed, the eternal rest petitioned in the Requiem Prayer of the Office of the Dead.[5] He was dressed in his robes of state, a long belted tunic and a mantel, and, according to Canon Hugot, wore a skullcap rather than a crown over his short curly hair. Above the effigy, a cover framed by the chest entablature was decorated with a cross in five compartments, in the center of which was a small enamel figure of the prophet Isaiah carrying a tree, whose single flower supported the dove of the Holy Spirit, signifying Isaiah's prophesy of the coming of Christ. Christ himself was represented at the base of the cross, emerging from a cloud and flanked by the sun, the moon, stars, and two angels. Above the angels, two figures represented Count Henry presenting a model of the church to Saint Stephen.[6]

An eloquent epitaph inscribed on three levels of the monument emphasized the count's foundation of the church, indicated the chronological perimeters of his life, and highlighted his virtues. It began on the inner rim of the cover frame and read around the tomb:

HIC JACET HENRICVS, COMIS COMES ILLE TRECORVM,
HAEC LOCA QVI STATVIT, ET ADHVC STAT TVTOR EORVM.
ANNOS MILLENOS CENTENOS TERQVE NOVENOS
IMPLERAS, CHRISTE, QVANDO DATVS EST DATOR ISTE;
BIS DENI DEERANT DE CHRISTI MILLE DVCENTIS
ANNIS, CVM MEDIVS MARS OS CLAVSIT MORIENTIS.[7]

1. Tomb of Henry I, the Liberal, count of Champagne (d. 1181), formerly in Troyes, collegiate church of Saint-Etienne, from A. F. Arnaud, *Voyage archéologique et pittoresque dans le département de l'Aube et dans l'ancien diocèse de Troyes,* Troyes, 1837, II, pl. 14.

Here lies Henry that courtly Count of Troyes
Who founded this place, and still remains its protector.
You had completed one thousand one hundred and twenty-seven years, Christ,
 when this donor was given;
It was twenty years short of one thousand two hundred years in Christ when Mars,
 the mediator, silenced him, dying.[8]

The epitaph continued on the fillet above the chest arcade:

ME MEVS HVC FINIS PROTRAXIT DE PEREGRINIS

FINIBVS, VT SIT IN HIS HIC SINE FINE CINIS.

HVNC DEVS IPSE TORVM MIHI STRAVIT,

VT HIC COR EORVM ME RECOLAT, QVORVM RES REGO, SERVO CHORVM.

HVNC TVMVLVM MIHI FECI, QVI FVNDAMINA JECI

ECCLESIAE TANTAE, QVAM NVNC REGO SICVT ET ANTE:

HIC MEA MEMBRA TEGI VOLO, SIC CONFIRMO QVOD EGI.[9]

My death drew me hither from foreign lands
So that my remains might be here forever.[10]
God himself made this funeral bed for me.
I watch over the choir so that here the heart of those whose affairs I rule may
 remember me.

I made this tomb for myself, I who laid the foundations of so great a church, which
 I govern now just as before.
Here I wish my members to be buried, thus I confirm what I did.

Taken literally, the lines "I made this tomb for myself, I who laid the foundations of so great a church" would imply that Henry had the tomb prepared during his lifetime, but we know from another source that his wife, Marie, was responsible for the actual commission.[11] Rather, these lines indicate that in founding Saint-Etienne, the count provided for his burial place. But more important, in indicating his burial at Saint-Etienne as confirmation of his foundation, the epitaph furnishes unequivocal evidence of the legal import of the possession of the founder's remains by the chapter. Moreover, in having the count say that he watches over the choir, and that he continues to govern the church just as he had done before, the epitaph furnishes valuable evidence of the implied continued presence of the count in his remains, and of the rationale for depicting his effigy with open eyes.

The inscription ended on the fillet just below the arcade:

HVIVS FIRMA FIDES, RATA SPES, DEVOTIO FERVENS,

MENS PIA, LARGA MANVS, LINGVA DISERTA FVIT.

HIC SVA, PLVS QVE SVIS MORIENS, SE CONTVLIT IPSVM.

HAC OPE POST TOT OPES MVNIIT AVTHOR OPVS.

CRASTINA POST IDVS MARTIS, FERIAEQVE SECUNDAE

VESPERE, SOLE SVO FECIT EGERE DIEM:

DESERITVR SOLVM; SIC SINE SOLE SOLVM.[12]

He was a man of strong faith, fixed hope, fervent in devotion,
With a pious mind, a generous hand, an eloquent tongue.
Here he offered his goods, but dying, he offered more than his goods, his very self.
With this gift after so many benefices, the founder secured the work.
The day after the Ides of March, and at vespers of the second holiday,
He made the day lack sunlight.
The country is deserted, like the land without the sun.

The epitaph is worthy of the gracious count who distributed the wealth provided by his wise rule prodigiously to the clergy, who read the Christian Fathers and the Latin classics for instruction and pleasure, and who fostered, with his consort, Marie de France, a significant and varied literary production.[13] With his effigy displayed within an open chest like a precious relic, his spirit in the choir must have been palpable. As stated twice in the epitaph, his body sealed and secured his gift to the Church of Saint-Etienne at the same time that it helped to sustain his memory in the hearts of his people. The relationship between the possession of founders' bodies and the legal existence of their foundations has been explained in discussions of early medieval foundations by both Karl Schmid and Christine Sauer.[14] Count Henry of Champagne's epitaph may be added to the body of evidence for the relationship between medieval ecclesiastical foundations, possession of their founders' remains by the communities, and liturgical intercession, with important monuments as the focus of memorial.

THE TOMB of Henry the Liberal conditions our understanding of the monument erected for his son and second successor, Thibaud III, which was designed to transfer the loyalty of the people of Champagne in turn to Thibaud's own son, Thibaud IV, the future poet prince, Thibaud le Chansonnier. Born shortly after his father's death in 1201, the young Thibaud was to pass his youth at the court of Philip Augustus, while the county was ruled by his mother, Blanche de Navarre, and his inheritance energetically and sometimes violently contested by his cousin, Philippa de Champagne and her husband, Erard de Brienne. Philippa's father, Count Henry II of Champagne, had ceded his rights to the county to his younger brother, Thibaud III, on departing for the crusade in 1190, in the event that he did not return. After marrying the heiress of the Kingdom of Jerusalem in 1192, Henry was elected king and remained in the Levant until his death in 1197.[15] He was survived at Acre by two daughters, whose claim to Champagne was effectively quelled by young Thibaud's mother during his minority, but not without a heroic effort aided by the pope, the king of France, the archbishop of Reims, and the majority of her husband's vassals.[16] It was thus in the context of an embattled regency that she commissioned her husband's tomb as a pendant to the monument for his father in the choir of Saint-Etienne.

The tomb of Thibaud III is only known from Canon Hugot's description, but we may deduce from it that the tomb was based on his father's in many respects.[17] The canon says that the chest had the same dimensions, was raised on a similar pedestal, and was articulated by four major arches on its long sides, with one on each end. But unlike the old count's tomb, its arches were closed and framed statuettes of family members identified by inscriptions. Above them, the chest cover now supported the effigy of the count. Although the description suggests that the architectural decoration followed Count Henry's tomb closely, the tomb as a whole was richer, with silver figures and trim predominating instead of gilt bronze.

Two primary actions of Count Thibaud were related in the epitaph that began on the band framing the effigy: his vow to go on crusade and his endorsement of his father's foundation:[18]

HAC DEVS VRBE MORI MIHI CONTVLIT VT GENITORI,

IVDAEAM PENETRARE, PIVM VOTVM, MEDITANTI SOLVERE;

QVOD VOVI DOMINO, PROBAT ISTA FIGVRA.

VT REQVIES DETVR MIHI, QVI LEGIT ISTA, PRECETVR.

FILIVS HOC TVMVLO GENITORI PROXIMVS HAERET,

MVNIAT VT STEPHANO DVPLICI SVA DONA SIGILLO.

ANNIS A CHRISTO COMPLETIS MILLE DVCENTIS,

ME, CAPVT AEVI, FINIS MAII CLAVDIT IN VRNA.[19]

God ordained that I die in this city like my father,
While planning to fulfill the pious vow to enter Judea, a vow to God that my image
 illustrates.[20]
May whoever reads this pray that peace be given to me.
The son abides close to his father in this tomb,
So that he might secure his gifts to Stephen with a double seal.
One thousand two hundred years after Christ
At the beginning of the century, the end of May closes me in a vessel.[21]

Like his father, the count was represented as a magnate in a long robe of state girded with a jeweled belt, from which a purse emblazoned with his arms was suspended. Over this he wore a still longer mantel, and as further marks of his rank, he wore bracelets and a jeweled coronet. His eyes were open and he held a pilgrim's staff as the attribute of the intended leader of the Fourth Crusade.[22]

As on Count Henry's tomb, the epitaph continued on two fillets encircling the sides of the chest, one above the arcade framing the family members, the other below. The upper inscription alluded specifically to Count Thibaud's son and heir who was represented with his sister on the chest's north side:

TANTA PALATINO NE PRINCIPE TERRA CARERET,
TRANSIT IN HAEREDEM VITA PATERNA NOVVM.
QVI PVER, VT PHOENIX, DE FVNERE PATRIS ABORTVS,
CONTINVET PATRIOS IN SVA JVRA DIES.
DAMNA REDEMPTVRVS CRVCIS ET PATRIAM CRVCIFIXI,
STRVXERAT EXPENSIS, MILITE, CLASSE, VIAM.
TERRENAM QVAERENS, COELESTEM REPPERIT VRBEM;
DVM PROCVL HAEC PETITVR, OBVIAT ILLA DOMI.[23]

So that so great a land not lack a palatine prince,[24]
Let the father's life pass into a new heir,
A boy who, sprung from his father's ashes like the phoenix,
Might continue his father's days in his courts.
Intending to redeem the injuries to the cross and the country of the crucifixion,
He had prepared the way with funds, an army, a fleet.
Seeking a terrestrial, he found a celestial city.
While the one is sought from afar, the other meets him at home.

The inscription ended on the fillet below the arcade. It addressed first the count, buried below, and then the viewer:

HOC, THEOBALDE, LOCO RECVBAS LVCTAMINE FORTI,
MORS VITAE, PRO QVO CONFLIXIT, VITAQVE MORTI;
VICIT IN HAC LITE VITAM MORS INVIDA VITAE:
INTVLIT INVITE VIRES ET ADEMIT EI TE;
QVA TIBI RVMPENTE FLORENTIS [25] FILA JVVENTAE,
VIM FACIT AETATI NIMIS AVSA LICENTIA FATI.
IVDAICIS OPIBVS INOPES RELEVANDO FIDELES,
PRINCIPIO SVMMI PRINCIPIS EGIT OPVS.
QVI LEGIT HOC, ORET PRO COMITE.[26]

In this place, Thibaud, you recline after the brave struggle
In which death fought with life, and life with death.
Death, jealous of life, conquered it in this contest,

It inflicted its force against your will and bore you away.
In ending for you the threads of a flourishing youth,
The license of fate, having dared too much, overcame your life.
By relieving the poverty of the faithful with the wealth of the Jews,
In the beginning he did the work of the supreme prince.[27]
May whoever reads this pray for the count.

The family members represented on the tomb were identified by inscriptions and the emblems of their rank or distinguishing attributes. They represented Count Thibaud's wife and two children, his mother and father, and his and his wife's siblings, all ranged between the kings of England and France (Fig. 2). Three of the identifying inscriptions are particularly meaningful. That above the figure of Count Henry described him as the builder of the church:

HIC EST HENRICVS, THEOBALDE, TVI GENITIVVS,
QVI FVIT ECCLESIAE PRAESENTIS COMPOSITIVVS.[28]

This is Henry, Thibaud, your father,
Who was the constructor of this church.

The inscription above Thibaud's wife, Blanche de Navarre, proves that she was responsible for the tomb:

HOC TVMVLO BLANCHA, NAVARRAE REGIBVS ORTA,
DVM COMITEM VELAT, QVO FEREAT IGNE REVELAT.[29]

With this tomb, Blanche, descendant of the kings of Navarre,
Reveals the ardor of her love while concealing the count.

That above his two children reassured his subjects of the continuance of his line:

DAT PRO PATRE DVOS DEVS HOS FLORES ADOLERE,
VT TIBI VER PACIS, CAMPANIA, CONSTET HABERE.[30]

God gives these two flowers in propitiation for their father
So that the springtime of peace may continue to abide with you, Champagne.

Three of the kings (France, Jerusalem/Cyprus, Navarre) were crowned, while the fourth (England) carried his crown as attribute. Two of them (France, Jerusalem/Cyprus) are mentioned as carrying scepters. Henry the Liberal carried a model of the Church of Saint-Etienne, emphasizing again his foundation, while Blanche de Navarre carried a model of the tomb. Bur assumes that the figures functioned as mourners as well as family members, but there is nothing in the description to suggest this, and it would be counter to all known thirteenth-century tombs of the type for the family members to have served a double function.[31] Rather, the emphasis appears to have been entirely on the House of Champagne as embodied in the person of the count and his immediate family, with their nobility emphasized by the presence of four kings to whom they were related.[32] Bur has suggested that the living family members represented a bud-

ding advocacy around the widow and her young children that included her brother, Sancho VII of Navarre.[33] June Hall McCash argues that the king of England at the head of the tomb, who was carrying his crown rather than wearing it, would have represented Count Thibaud le Grand of Champagne (d. 1152), rather than his younger brother, Stephen of Blois, who outdid him for the English throne. She also points out that the king of Spain might have portrayed Blanche's father, instead of her brother, thus representing the line of descent from her father to her son, who would eventually inherit the Kingdom of Navarre.[34] It seems quite possible that the identification of these statuettes, like that of a king of France at the foot of the tomb, was left imprecise deliberately, so that they could be identified according to political exigency, especially since the identification of all the other statuettes is unambiguous.

Taken together, the tombs of Henry the Liberal and Thibaud III of Champagne demonstrate the central place the founder's tomb occupied in a medieval religious institution. Crafted in precious materials, the monuments must have evoked an almost sacred veneration of the founders by their beneficiaries. We know that even into the eighteenth century, the tombs were the focus of the celebration of the founder's anniversary. According to Courtalon, writing before 1783, this began on the eve of the anniversary at the hour of compline with the singing of the Office of the Dead and the censing of the tombs. The Divine Office and a high mass were sung on the following day in honor of the founder. After the hour of sext, commendations were made, accompanied by continual censing of the tombs. They were censed again during the singing of a high Mass for the Dead, followed by the recitation of the Penitential Psalms. During the mass of the day that followed, a pittance was distributed to those canons who had attended the vigils, commendations, and Mass of the Founder.[35]

Although, as Bur has suggested, the monument's hidden message would seem to have been dynastic, as a natural response to the circumstances under which it was commissioned, the religious function of the monument was certainly paramount. Both Gerhardt Schmidt and Christine Sauer have recently emphasized the relationship between the medieval perception of saint's relics and the tomb of a venerated founder.[36] At Troyes this is particularly evident in the tomb of Henry the Liberal, for not only was his effigy displayed within the tomb chest like a holy relic, but its cover bore a parallel image of a cross framing figures of Isaiah, Christ, and Count Henry with Saint Stephen.[37] These images sanctified the count's gift to Saint-Etienne at the same time that they sheltered, both literally and figuratively, his effigy and body. Moreover, the figure of Isaiah holding a flowering tree from which issued the Holy Spirit might eventually be seen as a sacred prototype for the family tree that appeared on the accompanying tomb of Count Thibaud. It is no coincidence that the description of these early tombs reminds us of reliquaries, for they vividly represent the transfer of the sacred art of the Christian altar to the sanctified tomb of the Christian layperson.[38]

Closely related in form to Ottonian and Romanesque portable altars,[39] the tomb complex at Troyes finds a meaningful ideological parallel in a somewhat later cross reliquary from Saint Mathias in Trier that was fashioned to contain a fragment of the cross that the nobleman, Henry of Ulm, gave to the abbey in 1207 on his return from the Fourth Crusade.[40] This panel reliquary in gilt silver and copper exhibits the wood of the cross and the relics of twenty saints

N▷

Gr. U. ?

	KING of ENGLAND Stephen of Blois? d. 1154	

W

Sr.	SCHOLASTIQUE de CHAMPAGNE C. of Vienne d. 1221	S1		N1	MARIE de CHAMPAGNE C. of Flanders & Hainault d. 1204	Sr.
F.	HENRY I C. of Champagne d. 1181	S2	THIBAUD III Count of Champagne d. 1201	N2	BLANCHE de NAVARRE C. of Champagne d. 1229	W.
M.	MARIE de FRANCE C. of Champagne d. 1198	S3		N3	MARIE de CHAMPAGNE THIBAUD de CHAMPAGNE d. 1234	Da. S.
B.	HENRY II K. Elect of Jerusalem d. 1197	S4		N4	SANCHO VII K. of Navarre d. 1234	B.-in-l.

E

	KING of FRANCE Louis VII ? d. 1180	

Gf. ? after Bur

2. Program of the tomb of Thibaud III, count of Champagne (d. 1201), formerly in the Church of Saint-Etienne, Troyes.

3. Back of cross reliquary, Trier, St. Mathias.

on the front and a rich image of donation on its gilt and engraved copper back (Fig. 3). Here a *Majestas Domini* is framed by a rhomboid from whose corners flowering branches issue to form a cross, suggesting a tree of life, while Evangelist symbols inhabit medallions between its arms and branches. The panel is bordered at the top and the bottom by arcades framing standing figures. In the upper arcade, an enthroned Virgin and Christ Child are flanked by six saints whose relics are displayed on the front of the reliquary. Below, the two patron saints of the monastery, Matthew and Eucharias, are flanked by four benefactors holding disks alluding to transfers of property to the abbey, which is represented by an abbot and prior in the outer arches.[41]

The reliquary furnishes a frame of reference for understanding how the Champagne tombs could be viewed as a unit expressing the relation of the founder's body to his foundation. In an arrangement paralleling that on the back of the reliquary, Henry's gift of a church to Saint Stephen on his tomb cover was subordinate to a cross envisioned as a tree of the Holy Spirit, suggesting that his donation should be viewed in the context of the fruits of the spirit. Henry's effigy below bore the same relation to his actual remains that the images of the saints on the back of the Trier reliquary bear to the relics displayed on the front. His tomb attached a vision to the remains buried below it. The second tomb, for Count Thibaud, illustrated that with his gift to Saint Stephen, Henry had provided a legacy for his family, a legacy endorsed by his son, whose vow to go on crusade further enhanced his gift. Placing representations of Thibaud's children on the tomb chest thus seems to have been designed to suggest that the infant Thibaud's succession was part of the Divine Order. Although an exact date for the tomb is lacking, it is perfectly logical to see its commission as an additional measure taken by Blanche de Navarre to ensure her son's inheritance while she served as regent, from 1201 until 1222.[42]

4. Tomb of Adélais, countess of Joigny (d. after 1195), formerly in the church of the Abbey of Dilo. Joigny, Church of Saint-Jean.

THE FAMILY tomb complex of the counts of Champagne in Saint-Etienne at Troyes must have made an unforgettable impression on the young count's subjects. Thus it is not surprising that the earliest surviving tomb of kinship is located on the Champagne border, and was erected in memory of the mother of one of the count's vassals, Guillaume, count of Joigny. Companion of Count Henry II of Champagne on the Third Crusade, Guillaume de Joigny was one of the prominent barons of the Champagne contingent after his return from the Levant in 1198, during the minority of Thibaud IV and the regency of Blanche de Navarre.[43] The tomb (Fig. 4) for his mother, Adélais de Nevers, has long been recognized as one of the finest examples of French sepulchral art of the thirteenth century, but its displacement after the Revolution and the subsequent destruction of its original setting have compromised its cultural congruity; its history has been further confused by errors in documentation and stylistic perception.

The monument evolved from the association of the counts of Joigny with the Praemonstratensian cloister at Dilo, in the forest of Othe, roughly twenty kilometers northeast of their castle at Joigny. An early offshoot of the reform initiated at Prémontré by Saint Norbert in 1120, the canons at Dilo had received their initial charter of foundation from the king of France, Louis VI, in 1132, with the viscount of Joigny as one of the witnesses.[44] This was followed by subsequent grants and concessions from the archbishop of Sens and King Louis VII, various donations of land from the local gentry, and the protection of Popes Eugene III and Anastasius IV.[45] In 1164, Guillaume de Joigny's father, Renard IV, affirmed his protection of the canons with a series of exemptions and asked in return to be entered in their necrology.[46] Other donations to the abbey followed and were confirmed by his wife Adélais in 1172.[47]

5. Crécy-la-Chapelle, collegiate church, triforium of east bays of the nave.

After succeeding his father, Guillaume de Joigny followed his example by ceding an annual rent to the canons in 1179, in exchange for brotherhood in the community and the celebration of masses for himself and his family.[48] The transaction was approved or "lauded" by his wife, *Aalaat,* and his brother Gaucher.[49] He indicated in the same charter his desire to be buried at Dilo.[50] Just before leaving on crusade in 1190, Guillaume gave a vineyard at Joigny to the canons, to provide a lamp perpetually at the high altar of the church and eventually to ensure the celebration of his anniversary as well as those of his family. The gift was made with the provision that his mother would keep the vineyard as long as she lived and so wished, but that upon her death, it would revert to the abbey. Adélais herself lauded the charter of 1190.[51] When she died, probably shortly after she ceded the vineyard to the abbey in 1195, Adélais was buried at Dilo, and eventually the tomb that stood until the Revolution within a shallow arch on the north side of the abbey church choir was erected in her memory.[52] Victor Petit admired it there, honored it with two lithographs (Fig. 6), and recorded its dismantling and subsequent preservation in the collegiate church of Saint-Jean in Joigny.[53] With a wonderful article Louise Pillion brought the monument to the attention of a wider public in 1910, and it has since figured in most histories of Gothic sculpture or medieval sepulchral art.[54]

Countess Adélais's monument is a limestone tomb chest covered by a monolithic stone slab with the effigy of the lady carved in relief on top (Fig. 7). Like the effigies at Troyes, the countess's bearing is alert, for although she is recumbent, with her head resting on a pillow and her feet against a sweetbrier-bordered plinth, her eyes are open as she folds her hands in prayer. The faithful hound at her feet also seems watchful as he gazes toward her. She wears, befitting a countess, a long, belted gown fastened at the neck with a fibula and encircled with a jeweled belt from which a small purse is suspended. A mantle and a fluted touret with chin strap complete her costume.

The arcade that frames the tomb chest on three sides shelters figures in relief at the head and on the front.[55] Pillion suggested that the figures of two lords and two ladies on the front

6. Tomb of Adélais, countess of Joigny (d. after 1195), formerly in the church of the Abbey of Dilo. Lithograph by Victor Petit in Arcis de Caumont, *Abécédaire,* Paris, Caen and Rouen, 1850, 279.

represent Adélais's four children: Guillaume, who succeeded his father as count of Joigny; Agnès, wife of Simon de Broyes; Hélissent, wife of Milon IV, count of Bar-sur-Seine; and Gaucher, lord of Châteaurenard and seneschal of Nevers.[56] This would seem likely in the context in which the tomb must have been erected, and the figures are commensurate in attire and attitude with family members on later tombs of kinship. Reading from left to right (Fig. 4), they represent a lord clad in a belted tunic and mantle and holding a pair of gloves, no doubt the elder son, Guillaume, count of Joigny, occupying the place of honor at the head of the tomb. The lady next to him, who demurely holds a book, is much less imposing than her coquettish sister to the right, who draws attention to her mantel as she catches its strap with one hand and lifts its train with the other. These would be Guillaume's sisters, Agnès and Hélissent de Joigny, the latter the countess of Bar-sur-Seine. The fourth figure, a falconer, represents the favored noble pastime, as he quiets the hawk perched on his left hand with a lure held in his right.[57] He must represent the younger son, Gaucher de Joigny.

On first glance, the relief at the head of the chest (Fig. 8) seems to echo or expand the courtly ambiance suggested by the demeanor of the family members on the front. Here a charming young prince stands smiling in a leafy bush whose trunk is being gnawed by two dragons. Pillion recognized the image as an abbreviated illustration of a tale from the Eastern prose romance *Barlaam and Josaphat,* one of the most popular stories of the Western Middle Ages after its transmission to the West from Byzantine sources.[58] Influenced by the Buddha legend, the story describes the education and conversion of a young Indian prince, Josaphat, by the Christian hermit, Barlaam. To instruct the prince, Barlaam recounts a number of parables, none so popular

8. Parable from *Barlaam and Josaphat*. Tomb of Adélais, countess of Joigny (d. after 1195), formerly in the church of the Abbey of Dilo. Joigny, Church of Saint-Jean.

7. Tomb of Adélais, countess of Joigny (d. after 1195), formerly in the church of the Abbey of Dilo. Joigny, Church of Saint-Jean.

as the "Man in the Bush or Tree." In the tale, Barlaam compares those people who neglect the Lord's commandments, to serve the world, to a man fleeing a unicorn (death), who, falling into an abyss (the world), manages to catch hold of the branch of a bush (his life), only to discover that the roots of the bush are being gnawed away by two mice, one white (day), the other black (night). Then he sees a terrible dragon (the mouth of hell) eyeing him, and four worms (his own constitution) emerging from the sides of the abyss. But, looking up at the bush, he notices that drops of honey (worldly delight) are dripping from its branches, and forgetting the dangers surrounding him, he loses himself in pleasure.

After being translated into Latin in the eleventh century, the story gained a general reception by the twelfth in the version known as the Vulgate.[59] An exaltation of Christian monasticism promoted by a clergy intent on opposing the influence of contemporary courtly literature, it was subsequently translated into most Western European languages.[60] The inclusion of a French translation of *Barlaam and Josaphat* in a *Life of the Holy Fathers* dedicated to Blanche de Navarre during her reign as countess of Champagne (1199–1229) suggests that by the early thirteenth century, the epic was part of the monastic and courtly culture of Champagne, and therefore would have been available to an artist working at Dilo.[61] The condensed version of the parable on Countess Adélais's tomb, though unique in tomb art as far as we know, fits logically within the promotion of this moralizing tale by reforming monks. Neighboring a courtly representation of the lady's family, the image expresses a benevolent concern for their welfare in warning of the dangers of worldliness.

WHILE PILLION signaled the tomb's family program and identified the unusual representation of the tale from *Barlaam and Josaphat*, she failed to convincingly place the monument in a historical context, although she alluded briefly to the fascinating situation that most probably stimulated its creation.[62]

This revolved around Guillaume de Joigny's burial site. In spite of his wish, expressed in 1179, to be buried at Dilo, at his death in 1221, his body was claimed by the monks of the cluniac priory in Joigny, a comital foundation where his forbears were buried.[63] The canons at Dilo protested, and in the altercation that ensued, they presented the charter of 1179, in which the count had expressed his desire to be buried at Dilo, but they eventually relinquished their claim, in 1224, in exchange for a beneficial settlement from the priory.[64] This would seem to have been a propitious moment for the erection of an important tomb at Dilo in honor of the comital family, and representing the count and his brother and sisters on their mother's tomb would have been a graceful gesture toward the survivors, designed perhaps to attract further burials and benevolences. Thus, it seems most likely that the tomb of Countess Adélais was intended to be the focus of the canons' prayers for her and other members of the comital family, and that the canons themselves saw to its creation.[65]

A date for the tomb relatively soon after the 1224 settlement may be consistent with the style of the monument, although this has not been generally recognized.[66] Pillion herself dated it to the 1250s, basing this date on costume and the style of the figures and the architecture. Her chronology has influenced all subsequent writers, and Willibald Sauerländer even placed

9. Fragment of the Last Judgment portal, Cathedral of Notre-Dame, Paris. Paris, Musée national du Moyen Age-Thermes de Cluny.

the tomb as late as circa 1260.[67] But Pillion cited no completely satisfactory stylistic parallels for the monument, and those suggested by Sauerländer seem more likely to represent a later development of the stylistic current that was in its earliest stages at Joigny. Indeed, the closest parallels to the main style at Joigny, seen in the effigy and the figures on the front of the tomb chest, are to be found neither in Champagne or Burgundy where Pillion searched, nor in Reims, as suggested by Sauerländer, but in Paris.

The link with Paris is proven by the stylistic relation of the Joigny sculpture to a fragment from the Last Judgment portal of the Cathedral of Notre-Dame (Fig. 9). The fragment, now in the Musée national du Moyen Age in Paris, was originally part of the lower lintel representing the Resurrection of the Dead, which was replaced during the restoration of the portal by Viollet-le-Duc in 1853.[68] A comparison of the head of the falconer at Joigny with the head of the figure to the far right in the fragment from Notre-Dame is sufficient to suggest that the Joigny master worked for a short time in the Notre-Dame lodge (Figs. 9–11). The structure of the head, neat and concise with a broad face, is virtually the same, and the arrangement of the hair, which is waved like a cyma over the cranium and collected in a tight roll at the nape of the neck, is identical. The mouth has the same terse lips curved in a smile like that of an archaic Greek kouros, while the eyes, more developed at Joigny, suggest that the tomb at Joigny was commissioned after the master had worked at the cathedral. Other details at Joigny, like the plain hand-

10. Detail of falconer on tomb chest. Tomb of Adélais, countess of Joigny (d. after 1195), formerly in the church of the Abbey of Dilo. Joigny, Church of Saint-Jean.

11. Detail of falconer on tomb chest. Tomb of Adélais, countess of Joigny (d. after 1195), formerly in the church of the Abbey of Dilo. Joigny, Church of Saint-Jean.

ling of the costumes, with only a few rather flat and angular folds breaking the rounded contours of the body, are matched by the costume of the trumpeting angel in the Notre-Dame fragment.

These parallels in figure style are matched by parallels between the architecture of the tomb chest and early thirteenth-century monumental architecture in the Ile-de-France and Picardy. The most striking feature of the main side of the Joigny chest is the breadth of its arches, which correspond closely to those in the triforium of the eastern bays of the collegiate church at Crécy-la-Chapelle, founded in 1202 and finished circa 1220 (Fig. 5).[69] The arch at the head of the Joigny tomb corresponds to the taller proportions of the arcade of the Amiens Cathedral dado, dating to the 1220s, or to the arch framing the effigy on the tomb of Bishop Evrard de Fouilloy (d. 1222).[70] The capitals in the arcade of the tomb chest at Joigny also suggest a relatively early thirteenth-century date for the tomb. They display a mingling of generalized foliage with specific species that Denise Jalabert has characterized as first and second Gothic flora.[71] As she observed, a mingling of the two types can be found throughout the first half of the thirteenth century, particularly in churches of the Ile-de-France influenced by Notre-Dame in Paris.

In short, taken together, both the sculpture and the architecture of the Joigny tomb point to a date in the first half of the thirteenth century, after the monks at Dilo had received their settlement from the Joigny priory. The question remaining is how soon after 1224 the project was undertaken. The fragment of the lintel at Notre-Dame that furnishes the key parallels to

12. Tomb of Henry II, duke of Brabant (d. 1248), formerly in the abbey church of Notre-Dame, Villers (Brabant). Brussels, Bibl. roy. Albert Ier, Ms. 7781, fol. 135r.

the Joigny sculpture is generally agreed to represent a departure from the dominant manner in the Notre-Dame lodge until circa 1220, the earlier style being seen notably in the Coronation of the Virgin portal on the north side of the facade and, with a somewhat slackened energy, in the archivolts and parts of the tympanum and lintels of the Last Judgment portal itself. The date of execution of this "new" sculpture has been the center of much recent discussion. Whereas a significant number of scholars have subscribed to a date in the 1220s, as persuasively argued by Sauerlander,[72] a date in the 1240s for the execution of the new sculpture and the completion of the Last Judgment portal has been advanced by Alain Erlande-Brandenburg.[73] His thesis has recently received strong support in a long article on the fabric of the portal by Jean Taralon.[74] The implications of this discussion for the history of French Gothic sculpture are significant, for if dated to the 1220s or 1230s, the Last Judgment Christ of Notre-Dame would announce the courtly manner in thirteenth-century French sculpture, a manner that was well advanced in Paris by the early 1240s, as can be seen in the figure of King Childebert from the trumeau of the refectory of Saint-Germain-des-Prés, which dates to 1239–43,[75] and by the mannered style of some of the statues of apostles from the Sainte-Chapelle, dateable to 1243–47.[76] For the moment, it seems sufficient to place the Joigny tomb between the 1224 settlement to the abbey and the statue of King Childebert, which to this writer displays a development toward preciosity that is only equaled at Joigny by the prince in the tree from the legend of *Barlaam and Josaphat*.

For although a revision of the date of the tomb of Adélais de Nevers has important implications for the history of thirteenth-century sculpture in France, especially when the *Barlaam and Josaphat* relief is taken into consideration, for the present study its chief interest lies in the tomb's early manifestation of many of the distinguishing characteristics of the courtly tomb of kinship.[77] As we shall see in the following chapters, its grace and its emphasis on the dress and manners peculiar to the ruling class were to be further developed and expanded on these tombs for two centuries.

THE TOMBS formerly at Troyes and Dilo suggest that relatives were apt to be associated in early tombs of kinship with subjects that set the theme of family continuity in a theological or moralizing context, thus adapting them to a pedagogical as well as liturgical function. Early evidence of the association of family members with religious models, or prefigurations, is furnished

13. Tomb of Henry II, duke of Brabant (d. 1248), formerly in the abbey church of Notre-Dame, Villers (Brabant). Brussels, Bibl. roy. Albert Ier, Ms. 22483, fols. 60v/61r.

by the tomb of Henry II, duke of Brabant (d. 1248), which formerly stood on the north side of the choir of the Cistercian abbey church at Villers-la-Ville (Brabant), where the duke was an important benefactor (Figs. 12 and 13).[78]

Villers, the first Cistercian house established in Brabant, was begun, according to its chronicler, by a cell of monks sent from Clairvaux by Saint Bernard himself in 1146.[79] By the middle of the thirteenth century, it had grown from a struggling outpost of Cîteaux to a thriving monastery crowned by an imposing Gothic church, supported by a vast network of possessions, and protected by the duke of Brabant.[80] Duke Henry I had shown the abbey particular favor in 1184, when he exempted it from all secular taxes,[81] and this example was followed by his son and successor, Henry II, who became a veritable advocate for the monastery.[82] In the decade before his death in 1248, Henry II was involved in founding a new abbey, Saint-Bernard-sur-l'Escaut, dedicated to Saint Bernard and under the jurisdiction of Villers.[83] This foundation, added to his protection and so many other benefices, must have qualified him in the eyes of the community for burial in their sanctuary, but there was probably another motive as well.

The epitaph inscribed on the monument emphasized the duke's military prowess in a tone of approbation that endorsed the established social order while bidding the monastic community to observe the prayers that would assist him in being admitted expeditiously to the joys of heaven:

> Mundi terrorem marmor tegit hoc et honorem,
> Qui Brabantinus dux fuit et dominus.
> Quem Deus huc misit, sub quo Brabantia risit.
> Quo vixit tuta sua gens, plebs altera muta.
> Submisit magnum quemcumque, velut lupus agnum.
> Hoc probat Aquensis,[84] Dalensis, Juliacensis.
> Corde Deum rogitemus eum cito glorificati,
> Ut per eum aethereo capiti valeat sociari
> Summa potentia gaudia caelica donat eidem,
> Cui Brabantia tota est patria subdita pridem.
> Obiit an. gubernationis Brabantie XXII.[85]

This marble covers the terror of the world and the honor.
Who was the Brabantine duke and lord.
Whom God sent here, under whom Brabant shone.
Because of whom his clan lived secure; the other, the masses, quiet.
He humbled all the great just as the wolf, the lamb.
This is demonstrated at Aachen, Daelhem (?), and Jülich.[86]
With our hearts raised to God, let us ask that he be soon glorified,
So that with His assistance, he may be able to be associated with the Heavenly
 Kingdom.
May the supreme power give him heavenly joys.
To whom all Brabant is a country subdued long ago.
He died in the twenty-second year of his rule of Brabant.

Color Plate I. Tomb of Elizabeth de Montfort, Lady Montacute (d. 1354). Oxford, Christ Church Cathedral (formerly Priory of St. Frideswide).

Color Plate II. Tomb of Marie de Bourbon, countess of Dreux (d. 1274), formerly in the abbey church of Saint-Yved, Braine (Aisne). Oxford, Bodleian Library, Ms. Gough Drgs.-Gaignières 1, fol. 79r. (Bodleian Library, University of Oxford)

TOMBEAU *de cuivre esmaillé a costé droit du choeur de l'Eglise de l'abbaye St Jued de Braine posé par moitié en dedans du choeur, moitié en dehors, il est de* MARIE *de* BOURBON *femme de* JEAN I *du nom Comte de Dreux*

Color Plate III. Tomb of Marie de Bourbon, countess of Dreux (d. 1274), formerly in the abbey church of Saint-Yved, Braine (Aisne). Oxford, Bodleian Library, Ms. Gough Drgs.-Gaignières 1, fol. 78r. (Bodleian Library, University of Oxford)

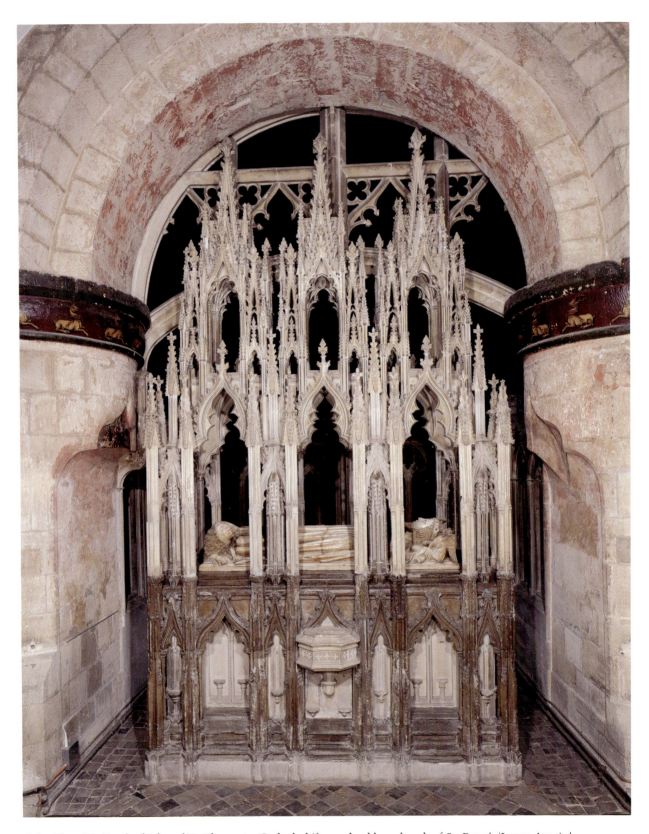

Color Plate IV. Tomb of Edward II, Gloucester Cathedral (formerly abbey church of St. Peter). (James Austin)

The militaristic tone of the epitaph reflects the political situation on the borders of Brabant in the High Middle Ages and the monks' reliance on the dukes of Brabant for support and protection against the control of their seigneurial neighbors. In 1957, Georges Despy dispelled the obscurity that had surrounded the founding of the abbey almost from the outset by uncovering evidence of the deliberate suppression of a charter of 1153, confirming the gift of part of the alodium of Villers to the monks by a local noble, Gauthier de Marbais, and his mother, which proved that they were the original founders of the monastery.[87]

Vassals of the count of Namur, the Marbais gradually strengthened their ties to the count in the course of the twelfth century while distancing themselves from the duke of Brabant in response to his expansionism on their border. At the same time, the monks at Villers aligned themselves with the duke, probably in order to escape the claim of an advowson by the Marbais.[88] Henry II was the first Brabantine duke to be buried at Villers. His tomb on the north side of the church choir, a place usually reserved for founders, would have suggested that he or his forebears had actually founded the monastery, and thus his tomb would have contributed to the monks' deliberate obfuscation of their real founders. But the program of the tomb suggests that they felt the need for even more justification for its presence in their choir.

At its inception, the Order of Cîteaux had prohibited burial within its precincts to outsiders, but gradually exceptions had been made in the course of the twelfth century, notably for founders and rulers.[89] But the issue continued to be raised, and at about the time that Duke Henry died, the general chapter of the order ratified anew the rule limiting burial in its church interiors to kings, queens, archbishops, and bishops.[90] Given this prohibition, and the history of reprimands and punishments that its violation had entailed in the past, it seems likely that the duke's tomb was designed to supercede the rule by suggesting his relationship to the *vita apostolica,* one of the founding principles of the Cistercian Order.

The monument is known from two seventeenth-century drawings in the Bibliothèque royale in Brussels. The first, showing it from the southwest (Fig. 12), is included in an anonymous compilation of texts pertaining to the abbey;[91] the other, in Charles van Riedwijck's "Sigillographica Belgica,"[92] shows it from the northwest (Fig. 13). Together they give a complete view of the tomb as it looked in the seventeenth century, since Riedwijck also shows the east end of the chest in an inset detail. A comparison of the drawings suggests that the anonymous drawing was done before a seventeenth-century restoration of the tomb, and Riedwijck's after the restoration.[93] The main work of the restorer seems to have been to strengthen the tomb's structural elements, since there are no striking differences in the representation of the figures in the two drawings but obvious differences in the representation of architectural details.[94]

The effigy of the duke, clad in belted tunic and mantle, lies praying, with his feet resting on a lion.[95] His figure is framed by a Gothic canopy and flanked by censing angels.[96] At the head of the chest, a crowned and enthroned figure, no doubt the Virgin Mary with the Christ Child, is flanked by kneeling and censing angels.[97] The foot of the chest was decorated with a relief representing the soul of the duke as a small figure crowned and kneeling in a shroud held by two angels, obviously reflecting the *subvenite,* the anthem or response for the moment of death from the ancient Roman ordo: "Come help, saints of God; hasten, angels of the Lord, receiving his soul, offering it before the highest one."[98]

Linking the two ends, the long sides of the chest were decorated with an arcade framing standing male figures. According to the legend on Riedwijck's drawing, they represented the ancestors and relatives of the duke. He even identified two knights by the shields they bore as Duke Henry's father, Henry I, duke of Brabant, and his uncle, William of Perweys.[99] His drawing actually appears to represent an apposition of knights and apostles, for he represents three bearded figures clad in long robes carrying books, followed by three knights in chain mail bearing shields. The earlier drawing shows the same arrangement on the other side of the chest, with the important detail that the first of the robed figures carries a key that identifies him as the apostle Peter, suggesting that the other robed figures represented apostles also. Although Riedwijck overlooked this important element in the tomb's iconography, he was apparently correct in identifying the knights as the ancestors and relatives of the duke, for the shields held by the last two knights in the earlier drawing are partially blazoned, one with a golden lion, the other with *Gules, a fess.* These shields correspond to the coats indicated by Riedwijck for these two figures, one carrying a shield emblazoned *Sable, a lion Or,* for the duke's father, Henry I, duke of Brabant (d. 1235), the other with a shield blazoned *Gules a fesse Argent* for his uncle, William, sire of Perweys and Ruysbroeck (d. 1233).[100]

Read as a whole, the figures represented on the chest display a hierarchy beginning at the head with a votive image of the Virgin and Christ Child, then descending on both sides where the apostles precede the relatives of the duke, and ending at the foot where his soul is supported by angels.

The apposition of Henry's warrior relatives to the apostles reflects the two kinds of Christian service outlined by Carolingian churchmen, to serve and to defend the faith.[101] Its iconological roots are probably in the separation of ecclesiastical and military saints on Byzantine ivories as seen, for example, on the Harbaville triptych,[102] but the choice of these figures also probably reflects the situation of the abbey relative to the ecclesiastical and secular authorities. Its abbots had obtained exemption from diocesan jurisdiction at the end of the twelfth century;[103] hence they were subject only to the pope, which would explain the specific identification of Saint Peter at the head of the apostles on the tomb chest. This apostolic authority is followed by representatives of civil protection, in this case, apparently Henry II's ancestors. Moreover, in an abbey begun by Saint Bernard, the association of Christian knights with the apostles would have been a natural continuation of their association with the evangelical promotion of the Crusades.[104]

The Life of the Apostles (*Vita Apostolica*) had inspired most of the reform movements of the twelfth century, including the foundation of the Cistercian Order itself.[105] After the election of a Cistercian to the papacy in 1145, in the person of Eugene III, a former pupil of Saint Bernard at Clairvaux, Bernard and, consequently, the Order, became directly involved with launching the Second Crusade, a precedent that was to be followed not only in subsequent crusades against the Saracens in Palestine but also against heretical movements in Europe.[106] Duke Henry I of Brabant had taken the cross and gone on a token crusade to Palestine in 1197, while Henry II himself led a "crusade" into Friesland in 1234, against a religious sect called the "Stadingers," who were accused of heresy.[107] Thus it seems probable that the other warriors represented on

the duke's tomb were crusaders or relatives who had supported the abbey, thereby representing the collaborative endeavor of the monks at Villers and the Brabantine ducal family to realize the apostolic calling for both clergy and nobility. Seen from this perspective, the tomb identified the duke with the mission of the monastery and the Cistercian Order.

In its obvious exaltation of military virtues and ideals, the tomb of Henry II furnishes an important precedent for the kinship tombs of territorial lords. Moreover, the hierarchy exhibited on its chest establishes a clear progression from head to foot. As we shall see in the following chapters, this was to be the normal order observed in projecting family structure onto Gothic tomb chests. The use of blazoned shields to identify Henry II's relatives follows the practice that had appeared on the battlefields of Europe and the Near East in the preceding century, and had already been used on tombs to identify effigies and, more rarely, their family connections.[108] Used here to refer to a particular family member, it introduces a convention that was to be an important element on subsequent tombs of kinship.

THE RECOGNITION that the earliest tombs of kinship were erected for the founders or great benefactors of ecclesiastical institutions is fundamental to understanding their genesis and subsequent development. These monuments reflect the obligation and gratitude that the spiritual communities owed, and usually bestowed on, founders and advocates. While the epitaphs of the Champagne counts made the legal bond sealed by the physical remains of the counts evident to all the literate, the placement of Countess Adélais of Joigny on the north side of the church choir at Dilo and Henry II of Brabant in a comparable place at Villers demonstrated that these benefactors, with their families, held an equally important place in the memory of these communities.

These three early tombs suggest that although they were formed within a theological matrix, tombs illustrating kinship were emerging by the middle of the thirteenth century equipped with effective conventions for identifying family members. Already at this early stage, a family might include several generations, with emphasis on illustrious lineage and the line of descent, as seen on the tomb of Count Thibaud. As we shall see in the next chapter, the order of the figures would eventually reflect successive generations and sometimes different sides or branches of the family. As the type developed, the conventions for identifying family members would remain the same. Inscriptions would continue to be used occasionally until the fifteenth century, but the use of armorial shields, and in the fourteenth century, armorial dress, was to be much more common. On tombs that emphasized the military duties of the nobility, notably on solitary tombs for knights, family members were apt to be exclusively male, or at any rate, arranged according to gender, with the males clad in armor and carrying the shields that identified them, as in the tomb of Henry II of Brabant. On tombs for ladies, and later for lords as well, the shields were placed near the figures they identified, while family members were more apt to assume the graceful attitudes denoting members of a polite society, as seen on the tomb of the countess of Joigny.

[CHAPTER TWO]

The Genealogical Tomb

THE GENEALOGICAL ELEMENT in kinship tombs was given a powerful stimulus in Paris in the 1260s, with the erection of sixteen tombs in the church crossing of the Abbey of Saint-Denis in memory of the Carolingian and Capetian ancestors of the reigning monarch, Louis IX. Georgia Wright has observed that the effigies of the kings, grouped by dynasty, were originally arranged in chronological, that is, genealogical order, if considered from west to east.[1] And Caroline Bruzelius has linked the reconstruction of the church, with an enlarged transept to accommodate the tombs, to the threatened circumstances of the early reign of the young king while his mother, Blanche de Castile, was regent.[2] Elizabeth A. R. Brown has emphasized that the order of installation of the tombs reflected the specific relationship between the Capetian Dynasty and the Carolingian line that preceded it, resolving a threat posed by an old prophesy that the Capetians would reign for seven generations, and no more.[3] This remodeled royal necropolis must have made a profound impression on contemporaries,[4] and although no other noble necropolis would equal it in its time, the concern with genealogy that it displayed is reflected in the record of several tombs that can feasibly be linked to the art of the French royal court during the reign of Saint Louis.

The earliest monument in this group was outside the royal domain, again in Brabant, an imperial duchy with a cultivated court now graced by a French princess, Adelaide of Burgundy. She was probably responsible for the tomb for her husband, Henry III, duke of Brabant (d. 1261), that she was to share in the church of the Dominican monastery in Louvain. Although the Dominicans had been established in Louvain near the ducal castle since 1228, Henry III sponsored the building of a new monastery for them, with a Gothic church, on the site of the old ducal castle roughly a decade after his father abandoned it for a new castle on Mont César.[5] As reflected in the epitaphs on the tomb of Duke Henry and Countess Adelaide, the Dominicans considered the ducal couple their real founders:

> Hic subtus jacet Dominus HENRICUS ejus nominis tertius Princeps Illustris, Dux Lotharingiae & Brabantiae Sextus, hujus Claustri Fundator, & totius fundi Dotator, qui Obiit Anno Domini M.CC.LX. Ultima die Februarii.[6]

> Here below lies Lord Henry, third illustrious prince of his name, sixth Duke of (Lower) Lorraine and Brabant, founder of this cloister, and donor of all its estate, who died in the year of Our Lord 1260 (o.s.), on the last day of February.

> Hic jacet Domina ALEYDIS DE BURGUNDIA Ducissa Brabantiae ejus Uxor, istius Claustri & Claustri de Ouderghem Pia Fundatrix, nec non Ordinis Praedicatorum benigna amatrix, quae obiit anno Domini M.CC.LXXIII. XXIII die Octobris.[7]

14. Tomb of Henry III, duke of Brabant (d. 1261), and Adelaide of Burgundy (d. 1273), formerly in the Church of the Dominicans, Louvain. Brussels, Bibl. roy. Albert Ier, Ms. 22483, fol. 65r.

Here lies Lady Adelaide of Burgundy, Duchess of Brabant, his wife, pious foundress of this cloister and that at Oudergem, as well as kind friend of the Order of Preachers, who died in the year of Our Lord 1273, on the twenty-third day of October.

The tomb stood between the choir of the church and the ducal chapel to the north until 1764.[8] It has been largely destroyed. Only a badly battered tomb slab remains, showing vestiges of the effigies carved in relief, but a watercolor by Charles van Riedwijck in the Bibliothèque royale in Brussels allows us to judge its appearance in the seventeenth century (Fig. 14).[9] Riedwijck showed the effigies framed by a double canopy rising above simple side shafts, with their hands in attitudes of prayer, their feet resting on a lion and a dog. While the duke was dressed for battle, in chain mail and surcoat, his sword suspended from his shoulder, the duchess wore a barbette and veil over her dress and mantle. The tomb slab with its effigies rested on a chest with a double-gabled headpiece, where the souls of the couple represented as children were presented by angels to Christ as the Man of Sorrows and to an enthroned Virgin and

15. Fragments of the tomb chest of Philippe Dagobert, formerly in the abbey church at Royaumont. Paris, Musée du Louvre and Musée national du Moyen Age-Thermes de Cluny (on loan to the Musée du Louvre).

Child.[10] This left three sides of the chest exposed. The drawing shows a blind arcade on the north side and four gabled niches framing figures at the foot. Apparently the arcade on the north side and an analogous one on the south were also originally figured, for nineteen figures are identified in a second "epitaph" transcribed by the Belgian antiquarian Antoine de Succa in 1602, seven on the south side, four at the foot, and eight on the north side.[11] It seems most likely that Succa's "epitaph" was an affixation from a later period, and that the genealogy that it records was culled from subordinate inscriptions identifying the figures decorating the tomb chest that were at risk of destruction when the tomb was restored in the fifteenth century.

The monument was apparently already in a dilapidated state in 1435, when the Valois descendant of Henry and Adelaide, Philippe le Bon, duke of Burgundy and Brabant, financed its restoration.[12] The blind arcade seen on the long side of the chest in the drawing must be a result of this restoration, for it appears to be a denuded version of that at the foot. There, a series of trefoil arches resting on columns formed niches for figures that must have been carved in relief. The cusps of the trefoil appear to have been framed closely by gables in a manner similar to that in a relief from the tomb chest of Philippe Dagobert, brother of Saint Louis, at Royaumont (Fig. 15).[13] At Louvain, pinnacled aediculae rose above the colonnettes, a variation on the castles at Royaumont. The arcade on the long side of the Louvain tomb, with its broad, round-arched niches, must have resembled that on the end of another royal tomb at Royaumont, for Louis de France, son of Saint Louis, who died in 1260 (Figs. 16 and 17).[14] Here, where the long side of the chest represents a refinement of the gabled arcade on the tomb of Philippe Dagobert, a broad round arch supported by clustered colonnettes originally spanned the entire foot of the chest, while trefoils framed by roundels pierced the spandrels. The long side of the tomb in Louvain corresponded to the foot of the tomb at Royaumont except for the absence of figures and the unnaturally bare area above the arcade. If these differences are due to the fifteenth-century restoration of the monument, as seems likely, then the Louvain design was a variant of those at

16. Tomb of Louis de France (d. 1260), formerly in the abbey church at Royaumont. Saint-Denis, abbey church.

17. Tomb of Louis de France (d. 1260), formerly in the abbey church at Royaumont. Paris, Bibl. Nat., Ms. Clairambault 632, fol. 130.

Royaumont and probably influenced by them. The chronology of the monuments allows for such a relationship. The abbey church at Royaumont was dedicated on October 19, 1235, and it is thought that Philippe Dagobert died at about the same time.[15] His tomb has generally been dated to midcentury, but Sauerländer has suggested a date soon after 1235, on the basis of the style of the effigy.[16] This would help to explain the relative severity of the chest design, which even circa 1235, would have lagged behind contemporary monumental decoration.[17] In contrast, the obviously later tomb of Louis de France, who died in 1260, reflects decorative innovations of Rayonnant design that were largely absent in the Louvain tomb.[18] This suggests that the tomb of Henry III and Adelaide was largely dependent on the design represented by the tomb of Philippe Dagobert, and that if it was designed after the duke's death in 1261, as is likely, it was very conservative, with only a few decorative elements added to a formula of the 1230s. In addition to the design of the chest, the fact that the duke was represented as a knight in military, rather than civilian dress, also suggests the influence of French culture in Brabant by the 1260s. In contrast to the situation in France, the knights in the imperial provinces remained socially inferior to the established nobility until relatively late, when cultural models, including the enhanced prestige of knighthood, were adopted along with French courtesy.[19] Henry III's effigy, in contrast to the effigy of his father in robes of state at Villers a generation earlier, represented this change.

At thirty years of age, Duke Henry apparently died with little warning, for he left a hastily written will that made no provision for his burial.[20] The most likely person to have commissioned his tomb was his widow, who survived him for twelve years. That indeed she was responsible for the tomb is suggested not only by its design but by her construction of a new residence for herself in the vicinity of the monastery after Henry's death in order, as she expressed it, to be near his tomb.[21] If the duchess may be credited with the program, she planned it in the context of a minority. Henry left three sons at his death, all minors, and Adelaide ruled the duchy for six years until the second son, John, was recognized as duke in 1267.[22] These circumstances must have contributed to the program, which was remarkable for the depth of its genealogy and for its male dominance.

According to Succa's "epitaph," and as is demonstrated by Figures 18 and 19, eight generations were represented on the chest, seven previous to Henry and Adelaide, plus their children—a span somewhat longer than two centuries. This represents a comparatively long family memory.[23] The programmer was obviously concerned to show the male representatives of seven consecutive generations of the House of Brabant and a selective representation of Henry's mother's illustrious male ancestors. In fact, this tomb demonstrates to a remarkable degree the "agnatic principle" of inheritance, that is, through the male line, that had become the rule for the great princes in the tenth and eleventh centuries.[24] But it also reflects the ancient system of social ascent through marriages with women of more noble origin.[25] The duke's mother was descended from a race of Byzantine and German emperors, a lineage that is reflected on his tomb by a representation of her most illustrious male ancestors, including two emperors of the Salian House and Frederick Barbarossa, as well as her father, Philip, duke of Swabia, king of the

Romans. At the same time, the inclusion of four of the duke's cousins, three of them kings, demonstrates that in typical fashion, the tomb displayed his most eminent contemporary kin.[26] The cognatic line of the duke's ancestry dominated one long side of the chest, the agnatic, the other; Henry and Adelaide's children were ranged at the foot.

A review of the family program thus illustrates that the tomb was not only conservative artistically but in its choice of family members as well. In fact, this genealogy reflects the same attitude toward the women of the family, who are remarkable in their absence, that was illustrated over twenty years ago by Cinzio Violante with a genealogy of the eleventh century written by one Anselmus de Besate.[27] In constructing his family's genealogy, Anselmus never mentioned the women by their proper names but only as daughters or sisters, while kinship with great families established by marriage with their daughters was mentioned with pride. In an analogous way, Adelaide of Burgundy, sharing her husband's tomb, figured only as his consort and as the mother of the children ranged at their feet. This dearth of ladies on the tomb chest was somewhat alleviated by the program of the windows in the choir and ducal chapel. Succa sketched kneeling figures of four women relatives in the choir glass, and of Henry and Adelaide with their daughter Marie in the ducal chapel.[28]

In any event, the message of this family tomb was clearly dynastic. Ranging the children of the duke and duchess at the foot of a program that recorded seven generations of his illustrious ancestors was an obvious illustration of the succession to the duchy. Most probably erected while the heirs were yet minors, the monument is a clear reflection of the political utility of a tomb of kinship.

A FINE COUNTERPOINT to the male preponderance of the Louvain monument is provided by three women's tombs from the second half of the thirteenth century that may also have been inspired by the art of Saint Louis's court, for they were made for ladies with close ties to the French monarch. The earliest of these was the tomb of Marie de Bourbon, countess of Dreux (d. 1274), who lost both her husband, Jean I, count of Dreux, and her brother, Archambaud VIII, sire of Bourbon, on Saint Louis's first crusade.[29] Her tomb, which has recently been discussed by Andrea Teuscher and Michel Bur, formerly stood in the family necropolis, the abbey church of Saint-Yved at Braine (Aisne).[30] It is known from two drawings executed for Roger de Gaignières, seventeenth-century antiquarian in the service of the duke of Guise (Plates II and III).[31]

The countess's monument is one of the few kinship tombs in the Gaignières Collection and the earliest among them that has figures accompanying its heraldic program.[32] According to Gaignières's draftsman, the tomb was in enameled copper, a less expensive metal than the bronze and silver employed for the tombs of the counts of Champagne but equally spectacular, no doubt, with its array of blazons. Since enameled copper lent itself to heraldic display, it was a natural choice for kinship tombs by the second half of the thirteenth century, when the use of heraldry was becoming widespread. Marie de Bourbon's tomb, although extraordinary, was probably not unique, but representative of a type of monument in this period.[33] The famous casket of Saint Louis is representative of his heraldic art, and it is important to note in this context that

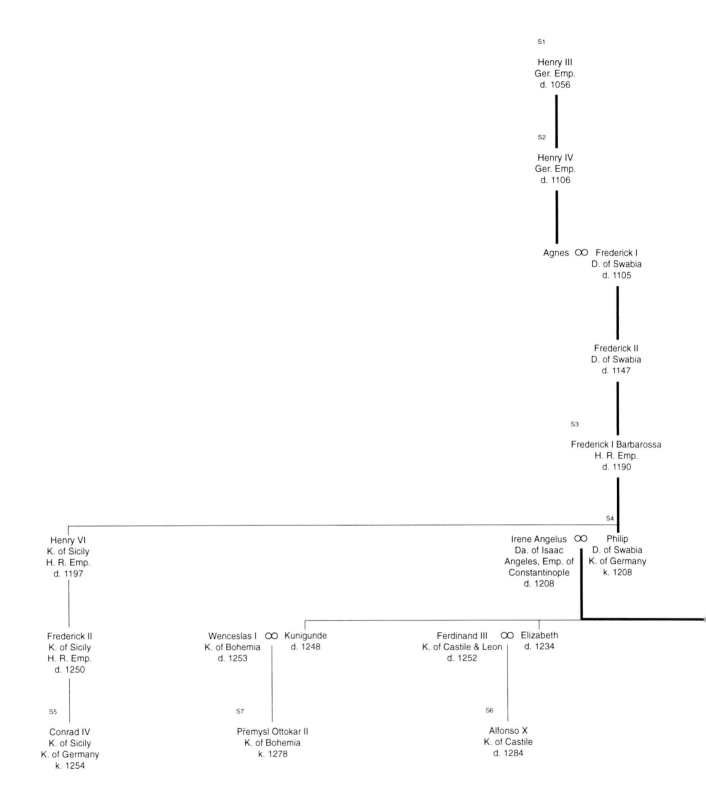

18. Genealogy of Henry III, duke of Brabant (d. 1261).

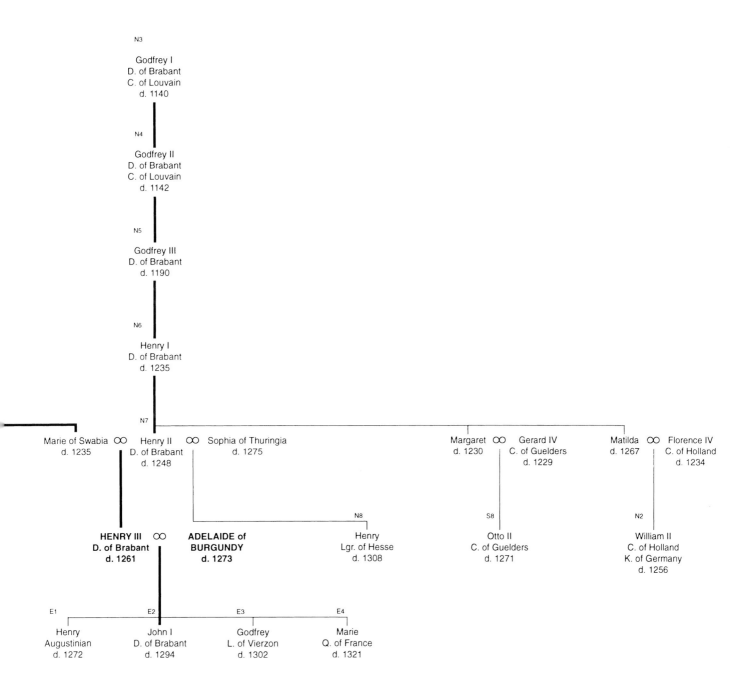

N3
Godfrey I
D. of Brabant
C. of Louvain
d. 1140

N4
Godfrey II
D. of Brabant
C. of Louvain
d. 1142

N5
Godfrey III
D. of Brabant
d. 1190

N6
Henry I
D. of Brabant
d. 1235

N7

Marie of Swabia ∞ Henry II ∞ Sophia of Thuringia
d. 1235 D. of Brabant d. 1275
d. 1248

Margaret ∞ Gerard IV
d. 1230 C. of Guelders
d. 1229

Matilda ∞ Florence IV
d. 1267 C. of Holland
d. 1234

N8
Henry
Lgr. of Hesse
d. 1308

S8
Otto II
C. of Guelders
d. 1271

N2
William II
C. of Holland
K. of Germany
d. 1256

HENRY III ∞ ADELAIDE of
D. of Brabant BURGUNDY
d. 1261 d. 1273

E1
Henry
Augustinian
d. 1272

E2
John I
D. of Brabant
d. 1294

E3
Godfrey
L. of Vierzon
d. 1302

E4
Marie
Q. of France
d. 1321

not only his two infants were buried at Royaumont beneath Limoges enameled copper plates bordered by shields, but the tomb of his mother, Blanche de Castille (d. 1252), at Maubuisson was also said to have been in copper.[34]

Thanks to the scruples of Gaignières's draftsman, we have a complete rendering of the tomb of Marie de Bourbon, which stood between the choir of Saint-Yved and the adjacent Chapel of Saint-Sébastien on its south side.[35] The effigy of Marie was shown as if standing on a capital or console against a foil of enameled lozenges displaying alternately the arms of Bourbon and Dreux, and framed by a trefoil arch.[36] Her hands were joined in prayer, and she wore a simple tunic and mantle and an important headdress consisting of a veil worn over a fluted coronet and chin strap. Her head rested on a small square pillow. The plainness of the effigy against the tessellated background throws it into relief.

An arcade of trefoil arches supported by buttressed piers surrounded the tomb chest on all four sides. Thirty-six statuettes representing members of the countess's family filled these arches and were apparently cast separately from their settings, since five had disappeared by Gaignières's time.[37] They were identified by shields bearing their coats-of-arms in the frieze above their heads and further by inscriptions in the colored band above the shields. They represented Marie's parents, Archambaud VII of Bourbon and Béatrice de Montluçon, those brothers and sisters who married, their spouses, their illustrious children and grandchildren, and Marie's own family (see Figs. 20 and 21 and Appendix II). The countess's brothers who became ecclesiastics were not included, although one clerk, Master Guillaume, son of the king and queen of Navarre, was (S11).[38] He must have been particularly dear to his Aunt Marie to have figured among the family members represented on her tomb. One wonders if he was not a member of her household and perhaps was the clerk responsible for the genealogy recorded on the tomb.[39]

The program of the tomb can be dated after March 1, 1271, when Henri I (S4) was crowned king of Navarre, since he is identified as king. Bur suggests a *terminus a quo* of 1284–86 for the program based on the absence of two great nieces and one grandchild who made brilliant alliances in these years, two by marrying kings, the third by marrying the emperor Rudolph of Habsburg.[40] The drawing is an extremely important document for charting the development of the tomb of kinship in the second half of the thirteenth century, since all of the characteristics that appear to denote the French courtly tomb of kinship are to be found here. In the first place, the record of its inscriptions allows us to state confidently that the spectator was expected to read the tomb program from head to foot. We have already seen this convention at work on the tomb of Henry II of Brabant at Villers, and it can usually be established by comparing the arrangement of figures on kinship tombs with a corresponding family tree; however, nowhere is it so effectively demonstrated as here, where the relationship of figures is often described in terms of those previously mentioned, *"desus dit"* (see Appendix II).

In every instance except at the foot, where the order is from right to left, the previously mentioned personage appeared nearer the head of the tomb.[41] The generations were carefully ordered, with the first being placed at the head of the tomb, in this case, Marie's mother and father; her peers at the sides where they were arranged hierarchically from head to foot, and her children at the foot. Couples were placed side by side, followed immediately by their children. Husbands usually preceded wives, but this was not an absolute rule, and sometimes the

	West (S)			East (N)		
Gr.(5) Gf. (cog.)	HENRY III — Ger. Emp. — d. 1056	S1		MANUEL COMNENUS — Byzantine Emp. — d. 1180	N1	Cous. of Gr. Gf. (cog.)
Gr.(4) Gf. (cog.)	HENRY IV — Ger. Emp. — d. 1106	S2		WILLIAM II — C. of Holland, K. of Germany — d. 1256	N2	Cous. (ag.)
Gr. Gf. (cog.)	FREDERICK BARBAROSSA — H. R. Emp. — d. 1190	S3		GODFREY I — D. of Brabant — d. 1140	N3	Gr.(3) Gf. (ag.)
Gf. (cog.)	PHILIP — D. of Swabia, K. of Germany — k. 1208	S4		GODFREY II — D. of Brabant — d. 1142	N4	Gr.(2) Gf. (ag.)
2nd Cous. (cog.)	CONRAD IV — K. of Sicily — k. 1254	S5		GODFREY III — D. of Brabant — d. 1190	N5	Gr. Gf. (ag.)
Cous. (cog.)	ALFONSO X — K. of Castille — d. 1284	S6		HENRY I — D. of Brabant — d. 1235	N6	Gf. (ag.)
Cous. (cog.)	PREMYSL OTTOKAR II — K. of Bohemia — k. 1278	S7		HENRY II — D. of Brabant — d. 1248	N7	F.
Cous. (ag.)	OTTO II ? — C. of Guelders — d. 1271	S8		HENRY I — Landgrave of Hesse — d. 1308	N8	Hf. B.

Center:

HENRY III
Duke of Brabant
d. 1261

ADELAIDE of BURGUNDY
Duchess of Brabant
d. 1273

	E1	E2	E3	E4	
	HENRY of BRABANT ? — Augustinian — d. 1272	JOHN I — D. of Brabant — d. 1294	GODFREY of BRABANT — L. of Vierzon — d. 1302	MARIE of BRABANT — Q. of France — d. 1321	
	S.	S.	S.	Da.	

19. Program of the tomb of Henry III, duke of Brabant (d. 1261), and Adelaide of Burgundy (d. 1273), formerly in the Church of the Dominicans, Louvain.

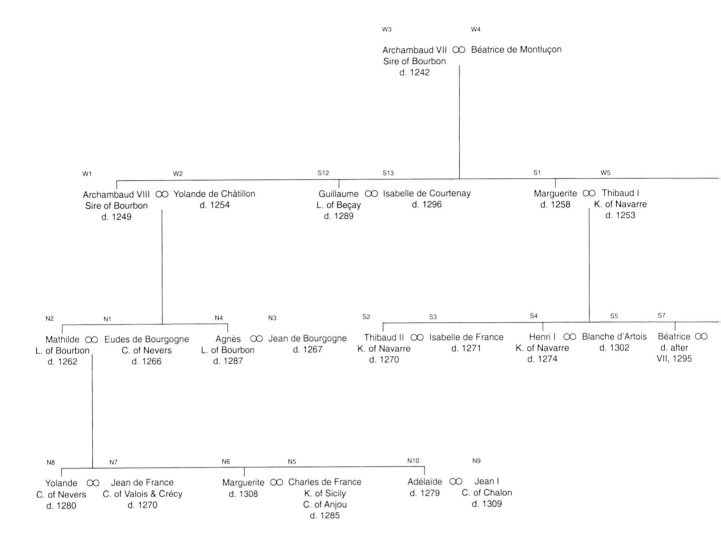

20. Genealogy of Marie de Bourbon, countess of Dreux (d. 1274).

wife was placed first, as at the head of the tomb, to ensure an alternation of lords and ladies, a concern that reflects courtly etiquette.[42] The figures in the drawings are graceful in bearing and couples turn toward one another, often with a gesture toward their partners. In arranging siblings, age seems to have determined placement except when it was superceded by rank, as in the case of Marguerite de Bourbon (S1) who, as queen of Navarre, was placed before her older brother Guillaume (S12) on the south side, or of Marguerite de Nevers who, as queen of Sicily, was given precedence over her sister Yolande on the north (N6 and 8). While the royal House of Navarre was given pride of place with Marie's Bourbon family at the head of the tomb and on the south side, precedence was given to the Bourbon line on the north side.[43] The effect of this was to relegate Marie's brother Guillaume de Bourbon, lord of Beçay, with his wife to the last places on the south side, and her sister Béatrice, lady of Mercoeur, with her husband and Marie's

own husband, Jean de Dreux, to the last places on the north, while her children with their spouses were ranged at the foot.

Bur has emphasized the feminine character of the program, which he interprets as highly personal, reflecting the medieval lady's role in social strategy as planner of social events, and thus encounters and not incidentally, a strategist in forming couples.[44] As he points out, the program of the tomb only spanned four generations, but it was remarkable in its lateral development. Included were not only the countess's siblings who married, but in the case of those branches that were particularly brilliant in their alliances, the children with their spouses were included as well. This no doubt reflects the desire of the Dreux family to demonstrate their connection to three royal houses but perhaps also speaks to the importance of the relation between Marie and her nieces. To my knowledge, the particular bond between uncles and nephews

characteristic of the Middle Ages has not been demonstrated for aunts and nieces.[45] But the program of this tomb, which so clearly illustrated the brilliant marriages of Marie's Bourbon nieces, suggests that a parallel relationship may have been normal for noblewomen. There was probably yet another reason for the dominance of the countess's family on her own tomb. It seems highly probable that a pendant to her tomb was erected for her son, Robert IV, count of Dreux, whose tomb stood near hers.[46] Since his tomb was completely destroyed in 1650, it was not depicted by Gaignières's draftsman, but a description by the sixteenth-century chronicler of Braine, Mathieu Herbelin, suggests that it was comparable to the countess's tomb, with his genealogy represented by figures identified by coats of arms.[47] The House of Dreux and its alliances would no doubt have been adequately represented on his tomb, since it seems very likely that the two monuments would have complemented each other. Moreover, since Robert made an important gift to the monastery just before his death in 1282, he was also probably ultimately responsible for the tomb project, although his mother's wishes and perhaps her active participation in the project cannot be ruled out.[48]

THE DRAWING of the tomb of Marie de Bourbon provides a useful reference for judging the accuracy of an engraving of the roughly contemporary tomb of the mother-in-law of Saint Louis himself, Béatrice de Savoie, countess of Provence (d. 1267). The engraving published by Guichenon in 1660 (Fig. 22), with a description, is one of the few records of the tomb, which the countess destined for the chapel of her castle at Les Echelles in a will of 1264, a property that she had transferred to the Order of Saint-Jean-de-Jerusalem in 1260.[49] According to Guichenon, the tomb was destroyed in 1600, so we may infer that he culled his description of the monument from various sources.[50] He says that there were twenty-two statues of the relatives, who were dressed in robes of mourning and identified by shields placed above their heads.

One wonders if the engraving of the tomb published by Guichenon and probably executed expressly for him by A. Lhoste and J. J. Thurneÿsen is not a reconstruction based on his sources and perhaps a few fragments of the tomb chest. This is suggested above all by the series of shields in enlarged scale found above and below the tomb, with inscriptions designating their location on the tomb chest and the figures they identify. The form of these shields, with their rounded bases, is not thirteenth century; rather, their representation in a series corresponds to antiquarian conventions characteristic of circa 1600, as can be seen in Nicolas Charles's manuscript in England (ca. 1590) or in the sixteenth-century *Recueil d'épitaphes . . . de Flandres* in the Bibliothèque Nationale.[51] Moreover, when transferred to Lhoste's rendition of the tomb, the shields are out of proportion with the series of figures that they accompany, as can be seen by comparing them with the drawing of the tomb of Marie de Bourbon (Plates II and III). And the shields are surmounted by crowns. The earliest known examples of crested shields date from the last decade of the thirteenth century and the early fourteenth, when the crowns were di-

>21. Program of the tomb of Marie de Bourbon, countess of Dreux (d. 1274), formerly in the abbey church of Saint-Yved, Braine.

Top row (North):

	B.-in-l.	M.	F.	Sr.-in-l.	B.
	THIBAUD I K. of Navarre d. 1253	**BEATRICE de MONTLUÇON** L. of Bourbon	**ARCHAMBAUD VII** Sire of Bourbon d. 1242	**YOLANDE de CHÂTILLON** L. of Bourbon d. 1254	**ARCHAMBAUD VIII** Sire of Bourbon d. 1249
	W5	W4	W3	W2	W1

MARIE de BOURBON
Countess of Dreux
d. 1274

Left column (West / S):

Relation	Code	Person
Sr.	S1	MARGUERITE de BOURBON, Q. of Navarre, d. 1258
N.	S2	THIBAUD II, K. of Navarre, d. 1270
Ne. by marr.	S3	ISABELLE de FRANCE, Q. of Navarre, d. 1271
N.	S4	HENRI I, K. of Navarre, d. 1274
Ne. by marr.	S5	BLANCHE d'ARTOIS, Q. of Navarre, d. 1302
N. by marr.	S6	HUGUES IV, D. of Burgundy, d. 1273
Ne.	S7	BÉATRICE de NAVARRE, D. of Burgundy, d. after VII/1295
N. by marr.	S8	FERRY II, D. of Lorraine, d. 1303
Ne.	S9	MARGUERITE de NAVARRE, D. of Lorraine, d. 1310
N.	S10	PIERRE de NAVARRE, L. of Muraçabal
N.	S11	GUILLAUME de NAVARRE, Clerk, liv. 1264
B.	S12	GUILLAUME de BOURBON, L. of Beçay, d. 1289
Sr.-in-l.	S13	ISABELLE de COURTENAY, L. of Beçay, d. 1296

Right column (East / N):

Code	Person	Relation
N1	EUDES de BOURGOGNE, C. of Nevers, d. 1266	N. by marr.
N2	MATHILDE de BOURBON, C. of Nevers, d. 1262	Ne.
N3	JEAN de BOURGOGNE, d. 1267	N. by marr.
N4	AGNÈS de BOURBON, L. of Bourbon, d. 1287	Ne.
N5	CHARLES de FRANCE, K. of Sicily, C. of Anjou, d. 1285	Gr. N. by marr.
N6	MARGUERITE de NEVERS, Q. of Sicily, d. 1308	Gr. Ne.
N7	JEAN de FRANCE, C. of Valois, Crécy & Nevers, d. 1270	Gr. N. by marr.
N8	YOLANDE de NEVERS, C. of Valois, Crécy & Nevers, d. 1280	Gr. Ne.
N9	JEAN I, C. of Chalon, d. 1309	Gr. N. by marr.
N10	ADÉLAÏDE de NEVERS, C. of Chalon, d. 1279	Gr. Ne.
N11	BÉRAUD VIII, L. of Mercoeur	B.-in-l.
N12	BÉATRICE de BOURBON, L. of Mercoeur, liv. 1251	Sr.
N13	JEAN I, C. of Dreux, d. 1248	H.

Bottom row (South):

	E1	E2	E3	E4	E5
	JEAN de DREUX Templar liv. 1275	**JEAN** C. of Dammartin d. 1304	**YOLANDE de DREUX** C. of Dammartin d. before VII/13/1313	**ROBERT IV** C. of Dreux d. 1282	**BÉATRICE de MONTFORT** C. of Dreux d. 1311
	S.	S.-in-l.	Da.	S.	Da.-in-l.

22. Tomb of Béatrice de Savoie, countess of Provence (d. 1267), formerly in the chapel at Les Echelles. Samuel Guichenon, *Histoire généalogique de la royale maison de Savoie*, Lyon, 1660, 1, 264.

minutive, spanning only about a third of the width of the shields' chiefs.[52] Finally, the way the series of figures is framed, as if set into a context imagined by the artist, suggests that some fragments of the relief from the tomb chest may have served as a point of departure for a reconstruction drawing by the artist. This is confirmed by the representation of the effigy, which seems to be based on a sixteenth-century model, for the coiffure and costume are more sixteenth century than thirteenth, and the pillow with its tassels is far too large and sumptuous for a thirteenth-century monument.

As for the heraldry, the coats of arms ostensibly identifying six generations of the lady's family exhibit some inconsistencies with the heraldic conventions of the time and with the arms known to have been used by the persons identified in the accompanying inscriptions.[53] On the other hand, the program indicated by the inscriptions is supported by Béatrice's genealogy, a remarkable lady who presided over a brilliant court as countess of Provence, and who during her long widowhood could boast of being the mother of four queens of Europe and a host of royal grandchildren. The program of her tomb given by Guichenon also suggests that she was no less proud of her Savoy family, since according to his list, all her close male blood relatives were represented on the tomb.

The chief value of the somewhat dubious record furnished by Guichenon of the tomb of Béatrice de Savoie is that, in spite of numerous problems, it does seem to indicate beyond a doubt that the mother-in-law of Louis IX, but also of Charles I of Sicily and Henry III of England, had an important kinship tomb that was probably commissioned by the two daughters who were her coheirs, Marguerite, queen of France, and Eleanor, queen of England, both of whom survived her by more than twenty years.[54] Ironically, we have the least evidence for either a prototype or parallels for this monument at the court of France, which probably inspired it and where we would expect comparable monuments. In contrast, the material remains of the courts of Naples/Sicily and England both furnish related monuments from succeeding generations. The tombs erected in Naples in the first half of the fourteenth century for members of the Angevin court usually contain a kinship element combined with other themes in the elaborate wall tombs for which that court is famous.[55] And as we shall see in Chapters 4 through 7, the kinship tomb was destined to become the most important funerary monument at the English court in the fourteenth century, beginning with the reign of Béatrice de Savoie's grandson, Edward I.

BESIDES inspiring the elaborate family programs depicted on tombs as far flung as Brabant and Provence, the French court also probably inspired the program of the earliest tomb that can be documented as uniquely devoted to the ancestry of its occupant. The tomb for Blanche de Sicile, eldest daughter of Charles de France, count of Anjou and king of Sicily (Charles I), is known from three drawings in the *Memoriaux* of the seventeenth-century Flemish antiquarian, Antoine de Succa (Figs. 23–25).[56] The accuracy of Succa's drawings is confirmed by a description of the monument by his contemporary, Jean Lalou.[57]

Blanche de Sicile was the first wife of Robert de Béthune, heir apparent to the county of

23. Tomb of Blanche de Sicile (d. 1269?), formerly in the abbey church of L'Honneur-Notre-Dame, Flines. Brussels, Bibl. roy. Albert Ier, Ms. II 1862, fol. 15v.

24. Tomb of Blanche de Sicile (d. 1269?), formerly in the abbey church of L'Honneur-Notre-Dame, Flines. Brussels, Bibl. roy. Albert Ier, Ms. II 1862, fol. 16r.

Flanders, who had assisted her father in his conquest of Sicily, and who became count of Flanders long after her death, in 1305. Blanche's tomb in the convent of L'Honneur-Notre-Dame at Flines, near Douai, was part of a small necropolis founded by Robert's grandmother, Marguerite de Constantinople, countess of Flanders and Hainault, whose legacy will be discussed in Chapter 3. Blanche's tomb was relatively modest, to judge from Succa's drawings, which show one side of the chest and enlarged drawings of the figures that stood in its six niches, a scheme that suggests that it was set against a wall. The figures shown in detail represented alternately kings and queens of the House of France, to judge by their attributes and Succa's color notes, indicating that the kings wore azure surcoats figured with gold fleur-de-lis. Moreover Lalou described the

25. Tomb of Blanche de Sicile (d. 1269?), formerly in the abbey church of L'Honneur-Notre-Dame, Flines. Brussels, Bibl. roy. Albert Ier, Ms. II 1862, fol. 15r.

26. Statuette of a lady from a tomb chest. Moulins, Musée Anne de Beaujeu.

statuettes as a king and queen of France, a king and queen of Sicily, and again as a king and queen of France.[58] We may thus conclude that the French kings and queens were Blanche's ancestors and the king and queen of Sicily, her father and mother. With its concentration on Blanche's lineage, the tomb provides a direct link to the foundation of tombs at Saint-Denis. The tomb of ancestry, which underscores the value placed on distinguished lineage at this time, was to be an important variant on the tomb of kinship, particularly for women. Several of the tombs

for women in Valenciennes to be discussed in the next chapter displayed their lineage, and even at the end of the fourteenth century and into the fifteenth, when the tombs of their male counterparts were shifting to a display of progeny, the tomb of ancestry remained viable for highborn ladies.[59] Another important characteristic of the tomb of Blanche de Sicile that we have not encountered before is that family members were identified by armorial dress, a widespread practice for effigies in the fourteenth and fifteenth centuries that was probably used to identify family members on tomb chests more often than we can gauge because of losses of polychromy.

The innovations represented by the tomb of Blanche de Sicile make its date an important issue.[60] The monastery church at Flines, where the tomb stood, was dedicated in 1279, a date that suggests that the building was under construction during the previous decade, and that Blanche's tomb might have been in the works at the same time. The date of the lady's death provides a terminus a quo. Anselme brackets the date of her death between July 1269, the date of her will, and March 1272, the date of the contract of her husband's subsequent marriage to Yolande de Nevers.[61]

The political history of Flanders suggests that the tomb was probably erected soon after Blanche's death. In 1280, the revolt of the artisans against the merchant patriciate in Bruges, Ghent, Ypres, and Douai set in motion a chain of events that led eventually to a confrontation between the count and his liege lord, the king of France. By August 27, 1298, when Blanche's husband made a will expressing his desire to be buried in the chapel at Flines, where his beloved first wife lay, he was already deeply involved in the revolt of his father, the old count, Guy de Dampierre, against their sovereign, Philippe IV le Bel.[62] Flines was under French control after September 1297, and when the king's army overran the rest of the county in 1300, Robert and his father were forced to surrender and were subsequently imprisoned in France. Although in their absence the Flemish people, led by a remnant of the nobility, staged a heroic comeback at Courtrai in 1302, the Treaty of Athis-sur-Orge (June 1305) left francophone Flanders in gage to the Crown, and after becoming count, Robert was obliged to cede the towns of Lille, Douai, Orchies, and Béthune to the king. His wish to be buried at Flines was never fulfilled.[63]

Dating the tomb of Blanche de Sicile securely between 1272 and 1298 leads to a reconsideration of the date usually assigned to a related statuette, and also provides a likely glimpse of the quality of the tomb's sculpture. The figure of a lady in carboniferous limestone now in the Musée Anne de Beaujeu in Moulins (Fig. 26),[64] which has been cut away from a relief and long recognized to be a fragment of a tomb chest, matches Succa's drawings of Blanche's tomb in many respects. She wears a headdress consisting of a barbette and veil with rippling edges exactly like that worn by the effigy on Blanche's tomb (Fig. 25). Furthermore, the figure in Moulins seems to turn ever so slightly as she gathers up the skirt of her long loose dress under one arm, while clutching the strap of her mantle and lifting its skirt with her free hand, also the costume and the gestures of the queens on the chest of Blanche's tomb as depicted by Succa. The correspondence is most easily seen in comparing the statuette with Succa's Figure 4 (Fig. 24), but the gestures are simply reversed in numbers 2 and 6 (Figs. 23 and 24). The Moulins statuette has been much admired since it was acquired by the museum in the second half of the nineteenth

century and has usually been dated to the first half of the fourteenth century on the basis of style.[65] But the piece has never before been associated with any monument. It corresponds so closely to the drawings of Blanche's tomb at Flines that it must be a product of the same school at roughly the same time. The material of the statuette, probably Tournai stone, and the proximity of Flines to Tournai, suggest that both monuments originated there. This gives a good indication of the source of the tomb of Blanche de Sicile and also suggests that the statuette in Moulins is somewhat earlier than has previously been thought.

THE TOMBS discussed in this chapter suggest that by the end of the thirteenth century the tomb of kinship had emerged from its theological context to the degree that family consciousness dominated its programs. The expanded genealogies displayed on three of these tombs have become meaningful indicators of political realities and social mores. Although all four displayed a developed genealogy, two of them were particularly evocative of the difference between the social position of a territorial lord in the thirteenth century and that of his feminine counterparts. Whereas the vertical genealogy represented on the tomb of Henry III of Brabant and Adelaide of Burgundy (Fig. 18) was remarkable for its dynastic emphasis, the horizontal program represented on the tomb of Marie de Bourbon was rich in sibling and peer relationships (Fig. 20). Whereas the duke's tomb illustrated the line of patrilineal descent that represented his sons' claim to the duchy, reflecting the inheritance practice customary for princes since the eleventh century, the tomb program of the countess of Dreux suggests the importance of distinguished lineage and family connections for his feminine counterpart. But both monuments, as well as those for Blanche de Sicile and Béatrice de Savoie, demonstrated a desire to emphasize illustrious family connections, especially with royal houses, reflecting an important element in the family consciousness of the medieval noble.

The family programs of the tomb of Henry III and Adelaide of Burgundy, on the one hand, and of Marie de Bourbon and Blanche de Sicile, on the other, also suggest a difference in social conventions between the empire and France. The almost exclusively male presence on the Brabantine monument probably conserved Germanic customs that segregated women.[66] This was to continue in altered form in the tombs of the Avesnes counts of Hainault, to be discussed in Chapter 3, on which ladies appeared, although separated from their lords. Without a comparable French monument for a territorial lord from the second half of the thirteenth century, it is impossible to determine if the courtly couples on the tombs for Marie de Bourbon and Blanche de Sicile were limited to tombs for women. However, the tomb of Thibaud de Champagne discussed in Chapter 1 and the monuments to be erected in England under French influence in the late thirteenth and early fourteenth centuries suggest that alternation by gender was dependent on French manners, and would have been considered appropriate for the tombs of lords as well as ladies.

Heraldry was being used increasingly to identify family members in the second half of the thirteenth century. Shields had already been used to identify knights on the tomb of Henry II of Brabant at midcentury, as we saw in Chapter 1. Combined with inscriptions, they were also used

for ladies on the tomb of Marie de Bourbon, and they appear to have been the only means of identification on the tomb of Béatrice de Savoie. Shields were supplanted in turn by armorial dress for both lords and ladies on the tomb of Blanche de Sicile. This use of heraldry to reflect family identity was by no means new, but its adoption for ladies on tombs suggests that it had become prevalent at court as well as in the martial arts by the second half of the thirteenth century.

The Tomb of Kinship in the Low Countries During the Late Thirteenth and Early Fourteenth Centuries

T HE TOMB of Blanche de Sicile at Flines was one of the first erected in the new necropolis of the richest and most powerful vassal of the French king, the countess of Flanders. The wealth of the Flemish towns, the strategic situation of the county in relation to both England and the empire, and the traditionally independent attitude of its counts made Flanders a natural target for the exercise of Capetian ascendancy. The Crown's ambitions in Flanders, which reached a climax at the end of the thirteenth century under Philippe le Bel, had been checked temporarily at its beginning by Baudouin V of Hainault, who claimed Flanders as his wife's inheritance when her brother the count died without an heir in 1191. As a result, Flanders was joined to Hainault under their son, Baudouin VI (IX in Flanders) in 1195. Baudouin IX might have quelled French ambitions in Flanders permanently had he stayed at home. But as one of the leaders of the Fourth Crusade, he was elected the first Latin emperor of Constantinople in 1204, after the expedition had been deflected into an assault on the Byzantine capital. Soon afterwards captured by the Bulgarians, he apparently died in prison, leaving two very young orphans, Jeanne and Marguerite, in Flanders, both of whom were destined to be instruments of Capetian control.[1] The political situation blighted Marguerite's personal life, resulting in a famous family quarrel that was to cloud the political life of the Low Countries for over a century, and had as one by-product the most extensive series of kinship tombs on record (Fig. 27).[2]

In 1212, soon after her older sister Jeanne had married Ferrand de Portugal and assumed the title of countess of Flanders and Hainault, Marguerite married Bouchard d'Avesnes, a knight then serving as bailiff of Hainault who had previously been a cleric. Two sons were born to the couple before they were separated at Jeanne's instigation. The marriage was subsequently annulled by the pope, and Marguerite married Guillaume de Dampierre, by whom she had five children whom she considered her heirs. But when she inherited the counties of Flanders and Hainault at Jeanne's death in 1244, the children of her first marriage asserted their claim to her lands as her firstborn sons. Eventually the matter was brought before Louis IX as arbitrator, and in 1246, he pronounced in the Court of Peers that after Marguerite's death, her legacy should be divided, with the imperial counties of Hainault and Valenciennes and their dependencies going to the children of the first marriage, and the French county of Flanders and its dependencies to

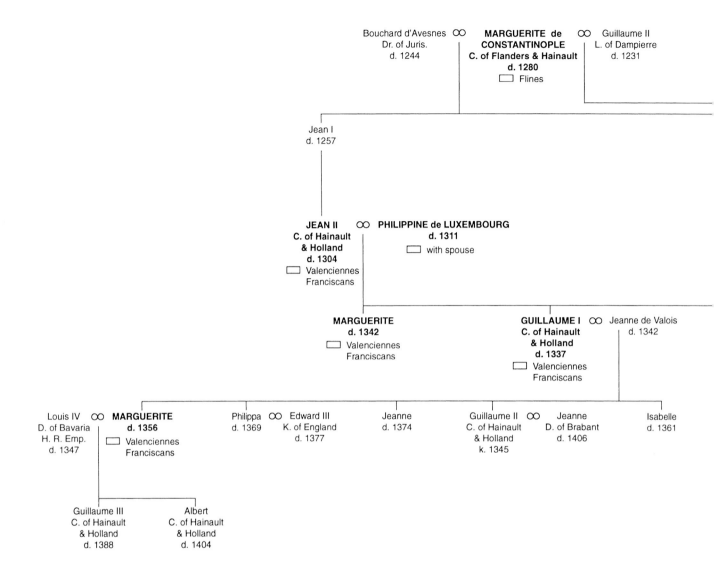

27. Genealogy of the family of Marguerite de Constantinople, countess of Flanders and Hainault (d. 1280), and record of kinship tombs erected for her succession at Flines and in Valenciennes.

those of the second. Marguerite subsequently established her son Guillaume de Dampierre as count of Flanders, and after he was killed in 1251, his younger brother, Guy. But only at her death in 1280 did her Avesnes grandson, Jean II, realize his father's claim to Hainault, and the rivalry between the Houses of Dampierre and Avesnes continued until the early fourteenth century.[3]

Soon after the pronouncement in the Court of Peers concerning the division of her lands, Marguerite transferred the Cistercian Convent of L'Honneur-Notre-Dame that she had founded

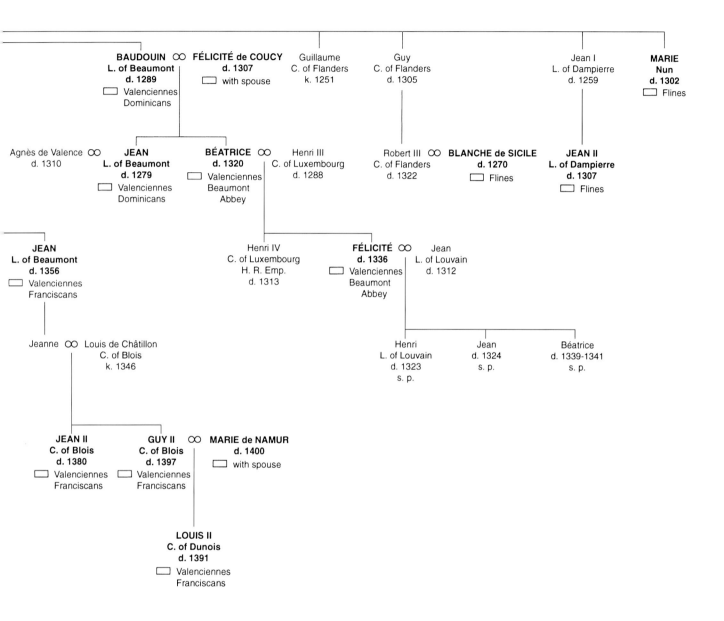

at Orchies to a new site at Flines in French-speaking Flanders.[4] The language of the Grand Charter of Flines, dated 1253, makes clear that already at that date, she envisioned a Dampierre necropolis at Flines, for it states that the convent was founded for the salvation of her soul, for that of her husband, Guillaume de Dampierre, and for those of all their ancestors and descendants.[5] Marguerite founded a chantry in 1263 to celebrate daily mass for herself, her predecessors, and her successors.[6] She continued to shower property and privileges on Flines until her death, and in her will of November 1273, she left 1000 pounds to Flines as endowment for the mainte-

nance of the convent and 120 pounds for anniversary almsgiving, besides providing more than 350 religious institutions with alms for her anniversaries.[7]

Early on, Marguerite associated her Dampierre family with her foundation at Flines, especially her son Guy, who, as accomplice to her reign, confirmed her acts as well as initiating some benefices of his own.[8] His wife, Mahaut de Béthune, and daughter-in-law, Blanche de Sicile, both buried in the conventual church, were also among the early benefactors of the abbey.[9]

Although only two generations of Marguerite's succession were buried at Flines, three of the tombs besides that of Blanche de Sicile were genealogical: the countess's own tomb, that of her daughter Marie, and that of one of her sons or grandsons. As mentioned in the discussion of the tomb of Blanche de Sicile, a probable terminus a quo for these tombs is furnished by the dedication of the church on May 28, 1279, although it is conceivable that Blanche's tomb was begun while it was still under construction.[10]

The three manuscripts cited in relation to the tomb of Blanche de Sicile also furnish a record of these tombs at Flines.[11] Marguerite's own tomb, which stood in the middle of the nuns' choir, formed the center of her necropolis.[12] Jean Lalou's description of it suggests that its program reflected the concerns stated in the foundation charter.[13] According to his account, an image of God stood at the head of the chest, with an emperor and his wife on the right (long side?); three women and nuns were on the left (long side?); and at the foot was yet another woman with a figure that had been completely destroyed.[14] This description suggests that in addition to a devotional image, the program of Marguerite's tomb included statuettes of her father and mother, her daughter Marie, who was a nun at Flines, and probably other members of her family.

Marguerite's daughter, Marie de Dampierre (d. 1304), also had a tomb in the nuns' choir near her mother's, and according to Jean d'Assignies, it corresponded in form to Marguerite's.[15] Moreover, d'Assignies gave a heraldic program for the chest and associated four of the eight shields on its sides with specific persons: the count of Hainault and Flanders, emperor of Constantinople; the count of Alsace and Flanders; Dampierre; Bourbon; the count of Champagne; the king of France; Flanders; and Champagne: enough to suggest that the program represented a family tree, and most probably the lady's ancestors. The shields of Flanders at the head and foot of the tomb were associated with Marie herself by an inscribed scroll at the foot of the chest.

Tombs for family members were also placed in chapels radiating from the ambulatory around the chancel or priests' choir.[16] The tomb of Blanche de Sicile stood in one of these chapels, which was dedicated to Saints James and Philip, and yet a fourth kinship tomb was in the Chapel of St. Andrew behind the high altar. Its occupant remains uncertain, although the effigy represented a knight bearing the arms of Flanders. The tomb has been assigned previously to either the first or the second Guillaume de Dampierre, that is, to Marguerite's second husband or her first son by him, but neither of these identifications is satisfactory.[17] Although the body of the first Guillaume, who died in 1231, was probably transferred to Flines at some time during Marguerite's lifetime, the arms of Flanders borne by the knight would seem to rule out identifying the monument as his.[18] Its association with Marguerite's first son by Guillaume de Dampierre, who was killed in 1251, is based on a postmedieval epitaph painted on the extrados of the arch that framed the tomb, which identified its occupant as "Guillaume de Dampierre

frere de Guy cote de Fladre qui trespassa 1251."[19] This identification is weakened by the fact that Guillaume had a tomb in the Abbey of Marquette, which he shared with his wife, Béatrice de Brabant.[20] Moreover, Lalou says that the effigy on the tomb at Flines bore the arms of Flanders with a label on his coat and on his shield, arms that are confirmed by Succa's drawing of the figure, although the label does not appear on the drawing of the monument by d'Assignies.[21] Whereas Guillaume is not known to have ever used a label, his younger brother Jean, lord of Dampierre (d. 1259), bore the arms of Flanders with a label of five points, as did his son and heir, also named Jean (d. 1307).[22] The tomb must therefore have been for either one or the other member of this cadet branch of the House of Dampierre.

Jean I had established a chantry for himself at Flines during his lifetime, a foundation for which his son Jean II provided funds in 1284.[23] This seems a plausible time for the son to have erected a monument either to his father's memory or to his own. The program recorded by Lalou suggests the latter, for he says that the chest was decorated with seven statuettes representing the emperor of Constantinople, his two daughters, Marguerite and Jeanne, a second emperor, and three men bearing, respectively, the arms of Flanders and Nevers, Flanders, and Champagne impaling Flanders.[24] The coupling of the arms of Flanders and Nevers must refer to the son of Robert de Béthune by his second wife, Yolande de Nevers, countess of Nevers. This son, Louis, count of Nevers, displayed his father's arms impaling his mother's on a seal of 1292.[25] If Lalou was correct in identifying the arms represented on the tomb, Louis, count of Nevers, was represented on his cousin's tomb chest, and the tomb of a knight in the Chapel of St. Andrew seems most likely to have been erected in memory of Jean II de Dampierre, grandson of the foundress, for himself before September 1297, when the convent was under French control.[26] If Jean II did establish his own tomb during his lifetime, this would represent an early example of a practice that had become common by the end of the next century.

The war between Flanders and France halted the growth of the Dampierre necropolis at Flines. Although the body of the old count, Guy, was transferred there after his death in prison in 1305, a monument to his memory was not erected until the sixteenth century.[27] As we saw in Chapter 2, his successor, Robert de Béthune, had expressed his wish to be buried at Flines beside his first wife, Blanche de Sicile, but when he died in 1322, francophone Flanders had been annexed by France, and he was buried provisionally in the Church of Saint-Martin at Ypres until the time when the territory was to be restored to Flanders.[28] This did not happen until the end of the century when the great (3) granddaughter of Marguerite de Constantinople, also named Marguerite, married Philippe le Hardi, duke of Burgundy.[29] Robert de Béthune's body was never transferred to Flines and his successors were buried elsewhere.

THE TOMBS of kinship at Flines set a precedent that Marguerite de Constantinople's Avesnes descendants were quick to emulate, and eventually to exceed, for to judge from the record left by the chief antiquarian of Valenciennes, Simon Le Boucq, and others, they erected at least a dozen kinship tombs in the churches of the mendicant orders in Valenciennes for three branches of the comital family over a period of roughly a century (Fig. 27).[30] Thus, ironically, monasteries founded by Jeanne and Marguerite in Valenciennes were to become symbolic of Avesnes rule in

Ancestor chart of Jean II, Count of Hainault and Holland, and Philippine de Luxembourg

Top row:

Gf.	Gr.Gf.	Gr(3)Gf.	M.	F.
W5 — BOUCHARD D'AVESNES, Dr. of Juris., d.1244	W4 — BAUDOUIN IX, C. of Flanders, Emp. of Constantinople, d.1206	W3 — LOUIS VII, K. of France, d.1180	W2 — ALIX de HOLLANDE, d.1284	W1 — JEAN I D'AVESNES, d.1257

Left column (paternal):

Relation	Box
Gr.(2)U.	S1 — HENRI de FLANDRE, Emp. of Constantinople, d.1216
U.	S2 — GUILLAUME II, C. of Holland, K. of the Romans, k.1256
U.	S3 — BAUDOUIN D'AVESNES, L. of Beaumont, d.1289
Gr.U.	S4 — HENRI II, D. of Brabant, d.1248
Gr.(2)U.	S5 — HENRI II, C. of Champagne, d.1197
Cous.	S6 — HENRI III d.1301 or EDOUARD I d.1336, Cs. of Bar
Cous.	S7 — RENAUD I, D. of Guelders, d.1326
Hf. Cous.	S8 — ROBERT III, C. of Flanders, d.1322
Hf. Cous.	S9 — HUGUES II de CHÂTILLON, C. of Blois & Dunois, d.1307
Hf. Cous. & N.	S10 — JEAN de FLANDRE, C. of Namur, d.1330

Center:

JEAN II — Count of Hainault and Holland — d.1304

PHILIPPINE de LUXEMBOURG — d.1311

Right column (maternal):

Box	Relation
N1 — MARIE de CHAMPAGNE, Emp. of Constantinople, d.1204	Gr.Gm.
N2 — ISABELLE de HAINAUT, Q. of France, d.1190	Gr.(2)A.
N3 — MARGUERITE de BRABANT, C. of Luxembourg, H. R. Emp., d.1311	Ne.
N4 — JEANNE de NAVARRE ?, Q. of France & Navarre, C. of Champagne, d.1305	Cous.
N5 — ISABELLE de FRANCE ?, Q. of England, d.1357	Cous.
N6 — MARIE de FRANCE, C. of Champagne, d.1198	Gr.(2)Gm.
N7 — MARGUERITE de CONSTANTINOPLE, C. of Flanders & Hainault, d.1280	Gm.
N8 — FÉLICITÉ de COUCY, L. of Beaumont, d.1307	A.
N9 — YOLANDE de HAINAUT, C. of Soissons ?	
N10 — SYBILLE de FLANDRE & HAINAUT ?, L. of Beaujeu, d. after IX /18/1216	Gr. (2) A.

Bottom row:

E1	E2	E3	E4	E5
GUY de HAINAUT, Bp. of Utrecht, d.1317	GUILLAUME de HAINAUT, Bp. of Cambrai, d.1296	BOUCHARD de HAINAUT, Bp. of Metz, d.1296	FLORENT de HAINAUT, Pr. of Achaea, d.1297	BAUDOUIN de HAINAUT ?, Knight, d. after VI/1283
B.	B.	B.	B.	B.

Hainault.[31] The Franciscans had been established on the site of the old comital residence by Jeanne in the 1220s, in spite of considerable reluctance on their part,[32] whereas the Dominicans were initially sponsored by the bishop of Cambrai, Godefroy de Fontaine, and authorized by Jeanne in 1233, who subsequently started a building campaign for them completed during Marguerite's rule.[33]

Our knowledge of the Avesnes kinship tombs has been considerably enriched by recent excavations in Valenciennes.[34] This work has been guided by Le Boucq's record, and it has generally confirmed his perspicuity while revealing the exceptional quality of some of the tomb sculpture. Marguerite's first son, Jean d'Avesnes (d. 1257), apparently had an imposing tomb in the middle of the choir of the Dominicans' church that he shared with his wife, Alix de Hollande, but Le Boucq's record of it suggests that it was embellished only with effigies of Jean and Alix, and shields bearing their coats of arms.[35] Jean's younger brother Baudouin, lord of Beaumont (d. 1289), had his mother with her two husbands and his grandfather represented on the tomb that he shared with his wife, Félicité de Coucy, in the same church. Le Boucq's notes suggest that they were arranged in relation to a votive image of the Coronation of the Virgin, and that this tomb was thus roughly comparable to his mother's tomb at Flines.[36] It remained for the next generation, represented by the first count of the House of Avesnes, Jean II, and his cousins Jean and Béatrice d'Avesnes of Beaumont to have tombs with more elaborate programs than those at Flines.[37]

A magnificent tomb in black "marble" with painted stone effigies of Count Jean II d'Avesnes and his wife, Philippine de Luxembourg, stood in the middle of the choir of the Franciscans' church in Valenciennes, which, according to Outreman, was richer than any other church in tombs of the House of Hainault.[38] The tomb was probably initiated by Philippine. The accounts of the executors of her will, dated April 6, 1311, and September 6, 1313, suggest that the tomb was already under way when she died in 1311, and that it was complete and in the process of receiving final fittings and paint in 1313.[39] Le Boucq alluded to thirty shields on the four sides of the tomb, five at the head and foot and ten on each long side. Although he mentioned no statuettes, he associated the shields with specific kinsmen and women of the countess, implying, it would seem, that the shields had originally identified statuettes.[40]

The program of the tomb of Jean II and Philippine reflected to some degree the family's troubled history (Fig. 28).[41] While Jean's parents, Jean I and Alix de Hollande, were placed at the head of the chest with his grandfather, Bouchard d'Avesnes, and two illustrious male ancestors, Baudouin, emperor of Constantinople, and Louis VII, king of France, his grandmother, Marguerite, was relegated to seventh place among various other women relatives on the north side. Beyond these reflections of family history, there was the usual concern to include the most illustrious members of the count's family, especially among the ancestry, as we can see from the inclusion of Louis VII and Baudouin de Constantinople.

The program is remarkable in its organization of family members according to gender on the long sides of the chest, with the ladies placed on the north, or gospel side, the lords on the south, or epistle side. Moreover, there seems to have been a conscious organization of the male

<28. Program of the tomb of Jean II d'Avesnes, count of Hainault and Holland (d. 1304), and Philippine de Luxembourg (d. 1311), formerly in the Church of the Franciscans, Valenciennes.

relatives by degree of kinship, with the uncles taking precedence over the cousins on the south side, and the count's brothers, three of whom were bishops, occupying the entire foot of the chest. Moreover, all the relatives but four were from Jean's side of the family, as could be expected in an Avesnes necropolis.[42]

The second son and heir of Jean and Philippine, Guillaume I (d. 1337), also had a genealogical tomb in the choir of the Franciscan church with a very similar program.[43] As on his parents' tomb, his most distinguished male relatives were placed at the head of the chest (precisely the same persons were placed at the foot as on his parents' tomb), the remaining male relatives were placed on the south side, and the women were on the north.[44]

The programs of these tombs of the counts of Hainault expressed, in a milder form, the male prerogative seen earlier in the thirteenth-century tombs of the House of Brabant. They also represent an alternative arrangement of family members on the sides of the tomb chest, where men and women were separated. This order was also used in a roughly contemporary tomb at Cambron Abbey in Hainault where, on the double tomb of Nicolas de Condé (d. 1293) and his wife Catherine de Carency, the men were all ranged on his side of the tomb and the women on her side.[45] This must reflect the ancient custom of separating men and women for worship, with the ladies on the north and the men on the south side of the sanctuary, a practice that persisted in France into the thirteenth century, as described by William Durandus.[46] The programs of these tombs suggest that the custom was still in effect in the empire in the early fourteenth century.

As signaled by Françoise Baron and Ludovic Nys, the recent discoveries in Valenciennes reveal the importance of tombs in carboniferous limestone, which were probably imported from Tournai, in the Avesnes necropolis.[47] But this should not eclipse the significance of the local production suggested by fragments of a white limestone tomb chest found during excavation on the site of the convent of Beaumont in 1973.[48] These fragments, in six pieces, represent the remains of seven or eight niches housing lords and ladies carved in relief (Fig. 29).[49] The largest pieces represent two ladies and a lord standing in niches framed by a gabled arcade, superbly modeled and faced with slender engaged colonnettes that carry the outer molding of the traceried arches.

Beaumont Abbey was founded in 1310 by Béatrice d'Avesnes, countess of Luxemburg, cousin of Count Jean II of Hainault and mother of the Holy Roman Emperor, Henry VII.[50] Granddaughter of Marguerite de Constantinople (Fig. 27), the countess followed her grandmother's example at Flines by creating a convent around the family property at Beaumont that would become a haven for both her daughter and granddaughter. After her death in 1321, she was buried in a freestanding tomb in the middle of the choir of the abbey church.[51] Nearby, in an *enfeu* tomb in the wall of the choir, stood the tomb of her daughter, Félicité de Luxembourg, lady of Louvain (d. 1336), who spent her last years in the convent. Both tombs were described by Le Boucq as having tomb chests decorated with figures illustrating their lineage, and it thus seems probable that the fragments in the Valenciennes Museum belong to either one or the other tomb, if we allow for the possibility that they were painted in armorial dress, or that shields were placed in the quatrefoils between the gables.[52] A provenance from either tomb implies a date

29. Fragments of a tomb chest from Valenciennes, Abbey of Beaumont. Valenciennes, Musée des Beaux-Arts.

relatively early in the fourteenth century for the fragments, which is entirely consistent with the style in which they are carved. Erlande-Brandenburg and Hardy and Beaussart have already challenged the date to the third quarter of the thirteenth century assigned them in the Lille exhibition of 1978–79.[53] The evidence presented above suggests a date after 1310 at the earliest, and one possibly as late as the 1330s.

A DISCUSSION of tombs for members of the Houses of Dampierre and Avesnes would be incomplete without reference to a monument that appears to have been an offshoot of the activity at Valenciennes in the late thirteenth and early fourteenth century. Its patron, Béatrice de Louvain, a nun at Beaumont Abbey in the early fourteenth century, was the granddaughter of the abbey's founder, Béatrice d'Avesnes, for whom she was named, and the great great granddaughter of Marguerite de Constantinople. After the death of her mother, Félicité de Luxembourg, at Beaumont Abbey in 1336, it fell to Béatrice to look after a tomb for her grandfather, father, and brother, the last sires of Louvain from the House of Brabant. The tomb for

Henry (d. 1285), John (d. 1312), and Henry the Young of Louvain (d. 1323) in the church of the Franciscan monastery in Brussels was commissioned by Béatrice on February 7, 1339, in a contract with the Tournaisian sculptor Guillaume du Gardin. Since she died before the tomb was finished, the contract was renewed by the duke of Brabant, John III, in September 1341. As a result, we have two records of the tomb that allow us to observe the evolution of its program from the time of its inception to its near completion.[54]

The first contract includes a rather clumsy set of specifications for the monument that evokes a canopied tomb with the two long sides of the chest decorated with niches framing statuettes. The architecture was to be in stone from Antoine (Tournai carboniferous limestone), the effigies in painted white stone, and the statuettes in alabaster. The contract suggests that the program had not been completely worked out when the lady hired her sculptor. It specifies that the chest should display images of knights and ladies, expressing sorrow or other bearing, or perhaps even apostles.[55] Later in the same document, when she outlined the program, Béatrice specified ten figures for young Henry's side of the chest and six or more for the other side, although it too was to have ten niches. She then listed eight persons for the latter. The figures on young Henry's side represented his mother, Félicité de Luxembourg, and his brother and sister (Béatrice herself), as well as other relatives from the matrilineal side of his family, including the Emperor Henry VII; Baldwin of Luxemburg, archbishop of Trier; and the counts of Flanders and Hainault. The other side of the chest was to represent the paternal side of the family, including their cousins, the dukes of Brabant, and the wife of the elder Henry, Isabelle of Beveren. Considering that three generations were represented by the tomb's occupants, its genealogy is not particularly deep, but like the tombs examined previously, there was an obvious concern to display illustrious family connections. Béatrice gave very specific instructions for the dress of the members of the family depicted. Both lords and ladies were to be identified by armorial dress, except for the ladies in orders. The latter included not only Béatrice herself and her aunt, Marguerite de Luxembourg, but also her mother and great grandmother, Isabelle of Beveren, who had entered the convent as widows, and were to be clad in Dominican habits. The patron even prescribed for herself a black mantle without a cowl, lined with squirrel, and a wimple. She further ordered that shields of Louvain and of Luxemburg should be placed above the heads of the figures of her mother, her aunt and herself, wherever appropriate. She obviously wanted even the ladies in orders to be identified precisely.

By the time of the second contract, the program for the chest must have been settled. Apostles were no longer mentioned, and twenty statuettes were specified. On the other hand, they were to be made of painted and gilded stone, rather than alabaster.[56] Although Béatrice had been uncertain of what attitude the statuettes should have, a sorrowful bearing prevailed in the end, for it is specifically confirmed in this contract.[57] Here for the first time is unambiguous evidence of family members cast in the role of mourners, an important innovation in the iconography of the tomb of kinship. But this by no means implies the representation of an actual funeral procession.[58] For the idea of an entire lineage and family connection grieving at the death of three of its members is abstract, involving people who were already dead in 1285, when the elder Henry died. It seems moreover particularly appropriate in the context of this tomb, which marked the extinction of a line.

THE RECORD of these kinship tombs in the Low Countries and the quality of the fragments that have been excavated make us keenly aware of the loss to medieval art and culture that their disappearance represents, a loss that can only be properly addressed today by a scrupulous examination of the documents preserved followed by the methodical excavation, where feasible, of the monastery sites. But the record of the tombs itself evokes the human dimensions of the subject, and also demonstrates how politicized the tomb of kinship could become when used by both sides in a family dispute. Although much remains to be recovered, what has been educed of the Dampierre and Avesnes tombs and their off-shoot in Brussels provides the background for the full development of the tomb as a political instrument and as an expressive work of art that was to be fully realized in England in the fourteenth century.

[CHAPTER FOUR]

The First Tombs of Kinship in England

THE FAMILY and retainers of King Edward I (reigned 1272–1307) introduced the Gothic tomb of kinship into Westminster Abbey at the time the monastery was becoming a royal necropolis. The rebuilding of the church undertaken by Henry III, beginning in 1245, extended only from the new choir to the first bays of the nave when he died in 1272, but even as work on the church slowed, his family began to claim burial sites near the chapel of Edward the Confessor. The chapel itself, which comprises the apse and one bay of the choir, is dominated by the confessor's shrine, while royal tombs are placed in a ring around it between the choir piers. The first of these, for King Henry himself and his daughter-in-law, Queen Eleanor of Castile, were completed by Edward I on the north side of the chapel soon after the queen's death in 1290.[1] Queen Eleanor's own tomb displayed shields referring to her royal lineage (Castile/Leon), her personal property (Ponthieu), and her marriage (England) on the side of the chest facing the ambulatory, but family references were much more extensive on some subsequent tombs for less prominent members of the royal family, intended no doubt to illustrate the ties that linked them to the throne, as well as other extended family connections.

The first of these was erected in memory of King Henry's half brother, William de Valence. The tomb celebrating his extended family may even have originally stood on the south side of the royal chapel in one of the spaces since occupied by sovereigns.[2] Today, in much altered condition, it is in the ambulatory chapel of Sts. Edmund and Thomas the Martyr (Fig. 30).

Considered a foreign adventurer by the English aristocracy, William de Valence was a younger son of the sire of Lusignan from the Poitou, Hugh X, count of La Marche, by Isabelle of Angoulême, the widow of King John of England. Henry III invited him to England in 1247, arranged an advantageous marriage with Joan of Munchensy, coheir of the earls of Pembroke, subsequently knighted him and granted him many favors. In return, William remained Henry's loyal supporter in his struggles with the English barons, and also represented him and his successor, Edward I, in war and diplomacy in France, Scotland, and Aquitaine. He went on crusade to the Holy Land twice, the second time with Prince Edward in 1270. He died in England from wounds apparently received during Edward's unsuccessful Gascon expedition of 1296.[3]

A tomb at Westminster Abbey must have seemed a fitting honor for this royal relative, and considering William's family history, it is not surprising to find that part of the monument was imported from Limoges or that its program reflected his family connections. The tomb consists of two parts, a stone base decorated with large shields in recessed panels, and an upper chest in

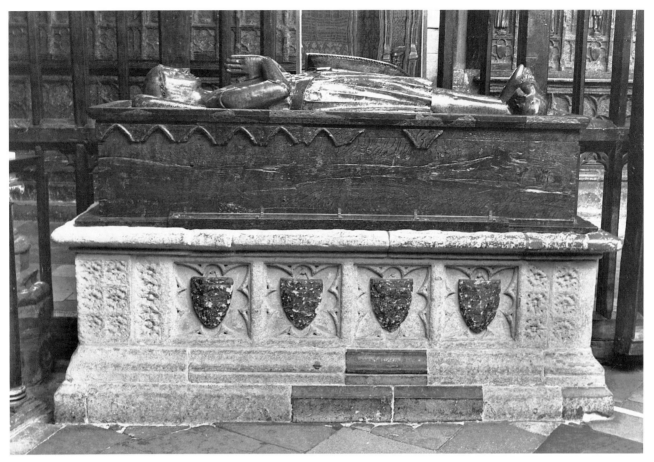

30. Tomb of William de Valence (d. 1296). London, Westminster Abbey.

oak formerly covered with gilt and enameled copper. Besides supporting William's effigy, this upper chest also formerly housed thirty-one little statuettes in the niches on its sides, accompanied by shields.[4]

The base, which bears the arms of England, Valence, and Valence dimidiating Clermont Neslé, was probably made in England after William's death. Certainly, the shield displaying Valence/Clermont Neslé, which refers to the marriage of his second son and heir, Aymer, to Beatrice of Clermont Neslé, suggests that Aymer was responsible for this part of the tomb, probably at the time of its installation.[5] The upper chest with the effigy has long been recognized as Limoges work,[6] and it seems most likely to have been ordered by William himself, for he was constantly in Aquitaine from 1273 to 1279, with visits to Limoges recorded in 1273 and 1274.[7] This hypothesis is further suggested by the program that can be reconstructed of the upper chest, which mostly reflects his French family connections. Five shields are still in place on the south side, placed horizontally on the chest's lower molding. They bear the arms of France, England twice, Valence, and Lusignan differenced.[8] A more complete program can be established from the shields drawn by Nicolas Charles.[9] Charles's notes, which record ten shields on the

31. Tomb of Juhel de Mayenne (d. after 1204), formerly in the church of the Abbey of Fontaine-Daniel (Maine). Oxford, Bodleian Library Ms. Gough Drgs.-Gaignières 14, fol. 200r.

"upper edge" and fourteen on the "nether edge," suggest that each figure was associated originally with two shields, one above it and one below. In addition to those referred to above, these shields displayed the arms of Lusignan, Lusignan with a bend, Angoulême, Clare, Brittany, Thouars, Hastings, Richard of Cornwall, the empire, and De Lacy.[10] The first six refer to William's French family and their alliances, the latter four to his English family and associates. As mentioned above, William's mother was the daughter of the count of Angoulême, and through her, this title passed to the Lusignans. His sister Alice of Lusignan married Gilbert de Clare, earl of Gloucester.[11] His brother Hugh married Yolande of Brittany.[12] The vice count of Thouars, Aimery VII, was his sister Margaret's second husband.[13] His daughter, Isabel, married John Hastings. Richard, earl of Cornwall, was his half brother, and his half sister, Isabel of England, married Frederick II, emperor of Germany. Finally, his career in the service of the Crown must have brought him into contact with Henry de Lacy, earl of Lincoln, one of the most eminent noblemen of the period, and a favorite of Edward I.[14]

The tomb's effigy, like the upper chest, has a wooden core that has retained most of its copper sheathing. It represents William as a knight in the simple frontal position typical of French effigies, with straight legs and hands quietly pressed together in prayer. Burges pointed out the French characteristics of its metal technique and also of the knight's garb: the chain mail

armor with no mixture of plate, the small shields that powder the surcoat, the sword worn on the hip, and the gauntlets divided into fingers. He compared the figure with a drawing of the tomb of Juhel de Mayenne (d. after 1204) formerly at the Abbey of Fontaine-Daniel (Maine) (Fig. 31),[15] which appears to have been an earlier example of Limoges funerary art displaying a series of shields to establish the family connections of its occupant.[16]

The tomb of William de Valence is an important historical document, for not only is it one of the earliest examples of the tomb of kinship in England but its link to the Continent is twofold. In the first place, it was probably inspired by kinship tombs for family members in Aquitaine or even Hainault, for William's daughter Agnès was married to Jean d'Avesnes, lord of Beaumont, whose tomb in the Dominican church of Valenciennes formed part of the Avesnes necropolis discussed in Chapter 3 (Fig. 27).[17] In the second place, William's tomb is one of the few surviving tombs from Limoges, where the production of funerary monuments appears to have bolstered a declining industry somewhat in the second half of the thirteenth century.[18]

Moreover, the Valence tomb may have contributed to the vogue for tombs of kinship that came in with the fourteenth century in England. At Westminster Abbey, three monuments for other members of the royal family in painted and gilded stone on the north side of the sanctuary gave the type a new prominence by sheltering the tomb chest and effigy beneath an architectural canopy or baldachin (Fig. 32).[19] The first of these was for the sister-in-law of Edward I, Aveline de Forz, the young wife of his brother, Edmund, earl of Lancaster (Crouchback). She died in 1274, at the age of only fifteen years.[20] Located between the two westernmost piers on the north side of the sanctuary, her tomb was among the first in the series that screens the sanctuary and the royal chapel from the ambulatory, serving as a relatively modest exordium to the splendid monuments that were soon to rise just east of it. Apparently derived from similar tombs in northern France that were built against a wall, it is closed on the north side and only visible from the crossing and the sanctuary.[21] Its canopy consists of a ribbed vault on clustered colonnettes, framed by a trefoil arch, braced by framing pinnacled buttresses, and crowned with a crocketed gable pierced with a trefoil. As L. L. Gee pointed out, the architectural motifs of the tomb are similar to those of thirteenth-century canopied tombs from the Abbey of Chaalis, La Couture at Le Mans, and Rouen Cathedral (Fig. 33).[22] These northern French tombs provide a general conceptual source but no firm date for the Westminster monument, which can be bracketed between the death of Aveline in 1274, and that of her husband, Edmund, in 1296, whose monument in the adjoining bay appears to be an expanded version of hers. Edmund would have been the relative most likely to erect Aveline's tomb, so the date of his death, 1296, can be taken as a probable terminus ad quem, but the evolution in architectural form that separates his tomb from hers suggests a time lag between them, and a likely change of designer.[23]

For our study, the most interesting part of Aveline's monument is the tomb chest, for with its series of graceful little figures accompanied by shields, the tomb of kinship in England assumed the form that was to characterize its history. The chest is decorated with a series of gabled niches sheltering figures carved in relief (Fig. 34). Despite their deplorable condition, we can determine from their ankle-length robes that all are male, and probably secular, as suggested by a few details of costume and the fact that one (no. 5) carries gloves. Like the figures on the

32. Tombs of Aveline de Forz (d. 1274), Aymer de Valence (d. 1324), and Edmund Plantagenet (Crouchback) (d. 1296), seen from the presbytery. London, Westminster Abbey.

tombs of Marie de Bourbon and Blanche de Sicile, they were conceived as pairs who turn toward each other.[24] Two shields were placed above each figure on either side of the gables above them. The present traces of the shields, light silhouettes on a darkened field, suggest that like those on Edmund's tomb in the adjacent bay, they were originally raised in gesso relief that has peeled away, leaving a relatively clean surface.[25] In view of the kinship tombs on the Continent, it seems that the figures most likely represent male relatives, ancestors of the princess, or both, but the problematic relationship between the figures and the shields on Edmund's tomb, as we shall see below, precludes assuming that the shields would necessarily have identified the figures.

The tomb of Aveline de Forz seems to have served as a modest point of departure for the design of the tomb of her husband, Edmund, known as Crouchback, in the adjacent bay (Fig. 35).

33. Tomb of Archbishop Eudes
Rigaud (d. 1275), formerly in
Rouen Cathedral. Paris, Bibl. Nat.,
Ms. lat. 17044, fol. 125.

34. Tomb of Aveline de Forz (d. 1274), detail of tomb chest. London, Westminster
Abbey.

Expanded to fill the entire space between the second and third piers of the sanctuary, it rises to
a height that relates it, visually, to the upper reaches of the interior and, as it is open to both the
sanctuary and the ambulatory, it allows the spectator in the ambulatory to see the prince in
effigy turning toward the altar with hands clasped in prayer. The tomb thus brought a visibility
to the English nobleman's monument that had already appeared in France but had been un-
known on the island.[26] The tripartite design of the canopy depends, ultimately, on the screenlike
portals created for the transepts of Notre-Dame in Paris by Jean de Chelles and Pierre de Mon-
treuil in the 1250s and 1260s.[27] But this architect, long believed to be Master Michael of Canter-
bury,[28] used the principles of the progression and subordination of architectural forms to effec-
tively rivet attention on the main image as *gisant*.[29] Undergirded by the diminutive gabled

35. Tomb of Edmund, earl of Lancaster (Crouchback) (d. 1296). London, Westminster Abbey.

36. Tomb of Edmund, earl of Lancaster (Crouchback) (d. 1296), detail of tomb chest (N4 and N3). London, Westminster Abbey.

37. Tomb of Edmund, earl of Lancaster (Crouchback) (d. 1296), sketch by John Carter of knights painted on tomb base. London, Westminster Abbey.

arcade of the chest, its prayerful repose is exalted by the triple canopy above, which repeats and magnifies progressively the gabled arches below. Moreover, the handling of form is much richer than in its austere French prototypes. There is greater plasticity in the design of individual architectural elements, with the addition of typical English decorative details like the elaborate cusps on the main arches and the brackets for angels that sprout behind the crockets on the central gable.[30] Moreover, the equestrian apotheosis of Edmund in the crowning trefoil, which has been aptly compared with images of the knight on noble seals, is unprecedented, to my knowledge, in French tomb sculpture.[31]

Within this splendid setting, the tomb chest, with its gabled niches occupied by royal couples, relates most directly to the spectator, for it is set on a base that places it at eye level with the viewer standing in the ambulatory. Ten statuettes are carved in relief on each side of the chest, arranged as couples (Fig. 36), as on the tomb of Aveline de Forz. To judge from their present state of preservation, they all wore long robes and mantles, were crowned, and carried either rods or scepters, suggesting that they represent the earl's lineage and royal relatives.[32] Alternately lords and ladies who turn and gesture toward each other, they too reflect continental sources such as the tomb of Marie de Bourbon or that of Blanche de Sicile (Plates II and III, Figs. 23 and 24). Comparison of the figures with those from the latter tomb is particularly instructive, for they correspond almost exactly in attitude, costume, and attributes, the only major difference being that the lords' robes are longer and that here the ladies, as well as the lords, carry scepters.[33]

Despite its obvious dependence on continental precedent, the program of the chest does not adhere strictly to the principles normally observed on the continent for identifying the figures. As on the tomb of Aveline de Forz, each figure is surmounted by two shields, but here the blazons have survived, though in altered state, and they can be supplemented by the record left by Nicolas Charles and Francis Sandford.[34] Both Richard Gough, who left an imperfect record of the coats, and the Royal Commission surveyors concluded that the shields on the chest bear little or no relation to the figures below them in the niches.[35] Moreover, there is no surviving precedent on the Continent for the association of two shields with one family member in a comparable series, and this in itself suggests that here the heraldry does not necessarily identify the figures.[36] And although paired shields can be cited on seals to refer to marriages,[37] lineage,[38] and comradeship in arms,[39] the shields paired here are readily meaningful in relation to each other in only a few cases.[40] If the pairing of the shields is significant, its references remain unresolved for the most part, but it is safe to say that collectively the heraldry on the chest refers to Edmund's relatives and closest associates.

The heraldic program was extended to the gables of the canopy where John A. Goodall has detected fifty-five coats, representing the arms of all the English earls of the end of the thirteenth century except Hereford/Essex and Richmond, four titles of fiefs granted to Crouchback or to the family of his first wife, and a selection of baronial and knightly families, in addition to most of the royal and Lancastrian coats represented on the tomb chest.[41] This heraldic display is in accord with the chivalrous tone of the monument, with the earl represented twice as a knight.[42] Moreover, ten knights, like the earl, wearing chain mail and surcoats, were painted on the base of the tomb facing the ambulatory. Now only faintly visible, they were drawn by John Carter in

1782, carrying banners and turning toward each other to form pairs in a manner similar to the royal couples in relief just above them on the tomb chest (Fig. 37).[43] To judge from Carter's identifications and the blazons he represented on the surcoats, they depicted the earl's grandfather, Raymond Berengar, count of Provence; his uncle, William de Valence; his great-uncle, the count of Savoy;[44] his uncle, John, earl of Warenne and Surrey; a Neville;[45] and Roger de Clifford.[46] Feasibly the whole company represented an assembly of chivalric forebears analogous to the royal ancestors represented on the chest.[47]

Crouchback was killed in Bayonne in 1296, and his body brought back to London for burial, which did not actually take place until March 1300 or 1301.[48] The presence of the arms of Brabant on the canopy gable suggests that the tomb was painted after the marriage of his niece, Margaret of England, to John II, duke of Brabant, in 1290,[49] and the prominence of the earl of Lincoln's arms on the chest suggests a terminus a quo for the tomb after the marriage of Edmund's son and heir, Thomas of Lancaster, to Alice de Lacy, daughter of Henry de Lacy, earl of Lincoln, in 1294.[50] These details in the heraldry confirm the usual assumption that the tomb was erected postmortem.

THE TOMB of Edmund, earl of Lancaster, was the most important funerary monument created in England at the turn of the century, and as such, it set the standard for the English prince's tomb of the fourteenth century. While its immediate impact can be seen in the commissioning of derivative monuments at Ely and at St. Paul's, London, its imposing design was to be modified and varied at Westminster itself in the tombs of Aymer de Valence, earl of Pembroke, and John of Eltham, son of Edward II.[51]

The first, erected for the son and heir of William de Valence, who followed his father's lead and became one of the most important magnates of the reign of Edward II,[52] shares the space between the first two piers of the sanctuary with the tomb of Aveline de Forz (Fig. 32). Perhaps because the space was more restricted, the side canopies of the Crouchback tomb were eliminated, and the tomb serves architecturally as an effective transition between the modest dimensions of Aveline's tomb and the fully expanded splendor of Crouchback's.

While the earl's knighthood is celebrated in the noble recumbent effigy in chain mail and surcoat, and in the triumphant equestrian relief in the gable that crowns the whole, his soul is collected at the head of the effigy by two angels, while his family engages the viewer standing in the north ambulatory (Fig. 38). Depicted as a captivating series of couples in graceful attitudes, the figures are identified by shields above them framed by quatrefoils between the gables. This is the earliest tomb of its type in England for which an unambiguous program can be established, and for this reason if for no other, it warrants particular attention. In contrast to Crouchback's tomb, where the arms of close associates were mingled with those referring to family members, this is strictly a tomb of kinship.

As remarked by Veronica Sekules, the monument was no doubt commissioned by the earl's second wife, Marie de Saint-Pol, daughter of Guy III de Châtillon, count of Saint-Pol, and great granddaughter of Henry III of England.[53] Marie was about eighteen years old when she married the aging earl, who died three years later.[54] She consulted Edward II about burial immediately after his death in June 1324,[55] and was granted a privileged site befitting a loyal retainer who had

38. Tomb of Aymer de Valence (d. 1324). London, Westminster Abbey.

stood by the king during the frequent revolts provoked by his reign. The tomb has long been recognized as one of the finest of the period, but although the heraldry establishing its family program was carefully recorded by a score of antiquarians, and partially identified in the Inventory of the Royal Commission on Historical Monuments in 1924, it has never been entirely solved, or adequately explained.[56] And indeed its program is highly unusual (Fig. 39).

The heraldic series opens with half shields at the head of the tomb on both the ambulatory and sanctuary side that refer to the earl's parents, but with no corresponding figures.[57] On the ambulatory, the next two shields identify family members of the earl's two sisters and coheirs, Isabel and Joan de Valence. His nephew, John Hastings, son of his elder sister, or Hastings's son Laurence, occupies the second niche (Figs. 38 and 40). Although the Hastings shield has long

N ▷

M.-in-l.	MARIE de BRETAGNE C. of Saint-Pol d. 1339	S 1	N1	ATHOLL Daughter-in-law?	Gr. Ne. by marr.
Cous.	HENRY E. of Lancaster d. 1345	S 2	N2	JOHN d. 1325 or LAURENCE HASTINGS d. 1348	N. or Gr. N.
Sr.-in-l.	ISABELLE de SAINT-POL L. of Coucy liv. 1367	S 3	N3	BLANCHE de BRETAGNE d. 1328	A. by marr.
B.-in-l.	GUILLAUME Sire of Coucy d. 1336	S 4	N4	ROBERT d'ARTOIS d. 1343	Cous. by marr.
Sr.-in-l.	MAHAUT de SAINT-POL C. of Valois d. 1358	S 5	N5	BÉATRICE de SAINT-POL L. of Crèvecoeur liv. 1350	Sr.-in-l.
B.-in-l.	CHARLES de FRANCE C. of Valois d. 1325	S 6	N6	JEAN de FLANDRE L. of Crèvecoeur k. 1325	B.-in-l.
W.	MARIE de SAINT-POL C. of Pembroke d. 1377	S 7	N7	MARIE de SAINT-POL C. of Pembroke d. 1377	W.
F.-in-l. or B.-in-l.	GUY d. 1317 or JEAN de CHÂTILLON d. 1342 Cs. of Saint-Pol	S 8	N8	JEAN II d. 1305 or ARTHUR II d. 1312 Ds. of Brittany	Gf. by marr. or U. by marr.

The central column reads: AYMER de VALENCE, Earl of Pembroke, d. 1324

39. Program of the tomb of Aymer de Valence, earl of Pembroke (d. 1324), Westminster Abbey.

40. Tomb of Aymer de Valence
(d. 1324), detail of tomb chest (N2 and
N1). London, Westminster Abbey.

been recognized, its usefulness for establishing a terminus ad quem for the monument has gone
unnoticed. Since the earl died without progeny, John Hastings was clearly destined to inherit
the Pembroke title along with his mother's share of the land, but he only survived his uncle by
a year, and the inheritance eventually passed to his son, Laurence, who was only four years old
when his father died. Laurence bore the Hastings arms until he was recognized as earl of
Pembroke in 1339, when he quartered them with Pembroke, a heraldic change that would cer-
tainly have been registered on the Valence tomb if it had been erected after 1339.[58] Marie de
Saint-Pol was in France from 1331 to 1334,[59] which leaves two periods open for the construction
of the tomb: 1324–30 or 1335–39. The style of the monument has led most scholars to date it
to the earlier period, and this is confirmed by the family program.[60]

41. Tomb of Aymer de Valence (d. 1324), detail of tomb chest (N4 and N3). London, Westminster Abbey.

Occupying the second, rather than the first place in line, Hastings seems to bow to courtesy, for an unidentified lady, probably the wife of a cousin from the Scottish House of Atholl, occupies the first niche, and turns toward him with her right hand placed over her heart. Her shield suggests that she is the daughter-in-law of Hastings's Aunt Joan, the second sister of the earl. Although she cannot be identified more precisely, her presence suggests that Countess Marie observed the protocol expected in recognizing both branches of her husband's surviving family, while minimizing the Atholls' secondary claim to the Pembroke title by representing them with a daughter-in-law.

The rest of the program is almost entirely given over to Countess Marie's own family. Reading down, or left, of John Hastings, we find Blanche de Bretagne, Marie's aunt, accompanied

42. Tomb of Aymer de Valence (d. 1324), detail of tomb chest (N8 and N7). London, Westminster Abbey.

by her son, Robert d'Artois (Fig. 41). Next in line are Marie's sister and her husband, Jean de Flandre. The last couple in this line represents Marie herself, accompanied by either her grandfather, Jean, or her uncle Arthur, the last dukes of Brittany to bear the arms of Dreux (Fig. 42).

On the other side of the tomb, after the half shield alluding to the earl's father, a comparable gallery begins with Marie's mother, Marie de Bretagne, escorted by her cousin, Henry, earl of Lancaster, who was also a cousin of the earl. The Lancaster shield furnishes the earliest probable date for the painting of the tomb, for it can only refer to Henry after the restoration of the Lancaster title and lands to him in 1326.[61] After Henry Lancaster follow Marie's two other sisters and their husbands. Finally Marie appears again, this time escorted by her father Guy or her brother, Jean, both counts of Saint-Pol.

This is a surprising program for the tomb of a lord with its emphasis on his affinal relatives, for, after a nod to her husband's family with representations in the places of greatest honor and visibility, Marie displayed her own siblings and cousins accompanied by their spouses or elders, and herself twice, escorted by the patriarchs of the two sides of her French family. The prevalence of Saint-Pols is novel in view of earlier lord's tombs on the Continent, such as that of Henry III of Brabant or the counts of Hainault, where even when they shared their tombs with their wives, their affinal relatives were largely or altogether absent. In contrast, Aymer de Valence's tomb includes more of his wife's family than his own.

What can be made of this highly unusual program? Unlike the Montacute tomb, it does not seem to represent chantry commendations, for no other relatives are mentioned either at Westminster, where Marie finally established a chantry in her will of 1377, for one priest-monk to chant daily for her husband, and to observe anniversaries for him and for herself,[62] or in the hermitage at Cripplegate, where she had founded a chantry of one monk in 1347, with commendations for herself, her husband, and their parents.[63] Moreover, the lively and fashionable family represented on the tomb at Westminster seems quite remote from these latter-day concerns. Given its character, the tomb in the abbey seems best understood as a display intended for the court. It appears to have had two main objectives. On the one hand, in the absence of children, it indicates the rightful heir of the deceased. On the other, it displays the patron's family. Both intentions are more feasible in the period immediately following the earl's death in 1324, a precarious time in England, than after the countess's return to England in 1334. For in spite of Aymer de Valence's loyalty to Edward II, his widow and coheirs were harassed by infringements on his estate by the king and his favorites, the Despensers, immediately following his death.[64] These circumstances would have conditioned the tomb's program, and the prominent placement of the heir to the earl's title in the company of his widow's family can be viewed as a deliberate display of family solidarity in the face of aggression.

The tomb of Aymer de Valence was most likely erected, therefore, immediately after his death in 1324, with 1330 taken as the most likely terminus ad quem. Its program seems, in the end, to be entirely in character with the astute, resourceful, but mysterious lady tracked by Sir Hilary Jenkinson, who concluded, rather disappointingly, that during her fifty-three-year-long widowhood, and in spite of her station and large family connection, the countess failed to establish many meaningful contacts with people of her own class in England.[65] But the last word has probably not been said on this remarkable woman, who, judging from this tomb, had extremely discerning taste and a bold innovative streak.[66]

The quality of the tomb sculpture has attracted much admiration. Other aspects of the family assemblage are equally important, for the figures are dressed in current fashions rather than ceremonial robes, and they assume a variety of attitudes that seem to reflect court life. In contrast to the traditional couples in formal attitudes on the chest of the Crouchback monument, these lords and ladies have a quotidian air about them that brings them psychologically much closer to the viewer. They effectively transport the locus of the tomb from an abstract aedicula to the here and now of the fourteenth century. It is no accident that tombs with such

figures have been confused with those that re-create an actual event in their depiction of the funeral rites for the deceased. For these family members step forward, swagger, and affect attitudes of gracefulness, melancholy, and quiet composure that were to be echoed on English tombs for the rest of the century. Inspired characterizations of an entire class at a precise moment, they give concrete illustration to the identifications indicated by the shields. With this tomb, we have a visual equivalent to the contract between Béatrice de Louvain and Guillaume du Gardin discussed in Chapter 3, with its specific instructions for the manner of dress and general attitude of individual family members.

The tomb of Aymer de Valence must have made a great impression when it was erected at Westminster. After this, contemporary costume and lively gestures and postures became the rule, although they were never executed with the same verve. Now and then the figures are close enough to Valence family members to suggest that they served as models. The figure of Marie de Saint-Pol, with her hands calmly clasped at her waist (Fig. 42), was to be repeated at Warwick on the tomb of Thomas Beauchamp and Catherine Mortimer (both d. 1369) (Fig. 43). The jaunty lord with his hands concealed in his surcoat, here representing Robert d'Artois (Fig. 41), reappears in ruder form at Reepham in the Kerdiston tomb (Fig. 45) and at Durham on the tomb of Sir John Neville (d. 1389) and Matilda Percy. Jean de Flandre, a striding figure at the Valence tomb (N6) reoccurs at Durham (W1), where he even turns his back on the viewer. Another change first noticeable on the Valence tomb parallels contemporary developments on the Continent, where we have seen that figures on kinship tombs began to express grief in the fourteenth century. In England too, figures expressing grief began to be mingled with those who strut or pose. The unforgettable figure of Blanche de Bretagne (Fig. 41) on the tomb of Aymer de Valence supports her head with her left arm propped up by her right in a timeless gesture of melancholy. Two lords on the Beauchamp tomb who hold their hands to their hearts seem to express devotion or deep feeling (Fig. 44). Those at Reepham pray or show signs of bereavement. In short, gradually, over the course of the fourteenth century in England, some family members and associates on kinship tombs can be truly understood by the term by which they are generally known. They are, in fact, weepers. But their mourning exists in a family context and, like the chantry prayers, seems intended to be perpetual.

ALTHOUGH these early kinship tombs for members of the royal family at Westminster differ among themselves, they all reflect French monuments, ultimately a result, no doubt, of the connections of their occupants and patrons with the Continent. The tomb for William de Valence, a French kinsman at the English court, was imported from Aquitaine. The patrons of the three presbytery tombs were also certainly aware of French tombs of kinship, beginning with Edmund Crouchback. He married the widow of the count of Champagne, Blanche d'Artois, a year or so after Aveline's death, and was count of Champagne for eight years until his wife's daughter by her first husband reached her majority.[67] During the entire period when Edmund would have been concerned with Aveline's tomb, he was constantly passing to-and-fro between France and England,[68] and the splendid monuments in Saint-Etienne at Troyes for two earlier

43. Tomb of Thomas Beauchamp, earl of Warwick, and Catherine Mortimer (both d. 1369). Lady on tomb chest (E3). Warwick, Church of St. Mary.

44. Tomb of Thomas Beauchamp, earl of Warwick, and Catherine Mortimer (both d. 1369). Lord on tomb chest (E6). Warwick, Church of St. Mary.

45. Tomb of Sir William de Kerdiston (d. 1361). Lord on tomb chest. Reepham (Norfolk), Church of St. Mary.

counts of Champagne might very well have excited the desire to have a Decorated Gothic counterpart for himself in Westminster Abbey. Thus, it seems likely that his widow initiated his tomb, although her own death in 1302 might have precluded her seeing its completion.[69] And finally, the tomb of Aymer de Valence fills a gap in our knowledge of court sculpture of the 1320s, and whether or not it was executed by a French sculptor, as has sometimes been suggested,[70] it brought a fresh portrayal of the nobility to the tomb of kinship in England that was destined to have a great future.

The Royal English Tomb During the Minority and Reign of Edward III (1327–1377)

THE FIRST TOMBS of kinship appeared in England during the reigns of the first two Edwards; under Edward III they gained unparalleled popularity. It seems probable that the precedent set by the members of the royal family at Westminster Abbey was taken up by Edward III early in his reign with the erection of two tombs intended to raise royal prestige in England. One of these tombs probably also illustrated the basis of his claim to the throne of France, a claim that eventually led him into a costly and exhausting war on the Continent. The tombs that were erected for his father, Edward II, his brother, John of Eltham, and his consort, Philippa of Hainault, were at the very least conditioned by the final events of his father's disastrous reign and the rivalry between England and France that culminated in the Hundred Years War.

Edward III inherited a disrupted kingdom. His father's weak character and apparently bisexual nature had caused him to place his personal life above royal responsibility, alienating his barons and, ultimately, his queen. Edward II's own father, Edward I, had left him a mountain of debts and an ongoing struggle for control of his barons and dominion over the intractable Scots. The latter contest was lost in a single battle at Bannockburn in 1314, where his mighty army was routed by a disproportionately small Scottish force led by Robert Bruce. The king's favoritism and his rivalry with his powerful cousin Thomas, earl of Lancaster, led to a revolt by a majority of his barons and tragic civil strife in England in the early 1320s, which ended with a decisive royal victory at Boroughbridge in 1322, and Lancaster's execution. However, it was to be a brief and hollow triumph, for Edward II was destroying the foundations of royal government in crushing his enemies, and creating an indomitable adversary in Queen Isabella.

Increasingly alienated from her husband after the royalist victory at Boroughbridge and the subsequent ascendance of his favorite, the younger Hugh le Despenser, the queen took advantage of the chance to join the English embassy in Paris in 1325, in negotiations with her brother, King Charles IV, over the Gascon question.[1] Here she found Roger Mortimer and other dissident exiles.[2] Her affair with Mortimer sparked the chain of events that led to Edward II's demise. Returning to England in September 1326, with Mortimer and a small army of Hainaulters and Germans, the queen received widespread support, wrecked vengeance on her enemies, and having convoked an assembly in London that the king refused to attend, oversaw his forced abdication and the crowning, in 1327, of his fourteen-year-old son and heir, Edward III. Incarcerated in

Berkeley Castle, Edward II was said to have been murdered less than eight months later, apparently at Mortimer's instigation.[3]

From 1327 to 1330, during the minority of Edward III, Queen Isabella served as regent, while Mortimer, newly created earl of March, virtually ruled England with a grasping hand, a situation against which the young king rebelled in 1330 with a *coup d'état.* Mortimer was subsequently condemned by his peers in Parliament, and executed.[4] Edward III's independent reign thus began three years after his father's deposition. He has often been credited with turning the situation to royal advantage by promoting a saint's cult for his father, an endeavor that began with an elaborate royal funeral and the erection of a shrinelike tomb at Gloucester (Plate IV).[5]

While art historians have regarded the tomb as the work of court artists,[6] it has usually been dated to the 1330s, with the implication that Edward III was responsible for it after assuming power.[7] But Christopher Wilson has argued convincingly for a date immediately following the funeral staged at Gloucester on December 20, 1327, and this would inevitably involve the queen in the conception of the monument.[8] The evidence from Champagne in Chapter 1 suggests that under normal circumstances a queen could be expected to see to her husband's tomb during his heir's minority. Although the circumstances under discussion can hardly be described as normal, the evidence for the tomb program suggests a political sophistication unlikely for even a king in his teens, but fully commensurate with that of Queen Isabella.

The tomb is a remarkable example of theatrical statecraft, for a monument *fit* for a saint was erected at Gloucester that remains today a powerful manifestation of the evocative power of great architecture. An image of the king surpassing the usual representation of the ruler in England was deliberately suggested by its form and content. Although its canopy has been restored and its chest divested of its figurative decoration, the general character of the monument is intact, and the power of its alabaster effigy remains unaltered (Fig. 46). Vested in tunic, dalmatic, mantle, and crown, and holding the royal scepter in his right hand and an orb in his left (Fig. 47), the king gazes heavenward, as if transfixed by a great light. The impression of a vision is confirmed by the participation of two angels who look upward as they gently support the monarch's head, and even by the lion at his feet, which gazes somewhat soulfully in the same direction. The translucent glow of the alabaster, employed for the first time in a royal effigy in England, contributes to the effect of a transcendental event.

But it is not only the sculptor's gift for working a sensitive medium that suggests a setting for miracles. Edward Stone has observed that King Edward's head follows the illuminator's conventional representation of God.[9] That this was not a coincidence is confirmed by the king's attributes, the traditional royal scepter, and an orb. Up until this time, the orb had been used as a symbol of royal power in England only on the king's seal, where it appears to have been adopted in emulation of the German emperors.[10] This appears to be the first use of an orb on a royal English tomb,[11] which raises the question of its significance here. Since no evidence suggests that the orb was part of the English regalia with which the monarch was invested at his coronation until the coronation of Richard II in 1377, the orb held by Edward II in effigy must signify something more than his inheritance.[12]

Beginning in the second half of the tenth century with the Ottonian emperors, the orb had

46. Tomb of Edward II, detail of the effigy. Gloucester Cathedral (formerly abbey church of St. Peter).

been used consistently in the empire as a symbol of the emperor's dominion, both on seals and in manuscript illumination, and eventually in the coronation rite itself.[13] But at the same time, Christ began to be shown with an orb.[14] For an eleventh-century monk at Reichenau, the orb was a sign of victory in Christ's hands, obviously His victory over death, but that it could also signify heaven is demonstrated in a tenth-century manuscript from Lorsch, where an angel holds an orb inscribed *coelum*.[15] Subsequently, representations of both Christ and God the Father carrying an orb became rather general, and extended from the Continent to England.[16]

The orb would therefore seem to associate the effigy and thus the remains of Edward II with Christ. An anagogic identity of the Christian ruler with Christ is expressed more than once in Western medieval royal theory and ceremony. It is central to the meaning of the king's anointing at his coronation, whereby he is transformed from a layman into a *Christus Domini*, the anointed of the Lord, like the Old Testament kings and Jesus Christ himself.[17] The order for the

47. Electrotype of the effigy of Edward II from Gloucester Cathedral. London, National Portrait Gallery.

Honoratiſſimo et Nobi- -liſſimo Domino Dn.º
GEORGIO Baroni BERKLEY de BERKLEY in agro
Gloverniensi Tumuli hanc Regis EDWARDI
Secundi Figuram H: D: D: D: F. S.

48. Tomb of Edward II. Gloucester Cathedral (formerly abbey church of St. Peter). Francis Sandford, *A genealogical history of the Kings of England*, London, 1683, 152.

coronation of the emperor revised at Mainz circa 960, which became standard for Germany for many centuries and which was reflected in the English Order of Edgar (973), expressed it thus:

Jesu Christo, cuius nomen vicemque gestare crederis.

In Jesus Christ, whose name and function you are believed to bear.[18]

In England, this concept is nowhere more clearly stated than in a letter written by a clerk at the court of Henry II (1154–89), Pierre de Blois, who said categorically that the king is a saint, the Christ of the Lord.[19] In the thirteenth century, Bracton, the leading jurist of his time, reaffirmed that the king is the vicar of God, and corresponds here on earth to Christ.[20] In 1308, when the coronation order was revised for the coronation of Edward II, the old anointing on the head with chrism, analogous to the consecration of a bishop, was reinstated after having been replaced by anointing with oil of catechumens, reasserting that the king's anointing was equal to that of a bishop and that he, like Melchizedek of old, was both king and priest, *rex et sacerdos.*[21]

The suggestion of a holy king mystically identified with Christ is intensified by the tomb architecture at Gloucester, an elaborate tripartite shrine of delicate attenuated piers that divide the tomb chest into alternately shallow and deep niches and bind it to the double-tiered pinnacled canopy that they support. This marvelous example of the Decorated style was thrice restored in the eighteenth century and once in the nineteenth.[22] But its general character remains that reflected in Sandford's engraving of 1683 (Fig. 48), and the architecture of the tomb chest is unchanged. As mentioned above, the chest has a series of alternating shallow and deep niches, the latter similar to those providing for the physical access of pilgrims on the shrine bases of saints at earlier English sites.[23] Each of the shallow, outer niches has a pedestal to support one figure, while the more ample, recessed niches provide pedestals for two. There are four shallow outer niches on each long side of the chest, and two on the short sides, providing for a total of twelve figures in the single niches. The larger, recessed niches sheltered sixteen figures. Evidence that figures were actually placed in the niches is furnished by the dowel holes and iron studs that remain on several bases.

The program of the tomb chest has never, to my knowledge, been mentioned in the literature on the monument, but a significant clue to the nature of the figures in the recessed niches is furnished by the fact that shields were formerly placed in the spandrels above the arches framing them. They are visible in Sandford's engraving and in subsequent engravings from the eighteenth and nineteenth centuries.[24] Moreover the relatively clean areas where the shields were attached are visible on the south side of the tomb (Fig. 49). The presence of these shields suggests that the double niches sheltered figures representing secular personages and that Edward II's was a tomb of kinship. However, this family set would have been secondary to the figures in the single niches, which numbered twelve. The number itself suggests a series of apostles, and this hypothesis gains strength by analogy.

A similar tomb chest with the same alternation of large and small niches is found in the Chapel of St. Stephen at Bures (Suffolk) to which it was transferred in 1935, from the Benedictine priory at Earl's Colne (Essex) (Figs. 50 and 52).[25] Associated by Prior and Gardner with the London Court school, the tomb is one of a series erected for the earls of Oxford at Earl's

49. Tomb of Edward II, detail of tomb chest. Gloucester Cathedral (formerly abbey church of St. Peter).

Colne, and probably belongs to Robert de Vere, fifth earl of Oxford, who died in 1296.[26] Only two sides of the chest are preserved at Bures, but a drawing in the Walpole papers (Fig. 51), which shows the north side and a flawed depiction of the west side, suggests that the same system of alternating niches was used on all four sides.[27] As formerly at Gloucester, the arches framing the large recessed niches carried shields in the spandrels, referring to a series of secular personages, and, as recorded by several antiquarians, the blazons once painted on most of these shields referred to members of the earl's family.[28] The small niches sheltered figures in relief which, to judge from their attire and attributes, represented apostles (Figs. 51 and 52).[29] The statuettes in the outer niches at Bures support our hypothesis that the outer series of figures at Gloucester represented holy figures, and most likely, the twelve apostles. Certainly the chest was designed to give them greater prominence than the figures in the recessed niches. This spatial hierarchy replaced the linear order employed in Brabant at the tomb of Henry II, where the duke's forebears were subordinate to the apostles.[30]

If, as suggested, the tomb chest at Gloucester displayed two series of statuettes that placed the ruling family in apposition to the holy apostles, it would have reinforced the association of Edward II with Christ while emphasizing the dynastic claim that he passed on to Edward III, with the intention of enhancing the status of the new king at a critical time. Certainly it transformed the mystery surrounding Edward's final trauma by building on the mystique that normally attached to kings in the Middle Ages. That mystique had been exploited earlier by both the Plantagenets and the Capetians with the myth that they could heal scrofula.[31] As a daughter of the Capetian kings of France, Queen Isabella would have been well aware that the legitimacy associated with the anointing and coronation of a king of ancient race conferred the ability to heal, which for over two centuries had been used to fortify royal power in England as well as France.[32] Moreover, although Edward II's thaumaturgic record had been mediocre if compared

50. Tomb of Robert de Vere? fifth earl of Oxford (d. 1296), formerly in Earl's Colne Priory. Bures, Chapel of St. Stephen.

51. Tomb of Robert de Vere? fifth earl of Oxford (d. 1296), formerly in Earl's Colne Priory. London, Brit. Lib., Ms. Add. 27348, fol. 29.

52. Tomb of Robert de Vere? fifth earl of Oxford (d. 1296), formerly in Earl's Colne Priory, detail of apostle on tomb chest. Bures, Chapel of St. Stephen.

with that of his father, he had introduced a new healing rite, first documented in June 1323, with the distribution of cramp rings, designed to cure epilepsy and other muscular spasms.[33] This natural propensity for royal miracles would have been intensified by Edward II's tribulation, and the rumor that he had been horribly murdered sufficed to transform his death into a martyrdom in the popular imagination.[34] In the magnificent tomb at Gloucester, that inchoate imagination was skillfully focused on a shrine proclaiming the dead king's saintliness and probably associating his family with Christ and the apostles, thus proclaiming the legitimacy of his dynasty at a time when it had been seriously compromised by his own inadequacy and the desperate machinations of his queen. If Queen Isabella did plan the pilgrim's site at Gloucester, it was for the future of her son, Edward III, and her own well-being.

We can only surmise that the tomb had the desired effect from the spare account in the Gloucester Chronicle, but even before the burial the crush of visitors to view the king's corpse was such that a wooden barrier had to be erected to protect it.[35] And the chronicler of Gloucester recorded that afterward, during the abbacy of John Wygmore (1329–38), the visitors to the king's tomb were so numerous as to strain the town's capacity to contain them, and their offerings in

less than six years sufficient to pay for the construction of the south transept of the church.³⁶ Eventually the king's burial place would be further enhanced by the remodeling of the choir; and the insertion of the great east window, where Jill Kerr has detected a decorative program representing the transmission of authority from heaven to earth, would complete the message of a divinely ordained dynasty.³⁷

No doubt elated by the extraordinary success of the Gloucester tomb, Edward III must have commissioned a second elaborate alabaster tomb within a decade of the completion of the Gloucester monument. This one, at Westminster Abbey, was for his younger brother, John of Eltham, after he was killed in Scotland in 1336 while commanding the royal army. This monument is no less stirring than the Gloucester tomb but in a completely different way, for if the tomb of Edward II has an aura of sanctity, that of John of Eltham is profane in the extreme. When complete with its exultant triple canopy, gallant effigy, and mannered family gallery, it must have seemed to liken the fanfare of heaven to that of a costly tournament (Fig. 53).

John of Eltham was buried at Westminster Abbey in 1337.³⁸ A letter written by Edward III from Brussels in August 1339, ordering the transfer of his body to a suitable place "entre les Roials" was interpreted by Lethaby to indicate that the tomb originally stood on the south side of the royal chapel, where the tomb of Edward III himself now stands, and by Stone to indicate that the tomb had not yet been begun in 1339.³⁹ One wonders, however, if the letter might not imply that the tomb was finished at this date and ready for the transfer of the body, which must have been buried elsewhere temporarily.⁴⁰ At any rate, the letter of 1339 makes it clear that Edward III intended that the spaces ringing the royal chapel should be reserved for himself and his heirs.⁴¹ Furthermore, it clearly associates Queen Isabella with the project of transferring Prince John's body, and probably, by implication, with the erection of his tomb.⁴²

Today the tomb of John of Eltham stands in rather cramped quarters with that of William de Valence in the Chapel of Sts. Edmund and Thomas the Martyr, directly across the ambulatory from the tomb of his brother the king in the royal chapel (Fig. 54). A good view of it from the ambulatory is blocked by a wooden screen that was erected in the fifteenth century, and it is divested of its canopy, which was condemned and taken down in the eighteenth century.⁴³ The statuettes on the tomb chest have also suffered considerable damage. Nevertheless it is a splendid monument, an elegant combination of fine materials superbly crafted.⁴⁴

The chest consists of a freestone base and a framed frieze of shields surmounted by an arcade in alabaster that houses the family gallery. The base formed the foundation for the canopy, also in freestone, which stood on eight slender piers that have now been cut back at the level of the molding that divides the base and frieze from the arcade above. The figures, which were no doubt identified by the shields below them, are carved like them in relief, but they are backed with dark touchstone, which sets them off to a degree comparable to the more elaborate architectural settings of earlier tombs. The tomb slab, in dark Purbeck stone, serves the same function, creating an effective foil for the effigy of highly polished white alabaster (Fig. 55). The figure is cross-legged, as was customary for English knights since the thirteenth century, and fully outfitted for combat in armor, cyclas, sword, and shield.⁴⁵ But his slender frame and the exqui-

I. Cole Sculp.

53. Tomb of John of Eltham, earl of Cornwall (k. 1336). London, Westminster Abbey. Dart, *Westmonasterium*, London, 1723, 1, 106.

54. Tomb of John of Eltham, earl of Cornwall (k. 1336). London, Westminster Abbey.

55. Tomb of John of Eltham, earl of Cornwall (k. 1336), effigy. London, Westminster Abbey.

56. Tomb of John of Eltham, earl of Cornwall (k. 1336), west end of tomb chest. London, Westminster Abbey.

site detail of the coronet and accoutrements lend him the air of a polished and chivalrous prince rather than a formidable knight.[46] Moreover, the atmosphere of the court is all-pervasive in the gallery below, where the ladies' attitudes seem almost coquettish and the lords' consciously elegant as they pose or strut, sometimes fingering the straps of their mantles, sometimes pointing to their scepters. The context of the tomb and the attributes of the figures suggest that all belong to the royal family, for those with heads and attributes intact wear royal crowns and carry scepters.[47] There were twenty-four in all, arranged in groups of three on all four sides of the chest. The arrangement of alternating lords and ladies is varied by this triple grouping, so that one has, alternately, a lord flanked by ladies (Fig. 56), followed by a lady flanked by lords. Their precise identities have been lost with the disappearance of the blazons from the shields.[48] However, one would not expect Edward III and Queen Isabella to have missed an opportunity to assert the dual royal lineage that Prince John shared with his brother, the king, and it therefore seems likely that the majority of the figures represented the kings and queens of England and France. If so, the new importance of the shields in the design of the tomb, both larger and more prominently displayed than formerly, would have emphasized the prince's lineage, who died unmarried and without progeny.

Christopher Wilson's suggestion that the alabaster effigy of Edward II was intended to emulate French royal monuments seems likely, and this would apply to the tomb of John of Eltham as well.[49] The earliest royal French tombs in marble, for Philippe III le Hardi (d. 1285) and his queen Isabelle d'Aragon in Saint-Denis, had appeared already at the end of the fourteenth century.[50] Both tombs had effigies in white marble that are still preserved at Saint-Denis, and tomb chests in black marble that are known from drawings.[51] By the time that comparable monu-

57. Tomb of Philippa of Hainault, queen of England (d. 1369). London, Westminster Abbey.

ments were being planned for Edward II and John of Eltham, black marble tomb chests with white marble effigies and other figurative decoration were becoming a standard luxury for members of the French royal family, and the taste for precious sobriety that they represent was reflected in manuscripts and stained glass windows as well.[52] If, as seems likely, Queen Isabella played a major part in planning the royal English monuments, the emulation of contemporary French funerary art is all the more understandable.

THE QUALITY and renown of Parisian tomb making probably prompted the choice of a Fleming residing in Paris as designer almost three decades later, when a tomb was commissioned for Edward's consort, Philippa of Hainault. In contrast to the tombs for his father and brother, the tomb for Edward's queen was begun while she was still alive. The monument, which is still in its original place between two piers on the south side of the royal chapel in Westminster Abbey, was begun before 1367, when the sculptor Jean de Liège received a partial payment for it, and it must have been well near completion when the queen died on August 15, 1369.[53] The choice of the sculptor and the program of the tomb both suggest that the queen had a major role in planning it.

Formerly a sumptuous monument in black and white marble, the tomb is much altered (Fig. 57), having suffered an encroachment on its northeast corner with the building of the

chantry chapel of Henry V in the fifteenth century, and the almost total destruction of the exposed parts of the chest decoration since that time.[54] As can be construed from the fragments of architectural decoration remaining on the chest and from Sandford's engraving of 1683 (Fig. 58), the queen's effigy rested on an elaborate chest faced on all four sides with alternately paired and single niches crowned by a continuous vaulted arcade that sheltered statuettes identified by shields beneath them. The effigy was originally framed by two shafts carved with niches housing statuettes. Above, an embattled wooden tester spans the entire space between the chapel piers.[55]

The graceful gallery surrounding the tomb chest displayed Philippa's extensive family connections. The program presented in Figure 59 has been reconstructed from the seven shields still in situ and from the record left by a host of antiquarians, none of whom left a complete account.[56] The program combines both traditions of family representation used on the Continent in the thirteenth and fourteenth century: the one, including only territorial lords, is strictly patrilineal; the other, which includes lords and ladies in the same company, suggests the more gracious and polite society that had evolved at the French court in the thirteenth century. Following the first tradition, and probably influenced by the programs of her father and grandfather's tombs in Valenciennes, Philippa had her most important kinsmen placed at the head of the tomb: her husband, Edward III; their son, Edward the Black Prince, heir apparent; her father, William I of Hainault; her cousin, either King John the Good or Charles V of France; and her brother-in-law, the Emperor Louis of Bavaria. Male relatives of almost equal distinction, but lesser kin, were placed at the foot. On the two long sides, lords and ladies alternated. The queen's living children and their spouses dominated the north side of the chest, facing the chapel. Her family from the House of Avesnes dominated the south side, overlooking the ambulatory, but two recently deceased daughters were also included there.[57] This was hardly a genealogical tomb to the same degree as its prototypes in Hainault. It included only four generations, and its program reflected more concern for contemporary society than for the queen's distinguished lineage. The protocol observed on the long sides, where lords and ladies alternated, suggests a civilized and sociable court, but one in which hierarchy was always a concern. In fact, the design of the chest provided for a secondary hierarchy in addition to that seen in the ordering of the figures in series. All sides show traces of the alternation of double and single niches depicted in Sandford's engraving.[58] This design gave preeminence to the figures in the single niches, with the result that the most prominent positions were occupied by the figures of King Edward III on the west end; King David of Scotland on the east end; Joan of Kent, princess of Wales; John of Gaunt, duke of Lancaster; and his wife, Blanche of Lancaster, on the north; and Margaret of Hainault, Holy Roman Empress; John II, count of Hainault; and Margaret of England, countess of Pembroke on the south. By placing Edward III at center on the west end, the program emphasized his place in his lady's heart, but with his brother-in-law, the emperor, on his right and his Valois cousin, the king of France, on his left, it also asserted his right to the throne of France, which, if realized, would have made him the equal of the emperor and the liege lord of his cousin.

Edward's pursuit of the French throne probably influenced the choice of the other lords represented on his queen's tomb, for a number of them represented his allies in the Hundred

58. Tomb of Philippa of Hainault, queen of England (d. 1369). London, Westminster Abbey. Sandford, *A genealogical history of the Kings of England . . .* , London, 1683, 173.

60. Tomb of Philippa of Hainault, queen of England (d. 1369), effigy. London, Westminster Abbey.

Years War. These included the emperor, Louis of Bavaria; William of Hainault; Reginald, duke of Guelders; Pedro of Castille; and Charles the Bad, king of Navarre.[59] In its inclusion of many members of Philippa's family, the tomb may also have reflected Edward's long-standing ambition in the troubled succession of Hainault and Holland. For when Philippa's brother, William II, had been killed in 1345, his title was claimed by both Edward, for Philippa, and by his brother-in-law, the emperor Louis IV of Bavaria, for Philippa's sister Margaret. But Edward was unable to pursue Philippa's claim before Margaret appeared in Hainault to take possession of the territory. She was recognized by the estates in Hainault after agreeing to conserve her brother's heritage intact and to leave it to her son, William III, but her claim was more difficult to enforce in Holland, where she became entangled in a civil war. In Holland, one faction recognized her, but the other recognized William. Edward III was called in as arbitrator in 1352. William inherited the two counties at his mother's death in 1356, but soon afterwards began to show signs of the mental illness that would lead to a confinement that only ended with his death in 1388. In the meantime, the provinces were governed by his younger brother Albert as regent. Given the unstable situation in Hainault and Holland, Edward's ambitions in the region probably remained latent until 1370, when the emperor, Charles IV, formally recognized Albert as the legitimate heir.[60] Finally, perhaps with a premonition of the tragic rivalry among their own descendants after Edward's death, Edward and Philippa included all the eligible candidates for the throne of England after the Black Prince on the north side, in strict order of succession.

In spite of these reflections of grim political realities, the visual impression of a courtly monument that is suggested by the alternation of lords and ladies on the long sides of the tomb is reinforced by the surviving sculpture. The effigy of the queen, although unsparing in its realistic depiction of a lady grown heavy with age, much childbearing and dropsy,[61] is graceful in demeanor and simply but elegantly clad (Fig. 60). She wears a kirtle laced to below the waist and

>59. Program of the tomb of Philippa of Hainault, queen of England (d. 1369), London, Westminster Abbey.

N ▷

Top row labels:

F.	Cous.	H.	B.-in-l.	S.
WILLIAM I C. of Hainault and Holland d. 1337	JOHN II d. 1364 or CHARLES V d. 1380 Ks. of France	EDWARD III K. of England d. 1377	LOUIS IV of Bavaria H. R. Emp. d. 1347	EDWARD P. of Wales b. 1330 d. 1376
W5	W4	W3	W2	W1

Left column (West side):

M.	JOAN of VALOIS C. of Hainault d. 1342	S1
B.	WILLIAM II C. of Hainault k. 1345	S2
Sr.	MARGARET of HAINAULT H. R. Emp. d. 1356	S3
B.-in-l.	REGINALD II D. of Guelders d. 1343	S4
Sr-in-l.	ELEANOR of ENGLAND D. of Guelders d. 1355	S5
Gf.	JOHN II ? C. of Hainault d. 1304	S6
Da.	MARY of ENGLAND D. of Brittany b. 1344 d. 1362	S7
N.	WILLIAM III C. of Hainault and Holland d. 1388	S8
Da.	MARGARET of ENGLAND C. of Pembroke b. 1346 d. 1361	S9
Gf.	CHARLES C. of Valois d. 1325	S10
Sr.-in-l.	JOANNA D. of Brabant d. 1406	S11

Center:

PHILIPPA of HAINAULT

Queen of England

d. 1369

Right column (East side):

N1	JOAN of ENGLAND Q. of Scotland d.1362	Sr.-in-l.
N2	JOHN of ELTHAM E. of Cornwell k. 1336	B.-in-l.
N3	JOAN of KENT P. of Wales d. 1385	Da.-in l.
N4	LIONEL of ANTWERP D. of Clarence b. 1338 d. 1368	S.
N5	ISABEL of ENGLAND C. of Bedford b. 1332 d. 1379	Da.
N6	JOHN of GAUNT D. of Lancaster b. 1340 d. 1399	S.
N7	ELIZABETH de BURGH D. of Clarence d. 1363	Da.-in-l.
N8	EDMUND of LANGLEY D. of York b. 1341? d. 1402	S.
N9	BLANCHE D. of Lancaster d. 1369	Da.-in-l.
N10	THOMAS of WOODSTOCK? D. of Gloucester b. 1355 d. 1397	S.
N11	PHILIPPA of HAINAULT Q. of England d. 1369	

Bottom row labels:

E1	E2	E3	E4	E5
PEDRO I K. of Castile k.1369	ROBERT I K. of Naples d. 1343	DAVID II K. of Scotland d. 1371	CHARLES IV ? K. of Bohemia and H. R. Emp. d. 1378	CHARLES II? K. of Navarre d. 1387
	Gr. U..	B.-in.-l.	U. by marr.	Cous. by marr.

61. Plaster cast of the statuette of Philippa of Hainault from her tomb. Westminster Abbey, Muniment Room and Library.

62. Tomb of Philippa of Hainault, queen of England (d. 1369). Statuette of Blanche of Lancaster (N9). London, Westminster Abbey.

encircled with a narrow but costly hip belt, the end of which extends to her ankles. With her left hand she clasps the strap of her mantle. In her right she probably originally held a scepter. Her headdress is typical for a queen in the fourteenth century. Two long braids encased in a jeweled net frame her face, and she originally wore a crown, probably in metal.[62] Her head rests on a draped pillow and her feet on a lion and lioness.

Philippa's headdress appears to have been identical to that of Figure 11 from the north side of the tomb, to judge from a cast made of the head by Sir Gilbert Scott during his restoration of the tomb (Fig. 61).[63] Scott suggested that Philippa herself was represented a second time in this figure, and in fact, this startling identification is supported by the coat of arms underneath the statuette, first recorded by the Royal Commission Inventory as quarterly France and England impaling Hainault.[64] Philippa was the only lady of her time who bore this coat. The body of the statuette has remained in place, concealed from view by a pier of Henry V's chapel, but the statuette still in Niche 9 on the north side is just visible to the viewer from the royal chapel (Fig. 62). Representing Blanche of Lancaster, wife of Philippa's fourth son, John of Gaunt, this is

a charming depiction of a fashionable lady wearing the sideless surcoat that was standard official attire for noble ladies of her time over a low-belted kirtle. She lifts one long pendent sleeve of the surcoat with her right hand, while the other is draped over her left arm, along with the chain restraining a tiny monkey, which she holds against her chest. A veil shelters her head and gives her whole demeanor a somewhat blinkered cast. What a provocative glimpse this little statuette offers of the English court of the late fourteenth century and what a pity that her companions on the tomb are either concealed or gone!

The effigy and two statuettes surviving from the chest are among the earliest extant sculpture that can be associated with Jean de Liège, who was later to become chief tomb maker at the court of the French king, Charles V. In a long article on the work of Jean de Liège, Gerhard Schmidt limited his consideration of the role of the sculptor on this tomb to the head of the effigy, and did not consider the possibility that he was involved in the execution of the tomb chest and its small statuary.[65] Wendebourg has already pointed out that the payment of 1367 suggests that the artist was responsible for the entire monument.[66] Moreover, the figure of the queen exhibits the shortened proportions also seen in the sculptor's effigy of Queen Jeanne d'Evreux from Maubuisson of 1372, and the handling of the garment has similar simply modeled sleeves and long stiff folds in the skirt that end in stilted facets as they collect around the feet.[67] Moreover, the statuette of Blanche of Lancaster and the plaster cast of the head from Niche N11 exhibit a style that is completely in accord with that of the effigy, although executed with less mastery and precision. The statuette displays the same simple but skillfully modeled form of the body, which is revealed by a tight-fitting bodice and the movement of the left knee against the long folds of the skirt. The head has the same simple structure with its rounded planes set off by the strongly projecting veil, comparable in sculptural effect to the queen's braids. Although the resemblance between the queen's head and that of the plaster cast is not as striking as that between it and the head of Blanche of Lancaster, the treatment of forms is similar, and one must allow for the loss of clarity entailed in casting. In short, it seems quite likely that Jean de Liège designed the statuettes as well as the effigy.[68] He was also probably responsible for the execution of the entire effigy.

THESE three royal tombs gave a new splendor to the tomb of kinship in England that must have inspired the adoption of the type by many of the king's barons, as discussed in the next chapter. Moreover, the program established for the tomb of Queen Philippa and the evidence for royal ancestry in the program of the monument for John of Eltham suggest that Edward III, probably advised by both his mother and his wife, promoted the dynastic potential of the tomb as a conscious political instrument in his bid for the French throne.

In its overall effect, Queen Philippa's tomb stands somewhat apart from the two previous royal monuments, especially in its use of a flat wooden tester rather than an elaborate canopy over the effigy. While its setting in the ring of biers around the royal chapel precluded an imposing canopy, its conception as a sarcophagus faced on all sides with an intricate arcade for freestanding statuettes was probably continental. The widespread destruction of tomb chests in France and the Low Countries precludes determining how closely the design of Philippa's tomb

reflects continental models, but the program of the tomb followed family precedent in Hainault rather closely, and this would have affected the design of the chest. However, the few French tomb chests known from drawings and fragments suggest that the design of Queen Philippa's bier may be a brilliant adaptation of French Rayonnant to a local English tradition, for the hierarchy of important single niches alternating with paired ones at the queen's tomb is a variant of the alternation used at Gloucester to separate the holy from the profane.

The knowledge that the queen's tomb was designed by a foreign artist has tended to constrain scholars from setting it within an English stylistic context, and the disappearance of most of its statuary hinders an assessment of its influence on subsequent sculpture in England. But one should note that Jean de Liège's effigy of the queen obviously influenced that of Anne of Bohemia, Richard II's consort, cast by Nicholas Broker and Godfrey Prest almost three decades later for the tomb at Westminster that she shared with the king.[69] And the design of Queen Philippa's tomb chest, where the alternation of paired and single niches is crowned with a continuous vaulted arcade (Fig. 58), seems to have been the point of departure for the design of the chests of the adjacent monument for Edward III at Westminster (Fig. 73), that for Richard II and Anne of Bohemia in the next bay to the west, and ultimately for that of Richard Beauchamp at Warwick (Fig. 93).[70]

The English Baron's Tomb
in the Fourteenth Century

FROM the English court, the tomb of kinship spread to the country seats of the royal servants and the landed gentry. These tombs were normally erected on or near their estates, so that in the course of the fourteenth century, the type was scattered over the English countryside and into Wales and even Scotland in settings that ranged from great cathedrals to small parish churches.

The Nevilles were the first laypersons to have tombs in Durham Cathedral. That of Ralph (d. 1367) and Alice Audley (d. 1374), originally at the east end of the nave, was moved in 1416 to a less prominent place under the south nave arcade.[1] The tomb of the next Lord Neville, Sir John (d. 1389), and Matilda Percy (d. before 1386) stands under the adjacent arch to the west. An equally splendid setting was appropriated by the Burghershes in the northeast corner of the Angel Choir in Lincoln Cathedral, where Henry Burghersh, bishop of Lincoln, founded a chantry in 1332 that was expanded by his brother, Sir Bartholomew, in 1345 with a foundation that associated the tombs of his brother, their father, and eventually himself with the chantry. The freestanding tombs of Thomas Beauchamp, earl of Warwick and his wife, Catherine Mortimer (both d. 1369), at St. Mary's, Warwick (Fig. 63), and that of Sir Hugh Calveley (d. 1394) at Bunbury (Cheshire) dominate the chancels of collegiate churches founded or rebuilt by them.[2]

The knights tended to have their monuments in churches on or near their country estates. So at Ingham and Reepham (Norfolk), the tombs of Sir Oliver Ingham (d. 1344) and Sir William de Kerdiston (d. 1361) are in the usual place reserved for founders against the north wall of the chancel, where, adjacent to the altar, they seem to represent the adaptation of the Westminster canopied tomb to a more modest setting (Fig. 64).[3] Lady Clinton's tomb in the chancel of the parish church at Haversham and the monument thought to be for Sir John de Seagrave (d. 1343) at Folkestone (Kent) are similarly placed.[4]

Without exception, these tombs, as well as others that might be cited, belonged to barons with close links to the court, to knights who fought in the Crown's wars in Scotland and France, or to their womenfolk. They must therefore be considered in the context of the Hundred Years War. That war, a series of conflicts interrupted by treaties and truces that culminated in a devastating civil strife in France in the early fifteenth century, was for Edward III primarily a war of conquest to stabilize his Aquitainian provinces and to pursue his claim to the French throne, but for his captains, it was a war of adventure and considerable economic gain, punctuated by stunning victories over the French at Crécy (1346), Poitiers (1356), and Agincourt (1415).[5] While

63. Tomb of Thomas Beauchamp, earl of Warwick, and Catherine Mortimer (both d. 1369). Warwick, Church of St. Mary.

the border with Scotland had to be constantly defended, the major campaigns took place on French soil, throttling the cultural eminence that the French had enjoyed for several centuries and ultimately threatening their very identity as a people with English occupation and rule.

Ralph Neville served Edward III primarily along the Scottish border, being appointed joint warden of the Scottish marches with Lord Percy in 1334, while his son and heir, John, was a distinguished soldier in the French campaigns.[6] The Burghersh brothers, Sir Bartholomew and Bishop Henry, had been willing instruments of Queen Isabella's policy under Edward II, being actively involved in the overthrow of the king and the subsequent regency. But after the accession of Edward III, they served him in both war and diplomacy, the bishop as the spokesman of the court party and as adviser on foreign affairs, and Sir Bartholomew as constable of Dover Castle and warden of the Cinque Ports, coadmiral of the English fleet, a banneret, and just before his death, guardian of the realm in the king's absence.[7] As we shall see below, the programs of their tombs reflect this royal allegiance. Thomas Beauchamp, earl of Warwick, was among the most distinguished soldiers of the Hundred Years War, serving as comarshal of England from 1344 until his death in 1369. He was a commander in most of the great battles of the king's French campaigns: at the Siege of Tournai (1340); at Crécy (1346), where he was in joint command of the Black Prince's division; at Calais (1346–47); and at Poitiers (1356), where he led the

vanguard. He was also a diplomat, treating for peace in 1342 and 1343, and witnessing the Treaty of Brétigny (1360).[8] Lady Montacute's first husband, William Montacute, had been a favorite of Edward II,[9] and their eldest son, also named William, was Edward III's closest friend and advisor until his death in 1344.[10] Sir Hugh Calveley, a famous soldier of fortune, fought in the French campaigns, was eventually seneschal of Calais, coadmiral of the fleet, captain of Brest and governor of the Channel Isles.[11] Sir Oliver Ingham was one of the twelve councilors of Edward III during his minority, and seneschal of the duchy of Aquitaine from 1333 to 1343.[12] Sir William de Kerdiston was with Edward III at Sluys, and fought at Crécy and at the Siege of Calais. He was a member of the council of Thomas of Woodstock in 1359, when Edward III left his son in charge of the kingdom during his campaign in France.[13] In short, there appears to have been a direct relationship between service to the Crown and the baron or knight's tomb of kinship in the fourteenth century in England. It is as if the war with its dangers and its acts of valor and comradeship had heightened the warrior's consciousness of his own worth, and with it his sense of family and loyalty to the king and to comrades in arms.[14] Above all, the war enabled him or his heirs to finance expensive monuments in his honor.

One of the most obvious examples of the correspondence between military experience and the English tomb of kinship is the celebrated brass of Sir Hugh Hastings (d. 1347) at Elsing (Norfolk) (Fig. 65).[15] This descendant of John Hastings by his second wife, Isabel le Despenser, fought in the Hundred Years War in Flanders and Gascony. He was in the retinue of Henry of Lancaster at the Battle of Sluys (1340), and accompanied him to Gascony in 1345, in the retinue of his own nephew, Laurence Hastings. In 1346, he was appointed captain and lieutenant of the king in Flanders. He fought at Crécy and died before Calais in June 1347.[16] The eight knights represented in the shafts that frame his effigy at Elsing almost seem to represent the chain of command in the battles in which Sir Hugh took part, for at the top on the left (south) side, a figure representing Edward III is followed on the same side, reading down, by figures representing Thomas Beauchamp, earl of Warwick, comarshal of the army (d. 1369); a Despenser;[17] and John Grey (d. between Oct. 25, 1348 and May 4, 1350).[18] These figures correspond to a series of knights on the right (north) side that begins at the top with Henry, earl of Lancaster (d. 1361), followed by Laurence, Lord Hastings, earl of Pembroke (d. 1348); Ralph, Lord Stafford (d. 1372); and Amauri de St. Amand (d. 1381). Sir Hugh le Despenser and Ralph Stafford were in the Battle of Sluys, and all except Laurence Hastings fought at Crécy. Laurence Hastings, Warwick, Sir Hugh le Despenser, Amauri de St. Amand, Lord Stafford, and John Grey had participated with the deceased in the siege of Calais in 1347.[19] On the other hand, only five of these comrades-in-arms were his relatives: his half nephew, Laurence Hastings; his nephew, John Grey; and his cousins, Sir Hugh or Edward le Despenser, Thomas Beauchamp, and Amauri de St. Amand.[20] Thus the program of this brass suggests that the knight's tomb of kinship in Britain was apt to include fellow warriors as well as members of his family. We have seen that chivalric kinsmen were painted on the base of Edmund Crouchback's tomb at Westminster Abbey, and that the coats of arms of his brothers-in-arms were included with those of his kindred in the tomb's heraldry. It seems that other knight's tombs, such as the tomb chest at Abergavenny (Gwent) recently associated with the effigy of John, second Lord Hastings, by Claude Blair, and

64. Tomb of Sir William de Kerdiston (d. 1361). Reepham (Norfolk), Church of St. Mary.

65. Brass tomb plate of Sir Hugh Hastings (d. 1347). Elsing (Norfolk). E. M. Beloe, *Monumental brasses and matrices of the fourteenth and fifteenth centuries . . . in . . . Norfolk.* Kings Lynn, 1890.

the similar tomb chest at Sparsholt (Oxon), also demonstrate the kinship felt in fighting for a common cause.[21]

Besides illustrating chivalric kinship, Sir Hugh's brass furnishes an unusual bit of evidence for the potential legal function of these tombs. In a suit brought before the English Court of Chivalry, between 1407 and 1417, over the right to bear the Hastings arms without a mark of difference or abatement, Sir Hugh's great grandson, Sir Edward Hastings, cited the tomb at Elsing as evidence. Subsequently the commissioners to the court journeyed to Elsing to view the brass, producing for their register a detailed description of the monument.[22] The Hastings trial suggests that kinship tombs provided the heirs with a visual reminder of their claims to property, as well as the honors and dignities that accompanied land grants under the feudal system.

Sir Hugh's brass is unusual in yet another respect, for the programs of fourteenth-century English country tombs are rarely as intelligible as his or those at court, and this must always have been the case. As one might expect, there seems to have been a direct relationship between established ancestry, family standing, and the degree of identification given on the tomb chests. For example, on the tomb of the Beauchamps at Warwick (Fig. 63), a shield frieze like that on the tomb of John of Eltham was employed to identify each member of their illustrious extended family.[23] However, the tomb of Sir Hugh Calveley merely displayed an alternation of Sir Hugh's arms with those of his comrade, Sir Robert Knolles, beneath the twenty-eight figures surrounding the chest,[24] while on the Kerdiston (Fig. 64), Ingham, and Seagrave tombs the shields were eliminated altogether. In these tombs, only the civilian dress of the statuettes, the strict alternation of men and women and above all, the design of the monuments suggest that they were derived from court precedents.

THE INFLUENCE of monuments made for the court on the design of those commissioned by the English aristocracy in the fourteenth century is well known.[25] The monuments cited above all show stylistic traits that relate them in various degrees to court precedents, and we saw in Chapter 4 how influential the tomb of Aymer de Valence was on tombs in the shires. But several of these monuments have an even greater interest in that they can be associated with specific prayer foundations, proving that the religious function of the tombs was preserved well into the fourteenth century in England.

The tomb of Lady Elizabeth Montacute at St. Frideswide's priory in Oxford (Plate I) was discussed in the introduction as an abbreviated reference to the chantry that she established to be celebrated near it after her death. As already mentioned, her four sons and six daughters have been identified in the figures of four ecclesiastics and six laymen and laywomen displayed in the niches that decorate the long sides of the tomb chest.[26] In fact, the stations and gender of the lady's children correspond to the figures represented.[27] The bishop in the central niche on the south side must represent her son, Simon de Montacute, bishop of Ely at his death in 1345. He is flanked by two ladies in fashionable secular dress on his right (Fig. 66) and by two gentlemen in lay attire on his left, one of whom, a lord in a long robe and mantle who is holding gloves, must represent William de Montacute, earl of Salisbury. The bishop of Ely's feminine counter-

66. Tomb of Elizabeth de Montfort, Lady Montacute (d. 1354). Two daughters of the deceased. Oxford, Christ Church Cathedral (formerly Priory of St. Frideswide).

67. Tomb of Elizabeth de Montfort, Lady Montacute (d. 1354). Son and daughter of the deceased. Oxford, Christ Church Cathedral (formerly Priory of St. Frideswide).

part occupies the central niche on the north side of the tomb, a lady in Benedictine habit carrying the base of a crosier. She must represent Matilda de Montacute, abbess of Barking until 1352. She is flanked on her right by her sister Isabel, who succeeded her as abbess and is also dressed in a habit and carries the base of a crosier against her left arm (Fig. 67), and a brother in juvenile costume. On her left are two sisters, one a Benedictine, who must represent Elizabeth, prioress of Holywell.

The presence of two abbesses among the de Montacute children proves that the tomb was completed after Isabel de Montacute succeeded her sister Matilda as abbess of Barking in 1352. But even if the tomb was only commissioned after Lady Montacute's death in 1354, she must have planned it in relation to the prayers that she had established in 1348.

Lady Montacute's foundation at Oxford could have been inspired by the lavish chantry established in Lincoln Cathedral by the bishop, Henry Burghersh, in 1332, for Oxford was in the diocese of Lincoln at that time, and the lady's granddaughter and namesake, Elizabeth, was married to the bishop's cousin, Giles Badlesmere.[28] At any rate, as with the Montacute foundation, there is a close correlation between the Burghersh chantry and a series of tombs begun at Lincoln for the Burghersh family in the 1340s.

In the initial ordinance for the Burghersh chantry, Bishop Henry provided for two chaplains and supplemented the maintenance of eleven poor cathedral clerks to celebrate a daily mass at

the altar of St. Katherine for himself and his successor bishops of Lincoln; for King Edward III and Queen Philippa; for the Queen Mother, Isabella; and for the living members of his immediate family and his benefactors, some of whom were named. Moreover, prayers were to be said for the souls of the deceased members of his immediate family.[29]

By the time that the chantry founded by Bishop Henry was amplified by his brother, Sir Bartholomew Burghersh in 1345, after he had been received into confraternity by the cathedral chapter, two tombs must have been erected south of the altar of St. Katherine, one for the bishop (d. 1340) and one for their father, Sir Robert Burghersh (d. 1306).[30] The ordinance of 1345 referred to the burial of both Burghershes in the chapel and specifically to the tomb of Sir Robert.[31] It expanded the number of chaplains to five, endorsed the beneficiaries of the prayers already established, with some exceptions, and made some additions.[32] This ordinance also established four solemn masses or anniversaries per year: one for King Edward III, one for Bishop Henry, one for Sir Robert, and one for Sir Bartholomew himself after his death.[33]

Three tombs for the Burghershes are still standing in the northeast corner of the Angel Choir at Lincoln (Fig. 68). Their placement suggests that the Chapel of St. Katherine was essen-

68. Lincoln Cathedral, Angel Choir, former Chapel of St. Katherine.

69. Tombs of Sir Robert Burghersh (d. 1306) and Bishop Henry Burghersh (d. 1340), north side. Lincoln Cathedral, Angel Choir.

tially the easternmost bay of the north aisle, expanded somewhat into the center aisle in order to link the tombs of Bishop Henry and Sir Robert to the base of the shrine of St. Hugh's head.[34] These three monuments stand in tandem, with the shrine base at the west, the tomb of Bishop Henry next, and finally, that of Sir Robert, which abuts the eastern wall of the retrochoir. Although the shrine base and the tombs are discrete monuments and do not bond architecturally, they stand on a common base, and the architectural decoration of the shrine base is consistent with that of the north side of the tomb chests (Fig. 69), facing the chapel, suggesting the same campaign.[35] In her discussion of the shrine base, Nicola Coldstream suggested a date in the 1330s for these monuments,[36] but the heraldry on the tombs, together with the evidence provided by the chantry ordinance of 1345, suggests that they were completed a decade later. The arms adopted by Edward III in 1340 (Quarterly Old France and England), and those of four of his sons (Quarterly Old France and England with a label), appear on the tomb chest of Bishop Henry.[37] The birth date of the fourth surviving son, Edmund of Langley, provides a relative date of 1341. Furthermore, two shields on the tomb of Sir Robert refer to a marriage that took place

in 1344–45.[38] This suggests that the tombs had just been finished when Sir Robert's was mentioned in the ordinance of 1345.

While the tombs of Bishop Henry and Sir Robert define the southern boundary of the Burghersh chapel, the tomb of Sir Bartholomew is built into its north wall (Fig. 72). Whereas the first two must have been finished by 1345, the tomb for Sir Bartholomew exhibits a different style, suggesting that it was erected in a second campaign, either when he amplified his brother's chantry or, more likely, soon after his own death in 1355.[39]

The programs of these tombs bear a complex relationship to the chantry commendations. On the side facing the chapel, the tomb chest of Bishop Henry is decorated with an arcade housing five pairs of clerks seated at lecterns as if participating in the Divine Office (Fig. 70), a likely reference to perpetual prayers.[40] Above them, shields would remind the celebrant of those to be remembered besides the bishop (see Appendix VII). Reading from head to foot (west to east) are the arms of Edward III; those of his first four sons who survived; those of Henry, earl of Lancaster; a Burghersh relative; Laurence Hastings, earl of Pembroke; Humphrey de Bohun, earl of Hereford and Essex; and Gilbert de Clare, earl of Gloucester. Six of these lords were mentioned in the

70. Tomb of Bishop Henry Burghersh (d. 1340). Lincoln Cathedral, Angel Choir.

71. Tomb of Sir Robert Burghersh (d. 1306). Lincoln Cathedral, Angel Choir.

chantry ordinances. While only Edward III had been mentioned in Bishop Henry's ordinance, the royal children and Gilbert de Clare were specified in the ordinance of 1345, made at the behest of Sir Barthomew, confirming that he was responsible for his brother's tomb after his death in 1340.

The tomb of Bishop Henry's father, Robert Burghersh, is also decorated on the side facing the chapel with an arcade housing figures, in this case, secular couples identified by shields (Fig. 71). They represent the surviving descendants of Sir Robert's sister and brother-in-law, Bartholomew Badlesmere, and their husbands, or in one case, a son (see Appendix VIII). Badlesmere had been mentioned in the chantry ordinance of 1332, along with his son Giles, and their arms appear on the tomb of Bartholomew Burghersh. Neither the Badlesmere daughters nor their husbands were mentioned in the chantry ordinances, but they vividly illustrate the clause "the rest of our (Badlesmere) kinsmen."

Finally the program of the tomb of Sir Bartholomew Burghersh (Fig. 72) includes much of the heraldry found on Bishop Henry's tomb, originally illustrating some of it with figures. The tomb chest with its effigy is sheltered by a triple-arched canopy that displays a row of shields corresponding to those above the first three niches of Bishop Henry's chest, reaffirming Sir

72. Tomb of Sir Bartholomew Burghersh (d. 1355). Lincoln Cathedral, Angel Choir.

Bartholomew's allegiance to Edward III and his family. Below on the tomb chest, surmounting six niches for figures, are eleven (originally twelve) shields that invoke his male kinsmen and brothers-in-arms. Only one of the blazons, for Badlesmere, refers to a kinsman mentioned in the chantry ordinances, but the blanket clause "the rest of our kinsmen and benefactors" could apply to all of them (see Appendix IX). Five of these arms had already appeared on one of the other tombs, referring to a Burghersh kinsman, William de Bohun, Laurence Hastings, John de Vere, and William Lord Ros or one of his sons. Those whose arms had not previously appeared included Sir Bartholomew's father-in-law, Theobald de Verdun, his uncle Bartholomew Badlesmere or his son Giles, his cousin John Tybotot, and his associates or comrades in arms Thomas Beauchamp, earl of Warwick; Ralph Stafford; and Reginald Cobham, all of whom can be construed as his benefactors.

Whereas the Burghersh foundations strengthen my interpretation of Lady Montacute's tomb by furnishing another example of a correlation between chantry commendations and family members represented on tombs, they raise further questions regarding the coordination between the tombs and the chantries. Whereas the Montacute tomb statuettes represent a simple abbreviation of the chantry commendations, here there is an inconsistent mixture of shields or statuettes referring to persons mentioned in the ordinances with others that are not. Although clearly the most important persons are cited in the documents *and* represented on the tombs, sometimes being mentioned by name in the ordinances seems to have precluded being represented on the tombs or vice versa. Moreover, other considerations seem to have played a part in the planning of the tomb displays. Protocol, affection, and political considerations must have conditioned the selection of those represented.[41] Whereas the royal family was given great prominence both in the placement of their shields and in their inclusion in two of the programs, no figures represented them. Marie de Saint-Pol was to be commended in the prayers, but her great nephew was represented on the tomb of Sir Bartholomew instead, while his shield figured on that of Bishop Henry, probably because the company in both was all male. The dominance of the Badlesmere nieces and their husbands on the tomb of Sir Robert suggests strong family affection and pride but also the desire to accentuate the surviving members of the Badlesmere family. And the inclusion of a significant number of his comrades-in-arms on the tomb of Sir Bartholomew suggests the importance attached to his military career. But I wonder if there is not yet another factor that helps to explain the apparent discrepancies between the chantry commendations and the tomb displays.

The figures and shields represented on the tombs should have been sufficient to call to mind all of the relatives and associates mentioned in the chantry ordinances to a chaplain equipped with a trained memory. As discussed by Mary Carruthers, the architectural method for fixing mental images in the mind, which had been revived in the thirteenth century by such luminaries as Albert the Great and Thomas Aquinas, used the mental image of a series of orderly places, like a tomb-chest arcade, as a setting for images to be remembered, along with associations attached to them.[42] As she points out, by adopting Cicero's linkage of memory to prudence, medieval writers made the conscious cultivation of memory a moral obligation as well as a scholarly necessity.[43]

That the art of memory was cultivated in England in the first half of the fourteenth century

is proven by a treatise on memory attributed to Thomas Bradwardine, learned theologian and mathematician, who was connected to both Oxford and Lincoln. Educated at Oxford, where he was a fellow at Merton College from 1325, and proctor in 1325 and 1326, he was summoned to London in 1335 by the bishop of Durham and chancellor of the realm, Richard de Bury.[44] He eventually became a chaplain to Edward III, and just before he died, archbishop of Canterbury. Bradwardine had received a prebendary at Lincoln Cathedral in 1333, just a year after Bishop Henry founded the Burghersh chantry.[45] The text of his *Ars Memorativa* draws on the earlier writers on memory in postulating two things necessary for the trained memory: firm locations and images of the things to be remembered. He further recommends that each location be of moderate size, as much as one's visual power can comprehend in a single glance. Among suitable locations, he cites both tombs and arcaded spaces, recommending units of five. He says that the images in the locations should be wondrous and intense, most beautiful or ugly, joyous or sad, worthy of respect or ridiculous, in order to be memorable, and he gives some melodramatic examples.[46]

If we assume that the chaplains appointed to the Burghersh chantry would have been expected to have well-trained memories in order to fulfill their duties adequately, and that they would have found the figures in the niches wondrous, most beautiful, or at least worthy of respect, the tombs at Lincoln are amply provided with the cues needed to call forth the chain of commendations set forth in the ordinances. Rather than employing the abbreviated system used for the tomb of Lady Montacute, the Burghersh tombs were designed to reinforce the commendations specified in the ordinances, and expand the blanket clauses.

A chaplain standing before the altar of the chapel would have had a view of each of the Burghersh tombs adequate to read the heraldry represented on the tomb chests. The shields of the king and his sons on the tombs of both Sir Bartholomew and Bishop Henry should have prompted him to mention not only these lords but also the Queen Mother and Queen Philippa, both mentioned in the 1332 ordinance. On Bishop Henry's tomb, the arms of Henry of Lancaster would have singled out this lord among the bishop's benefactors, covered in the ordinance by the blanket clause "the rest of our kinsmen and benefactors." The arms of a Burghersh kinsman could have prompted a string of commendations specified in the 1332 ordinance: Bishop Henry's mother, his other brothers, and his sisters. The arms of Laurence Hastings would have invoked the earl of Pembroke himself, and also his great-aunt, Marie de Saint-Pol, mentioned in the ordinance of 1345. The next two shields refer to a distinguished ally and an illustrious kinsman of the Burghershes, Humphry de Bohun and Gilbert de Clare, the latter mentioned in the ordinance of 1345. Glancing at the tomb of Sir Robert in the adjacent space, the chaplain would have been able to read the arms of four Badlesmere daughters, one granddaughter, and their consorts. The sight of these ladies would certainly have invoked the memory of their father and brother, Bartholomew and Giles Badlesmere, and their mother, Margaret de Clare. Finally, a glance at the tomb of Sir Bartholomew against the opposite wall of the chapel would have evoked his presence, of course, but also the memory of his wife and children, who were mentioned in the ordinance of 1345, and of those barons whose arms appear on the tomb chest, again making specific the blanket clause "the rest of our benefactors and kinsmen."

By extending the ordinance commendations, the Burghersh tombs demonstrate very well

how kinship tombs could be used over a long period to join the living with their dead. Not only does Bishop Henry's ordinance refer to the living members of his immediate family but to his successors as bishop of Lincoln, and the repeated clause in the chantry ordinances, "the rest of our kinsmen," could be extended indefinitely into the future, like much of the heraldry used on the tombs.

The value of considering these tombs of the English aristocracy thus goes beyond demonstrating the influence of the king and his court's commissions on them, for those that can be directly linked to chantries illuminate our understanding of their religious function and demonstrate how these tombs linked the surviving family with their dead by commending them in prayer and ultimately holding them together in memory.

The Tomb of Edward III and New Developments in England at the End of the Fourteenth Century

WHEN WE COME, finally, to consider the tomb of Edward III himself, whose long reign furnished both important examples of kinship tombs for his subjects to emulate and a climate in which they would flourish, we run the risk of reaching an anticlimax. For the king's tomb is modest in comparison with those at Gloucester and Westminster, except for materials, and its program not nearly so ambitious as those of some of his subjects. But as we shall try to demonstrate in this and the next chapter, his tomb was probably no less influential than the tombs for his father and brother, and even its program, which was restricted to his children, was, if not seminal, at least indicative of the future character of the kinship tomb in England and on the Continent.

The tomb stands between two piers on the south side of the royal chapel in the bay west of Queen Philippa's tomb (Fig. 73). Raised on a high dais decorated with traceried panels that frame shields bearing the arms of Saint George and France/England, the tomb chest in Purbeck stone is carved on its long sides with canopied niches alternating with narrow double-gabled panels. The entire upper plate, with the effigy, its architectural frame and canopy, and the epitaph rimming both long sides, is cast in finely chased and gilt bronze (Fig. 74). The statuettes still in place on the south side are also in gilt bronze, together with four of the shields that identify them in panels below. This is the first royal effigy in bronze since those of Henry III and Eleanor of Castile on the opposite side of the chapel, and the choice of materials probably represents a conscious continuation of the tradition established by Edward's grandfather.[1] The flat wooden canopy used to shelter the earlier royal tombs in the chapel has gained a new prominence by being faced on both sides with pierced gabled arcading set before a balustrade.

The program of the tomb is eminently succinct (Figs. 74 and 75). Vested in his coronation robes, the king held two scepters, of which only the handles remain. His feet rested on a lion, which has also disappeared.[2] He is flanked by small angels that stand in the niches of the framing shafts, while the epitaph describes him as a paragon of prowess and virtue:

> Hic decus anglorum flos regum preteritorum:
> forma futurorum rex clemens pax populorum:
> Tertius Edwardus regni complens iubileum:

73. Tomb of Edward III, king of England (d. 1377), from the ambulatory. London, Westminster Abbey.

74. Tomb of Edward III, king of England (d. 1377). London, Westminster Abbey.

Invictus pardus bellis pollens machabeum:
Prospere dum vixit regnum probitate revixit
Armipotens rexit iam celo, celice rex, sit.

Here lies the glory of the English, the flower of past kings,
The model of future kings, a merciful king, the peace of the people,
Edward III fulfilling the jubilee of his reign (fifty years),
Invincible panther, powerful as Machabeus in war.
While he lived in good fortune, his kingdom in goodness found new life.
He ruled valiantly, now let him be in heaven, a celestial king.

Below, the statuettes representing his twelve children looked out over the ambulatory or
into the royal chapel. It might be argued that the sheer number of them prohibited including
other family members, but dynastic concerns were a more likely cause for the program's content
and the clarity with which it was presented, as recently stressed by Binski,[3] although the repre-
sentation of even the children who died as infants suggests that these political concerns were
intended to be subordinate to religious observances.[4] In his will, written in 1376, the king estab-
lished a chantry at King's Langley for himself, Philippa, and all their children.[5] Although a com-

N ▷

	South figures		EDWARD III		North figures	
S.	EDWARD Pr. of Wales b. 1330 d. 1376	S1	King of England d. 1377	N1	ISABEL C. of Bedford b. 1332 d. 1379	Da.
Da.	JOAN of the TOWER b. 1333 d. 1348	S2		N2	WILLIAM of HATFIELD b. 1336 d. ?	S.
S.	LIONEL of ANTWERP D. of Clarence b. 1338 d. 1368	S3		N3	JOHN of GAUNT D. of Lancaster b. 1340 d. 1399	S.
S.	EDMUND of LANGLEY D. of York b. 1341? d. 1402	S4		N4	BLANCHE of the TOWER b. 1341? d. 1341?	Da.
Da.	MARY D. of Brittany b. 1344 d. 1362	S5		N5	MARGARET C. of Pembroke b. 1346 d. 1361	Da.
S.	WILLIAM of WINDSOR b. 1348 d. 1348	S6		N6	THOMAS of WOODSTOCK D. of Gloucester b. 1355 d. 1397	S.

75. Program of the tomb of Edward III, king of England (d. 1377). London, Westminster Abbey.

parable foundation is not documented at Westminster, the program of the tomb suggests that it may have been originally intended.

Only the statuettes on the ambulatory side remain, four of them also retaining their shields. But the original program can be reconstructed from the record left by the antiquarians, beginning with Nicolas Charles.[6] This record suggests that the children were arranged in order of birth, beginning with the first figure, Edward, Prince of Wales, on the south side, then moving

to the first figure on the north side, Isabel, countess of Bedford, then crisscrossing in similar fashion to the end of the series. This order is only broken once, with William of Windsor, eleventh child, in Niche N2, rather than William of Hatfield, whom we find in eleventh position (S6). Exchanging the identities of these figures would right the matter, and since the shield for neither figure was completed by Charles, it seems likely that the antiquarians confused the identity of these sons, both named William, who both died young and therefore never bore a coat of arms.

The tomb of Edward III makes an invaluable contribution to our understanding of tomb protocol. In the first place it corroborates the evidence culled from previous tombs that a program is to be read from the head to the foot of the chest, each side reading in descending order. Moreover, in a royal program of this magnitude, in which position in the program reflected the order of succession, it is remarkable that the conception was bilateral, with reciprocity between the two sides. Furthermore, the first place, occupied by the heir to the throne, is on the ambulatory side, where it would have been visible to the public.

Edward III died in 1377, eight years after Philippa. In a famous last request reported by Froissart, the queen had asked that he be buried at her side in Westminster.[7] This statement refers to his body, for both king and queen were actually buried in the Westminster crypt, while their memorials were planned independent of each other from the start, although in adjacent bays of the royal chapel.[8] A document of 1386, concerning a shipment of marble for the tomb of the king, establishes that it was still unfinished at that date.[9] But the document only pertains to the tomb chest, and it does not establish even a relative date for the figure sculpture, although one would normally assume that it was executed at about the same time, or even later.[10] However, other considerations demonstrate that the date of the sculpture for Edward's tomb remains problematic. No document for the figure sculpture is known, and Gardner's suggestion that the coppersmith John Orchard, who supplied angels for Philippa's tomb in 1376, also furnished the figures for the king's tomb shortly after his death has been generally accepted.[11] Parallels in style between the effigy and that of the Black Prince (d. 1376) at Canterbury led Stone to suggest that the same artist was responsible for both at about the same time.[12] There are enough similarities between the effigies to support his suggestion. There are above all striking similarities in the design of the heads (Figs. 76 and 77). They have the same straight brow, the same almond-shaped eyes that seem almost to burst from their lids, the same horizontal mouth, the same strong prominent nose, although Edward's is slightly bent at the bridge. There is above all a comparable quality in the crafting of the material. But along with these similarities, there are subtle but significant differences between the heads that suggest that the effigy of the king may have been made at some time distance from that of his son. There is a great difference in the degree of character and personality conveyed by the two heads that may be the result of the circumstances of their execution. For whereas the representation of the prince is rather generalized, and his gaze unfocused, that of the king is more sensitively modeled and chased to suggest an individual of rather advanced age whose glance is directed and cognizant. There is a more emphatic articulation of the ridge of the eyebrows against the forehead, with the eyebrows etched with parallel hatches to give them greater prominence. The modeling of the slightly swollen lower eyelids and the somewhat flaccid flesh over the cheekbones, with a

76. Tomb of Edward III, king of England (d. 1377), detail of the effigy. London, Westminster Abbey.

77. Tomb of Edward, Prince of Wales (the Black Prince) (d. 1376), detail of the effigy. Canterbury Cathedral.

gentle crease defining the cheeks below the nose, suggest a somewhat delicate constitution. In short, whereas the prince's effigy projects an image made to satisfy the demand for a suitable representation of his position, that of the king suggests a portrait made during his lifetime.[13]

All of the foregoing suggests that the style and execution of the effigy in comparison with that of his son is insufficient evidence for determining the chronology of the sculpture for King Edward's monument. Moreover, when we consider all the figures from the tomb, including the children, a date during the lifetime of the king seems most probable.

The program of the tomb precludes a date before 1355, when the last child represented was born, but the costumes worn by the children correspond to the fashions of the 1350s. They are especially similar to those in two French manuscripts, the *Bible moralisée* of John the Good (ruled 1350–64), dated by François Avril to the beginning of his reign, and an early copy of the *Oeuvres* of Guillaume de Machaut, also datable to the 1350s (Fig. 78).[14] The tight tunics worn by Lionel, duke of Clarence (Fig. 80), and William of Windsor, which end at midthigh and are belted around the hips, were introduced in the early 1350s, and they differ from those of the 1360s and 1370s, when padding around the chest made the torso appear almost spherical, as

78. Guillaume de Machaut, *Le Remède de Fortune*, Amour instructs the poet. Paris, Bibl. Nat., Ms. fr. 1586, fol. 14.

79. Tomb of Edward III, king of England (d. 1377). Joan of the Tower (S2). London, Westminster Abbey.

seen, for instance, on the Beauchamp tomb at Warwick (Fig. 82), and in the dedication page of the Bible of Jean de Vaudetar, dated 1372.[15] The cloak with scalloped hem worn by Edward, Prince of Wales, the Black Prince (Fig. 83), appears in the scene of the poet singing in Machaut's *Remède de Fortune*,[16] while the hairstyle and costume of Joan of the Tower (Fig. 79) could have almost been lifted from the pages of either the *Bible Moralisée* or the *Remède de Fortune*, with the face framed by straight braids, hands concealed in the ubiquitous slit pockets of a fitted super tunic with wide neck, front opening fastened with prominent round buttons, and above all tight-banded short sleeves with narrow pendants that extend to the ankles (Fig. 78). It is, moreover, notable that this super tunic matches exactly that worn by one of Lady Montecute's daughters (Fig. 66) on her tomb at Oxford, which seems most probably dateable to the 1350s.[17] With the strong parallels in costume between the figures on these English tombs and two works from the French court, it is pertinent that the French king, John the Good, captured at Poitiers in 1356, resided in London at the English court until 1360, when the terms of the Treaty of Brétigny secured his release, and again for a few months just before his death in 1364.[18] Moreover, a few of the royal statuettes seem to be reflected in statuettes on the tomb of the Beau-

80. Tomb of Edward III, king of England (d. 1377). London, Westminster Abbey. Lionel, duke of Clarence (S3).

81. Tomb of Sir Thomas de Ingilby (d. 1369) and his wife. Son Thomas on tomb chest (N2). Ripley (Yorkshire), Church of All Saints.

82. Tomb of Thomas Beauchamp, earl of Warwick, and Catherine Mortimer (both d. 1369). Lord on tomb chest (N10). Warwick, Church of St. Mary.

champs at Warwick, and on two Yorkshire tombs, for the Ingilby's at Ripley and the John Nevilles at Durham. The figure of Edmund, duke of York (Fig. 85), standing with folded arms, one cloaked by the mantle, the other emerging from its wide opening, corresponds to Warwick N3 (Fig. 86), Ripley S1 (Fig. 87), and Durham N6. Lionel, duke of Clarence (Fig. 80), with his mantle thrown over his shoulder, seems to have inspired one of the figures at Ripley (Fig. 81), and his pose with one hand poised tentatively at his waist, the other tucked into his belt, would seem to have been a model for Warwick N10 (Fig. 82), despite the change from the tunic to a short doublet and the introduction of a contrapposto stance. Edward, Prince of Wales (Fig. 83), seems to find rather weak echoes in three lords at Warwick (Fig. 84). The tomb at Warwick was probably begun shortly after the death of both Beauchamps in 1369; those at Ripley and Durham must be somewhat later.[19]

In summary, the evidence furnished by fashion and style suggests that the figures for the tomb of Edward III may have been designed well in advance of his death in 1377. Moreover, the king's pride bears on the problem. As we have seen, tomb making was an issue at the English

83. Tomb of Edward III, king of England
(d. 1377). Edward, Prince of Wales (the Black
Prince) (S1). London, Westminster Abbey.

84. Tomb of Thomas Beauchamp, earl of
Warwick, and Catherine Mortimer (both
d. 1369). Lord on tomb chest (E2). War-
wick, Church of St. Mary.

court in the 1360s, when an elaborate alabaster monument was under way for the queen. In spite
of his devotion to her, and although a prolonged illness might have made the construction of
her tomb seem more urgent than his own, it seems unlikely that Edward would have given her
monument precedence over his. And in fact, the construction of a tomb for the queen before
her death raises the question of whether a king as conscious of his own image and as aware as
Edward III was of the political implications of his tomb would have been content to leave its
program to his heirs.[20] One wonders if he himself did not devise that program, which so delib-
erately displays his succession, and oversee the execution of the figure sculpture for it. Edward's
contemporaries on the Continent were at this very time planning their own tombs and seeing
to their construction during their lifetimes. Jeanne d'Evreux (d. 1371), Charles V (d. 1380), Louis
de Mâle (d. 1384), and Philippe le Hardi, duke of Burgundy (d. 1404), all planned their tombs well
in advance of their deaths, and those of Charles V and Jeanne d'Evreux were actually completed
before they died.[21]

If Edward planned his monument in the late 1350s or early 1360s, he would simply have

85. Tomb of Edward III, king of England (d. 1377). Edmund, duke of York (S4). London, Westminster Abbey.

86. Tomb of Thomas Beauchamp, earl of Warwick, and Catherine Mortimer (both d. 1369). Lord on tomb chest (N3). Warwick, Church of St. Mary.

87. Tomb of Sir Thomas de Ingilby (d. 1369) and his wife. Son (S1). Ripley (Yorkshire), Church of All Saints.

been in step with his time. The program of the tomb itself is a sign of changing times. If it was conceived by the king, it may even have contributed to the growing number of tombs in which the children constitute the family program. The tomb of Lady Montacute is the first that we can cite confidently as an example of a family program limited to the children. And although tradition maintains, and it seems likely, that the four figures on the long side of the tomb of Adélais de Nevers, discussed in Chapter 1, represent her children, no other early examples can be cited. But at the end of the fourteenth century and during the fifteenth, the number of tombs in which the program is limited to or places emphasis on the children becomes significant.[22] In England, besides the Beauchamp tomb at Warwick, there is that of the Ingilby's at Ripley, the Elringtons at Shoreditch, and the two tombs of the Fitzherbert family at Norbury.[23] In the Rhineland, the program of the important freestanding tomb of Adolf I, count of Cleves (d. 1394), and his wife, Margaret of Berg (d. 1425), erected before 1425, consisted of their sixteen children ranged around images of the Throne of Mercy on its two short sides.[24] In Paris, the presence of two chrisom children among the four praying figures on the tomb chest of Philippe de Morvilliers (d. 1438) and Jeanne du Drac (d. 1436) in the Church of Saint-Martin-des-Champs suggests that the series portrayed their six children, two of whom died in infancy (Fig. 88).[25]

88. Tomb of Philippe de Morvilliers (d. 1438) and Jeanne du Drac (d. 1436), formerly in Paris, Church of Saint-Martin-des-Champs. Paris, Bibl. Nat., Est., Drgs. Gaignières, Pe. 11, fol. 69.

A SHIFT in emphasis in the programs of kinship tombs is not the only change that can be remarked with the approach of the fifteenth century. The end of Edward III's reign witnessed the development of a new kind of tomb making in England. A veritable industry specializing in alabaster monuments in Derbyshire and Yorkshire began to produce a quantity of standardized monuments in or near the quarries that were to have an inevitable effect on the subsequent history of the type. Edward III himself had introduced the use of alabaster in tombs with the monuments erected for his father at Gloucester and his brother at Westminster, and ostensibly custom-made alabaster tombs continued to appear until the end of the fourteenth century, as, for instance, the tomb of the Beauchamps at Warwick. But beginning in the last quarter of the century, a new type of alabaster monument appeared in the counties. Initially this production featured handsome and well-crafted effigies as seen, for example, at Bures in the monument for Thomas de Vere, eighth earl of Oxford (d. 1371). But these were followed in the fifteenth century by a host of morose effigies resting on tomb chests arrayed with phalanxes of dull and repetitive statuettes. These usually carry shields, which must have formerly identified them. Or they may have been identified by inscriptions that have long since disappeared. In one case, at Norbury (Derbyshire), a record of the inscriptions on the Fitzherbert tombs establishes that in both the tomb of Sir Nicolas Fitzherbert (d. 1473) and that of his son and daughter-in-law, Sir Ralph (d. 1484) and Lady Elizabeth Marshall (d. 1491), the program was limited to the children, plus, in the case of the elder Fitzherbert, two wives.[26]

In contrast to the Fitzherbert tombs, there seems to be little hope of reconstructing the

89. Effigy of Sir Thomas Foulshurst (d. 1404) on a late fifteenth-century tomb chest. Barthomley (Cheshire), parish church of St. Bertoline.

programs of most of these tombs, as the paint on the shields has long since disappeared, and only in a few cases does there appear to be an antiquarian source that recorded the coats before their disappearance. This information would be useful, for it would give a broader base to our tentative conclusions regarding a change in family emphasis that seems to have set in with the new century, but the character of the images is revealing in itself as evidence of a general satisfaction with standardization.[27] The tombs leave the impression that a patron would simply order a tomb chest of certain specifications to be decorated with a specified number of figures of a certain gender and estate, bearing shields painted with specified coats of arms. The contracts that have come to light bear out this impression.[28] They represent a significant change from the contract of Béatrice de Louvain, with its specific instructions regarding the dress of each family member. It must be said, however, that this assembly-line attitude is probably less indicative of a general dwindling in taste than of the greater demand for such monuments at a lower cost, for most of these monuments were made for knights of the shire. Such a widespread demand had been met in the Low Countries since the early fourteenth century with a similar kind of production, although to judge from the surviving monuments, the general level of quality there was higher.

Moreover, Paul Williamson has suggested that the downturn in the quality of English sculpture in the second half of the fourteenth century is attributable to conditions in the aftermath of the plague of 1348–49, a factor that certainly should be taken into account.[29]

Besides the general anonymity of the figures, the programs of these alabaster tombs are remarkable in that they consistently separate the sexes. In a typical example, all the lords appear on one side of the tomb and all the ladies on the other, as at Harewood and Thornhill (West Yorkshire) and at Kinlet (Salop), or, in a smaller program, the ladies are ranged at one end of a long side and the lords at the other, as at Ryther (North Yorkshire) and Barthomley (Cheshire) (Fig. 89).[30] No exception to this rule has been found among the alabaster shop tombs in England in the fifteenth century, and although angels bearing shields and even saints are sometimes mingled with family members, separation according to gender is preserved, even when this violates the principle of symmetry or distorts family structure, as at Norbury. As in the empire in the fourteenth century, these tombs must reflect the persistence of the ancient separation of men and women for worship in the shires, whereas dynastic claims, courtly etiquette, or both governed the arrangement of family members on courtly English tombs.[31]

By the end of the fourteenth century, tombs of kinship were no longer limited to the nobility. The tomb thought to be for Edmund Blanket, prominent Bristol cloth merchant, and his wife in the parish church of St. Stephen in Bristol has a tomb chest carved with a series of six statuettes accompanied by shields.[32] In Namur, a sculptor, Colars Jacoris (d. 1395), had a kinship tomb that formerly stood in the church of the lepers' hospital.[33] But it was above all in the tomb slabs that began to cover church pavements in the thirteenth century that we find a proliferation of the iconography of the kinship tomb in memorials for the middle class. The earliest tombstones displaying family members known to me date from the late thirteenth or early fourteenth century (Fig. 90), but the majority are from the fifteenth.[34] Since numerous tombstones for members of the bourgeoisie are recorded from the thirteenth century, the relatively late appearance of family suggests that the middle class was rather hesitant to adopt a type that was traditionally associated with lineage.[35] The tombstones of our type that can be cited in France include that of a merchant, a clerk, and a simple bourgeois among a majority of country squires and court officials; most of the latter were drawn, by the late fourteenth and fifteenth centuries, from the middle class. In these monuments, which were usually for a married couple, a series of little figures in civil costume were either ranged in a space below the effigies of their parents or clustered around their feet (Figs. 91 and 92). Two documents from the late fourteenth century indicate that these little figures were intended to represent the offspring of the deceased. The first, the will of one Jehan de Quinchy, bourgeois of Douai, merely indicates that the testator wished to be buried near his wife in the Church of the Franciscans at Douai, with a tombstone placed over them in memory of them and their children.[36] But the second, a contract between Guillaume de la Mare, bourgeois of Rouen, and Jaquemin Sause, "tombier," dated December 26, 1392, stipulates that eight children should be placed below four "ymages" or effigies on a tombstone for the Church of Saint-Eloi at Rouen.[37] In a few examples, the names of the children were inscribed beneath their feet or over their heads, but usually the onlooker was expected to understand who they represented. They were invariably dressed in lay costume, standing, with their hands clasped in attitudes of prayer. Sometimes the male children were all ranged beneath their

90. Tombstone of Marguerons and her husband. Troyes, Church of Sainte-Madeleine. C. Fichot, *Statistique monumentale du département de l'Aube,* Troyes, 1884–1907, 4, fig. 39.

91. Tombstone of Etienne Chevalier (d. 1474) and Catherine Bude (d. 1452), formerly in Melun, Church of Notre-Dame. Paris, Bibl. Nat., Est., Drgs. Gaignières, Pe 11a, fol. 41.

92. Tombstone of Jean de Bournant dit Franque-
lance (d. 1452) and Kathelyne de Mellygny
(d. 1407). Troyes, Church of Sainte-Madeleine.
C. Fichot, *Statistique monumentale du dépar-
tement de l'Aube*, Troyes, 1884–1907, 4, Pl. 11.

father, the female beneath their mother, but at other times a mingling of genders suggests that
they were presented in order of birth. In a few examples, as for instance in the tombstone of
Etienne Chevalier (d. 1474) and his wife, Catherine Bude (d. 1452), formerly in the Church of
Notre-Dame at Melun (Seine-et-Marne) (Fig. 91), only a few children filled the arcade that ex-
tended below the parents' feet, while the remaining arches were filled with tracery. This sug-
gests a degree of prefabrication in which a standardized frame was filled with a given number of
figures according to the size of the family. In England, only one tombstone comparable to those
in France can be cited, but it is perhaps worth noting, at least as a curiosity. This is the tomb-

stone of Sir Ralph Pudsay (d. 1468) and his three wives at Bolton-by-Bowland (West Yorkshire) with their twenty-five children ranged in a triple arcade at their feet![38]

Tombstones are relatively rare in England, but their counterparts in brass demonstrate that the Pudsay monument was only unusual in the material employed and the number of children represented. John Page-Phillips, who has studied the representation of children on their parents' brasses, reproduces, selectively, thirteen examples dating from the fifteenth century that correspond generally to those we have cited in stone on the Continent.[39] According to his study, the type was established only in the fifteenth century in England but extended well into the sixteenth. Variations on the type in England include the brass of Thomas of Woodstock (d. 1397), youngest son of Edward III and Philippa of Hainault, formerly at Westminster Abbey, where the prince's parents, brothers, and sisters, rather than his children, were ranged around his effigy, and that of Philipe Carrue (d. 1414) at Beddington (Surrey), where half-length representations of her brothers and sisters figure beneath the effigy.[40]

IN CONCLUSION we must wonder if the new developments remarked at the end of the fourteenth century are not to some degree interrelated. Standardization of production seems a natural result of the greater demand for monuments at a lower cost by a larger segment of the population, a result of the spread of the type into the lower ranks of the nobility and the middle class.[41] The tendency to limit family programs to the progeny also could be explained in part by the new clientele, whose social position did not depend on lineage and family connections but on money and the patronage of the ruler. The recent study of the Morvilliers tomb (Fig. 88) by Philippe Plagnieux, in the context of a family chapel richly decorated and endowed with a foundation of prayers for the deceased and the family, and the accompanying liturgical ornaments, evokes the social and political circumstances that might accompany the adoption of the kinship tomb by families in transition between bourgeois and noble status.[42] Plagnieux suggested that the function of the children represented on the tomb chest was to pray for their parents.[43] While a glance at the prayer postures of the surviving children represented on the chest might suggest this interpretation, the presence of the chrisom children suggests more strongly, to my mind, that here, as with the Montacute and Burghersh tombs, representation of the children was intended to evoke commendation of the surviving family along with the deceased in the daily prayers.

The Great Lord's Tomb of Kinship
in the Fifteenth Century in
England and Flanders

ALONGSIDE the standardized production of kinship tombs and tombstones in the fifteenth century, a few exceptional monuments were produced that continued to distinguish the commissions of the territorial lords from those of their subjects. Yet even these monuments were indubitably influenced by the developments that seem to have resulted from a widening of patronage. This is illustrated, notably, by two monuments, one produced in England, the other in the Low Countries. In both cases, the emphasis on the progeny of the deceased was a salient characteristic. Both tombs also combined a stone tomb chest with figure sculpture in metal, a tradition that we can trace in England to the royal tombs of Henry III and Eleanor of Castile from the late thirteenth century, but which was apparently unusual if not unknown in the Low Countries, in spite of the long tradition of metalwork in the region. In the English example, a highly developed degree of specialization in the various stages of production is proven by the documents. In other respects, these tombs reflect, as did their predecessors, the unique circumstances in which they were erected.

The tomb of Richard Beauchamp, earl of Warwick (d. 1439), still stands, like that of his forebears, in the Church of St. Mary in Warwick (Fig. 93), where a family chapel on the south side of the choir was built to house it in the decade after his demise.[1] A freestanding monument with a tomb chest of Purbeck stone and figures in gilt latten, it seems a later version of the tomb of Edward III at Westminster, on which it must have been consciously modeled. The effigy of the earl in full armor, his head resting on a tilting helmet and crest and his feet on a muzzled bear and griffin, lies on a latten plate fitted over the tomb chest, with his hands raised in a gesture of supplication.[2] He is sheltered by a latten hearse that formerly served as the armature for a velvet pall. The sides of the tomb chest are carved with niches for family members identified by shields, alternating with angels.

Apparently begun as the chapel was nearing completion in the late 1440s, and probably finished by 1456–57, the tomb is problematically documented, for the original contracts and accounts have been lost. However, notes made for Sir Simon Archer in the seventeenth century furnish the names of eight artisans involved in its manufacture and allow us to plot hypothetically the progress of its separate components in a process of remarkable specialization.[3] The Archer transcripts are useful not only for identifying the artists and charting the progression of

93. Tomb of Richard Beauchamp, earl of Warwick (d. 1439). Warwick, Church of St. Mary.

work on the monument; in that they describe its imagery in the language of its own time, they provide insights of the relative importance of the various parts of its program and their meaning for the fifteenth-century patron and viewer.

Four documents are concerned with the effigy, described as "an image of a man armed," beginning with the payment of eight pounds to a painter named Clare in 1448–49, for a "picture" of it, and ending with a contract with a Dutch goldsmith of London named Lambespring for its final polishing and gilding in 1454.[4] A separate contract of March 14, 1452, provided for the statuettes of family members, described as "images embossed of lords and ladyes in divers

vestures, called weepers."[5] This is the first appearance in the documents known to me of the term that is generally employed today to describe the figures representing family members on English tomb chests, and although, as we have seen, they do not always weep, it is important to note that on this tomb, where the term "weeper" is used, some of them do.[6]

At about the same time that work was begun on the effigy, or somewhat earlier, the executors must have signed a contract for the tomb chest. A contract with a marbler, John Bourde of Corfe (Dorset) for the chest and a marble pavement and steps for the chapel, was copied by Archer, but dated May 16, 1457.[7] Stone suggested that this document was misdated by the copyist and must have actually been drawn up in 1447, at the inception of work on the tomb.[8] In fact, Bourde was given advances in 1447–48, 1448–49, and 1449–50, amounting to a total of forty-five pounds, a sum corresponding exactly to that agreed to in the contract for the chest.[9] In the same period, he received payments for other work, stipulated in one case as the pavement and steps of the chapel.[10] His work must have been near completion early in 1450, for on February 12, the executors engaged two carpenters to make wooden furnishings for the chapel "where the Earl is buried or *where the Tombe standeth.*"[11] This document provides a terminus ad quem for the tomb chest, and suggests that the pavement was advanced to a point at which provision for furniture could be made. Thus the accounts suggest that Stone was correct and that the contract with Bourde was misdated by the copyist.

Only when the effigy was near completion, and the tomb chest finished, was provision made for the latten plate that covers the chest. The founder, William Austen, the coppersmith, Thomas Stevyns, and another marbler, John Essex, agreed to make the plate, as well as the hearse attached to its upper edge in a contract of June 13, 1454.[12] This contract must have been fulfilled by 1456–57, when the same three artisans were paid four pounds "in parte convencu ad hoc insolutione p*er* op*eribus* suis circa tumulu*m.*"[13]

The general character of the monument is remarkably well preserved, as can be appreciated by comparing it with a watercolor executed by William Sedgwick in 1641, just before it was defaced by vandals during the Civil War of 1642–46.[14] The tomb subsequently underwent considerable restoration, initially under the supervision of Sir William Dugdale, garter king-of-arms, who could be expected to have paid particular attention to preserving the original heraldry, but he did not live to see the project completed, and a careful reading of the records of this restoration suggests that of the twenty-four enameled shields that were originally attached to the monument (fourteen beneath the weepers and ten on the hearse), eight were re-enameled, two were repaired, and five were entirely remade.[15] Thus we cannot be sure that the blazons remaining on the shields correspond in every instance to the originals. The tomb was cleaned in 1972.[16] In preparing the chart of the family program (Fig. 97 and Appendix X), the shields on the south and east sides of the monument were checked against those represented in the Sedgwick watercolor and appear to be accurate, except for some deterioration of the tinctures. Since the shields on the west and north sides are consistent with those that could be verified, I have assumed that they also correspond in blazoning to the original monument.

The "lords and ladyes . . . called weepers" stand in afflicted postures, with distressed countenances, in the fourteen niches provided for them on the sides of the chest (Figs. 94 and 95).

94. Tomb of Richard Beauchamp, earl of Warwick (d. 1439). Henry Beauchamp, duke of Warwick (W2). Warwick, Church of St. Mary.

95. Tomb of Richard Beauchamp, earl of Warwick (d. 1439). Eleanor Beauchamp, duchess of Somerset (d. 1467) (N2). Warwick, Church of St. Mary.

The lords are ranged on the south side and in the adjacent niches on the short ends, while the ladies occupy corresponding niches on the north side and short ends. They represent primarily the earl's children by his two marriages and their spouses, but the monument also emphasizes the alliance between the two children of his second marriage and the Nevilles of Salisbury (Fig. 96). The children, Anne and Henry, married a brother and sister, Richard and Cecily Neville, the offspring of the earl's great friend, Richard Neville, earl of Salisbury. Moreover, Henry and Anne Beauchamp succeeded by turn to the Warwick title and lands, and one would assume that they both played a role in planning the program of their father's monument. Henry assumed his father's title in 1444, and was further crowned duke of Warwick in 1445, but died in the same year, leaving a young daughter, who died as a minor in 1449.[17] At her death, the inheritance fell to her nearest relative, Anne Beauchamp, who in turn brought it to her husband, Richard Neville the Younger, who, as the powerful earl of Warwick, called Kingmaker, was to

play a decisive role in later fifteenth century English history.[18] Thus, the last word on the arrangement of the figures on Richard Beauchamp's tomb was had by his daughter, Anne, and her husband. Its program is a tribute to their tact, in that it appears to reflect courtesy and family ties rather than the succession to the earldom.

A representation of the only son of the earl, Henry Beauchamp, duke of Warwick (Fig. 94), stands with his wife at the head of the tomb chest. In second place, in the first niches on the north and south sides, stand the elder Nevilles, father and mother of the duke's wife, Cecily. Next are the earl's second daughter by his first marriage, Eleanor (Fig. 95), and her husband, Edmund Beaufort, duke of Somerset. In third place are the duke and duchess of Buckingham, uncle and aunt of the earl's daughter-in-law. Then follow his first daughter of the first marriage, Margaret, and her husband, John Talbot, earl of Shrewsbury. In last place on the long sides are the earl and countess of Warwick at the time of the tomb's construction, that is, Anne Beauchamp and her husband, Richard Neville. Finally, at the foot, the third daughter of the first marriage, Elizabeth, is placed with her husband, George Neville, Lord Latimer. In placing themselves in last place on the long sides of the chest, the younger Nevilles deferred not only to the preceding duke of Warwick but to the elder Nevilles, to their aunt and uncle, the Staffords, and to Anne's elder half sisters and their husbands. Only Lord and Lady Latimer at the foot of the tomb could be construed as being in an inferior position. In fact, the prominence of the east end gives it a certain distinction, and as we have seen, it was sometimes reserved for eminences.

The reader will have already noticed that the separation by gender on the tomb chest follows the general trend in England in the fifteenth century remarked in Chapter 7. This is particularly noticeable in Warwick, since the fourteenth-century tomb of Richard Beauchamp's grandparents, Thomas Beauchamp and Catherine Mortimer, which stands in the adjacent choir, was an elaborate courtly tomb in which thirty-four family members, alternately lords and ladies, graced the sides of the chest.[19] Also to be seen on Richard Beauchamp's tomb is a marked conformity of dress, similar to that on standardized alabaster tombs. The lords all wear their Parliament robes, while the ladies wear belted gowns, mantles, and ram's head headdresses covered with veils. They carry either scrolls, books, or prayer beads, suggesting their devotional role. Their prayerful bearing is in accord both with the epitaph inscribed on the edge of the brass plate covering the chest, which begins with an admonition to the viewer to pray for the earl's soul, and also with the message of the little angels that occupy the smaller niches flanking the weepers, who bear scrolls inscribed "Sit deo laus et gloria defunctis misericordia" (Let there be glory and honor to God, and mercy to the deceased).[20]

Richard Beauchamp's tomb has often been compared with that of Philippe le Hardi, duke of Burgundy, in Dijon, with its impressive funeral procession. This comparison was made most aptly by Stone, who saw the Warwick weepers in the context of the general influence of Flemish-Burgundian sculpture in the course of the fifteenth century.[21] Although a general relationship is undeniable, there are profound differences in content between the two monuments, for the emphasis on family structure remains fundamental to the Warwick monument, although its

Elizabeth Berkeley
d. 1422

N4	S4	N2	S2	E2	E1
Margaret Beauchamp ∞ John Talbot		Eleanor Beauchamp ∞ Edmund Beaufort		Elizabeth Beauchamp ∞ George Nevi	
d. 1467 E. of Shrewsbury		d. 1467 D. of Somerset		d. 1480 L. Latimer	
d. 1453		k. 1455		d. 1469	

96. Genealogy of the family of Richard Beauchamp, earl of Warwick (d. 1439).

weepers with their expressive postures and countenances do suggest a funereal context. In fact, the Beauchamp tomb is much more closely related in subject to earlier kinship tombs in the Low Countries, like those of the counts of Hainault, than to the ceremonial tomb of Philippe le Hardi in Burgundy, and its closest contemporary parallels were the tombs erected in Flanders and Brabant by Philippe le Bon, duke of Burgundy, in the 1450s.[22] Although these monuments have not survived, their affinities with the Warwick monument can be seen in the visual record that remains.

ALTHOUGH Philippe le Bon continued the tradition represented by the tomb of his grandfather, Philippe le Hardi, at the Carthusian monastery of Champmol near Dijon, by sponsoring, somewhat intermittently, the creation of a tomb there for his parents, he respected the local tradition in his northern provinces by commissioning tombs of kinship. As we saw in Chapter 2, he sponsored the restoration of the tomb of his thirteenth-century forebears in Brabant in 1435, and perhaps inspired by that monument or others like it, he commissioned kinship tombs in the 1450s for the last members of the House of Dampierre in Flanders and the House of Brabant in Brussels, which were simultaneously promotions of his own succession. The duke was the third of the Valois dukes of Burgundy, a cadet branch of the Royal House of France, whose aggressive leadership, especially that of Philippe and his grandfather, Philippe le Hardi, had added the northern provinces of Flanders, Artois, Brabant, Hainault, Holland, Zeeland, Luxembourg, Limbourg, Namur, and Boulogne to Burgundy by means of advantageous marriages, diplomacy, and conquest. Philippe can be viewed as fulfilling his family duties in erecting tombs for his forebears in Flanders and Brabant, but in commissioning kinship tombs in their memory, he also demonstrated the link between his own reign and theirs.

In 1453, the duke signed a contract with the Brussels coppersmith, Jacques de Gérines, for a triple tomb in memory of his great grandfather, Louis de Mâle, count of Flanders; great grandmother, Marguerite de Brabant; and grandmother, Marguerite de Flandre, to be erected in the collegiate church of Saint-Pierre in Lille, a foundation of the eleventh-century count of Flanders, Baudouin V (d. 1067).[23] Five years later, he commissioned a similar monument in honor of his great-aunt, Joanna of Brabant, for the Church of the Carmelites in Brussels. Both tombs have been destroyed, but a visual record remains plus two sets of documents. Since the tomb of Joanna of Brabant appears to have been a slightly altered replica of the tomb in Lille, our discussion will be limited to the earlier monument.[24]

Louis de Mâle had died in 1384, leaving parts of a tomb by André Beauneveu in storage in his castle at Lille, and instructions in his will that it be completed by his executors.[25] His body was deposited in the Church of Saint-Pierre, but his wishes regarding the completion of his tomb languished for almost three quarters of a century before they were taken up by Philippe le Bon in 1453, with the project for a completely new monument that included the count's wife and their daughter, Marguerite de Flandre, from whom Philippe's father had inherited Flanders.

The contract for the monument, which was negotiated by the duke's wife, Isabelle, referred to a set of drawings that were to be followed.[26] It specified that the tomb's base, sides, and slab should be in Antoing stone. Three effigies were to recline on the slab surmounting the tomb chest, representing an armed prince flanked by two princesses. At their heads, two angels should

	HENRY BEAUCHAMP	CECILY NEVILLE	
	D. of Warwick	D. of Warwick	
	d. 1445	d. 1450	

W2 W1

Fr.	RICHARD NEVILLE E. of Salisbury d. 1460	S1	N1	ALICE MONTACUTE C. of Salisbury d. 1462	W. of Fr.
S.-in-l.	EDMUND BEAUFORT D. of Somerset k. 1455	S2	N2	ELEANOR BEAUCHAMP D. of Somerset d. 1467	Da.
Fr.	HUMPHREY STAFFORD D. of Buckingham d. 1460	S3	N3	ANNE NEVILLE D. of Buckingham	W. of Fr.
S.-in-l.	JOHN TALBOT E. of Shrewsbury d. 1453	S4	N4	MARGARET BEAUCHAMP C. of Shrewsbury d. 1467	Da.
S.-in-l.	RICHARD NEVILLE E. of Warwick k. 1471	S5	N5	ANNE BEAUCHAMP C. of Warwick d. 1492	Da.

RICHARD BEAUCHAMP

Earl of Warwick

d. 1439

E1 E2

	GEORGE NEVILLE	ELIZABETH BEAUCHAMP	
	L. Latimer	L. Latimer	
	d. 1469	d. 1480	

S.-in-l. Da.

97. Program of the tomb of Richard Beauchamp, earl of Warwick (d. 1439), in Warwick, Church of St. Mary.

[141]

98. Tomb of Louis de Mâle, count of Flanders (d. 1384), Marguerite de Brabant, countess of Flanders (d. 1380), and Marguerite de Flandre, countess of Flanders and duchess of Burgundy (d. 1405), formerly in Lille, Church of Saint-Pierre. A. L. Millin, *Antiquités nationales.* Paris 1790–99, 5, Part 54, Pl. 4.

support a helm and crest over the prince's head with one hand, while holding a shield emblazoned with the arms of the adjacent princess in the other. An arcade in latten surrounding the chest should frame twenty-four latten statuettes representing lords and ladies descended from the deceased. Each statuette should have a shield at its feet with the arms of the person represented; moreover, latten letters set in black cement along the base of the arcade should spell out the name of each person represented. Another inscription in latten letters set in black cement was to surround the tomb slab, giving the titles of the deceased, and the dates of their deaths. The total cost of the tomb was set at two thousand golden crowns, one thousand of which was to be paid at the beginning of work, five hundred a year later, and five hundred when the work was complete. A notice of the payment of five hundred golden crowns on December 29, 1454, indicates that it was expected to be finished two years from the date of the initial contract.[27]

The engraving of the monument, published by the French antiquarian Millin in 1798 (Fig. 98), suggests that the contract for the tomb was followed to the letter.[28] Louis de Mâle, clad in armor, with his helmet supported by angels at his head and his feet resting on a lion, was

flanked by his wife and daughter, identified by the shields held by angels at their heads. The program was completed on the sides of the chest with a series of small statuettes of lords and ladies representing the six grandchildren of Louis de Mâle and Marguerite de Brabant, the children of their daughter, Marguerite de Flandre, together with her grandchildren, and two of her great grandchildren (Figs. 99 and 101). Five generations were thus included in the program, spanning the period from the death of Louis de Mâle to Philippe le Bon and his heir, Charles, count of Charolais, the future Charles le Téméraire. Each statuette stood on a pedestal faced with a shield emblazoned with his or her coat of arms. In accord with the contract, they were further identified by inscriptions.[29]

To judge from Millin's record of the shields and inscriptions, the figures decorating the tomb chest were arranged in genealogical order in a series intended to be read from head to foot in two parallel lines descending on either side. The first son of Marguerite de Flandre by the Burgundian duke, Philippe le Hardi, Jean sans Peur, was represented in the center niche at the head of the chest. He began the first Burgundian line in Flanders, and the series of his children that followed on the tomb chest ended on the south side with Agnès de Bourgogne. The second branch of the House of Burgundy/Flanders also began at the head of the chest with the second son of Marguerite de Flandre and Philippe le Hardi, Antoine de Bourgogne, duke of Brabant. Then the order descended on the north side to include their other children and grandchildren. Finally, at the foot, their youngest daughter, Marie, was flanked by her children of the House of Savoy.

The pedestals with their little shields were apparently stationary, while the statuettes were subject to displacement. As a result, there is little accord in the identity of the figures between the various sets of drawings of the tomb, which reflect housekeeping at the Church of Saint-Pierre over a period of three centuries. Sorting out the resulting chaos has been the major concern of much of the modern scholarship on the tomb, with only eleven figures convincingly identified to date.[30] In our Figure 100, Millin's illustrations of eight of these figures have been placed in their appointed places in a reconstruction of the tomb's west end that allows us to make a few observations on the relationships illustrated by their design and placement.

The traditional use of posture and gesture to relate figures to each other, used for couples on earlier tombs, was apparently expanded in this tomb to express broader family relationships. Jean sans Peur, standing in the center niche of the west end of the tomb chest, was represented in a frontal position, but turned his head toward his son and grandson on his left, who in turn drew attention around to the south side, where his line continued. In a similar manner, the figure to the left of Jean sans Peur, which represented his younger brother Antoine, turned toward his son Jean, on his right, who directed attention around the corner to his brother Philippe on the tomb's north side. Philippe reciprocated with raised left arm, terminating this group. The next figure on the north side, the third son of Marguerite de Flandre and Philippe le Hardi, Philippe de Nevers, began a new line, and appropriately turned away from his nephew. We may assume that this principle of creating family groups by posture and gesture was observed in the remaining representations, although their anonymity precludes further demonstration.

In this tomb, the shift to the progeny already observed in fourteenth-century tombs was

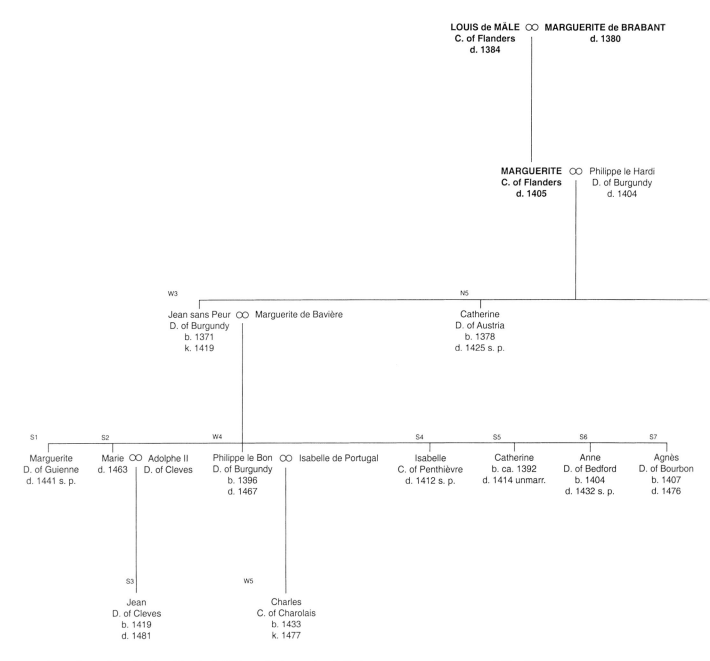

99. Genealogy of the family of Louis de Mâle and Marguerite de Brabant, count and countess of Flanders.

expanded to three generations, a result certainly of the circumstances of the tomb's creation and the patron's concern to demonstrate the continuity between his rule and that of his predecessors. Nevertheless, the tomb does bring that trend to a dramatic climax, and it should be understood as a continuation and even an exaggerated example of it. Moreover, family members were not cast as mourners, to judge by the record, and their somewhat affected postures and elaborate costumes place the monument strictly in the tradition of the courtly tomb of kinship. Great

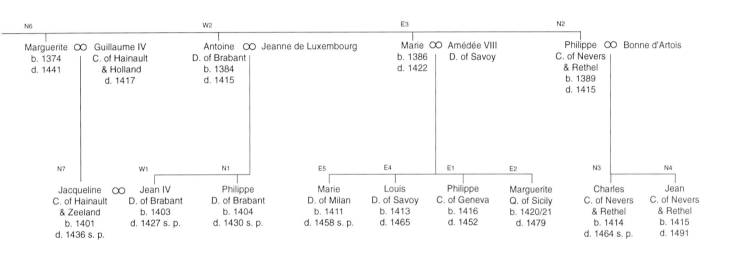

attention was apparently given to representing the individual family members in the fashions of their own time, so that the living were represented in the fashions of the 1450s, while the dead appeared in the costumes of an earlier era. This is especially evident in the fifteenth-century silverpoint drawings of four of the statuettes.[31] While Jean IV, duke of Brabant (d. 1427), wore the long houppelande with serrated sack sleeves that was in vogue in the Low Countries during his lifetime (Fig. 102), Louis, duke of Savoy (Fig. 103), wore the short riding cape over tights and the

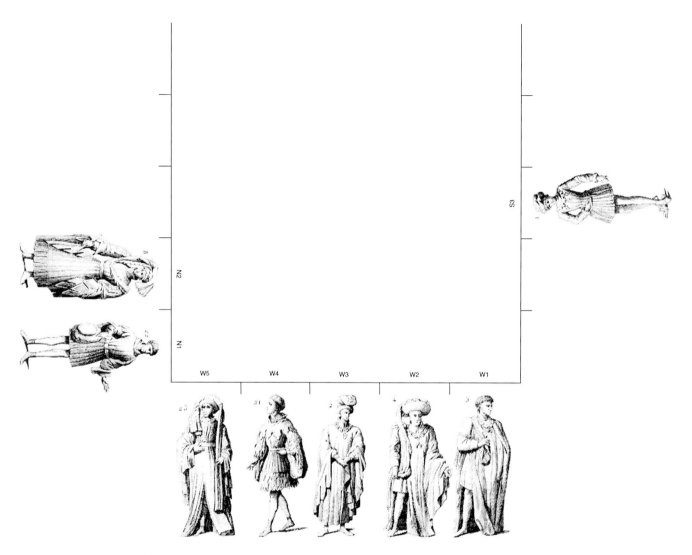

100. Reconstruction of the west end of the tomb of Louis de Mâle, count of Flanders (d. 1384), Marguerite de Brabant, countess of Flanders (d. 1380), and Marguerite de Flandre, countess of Flanders and duchess of Burgundy (d. 1405), formerly in Lille, Church of Saint-Pierre, using figures from A. L. Millin, *Antiquités nationales,* Paris 1790–99, 5, Part 45, Pls. 6 and 7.

short habit that were fashionable at the court of Philippe le Bon. Casting the statuettes allowed these costumes to be represented in the often exaggerated forms that they assumed in the fifteenth century, so that the ladies' elaborate ram's head coiffures, covered by stiff linen veils, and the lords' bulky short robes could be fully realized in the round. The suggestion that the statuettes were based on portraits of the persons in question is feasible, in fact, likely.[32] But this did not preclude the patterns for the statuettes being used again with a new identity, for apparently some of the same molds were used to cast statuettes for the tomb of Joanna of Brabant for a different family program. And mirror reproductions of them were made after the death of the coppersmith for the tomb of Isabelle de Bourbon in the Church of the Abbey of Saint-Michel in

Gr(2)Gs.	Gr.Gs	Gs.	Gs.	Gr.Gs.
CHARLES C. of Charolais b. 1433 k. 1477	PHILIPPE le BON D. of Burgundy b. 1396 d. 1467	JEAN sans PEUR D. of Burgundy b. 1371 k. 1419	ANTOINE D. of Brabant & Limburg b. 1384 d. 1415	JEAN IV D. of Brabant & Limburg b. 1403 d. 1427

W5 **W4** **W3** **W2** **W1**

Gr.Gd. MARGUERITE D. of Guienne C. of Gien d. 1441 **S1**		**N1** PHILIPPE D. of Brabant & Limburg b. 1404 d. 1430 **Gr.Gs.**		
Gr.Gd. MARIE D. of Cleves & La Marck d. 1463 **S2**	MARGUERITE de BRABANT Countess of Flanders d. 1380	LOUIS de MÂLE Count of Flanders d. 1384	MARGUERITE de FLANDRE Countess of Flanders Duchess of Burgundy d. 1405	**N2** PHILIPPE C. of Nevers & Rethel b. 1389 d. 1415 **Gs.**
Gr.(2)Gs. JEAN D. of Cleves b. 1419 d. 1481 **S3**	**N3** CHARLES C. of Nevers & Rethel b. 1414 d. 1464 **Gr.Gs**			
Gr.Gd. ISABELLE C. of Penthièvre d. 1412 **S4**	**N4** JEAN C. of Nevers & Rethel b. 1415 d. 1491 **Gr.Gs.**			
Gr.Gd. CATHERINE b. ca. 1392 d. 1414 **S5**	**N5** CATHERINE D. of Austria b. 1378 d. 1425 **Gd.**			
Gr.Gd. ANNE D. of Bedford b. 1404 d. 1432 **S6**	**N6** MARGUERITE C. of Hainault & Holland b. 1374 d. 1441 **Gd.**			
Gr.Gd. AGNÈS D. of Bourbon & Auvergne b. 1407 d. 1476 **S7**	**N7** JACQUELINE de BAVIÈRE C. of Hainault, Holland & Zeeland b. 1401 d. 1436 **Gr.Gd.**			

E1 **E2** **E3** **E4** **E5**

PHILIPPE de SAVOIE C. of Geneva b. 1416 d. 1452	MARGUERITE de SAVOIE Q. of Sicily b. 1420/21 d. 1479	MARIE D. of Savoy b. 1386 d. 1422	LOUIS de SAVOIE D. of Savoy b. 1413 d. 1465	MARIE de SAVOIE D. of Milan b. 1411 d. 1458
Gr.Gs.	Gr.Gd.	Gd.	Gr.Gs.	Gr.Gd.

101. Program of the tomb of Louis de Mâle, count of Flanders (d. 1384), Marguerite de Brabant, countess of Flanders (d. 1380), and Marguerite de Flandre, countess of Flanders and duchess of Burgundy (d. 1405), formerly in Lille, Church of Saint-Pierre.

102. Tomb of Louis de Mâle, count of Flanders (d. 1384), Marguerite de Brabant, countess of Flanders (d. 1380), and Marguerite de Flandre, countess of Flanders and duchess of Burgundy (d. 1405). Jean IV, duke of Brabant (W1). Rotterdam, Museum Boymans-van Beuningen, MB 1958/T-20.

103. Tomb of Louis de Mâle, count of Flanders (d. 1384), Marguerite de Brabant, countess of Flanders (d. 1380), and Marguerite de Flandre, countess of Flanders and duchess of Burgundy (d. 1405). Louis, duke of Savoy (E4). Rotterdam, Museum Boymans-van Beuningen, MB 1958/T-21.

Antwerp.[33] The preservation of ten statuettes in brass from this tomb (Fig. 104) not only allows us to gain a better idea of the character of the earlier statuettes but to realize fully the influence of the tombs of Louis de Mâle and Joanna of Brabant.[34] The figures from Isabelle's tomb represented her own family for the most part, with only three family members corresponding to those on the tomb of Louis de Mâle. Yet the archetypes for eight of the figures from her tomb have been identified in the drawings of the statuettes from the tomb at Lille.[35] This suggests that the identity of the statuettes on the new tomb was established simply by changing a few attributes, and associating the statuettes with a new set of shields. Although this was the period when great lords and ladies as well as wealthy burghers were having their portraits painted, the vogue created by an important monument, and the expediency with which it could be reproduced, obviously outweighed considerations of individuality in the mind of the patron.[36]

In erecting tombs of kinship for his predecessors in Flanders and Brabant, Philippe le Bon

104. Statuettes from the tomb of Isabelle de Bourbon (d. 1465), formerly
in the abbey church of St. Michael, Antwerp. Amsterdam, Rijksmu-
seum, Am. 33-g and 33-d.

affirmed the traditional iconography for the tombs of the ruling families in his northern prov-
inces. The tombs of Louis de Mâle and Joanna of Brabant furnished an important link with the
past for the next two generations of Burgundian rulers, whose tombs were to preserve the idea
of family structure, if not the form of the tombs that we have traced through three centuries.
On the tombs of the last Valois in the Netherlands, Charles le Téméraire, and his heir, Marie
de Bourgogne, in the Church of Notre-Dame in Bruges, the idea of a family tree was made
even more explicit than on the tombs studied here; the sides of the chest were decorated with
trees bearing coats of arms.[37] Moreover, around the tomb of Marie's husband, the emperor
Maximilian, in the Hofkirche in Innsbruck, the greater than life-sized bronzes of his family and
predecessors still stand like guardians near the sarcophagus where an image of the emperor
kneels in prayer, a monument properly understood, it seems to me, as a Renaissance aggrandize-
ment of a very old idea.[38]

Conclusion

THE APPEARANCE of a tomb celebrating the family in thirteenth-century northern Europe had deep roots in the culture, and many factors contributed to its development. Already in 1984, Oexle corrected the perception that genealogical images in ecclesiastical settings represent a "profane" subject by showing their relationship to liturgical *memoria*.[1] The thirteenth-century tombs discussed here confirm his observation, for, without exception, they commemorated either founders, great benefactors, or members of their families, thus serving both a religious and a legal purpose. Besides furnishing a context for prayers of intercession, they reflect that in a feudal society, the foundation of a monastic community was the beginning of a continuum, involving not only the initial act of foundation, but its maintenance by successive generations, if the family survived.[2] The monks' or nuns' cultivation of close relations with their noble benefactors was a natural outgrowth of their need for protection as well as of material support in a precarious society, and of their mission to reform and sustain that society by providing spiritual and moral counsel to the ruling classes along with intercession, in exchange for benefits that allowed them to care for the poor.[3] Moreover, monasteries often sheltered relatives of their benefactors, either as members of the order or as elderly retirees from court life. Many of the earliest written genealogies were produced in cloisters, based on the record of benefactions over the years, and by the twelfth century, some were illustrated, as, for example, the famous Guelph family tree from Weingarten (Fig. 105).[4] Therefore, the appearance of genealogies on the tombs of founders and their families was a natural result of monastic observation of liturgical *memoria,* and concern for family history and continuity. Moreover, the tombs of Adélais de Nevers at Dilo, and Henry II of Brabant at Villers, depicted family members in a context that suggests the influence that the monks hoped to have on their secular brothers and sisters. In having the family of the countess of Joigny depicted as fashionable and perhaps a little vain, or the ancestors of Henry II as bellicose, their religious counselors simply had them portrayed no doubt as they were, in a context that suggested the means of their redemption. Like most Christian art, these tombs must have been intended to instruct the community, clerical and lay, as well as to honor the noble founder or benefactor.

Seen from this perspective, it is unacceptable to view the genealogies represented on the tombs as separate from the religious community, for it is as impossible to separate the religious from the secular concerns of an ecclesiastical community in the high or the late Middle Ages as it had been in the early Middle Ages.[5] Following her discussion on the place of the founder in a monastic community, Christine Sauer concluded by citing a tract written in 1481 by Abbot Gunther of Nordhausen, on the utility of writing the history of a monastery, and what such a work should comprise.[6] First on his list was the securing of rights through written collections

105. Guelph family tree in the necrology from Weingarten Abbey. Fulda, Hessische Landesbibliothek, Ms. D11, fol. 13v.

of documents and privileges. Next in order was a reconstruction of the foundation of the community in an account of its early beginning and subsequent development, for the abbot believed that a knowledge of the ardent faith of the founders should result in an intensification of intercession for them, and a renewed fervor in protracting their deeds.[7] Therefore, he suggested that the text of such a history should treat the person of the founder; his or her *lineage*, life, and endeavors; the number and circumstances of the gifts made to the monastery; as well as the privileges transmitted, and then, ordered in relation to the successive abbots, the further history of the spiritual community. The abbot's prescription is traditional, reflecting the contents of early medieval memorial books and high medieval chronicles.[8] One could not ask for a clearer statement of the inseparability of the religious and the redeemed secular realms even in the late

medieval mind. That tombs of kinship also reflect this solidarity is vividly illustrated by one more example of the afterlife of Louis de Mâle's tomb in Lille. In 1480, a series of panels was painted for the great Cistercian abbey at Les Dunes in Flanders, at the request of the reigning countess, Marie de Bourgogne, and the behest of the cellarer, with the consent of the abbot (Fig. 106).[9] Full-length figures of twenty-nine generations of the counts and countesses of Flanders and their forebears dominate the series, framed by niches containing a series of abbots of the monastery depicted on a smaller scale. For Abbot Gunther of Nordhausen, these figures would no doubt have been appropriate illustrations of the history of the monastery. Recognizing that the counts and countesses were in part based on the statuettes in Lille (Fig. 98),[10] we realize that from Abbot Gunther's point of view Louis de Mâle's tomb would have been as much a part of the history of the chapter of Saint-Pierre as the record of the count's descendants.

As indicated in the introduction, as time went on, the daily life of a medieval monastery was increasingly permeated with prayers of intercession for many benefactors. Thus the prominent placement of a founder's tomb, usually in the middle of the choir or on its north side in the examples examined here, signaled his or her importance in the liturgical life of the community.[11] It is a logical assumption that when a monument was erected in honor of a founder, it became the focus of intercessory prayers, as documented for the counts of Champagne. The primary religious function of medieval tombs was to furnish a focal point for prayers, and the dramatic increase in chantries in the later Middle Ages helps to explain the increasing number of tombs. Megan McLaughlin's explanation of the increase in individualized prayer for the dead in the twelfth and thirteenth centuries as a means of reinforcing the social position of the nobility, lay and ecclesiastic, in a time of rapid social change, also helps to account for the emergence and widespread adoption of the tomb of kinship.[12] In a mobile world in which collective memory was no longer a guarantee of either intercessory prayer or social status, such monuments served as surety against oblivion in this world and desolation in the next.[13] The inclusion of family members in the tomb program, whether they were ancestors, peers, or progeny, suggests that prayers for the deceased often included the family, as was certainly the case in some of the chantries discussed. The concern for ancestors is attested to by innumerable monastery charters, including the one cited in our text for the monastery of l'Honneur-Notre-Dame at Flines. This potential function of a kinship tomb would have been particularly pertinent to a monument erected in memory of the last members of a line, for instance, the tomb of the last sires of Louvain, commissioned by their last surviving member, herself a nun.[14]

However, the material studied here suggests that in addition to their religious function, kinship tombs often provided a pious setting for a political statement, and increasingly so as the type developed. The first tombs appeared in France when the aristocracy was finally evolving into a true nobility, with all the symptoms of a self-conscious caste.[15] This involved a gradual fusion of the two levels within it, the lords and the knights, as well as the strengthening of the territorial princes, often at the expense of the lords or castellans.[16] While the lords were entering orders of knighthood, the knights themselves were adopting the principles of primogeniture and masculine privilege in matters of inheritance, practices that had been used by the heads of great houses since the early twelfth century to ensure the integrity of their estates.[17] Along with this

106. Panel painting of Counts Baudouin II and III, Arnoulf I and II, and their consorts, formerly in the Cistercian abbey, Les Dunes. Bruges, Groot Seminarie.

came an increase in written genealogies, for while the first written genealogies known in western Europe date from the seventh century, this initially royal prerogative was adopted by a few territorial princes only in the eleventh century, and extended to less-exalted households in the second half of the twelfth.[18] Moreover, the nobility as a whole was having to prove its status to escape taxation even as its economic superiority was being challenged by a rising merchant class, factors that must have increased its self-consciousness and contributed to its greater homogeneity.[19] The same conditions developed somewhat later in England.[20] The old families were consolidating their resources, and showing evidence of a heightened family consciousness not only in commissioning genealogies but also in commissioning vernacular chronicles, in establishing prayers with family commendations, in systematizing heraldry, and, I would submit, in erecting tombs of kinship.[21] This implies that the intended audience for such monuments extended beyond the religious community. Erlande-Brandenburg has called attention to the evidence of visits to the royal tombs at Saint-Denis furnished by the pocketbook chronicles that appeared as early as the late eleventh or early twelfth century,[22] evidence that is highly suggestive of the role that the royal necropolis played in the consciousness of the French in the high Middle Ages. In these little "guides" were recorded summary accounts of the kings' principal acts, their genealogies, and an indication of the exact location of their tombs. One of them, written by Guillaume de Nangis after the remodeling of the royal necropolis in the 1260s, suggests a widespread public interest: "[M]any people, and also the highly placed and the nobility, who often visit the Church of Saint-Denis where a large number of the vaillant kings of France lie buried, wish to know the birth and distinguished lineage of the kings and their marvelous feats that are recounted and published abroad in many lands."[23]

The potential usefulness of tombs in forming the self-consciousness of a people would have served the purposes of the king's great vassals in a time of crisis. For while the nobility as a whole was becoming more cohesive in the thirteenth century, the autonomy of the great territorial princes was being threatened by an ascending monarchy in France, and it is probably no coincidence that the kinship tomb was first employed by the most independent among the king's vassals, Champagne, followed by Flanders and then England (as duke of Aquitaine). In displaying lineage on the tombs of their dead, the heads of these houses clarified the basis of their claims to titles and territories, sending a message to their rivals and their liege lord at the same time. Moreover, when examined closely, many other tombs prove to have been vehicles for displaying claims to property and the titles that accompanied them, or distinguished lineage as the assertion of exalted social status. One is tempted to think of them as a kind of insurance carved in stone or cast in metal in the minds of their perpetrators. At least this is suggested by the circumstances in which a significant number were created.

Although inserted within a religious context that gave it a spiritual dimension, the tomb of Thibaud III of Champagne was already a case in point. The inclusion of four kings in the family program demonstrated the count's nobility, while the presence of his parents, wife, and children displayed the chain of descent, an important manifestation of the basis of his young son's claim to Champagne just before rival claims were actively pursued by his cousins. As suggested by Bruzelius, a similar situation may have even prompted the plan for a genealogical program of

effigies at Saint-Denis during the minority of Saint Louis. During the unstable minority of John I of Brabant, his mother had her husband's brilliant ancestry and six generations of his forefathers displayed on the tomb that she was to share with him in the Church of the Dominicans in Louvain. Even the tomb of Marie de Bourbon which, seen in isolation, seems largely concerned with family pride, was conditioned by a long regency.[24] The Hastings suit in the English Court of Chivalry confirms that tombs furnished a record that was valued and even used on occasion as evidence for claims, for the suit demonstrates that kinship tombs provided not only the heirs, but also successive generations, with a visual reminder of their claims to property, and the honors and dignities that accompanied land grants under the feudal system.[25] These considerations lead us to conclude that it is not coincidental that a significant number of lords' tombs of kinship were produced in the context of a contested inheritance or a minority. Like written genealogies, they often appear to reflect the need to legitimize or assert power.[26]

For ladies, on the other hand, the tombs were primarily a vehicle for displaying distinguished lineage and illustrious family connections, the most important assets for a noble lady during the Middle Ages, especially in feudalized territories where her claims to property were second to those of her brothers. This may be seen in the tombs of Blanche de Sicile at Flines and of Marie de Bourbon at Braine. Moreover, the tombs of Blanche de Navarre (d. 1398) and Jeanne de France (d. 1371) at Saint-Denis and of Isabelle de Bourbon (d. 1465) in Antwerp demonstrate that genealogical tombs continued to be erected for ladies in a period when those of their male counterparts were prone to display a limited genealogy or simply their progeny. The very populous and diverse programs of the tombs of Marie de Bourbon at Braine and Queen Philippa at Westminster, and probably that of Béatrice de Savoie at Les Echelles, also suggest the extent of these ladies' attachment to their families and may be indicative of the roles they had played in maintaining close family relationships and forming family consciousness. In short, overall the kinship tombs for the nobility reflect the man's privileged position in matters of inheritance during the period and the woman's recourse to lineage and family connections.

The primary role of women in caring for their families naturally extended to provision for their dead, although this concern has not yet received the attention it deserves in the prodigious literature that women's studies is currently producing.[27] Largely confined to either the home or the cloister, with her primary duty to produce heirs or to sanctify her community,[28] the medieval noblewoman was the natural living repository of family memory.[29] It is therefore not surprising that four of the tombs discussed above were commissioned by women,[30] and that they had at least a subordinate role in the production of a number of others.[31] Although dynastic claims are paramount in the programs of many of these tombs, it is difficult to imagine a more feminine concern than a tomb of kinship, especially as the genre developed in the course of the fourteenth century.

By the second half of the thirteenth century, probably inspired by the exhibition of royal effigies in the French necropolis, display of lineage or prominent family connections had become the salient characteristic of these tombs, whether to proclaim the favored heir, as in the case of the tomb of Henry III of Brabant and Adelaide of Burgundy, or to relate a lady's social position, as in that of Marie de Bourbon. By this time, a careful arrangement of family order and rank was

established on the tomb chests in relation to the orientation of the effigies within the church or chapel. On the best documented of these monuments, for Marie de Bourbon and Blanche de Sicile, evidence of rank by dress, attributes, and graceful bearing lend them the decidedly courtly appearance that was to be characteristic of fourteenth-century kinship tombs, mainly known from English examples ultimately based on continental precedents.

Given the present state of knowledge, we cannot follow the development of the kinship tomb in France during the fourteenth century, but in the Low Countries, the record of tombs for the Dampierre House of Flanders suggests that French social mores dictated a mingling of men and women on the tombs of the Dampierres, vassals of the king of France, whereas the separation of men and women on the tombs of their cousins, the counts of Hainault, reflects a more conservative protocol in the empire. Above all, these Dampierre/Avesnes monuments mirror the rivalry between the children of Marguerite de Constantinople, and its long-range ramifications, one of which was the increasing use of the kinship tomb as a political instrument. This is the tradition that was to be followed by Philippe le Bon in Lille and Brussels, when he commissioned tombs for his predecessors to promulgate his own claims to Flanders and Brabant. But this use of the tomb was above all to be seen in England, if the lineage of Edward III was displayed on the tombs of his father at Gloucester and his brother at Westminster as I have suggested. Certainly we can see the influence of the Avesnes tomb programs on the tomb of Edward's consort, Philippa of Hainault. Her presence at the English court, after her marriage to Edward in 1327, may well have been a factor in the dynastic turn that the royal tombs took in the fourteenth century. For in the program of the tomb of Queen Philippa, and, more obviously, in Edward III's own tomb, the right of succession was carefully indicated by the arrangement of their children in order of birth.

In England, the tomb of kinship assumed an importance that is unknown on the Continent, and although many monuments have been modified or destroyed in France and the Low Countries, the disasters of the Hundred Years War in France, compounded by the great plague, probably checked the development that is suggested by the remnants in Valenciennes and the imported tomb of William de Valence at Westminster Abbey. However, the tombs for the royal family in the presbytery at Westminster seem to reflect an important French development in the late thirteenth and early fourteenth century that can no longer be traced.

King Edward III is most responsible for the importance that the tomb of kinship assumed in England in the fourteenth century, for his long reign (1330–77) provided both the artistic leadership and the economic means for a flourishing industry. My hypothesis that his lineage was displayed on the tombs for his father and brother would help to explain why the kinship tomb became such a fashionable status symbol in England, as seen in a large number of barons' tombs that follow court precedent in varying degrees. Among these monuments for royal servants, many of whom achieved prominence during the Hundred Years War, the brass of Sir Hugh Hastings furnishes the clearest reflection of military command and the kinship felt by brothers-in-arms. But important evidence of the continued religious function of kinship tombs is furnished by four of these tombs in the shires, one for Lady Montacute at Oxford and three for the Burghershes at Lincoln Cathedral, where surviving chantry ordinances allow the prayer com-

The Program of the Tomb of Henry III, Duke of Brabant (d. 1261), and His Wife, Adelaide of Burgundy (d. 1273)

THE FIGURES decorating the chest are identified in an epitaph transcribed by the Belgian antiquarian Antoine de Succa in 1602 (Brussels, Bibl. roy., Ms. II 1862, fol. 68v). The excerpts quoted below are from the critical edition of this manuscript published by the Centre National de Recherches Primitifs Flamands in Brussels in 1977 (Succa, 2, fol. 68v). They have been checked against the genealogies published by K. G. P. Knetsch, and Isenburg and Schwennicke.[1]

There are some puzzling aspects to Succa's epitaph. Contrary to the norm, he mentions an unequal number of figures on the two long sides of the chest, seven on the south and eight on the north, and one of the duke's cousins, Otto II, count of Guelders, is placed at the foot of the tomb with the couple's children, while he would seem to belong in a niche adjacent to the other cousins on the south side, where Succa lists only seven figures. Moreover, one of the children is absent from Succa's record. This is the eldest son, Henry, who, during the six years following his father's death, when his mother ruled the duchy, was deemed unfit to rule. He entered the monastery of Saint-Etienne in Dijon in 1269, after his younger brother, John, was recognized as his father's heir.[2] Since four niches are represented at the foot of the tomb, three of them designated for children of the deceased couple, it seems more likely that Succa's epitaph was written at a time when Henry was no longer remembered than that he was actually omitted from the original program. Placing him in the niche that Succa's epitaph gives to the count of Guelders, and moving the count to the eighth niche on the south side would resolve the problem of an unequal number of niches on the long sides and an empty niche on the south, and at the same time place the count of Guelders with the other cousins and Henry with the other children. This hypothetical reconstruction is reflected in Figure 19.

From Succa's Epitaph	Identification and Relation to the Duke and Duchess
THE SOUTH SIDE	
in latere dextro tumbe, Henricus Romanorum imperator, pro avus eius,	S1. Henry III, German emperor (d. 1056), his great (5) grandfather (cognatic)
Henricus imperator Romanorum ipsius filiis, avus eius,	S2. Henry IV, German emperor (d. 1106), his great (4) grandfather (cognatic)

Fredericus imperator Romanorum, patruus eius, S3. Frederick Barbarossa, Holy Roman Emperor (d. 1190), his great grandfather (cognatic)

Philippus rex Romanorum, avus eius, S4. Philip, duke of Swabia, king of Germany (k. 1208), his grandfather (cognatic)

Conrardus, rex Jherusalem, subsobrinus eius, S5. Conrad IV, king of Sicily (d. 1254), his second cousin (cognatic)

Alphontius, rex Hispanie, consobrinus eius, S6. Alfonso X, king of Castile (d. 1284), his cousin (cognatic)

Rex Bohemie, consobrinus eius, S7. Přemysl Ottokar II, king of Bohemia (k. 1278), his cousin (cognatic)

THE EAST SIDE

Ad pedes tumbe,
Otto, comes Geldrie, consobrinus eius, E1. Otto II, count of Guelders (d. 1271), his cousin (agnatic)

Joannes, dux Brabantie, huius nominis primus, E2. John I, duke of Brabant (d. 1294), their son
dominus Godefridus, frater eius, E3. Godfrey of Brabant, lord of Vierzon (d. 1302), their son

et domina Maria, soror ipsius, regina Francie, E4. Marie of Brabant, queen of France (d. 1321), their daughter

liberi eius.

THE NORTH SIDE

In sinistro latere,
Emanuel, imperator Grecorum, proavus eius, N1. Manuel Comnenus, Byzantine emperor (d. 1180), cousin of Isaac Angelus, his great grandfather (cognatic)

Wilhelmus, rex Alemanie, et comes Hollandie, consobrinus eius, N2. William II, count of Holland, king of Germany (d. 1256), his cousin (agnatic)
Godefridus huius nominis dux primus Brabantie, attavus eius, N3. Godfrey I, count of Louvain, duke of Brabant and marquis of Antwerp (d. 1140), his great (3) grandfather (agnatic)

Godefridus secundus dux, abavus eius, N4. Godfrey II, count of Louvain, duke of Brabant and marquis of Antwerp (d. 1142), his great (2) grandfather (agnatic)

Godefridus tertius dux, proavus eius, N5. Godfrey III, duke of Brabant (d. 1190), his great grandfather (agnatic)

Henricus I quartus dux, avus eius. N6. Henry I, duke of Brabant (d. 1235), his grandfather (agnatic)

Henricus 2 quintus dux, pater eius, N7. Henry II, duke of Brabant (d. 1248), his father
Henricus Lantgravius, frater eius N8. Henry I, landgrave of Hesse (d. 1308), his half brother

Notes

1. Karl Gustav Philipp Knetsch, *Das Haus Brabant: Genealogie der Herzoge von Brabant und der Landgrafen von Hessen,* Darmstadt, 1931, Charts 2 and 3; Isenburg and Schwennicke 1980–, 2, Table 2.

2. Knetsch 1931, 33; Anselme, 2, 793–94; Butkens 1724, 1, 270–71, 279–80, 282.

The Program of the Tomb of Marie de Bourbon, Countess of Dreux (d. 1274)

THE DRAWING executed for Gaignières is our only source for the program of the tomb.[1] His draftsman numbered the figures continuously from left to right, beginning at the foot or east end of the tomb. His numbers and copies of the inscriptions above each figure are transposed below into the medieval system, whereby the program is read from the head to the foot of the tomb.[2]

Gaignières's Numbers and Copy of Inscriptions	Identification of Figures and Relation to the Countess

THE WEST END

19.	MESIRE.ERCHEMBAVT.FĪL.MESIRE ERCHEMBAVT	W1.	Archambaud VIII, sire of Bourbon (d. 1249), brother
20.	LA.FEMME.DV FIL MESIRE.ERCHENBAVT SVER.MESIRE.GAVANIER.DE.CHATILLON	W2.	Yolande de Châtillon, lady of Bourbon (d. 1254), sister-in-law
21.	MESIRE.ERCHEMBAVT.DE.BOVRBON. PERE.MA.DAME.DE.DREVES	W3.	Archambaud VII, sire of Bourbon (d. 1242), father
22.	LA.MERE.MAME.DE.DREVES.FEMME. MESIRE. ERCHEMBAVT.	W4.	Béatrice de Montluçon, lady of Bourbon, mother
23.	LE ROI.DE.NAVARRA.ThIBAVT	W5.	Thibaud I, king of Navarre (d. 1253), brother-in-law

THE SOUTH SIDE

24.	LA.ROINE.DE.NAVARRE.FILLE.MESIRE. ERCHEMBAVT.FEMME.DE.ROI.THIBAVT	S1.	Marguerite de Bourbon, queen of Navarre (d. 1258), sister
25.	LE.ROI.THIBAVT.DE.NAVARRE.FIVS.AV. ROI.ET.ALA.ROINNE.DE.NAVARRE.DESVS. DIT.	S2.	Thibaud II, king of Navarre (d. 1270), nephew
26.	LA ROINNE DE NAVARRE.FILLE.LE.ROI. LOYS.DE.FRANCE	S3.	Isabelle de France, queen of Navarre (d. 1271), niece by marriage
27.	LE.ROI.DE.NAVARRE.HENRI.FIL.AV.ROI. ET.ALA.ROINNE DESVS.DIT.	S4.	Henri I, king of Navarre (d. 1274), nephew
28.	LA.ROINE.DE.NAVARRE.FILLE.DE. CONTE.ROBERT.D'ARTOIS FRERES. LE.ROI.LOYS.DE.FRANCE.	S5.	Blanche d'Artois, queen of Navarre (d. 1302), niece by marriage

29. LE.DVC.DE.BOVRGOINGNE

30. LA.DUCHESSE.DE.BOVRGOINGNE.FILLE.
 AV.ROI.ET.ALA.ROINNE DENAVARRE.
 DESVS.DIT.

31. LE.DVC.DE.LOHOREINE.

32. LA.DVCHESSE.DE.LOHOREINNE.FILLE
 AV.ROI.ET.ALA.ROINE.DESVS.DIT.FEMME.
 AV.DVC.

33. MESIRE.PIERRE ESAVIERS.FIVS.AV ROI
 ET.ALA.ROINNE.DE.NAVARRE.DESVS.DIT.

34. MESIRE GVILLS.CLERC FIVS.AV.ROI
 ET.ALA.ROINNE.DE.NAVARRE.DESVS.DIT.

35. MESIRE.GVILLS DE.BOVRBON.FIVS.AV.
 SINGNEVR.DE BOVRBON DESVS DIT.

36. LA FEMME.MESIRE.GVILL9.FIVS.LE SINGNEVR
 DE.BOURBON DE SVS DIT.

S6. Hugues IV, duke of Burgundy (d. 1273),
 nephew by marriage

S7. Béatrice de Navarre, duchess of Burgundy
 (d. after VII/1295), niece

S8. Ferry II, duke of Lorraine (d. 1303), nephew by
 marriage

S9. Marguerite de Navarre, duchess of Lorraine
 (d. 1310), niece

S10. Pierre de Navarre, lord of Muraçabal, nephew

S11. Guillaume de Navarre, clerk (liv. 1264),
 nephew

S12. Guillaume de Bourbon, lord of Beçay (d. 1289),
 brother

S13. Isabelle de Courtenay, lady of Beçay (d. 1296),
 sister-in-law

THE NORTH SIDE

18. LE CONTE.DE.NEVERS.
 FIVS.LE.DVC.DE.BOVRGOIGNE

17. LA.FILLE.MESIRE.ERCHEMBAVT.LE.
 IOENNE.FEMME.AV.DIT.CONTE.DE. NEVERS.

16. MESIRE.IEHAN.FRERE.AV.DIT.CONTE.DE.
 NEVERS

15. LA.DAME.DE.BOVRBON.FEMME. AV
 DEVANT.DIT.IEHAN.SVER.A LA CONTESSE DE
 NEVERS.

14. LE.ROI.DE.SESILLE.

13. LA.ROINE.DE.SESILE.FILLE AV.CONTE.
 ET.ALA.CONTESSE.DE.NEVERS.DEVANT. DIS.

12. LE FIVS.LE.ROI.LOYS.MESISE.IEHAN.

11. LA CONTESSE.DE.NEVERS.SVER. A
 LA.ROINE.DE.SESILE.FEMME.MESIRE. IEHAN
 DESVS.DIT.X.

10. MESIRE.IEHAN.DE.CHALON.

9. LA FEMME MESIRES IEHAN.DESVS DIT
 SVER.ALA.ROINNE DE.SECILLE.

8. LI.SIRES.DE.MERCVEIL

7. LA.FEMME.AV.SEIGNEVR.DE.MARCVEIL. FILLE
 MESIRE.EN CH̄BT.DE BOVRBON LE.PERE.

6. LE CONTE IEHAN DE DREVES.MARIS. MADAME
 DE.DREVES

N1. Eudes de Bourgogne, count of Nevers
 (d. 1266), nephew by marriage

N2. Mathilde de Bourbon, countess of Nevers
 (d. 1262), niece

N3. Jean de Bourgogne (d. 1267), nephew by
 marriage

N4. Agnès de Bourbon, lady of Bourbon (d. 1287),
 niece

N5. Charles de France, king of Sicily, count of
 Anjou (d. 1285), great-nephew by marriage

N6. Marguerite de Nevers, queen of Sicily,
 countess of Anjou (d. 1308), great-niece

N7. Jean de France, count of Valois, Crécy, and
 Nevers (d. 1270), great-nephew by marriage

N8. Yolande de Nevers, countess of Nevers, Valois,
 and Crécy (d. 1280), great-niece

N9. Jean I, count of Chalon (d. 1309), great-
 nephew by marriage

N10. Adélaïde de Nevers, countess of Chalon
 (d. 1279), great-niece

N11. Béraud VIII, lord of Mercoeur, brother-in-law

N12. Béatrice de Bourbon, lady of Mercoeur
 (liv. 1251), sister

N13. Jean I, count of Dreux (d. 1248), husband

THE EAST END

1. FRERE.IEHAN.LI. TEMPLIERS.FIVS.AV.
 CONTE.IEHAN DESEVR.DIT.

E1. Jean de Dreux, knight templar (liv. 1275), son

2. LE CONTE DE.DAN-MARTIN.MARIS.LA. CONTESSE.DEVANT.DITE.

3. LA CONTESSE.DE.DANMARTIN.SVER AV. CONTE.ROBERT.

4. LE.CONTE.ROBERT.DE.DREVES.FIVS. AV DEVANT.DIT.CONTE.IEHAN.

5. MA.DAME.DE.MONTFORT.FEMME LE. CONTE.ROBERT.FIVS.AV CONTE.IEHAN DEVANT DIT.

E2. Jean, count of Dammartin (d. 1304), son-in-law

E3. Yolande de Dreux, countess of Dammartin (d. before VII/13/1313), daughter

E4. Robert IV, count of Dreux (d. 1282), son

E5. Béatrice de Montfort, countess of Dreux (d. 1311), daughter-in-law

Notes

1. Oxford, Bodleian Library, Ms. Gough Drgs.-Gaignières, fols. 78r–80r.

2. Gaignières's copies of the inscriptions were transcribed by Stanislas Prioux, *Monographie de Saint-Yved de Braine*, Paris, 1859, 74, but he did not recognize the logic of their order, and confused the order somewhat on the north side. Teuscher (1990, 192–94) followed Gaignières's system and accurately analyzed the family program, with a number of interesting observations, but she overlooked the morphology reflected in the inscriptions. Bur (1991, 308–11) based his analysis on the inscriptions, and arrived at virtually the same system projected here. The family tree projected in Figures 20 and 21 is based on Anselme, 1, 427–28, 544; 3, 158–61; Ernest Petit, *Histoire des Ducs de Bourgogne de la Race capétienne*, Paris, 1885–1905, 5, 128–39; Sirjean 1959–, 1, 2, Cah. 4; Isenburg and Schwennicke 1980–, 2, Table 43; 7, Table 17; and J.-B. de Vaivre, "Les tombeaux des Sires de Bourbon (XIIIe et première partie du XIVe siècles), *Bulletin monumental*, 138, 1980, 365–403.

The Program of the Tomb of Jean II d'Avesnes, Count of Hainault and Holland (d. 1304), and His Wife, Philippine de Luxembourg (d. 1311)

THE ANTIQUARIAN of Valenciennes, Simon Le Boucq, associated the shields that decorated the four sides of this freestanding tomb chest with thirty relatives of the count and countess, and indicated their relation to the count, except for the women on the north side of the chest.[1] His text is transcribed below and adapted to the medieval system. His identifications have been verified (Anselme, 2, 724–34, 779; 5, 508–12; Knetsch 1931, Table 3; Isenburg and Schwennicke 1980–, 2, Tables 4 and 12; 7, Table 18; Bur 1980, Fig. 2; G. Prop, *De Historie van het oude Gelre onder eigen vorsten (tot 1543)*, Zutphen, 1963; Jirí Louda and Michael Maclagen, *Heraldry of the Royal Families of Europe*, New York, 1981, Table 64).

Le Boucq's Text	Identification of Figures and Relation to the Deceased

THE WEST END

Le Boucq's Text		Identification of Figures and Relation to the Deceased
A la teste d'icelle tombe y avoit cincq armoiries, asçavoir:		
celle de Jean d'Avesnes son père;	W1.	Jean I d'Avesnes (d. 1257), his father
d'Alix de Hollande, sa mère,	W2.	Alix de Hollande (d. 1284), his mother
de Loys, 7ᵉ du nom, roy de France, grandave;	W3.	Louis VII, king of France (d. 1180), his great (3) grandfather
de Baulduin, empereur de Constantinople, comte de Flandres, etc.;	W4.	Baudouin I, Latin emperor of Constantinople, count of Flanders and Hainault (d. 1206), his great grandfather
et de Boscard d'Avesnes, son père grand.	W5.	Bouchard d'Avesnes, doctor of jurisprudence (d. 1244), his grandfather

THE SOUTH SIDE

Au costé dextre d'icelle y avoit dix aultres
 armoiries, asçavoir:

de Henry de Haynau, empereur de Constantinople;

 S1. Henri de Flandre, Latin emperor of
 Constantinople (d. 1216), his great (2) uncle

de Guillaume, roy des Romains, comte de Hollande;

 S2. Guillaume II, count of Holland, king of
 Germany (d. 1256), his uncle

de Baulduin de Flandres;

 S3. Baudouin d'Avesnes, lord of Beaumont
 (d. 1289), his uncle

du duc de Brabant;

 S4. Henri II, duke of Brabant (d. 1248), his great-
 uncle

de Henry, comte de Champaigne, tous cincq ses
 oncles.

 S5. Henri II, count of Champagne (d. 1197), his
 great (2) uncle

Item, celles du duc de Bar;[2]

 S6. Henri III (d. 1301) or Edouard I (d. 1336),
 counts of Bar, her cousins

du duc de Gueldres;

 S7. Renaud I, duke of Guelders (d. 1326), her
 cousin by marriage

du comte de Flandres;

 S8. Robert III, count of Flandres (d. 1322), his half
 cousin

du comte de Blois

 S9. Hugues II de Châtillon, count of Blois and
 Dunois (d. 1307), his half cousin

et du comte de Namur, tous cincq ses cousins.

 S10. Jean de Flandre, count of Namur (d. 1330), his
 half cousin and her nephew

THE NORTH SIDE

Au costé senextre d'icelle tombe y avoit dix aultres
 armoiries, asçavoir:

celle de Marie de Champaigne, impératrice;

 N1. Marie de Champagne, countess of Flanders,
 Latin empress of Constantinople (d. 1204), his
 great grandmother

d'Isabelle de Haynau, royne de France;

 N2. Isabelle de Hainaut, queen of France (d. 1190),
 his great (2) aunt

de Marguerite, royne des Romains;

 N3. Marguerite de Brabant, countess of
 Luxembourg, Holy Roman Empress (d. 1311),
 her niece

de la royne de France;

 N4. Jeanne de Navarre (?), queen of France and
 Navarre, countess of Champagne (d. 1305), his
 cousin

de la royne d'Angleterre;

 N5. Isabelle de France (?), queen of England
 (d. 1357), his cousin

de Marie Defrance, comtesse de Champaigne,

 N6. Marie de France, countess of Champagne
 (d. 1198), his great (2) grandmother

de Marguerite, comtesse de Flandres et de Haynau;

 N7. Marguerite de Constantinople, countess of
 Flanders and Hainault (d. 1280), his
 grandmother

de Félicitas de Couchy;

 N8. Félicité de Coucy, lady of Beaumont (d. 1307),
 his aunt

d'Yolente de Haynau, comtesse de Dreux;
et de Sibille de Haynau, comtesse de Ligne.

 N9. Yolande de Hainaut, countess of Soissons (?)[3]

 N10. Sybille de Flandre et Hainaut (?), lady of
 Beaujeu (d. after IX/18/1216), his great-aunt[4]

THE EAST END

Au piedt d'icelle y avoit pareillement cinq armoiries, sçavoir:	
celle de Guy, evesque d'Utrecht,	E1. Guy de Hainaut, bishop of Utrecht (d. 1317), his brother
de Guillaume, evesque de Cambray;	E2. Guillaume de Hainaut, bishop of Cambrai (d. 1296), his brother
de Boscard, evesque de Metz;	E3. Bouchard de Hainaut, bishop of Metz (d. 1296), his brother
de Florent, prince de la Morée,	E4. Florent de Hainaut, prince of Achaea (d. 1297), his brother
et de Jean, qui morut jeune, tous cincq frères au susdict comte Jean.	E5. Baudouin de Hainaut (?) (d. after VI/1/1283), his brother[5]

Notes

1. Le Boucq 1650 (pub. 1844), 113. Le Boucq's text was edited by Leuridan 1938, 10, 358–59, and collated with other antiquarian sources. His text of the description of the figures represented on the tomb chest differs from Le Boucq's only in the spelling of some words.

2. The county of Bar was not elevated to a duchy until after 1352 (Anselme, 5, 498–512).

3. No lady of the House of Hainault is known to have been married to a count of Dreux in this period (Ibid., 1, 423–36), but Yolande de Hainaut, daughter of Baudouin IV, count of Hainault, married Yves de Nesle, count of Soissons in 1151–52 (Michel Bur, *La formation du comté de Champagne, v. 950–v. 1150* [Mémoires des Annales de l'est, 54], Nancy, 1977, 489, no. 78; Anselme, 2, 500).

4. The barony of Ligne, a fief of the counts of Hainault, was not elevated to a county until the sixteenth century (Anselme, 8, 30–35). Moreover, I have not been able to verify that any daughter of the House of Hainault was married to a baron of Ligne in the period in question.

5. Le Boucq may be mistaken in naming this brother Jean, although Leuridan (1938, 10, 300) gives a postmedieval epitaph for the tomb of the parents of Jean II, Jean I d'Avesnes and Alix de Hollande, in the Church of the Dominicans in Valenciennes that also lists a brother Jean who died young. Rather than a second Jean who died young, Anselme (2, 779) lists Baudouin de Hainaut, knight, who made a will on the Tuesday before Pentecost, 1283, among the children of Jean I d'Avesnes and Alix de Hollande, and he appears a more likely candidate for the brother represented on the tomb of Jean II at Niche E5.

The Heraldry on the Tomb
of Edmund Crouchback,
Earl of Lancaster (d. 1296)

JOHN A. GOODALL, FSA, FRNS

THE HERALDRY on the tomb of the first earl of Lancaster, Edmund Crouchback, brother of Edward I, is of particular interest as presenting one of the largest collections on a single tomb in England during the Middle Ages, and because it is one of the first to give more than the arms of the deceased and perhaps his wife on the tomb. The tomb of his first wife, Aveline, seems to have had a similarly elaborate heraldic display, although only the outlines of the shields on her tomb chest can be seen, and the paintings of small banners said to have been visible on the canopy in the eighteenth century have not survived. The painting on the north side of Edmund's tomb, apart from the carved shields, has been largely lost as a result of fire started by a vandal in 1968, and the peaks of the central gables at least have been restored. Although the shields on the tomb chest have lost their colors, these are known from tricks or sketches of them made in the seventeenth century. Part of the painting on the gables survives on the south side but it is not possible to reconstruct the precise arrangement of all the banners.

The surviving details can be supplemented by the tricks already referred to, which were made by Nicolas Charles, Lancaster herald (d. 1613) around 1611, whose manuscripts were purchased by Clarenceux Camden, another great herald antiquary, for the relatively large sum of ninety pounds. These show the rows of shields from the tomb chest and a small selection of the banners from the canopies, but without specifying exactly where they were.[1] Some figures painted on the ambulatory side on the substructure of the tomb are faintly visible and were already badly damaged when sketched in the eighteenth century by John Carter.[2] Their relationship to the upper work is not certain, and the explanations proposed in the eighteenth century are clearly wrong.[3] The banners on the canopy work were described more fully by Neale and Brayley, although the identifications proposed were not always correct and have been ignored here.[4] The identifications given below have been based on our present knowledge of the contemporary rolls of arms and seals, the former having been indexed by Humphery-Smith, and use has also been made of the card indexes collected for the new Dictionary of British Arms at the Society of Antiquaries in London.

Apart from its elaborate display of heraldry, the tomb is interesting as the earliest example in England of the French type of ciborium tomb. The heraldic display is, however, more elabo-

rate than that found on any of the French tombs of the period drawn for Roger de Gaignières.[5] It consists of twenty shields on each side of the tomb chest in the spandrels of the arcade, and an undetermined number of banners on the chamfers of the gables, here with many repetitions. A few of the latter seem only to have been used on the north side of the tomb, and others are also found on the tomb chest, but most are new coats. While a small number cannot now be identified in the coeval sources, there must have been some rationale to the scheme, even if we cannot ascertain all aspects of it today. Had the intention been simply to fill the available space with banners of arms, there would have been no need for repeating anything as there were sufficient coats in use to more than fill the available space. Certainly there seems to be no ascertainable reason for the position of individual coats, nor for their juxtaposition, particularly in the canopy work. Some of the patterns will be discussed in the commentary.

Several of these coats are also found on the tombs of William and Aymer de Valence, and on that of Eleanor of Castile. Apart from Sir Otho de Grandison, all are connected by blood or feudal ties with the deceased, being either his kindred and ancestors, or in the case of Lincoln, a fief to which he was in remainder. For Grandison there was a particular reason for his inclusion in the more important series on the tomb chest. The whole scheme for the tomb chest and canopy must have been carefully planned, although the reason for the frequent repetitions in the canopy is not clear to us now.

The Tomb Chest

	Traces of Arms In Situ	Arms According to Charles	Identification of Arms
		THE NORTH SIDE	
N1a.		*3 leopards*	England
N1b.		*Gu. 3 leopards Or, a label Az. of 5 pts. semy of lis Or*	Lancaster
N2a.	*Qtrly.: 1, 4, a castle; 2, 3, traces of a lion*	*Qtrly.: 1, 4, Gu. a castle Or; 2, 3, Arg. a lion rampant Pur.*	Castile and Leon
N2b.	*A lion*	*Or a lion Pur.*	Lincoln
N3a.	Traces of *semy of lis and a label of 5 pts.*	*Az. semy of lis Or, a label of 5 pts. Gu.*	Artois
N3b.	Traces of *3 leopards*	*Gu. 3 leopards Or*	England
N4a.		*Arg. a lion rampant Gu. crowned Or, a border Sa. bezanty*	Cornwall
N4b.	Traces of *Or, 5 pales*	*Or 4 pales Gu.*	Provence
N5a.	*Gu.,* traces of *a cross*	*Gu. a cross Arg.*	Savoy?[6]
N5b.	*Gu.,* traces of *3 leopards*	*Gu. 3 leopards Or, a label of 5 pts. Az.*	Prince Edward
N6a.	Traces of *3 pales and a bend*	*Paly Arg. and Az., on a bend Gu. 3 escallops Or*	Otho de Grandison
N6b.	Traces of *Or and an eagle*	*Or an eagle displayed Sa.*	Empire

N7a.	Traces of *barruly and martlets Gu.*	*Barruly Arg. and Az., an orle of martlets Gu.*	Valence
N7b.	*Gu.* traces of *3 leopards and a label*	*Gu. 3 leopards Or, a label Az. of 5 pts. semy of lis Or*	Lancaster
N8a.	*Gu.,* traces of *3 leopards*	*Gu. 3 leopards Or, a bendlet Az.*	Henry of Lancaster
N8b.	*Qtrly.: 1, 4, Gu.,* traces of *castles; 2, 3,* traces of *a lion*	*Qtrly.: 1, 4, Gu. a castle Or; 2, 3, Arg. a lion rampant Pur.*	Castile and Leon
N9a.	Traces of *3 bends, a border*	*Or 3 bends Az., a border Gu.*	Ponthieu
N9b.	Traces of *a lion*	*Or a lion Pur.*	Lincoln
N10a.	*4 pales Gu.*	*Or 4 pales Gu.*	Provence
N10b.	Traces of *3 pales Az.,* and of *a bend charged with an eaglet*	*Paly Arg. and Az., on a bend Gu. 3 eaglets Or*	William de Grandison

THE SOUTH SIDE

S1a.	*Gu.* traces of *3 leopards*	*Gu. 3 leopards Or*	England
S1b.	*Gu.* traces of *3 leopards*	*Gu. 3 leopards Or, a label Az. of 5 pts. semy of lis Or*	Lancaster
S2a.	*Or* traces of *a lion*	*Or a lion Pur.*	Lincoln
S2b.	*Or* traces of *3 bends, a border Gu.*	*Or 3 bends Az., a border Gu.*	Ponthieu
S3a.	*Gu.* traces of *3 leopards Or*	*Gu. 3 leopards Or*	England
S3b.	Traces of *Or*	*Or 4 pales Gu.*	Provence
S4a.	*Qtrly: 1, 4, Gu.* traces of *a castle; 2, 3,* traces of *a lion*	*Qtrly: 1, 4, Gu. a castle Or; 2, 3, Arg. a lion rampant Pur.*	Castile and Leon
S4b.	*Gu.* traces of *3 leopards*	*Gu. 3 leopards Or, a label Az. of 5 pts. semy of lis Or*	Lancaster
S5a.	*Or a lion*	*Or a lion Pur.*	Lincoln
S5b.	*Gu.* traces of *3 leopards Or*	*Gu. 3 leopards Or, a label of 5 pts. Az.*	Prince Edward
S6a.	*Gu.* traces of *a cross*	*Gu. a cross Arg.*	Savoy
S6b.	Traces of *bars Az.*	*Barruly Arg. and Az., an orle of martlets Gu.*	Valence
S7a.	Traces of *a border bezanty*	*Arg. a lion rampant Gu. crowned Or, a border Sa. bezanty*	Cornwall
S7b.	Traces of *Or*	*Or an eagle displayed Sa.*	Empire
S8a.	Traces of *paly and a bend*	*Paly Arg. and Az., on a bend Gu. 3 escallops Or*	Otho de Grandison
S8b.		*Or 4 pales Gu.*	Provence
S9a.	*Gu.* traces of *a bendlet*	*Gu. 3 leopards Or, a bendlet Az.*	Henry of Lancaster
S9b.	*Az. semy of lis Or,* traces of *a label of 5 pts. Gu.*	*Az. semy of lis Or, a label of 5 pts. Gu.*	Artois
S10a.	Traces of *Or and a lion*	*Or a lion Pur.*	Lincoln
S10b.		*Paly Arg. and Az., on a bend Gu. 3 eaglets Or*	William de Grandison

Group I: The Royal Kindred

ENGLAND: *Gules three leopards Or.* N1a, N3b; S1a, S3a; for Henry III (d. 1272) and Edward I (d. 1307); being the royal arms as adopted on the second great seal of Richard I in 1195 and used thereafter.[7]

PROVENCE: *Or four pales Gules.* N4b, N10a; S3b, S8b; for Raymond Berengar, "Count of Provence father of the Queen."[8] When Henry III ordered glass windows for Rochester to commemorate his marriage, the design was specified as "The king's

shield in one and the shield of the late count of Provence in the other."[9] As a grandson of the king of Aragon, he bore the same arms. Raymond's daughter Eleanor married Henry III in 1236, and her sister Sanchia married his brother Richard, earl of Cornwall and king of the Romans, in 1243.

CASTILE AND LEON: *Quarterly: 1 and 4 Gules a castle Or* (Castile); *2 and 3 Argent a lion rampant Purpure* (Leon). N2a; N8b; S4a; for Eleanor of Castile, whose father, Ferdinand III, had united the two kingdoms in 1230.[10] She married Edward I in 1254, and died in 1290; the arms are carved on her tomb in Westminster Abbey and on the crosses erected at the places where her funeral cortege stopped.[11]

PONTHIEU: *Or three bends Azure, a border Gules.* N9a; S2b; for Eleanor of Castile as countess of Ponthieu by her mother Joan of Dammartin. The arms are also on her tomb, on the memorial crosses, and in the Camden roll (n.32).

SAVOY: *Gules a cross Argent.* N5a; S6a; either for Count Peter of Savoy (d. 1268), who spent much time at the English court, or his sister Béatrice,

who married Raymond, count of Provence, and was the mother of Eleanor and Sanchia of Provence (see above page 47).[12]

CORNWALL: *Argent a lion rampant Gules crowned Or, a border Sable bezanty.* N4a; S7a; for Richard, earl of Cornwall (d. 1272), brother of Henry III, or his son Edmund of Almain (d. 1300).[13]

EMPIRE, or GERMANY: *Or an eagle displayed Sable.* N6b; S7b; for Richard, earl of Cornwall, who was elected king of the Romans, or of Germany, in 1257. The later distinction between the double- and single-headed eagle for the emperor and the king only became fixed in the fourteenth century. It was first found circa 1275 in Walford's roll.[14]

PRINCE EDWARD: *England, a label of five points Azure.* N5b; S5b; Edward I's eldest son, who was killed after his deposition in 1327. The number of points to the label varies from roll to roll.[15]

VALENCE: *Barruly Argent and Azure, an orle of martlets Gules.* N7a; S6b; William de Valence, brother of the half blood to Henry III, who came with his brothers to England and is also buried in Westminster Abbey (see above, pages 64–67).[16]

Group II: The Lancastrian Family

LANCASTER: *England, with a label of France.* N1b, N7b; S1b, S4b; for the deceased, Edmund Crouchback, earl of Lancaster (d. 1296), or his eldest son, Thomas (executed 1322). There is some slight evidence from the rolls that they may have distinguished their arms by the number of points on the label, but more evidence is needed.[17]

ARTOIS: *Azure semy of lis Or, a label of five points Gules (on each point three castles Or).* N3a; S9b; for Blanche of Artois, who married Edmund in 1276, as his second wife.[18] She bore France with a label of Spain, but the castles were missing when Charles saw the tomb and in at least one English roll for her father.[19]

HENRY OF LANCASTER: *England, a bendlet Azure.* N8a; S9a; Edmund's second son, also called "of Monmouth."[20] After the execution of his brother

in 1322, he became earl of Lancaster and adopted the label of France (d. 1345).

LINCOLN: *Or a lion Purpure.* N2b; N9b; S2a, S5a, S10a; for Henry (de Lacy), earl of Lincoln and constable of Chester (1251–1311). After the death of his sons, he surrendered his lordships into the king's hands and received them again for life, with remainder to Edmund. In 1294, his heiress Alice married Thomas, the defunct's oldest son. Earl Henry originally bore the arms of Lacy: *Quarterly Or and Gules, a bendlet Sable and a label Argent,*[21] but had changed to the arms found here by 1297.[22] It has been conjectured that this may have been due to his marriage to Margaret, one of the coheirs of William Longespee, who bore the coat associated with the ancestor of the royal house, Geoffrey of Anjou: *Azure six lions rampant Or.*[23]

Group III: The King's Friends

SIR OTHO DE GRANDISON: *Paly Argent and Azure, on a bend Gules three escallops Or.* N6a; S8a; Sir Otho de Grandison (d. 1328) came to England with Count Peter of Savoy in 1258, and accompanied Edward I on his crusade. One continental chronicle records that he saved the king by sucking poison from a wound after an attempt on his life in Palestine.[24] It was no doubt this that caused him to

be commemorated at this point in the scheme and in the paintings below the tomb of the queen. The scallops are not included in the carving.

SIR WILLIAM DE GRANDISON: *Paly Argent and Azure, on a bend Gules three eaglets Or.* N10b; S10b; Sir William de Grandison was the defunct's yeoman and executor of his will.[25]

The Canopy Banners

The chamfer molding of the triple-canopy gables was painted on each side with a series of banners of arms, using those attributed to the earldom of Leicester as a separator. The upper part of at least the central gable has been renewed, apparently having been cut away during the preparations for a coronation, and those on the north face are no longer readable, as a result of fire damage in 1968. Unlike the shields carved on the tomb chest, our knowledge of the painted heraldry is largely dependent on two old accounts. The first is the series of tricks of the heraldry on the tomb made by Nicholas Charles already mentioned.[26] The shields on the tomb chest are drawn in two rows, and between and to one side of these rows are tricks of twenty-two or twenty-three banners described as, "This is the border runnyng up the edge of the tombe." The record is not complete, and the way the items are set down provides no clue as to their original position on the tomb, or the side from which they were taken. A more complete record seems to have been made by Neale and Brayley in the early nineteenth century, who recorded some fifty-eight banners.[27] These do not include some tricked by Charles; several were incorrectly identified, and these names have been ignored here. Taken together, the two sources provide a total of fifty-eight or fifty-nine coats.[28] Some are noted by Neale and Brayley as being seen only on the north side.

Given the number of duplications, and considering that there is no way of establishing the original sequence for the whole series on each face, it is best to look at these two in a series of four groups: the royal and Lancastrian kindred, including all but four of those on the tomb chest and adding two more; the arms of the English earls (omitting Hereford); a selection of baronial and knightly families; and a small group that cannot be identified in contemporary rolls of arms. The latter are not discussed, since it is possible that some of these have been wrongly described, and one of Charles's tricks was added over a separator and is unclear.

Group I: The Royal and Lancastrian Kindred

The following arms from the tomb chest are repeated in the banners: the earl of Lincoln, the king of the Romans, Provence, Ponthieu, Castile and Leon, England, earl of Lancaster, Prince Edward, Henry of Lancaster and the earl of Cornwall.[29] To these may be added the following:

FRANCE: *Azure semy of lis Or.* Noted by Charles and presumably for Louis VIII (d. 1226), grandfather of Blanche of Artois.[30]

BRABANT: *Quarterly: 1 and 4 (Sable) a lion rampant Or* (Brabant); *2 and 3 Argent a lion rampant Gules* (Limburg). In Charles's trick, the field in the quarter for Brabant is azure, but no such combination appears in the rolls. The quarterly coat for Brabant and Limburg first appears on the coins of John II, duke of Brabant circa 1294–1312.[31] In 1290, he married Margaret, daughter of Edward I (1275–1318).

Group II: The English Earls

The arms of all but two of the comital families in England during the reign of Edward I appear on either tomb chest or canopy, as do the arms of four by then extinct. The two notable omissions are Humphrey (de Bohun), earl of Hereford and Essex (d. 1298), and

John, duke of Brittany and earl of Richmond (d. 1305). The inclusion of four titles that had died out represent fiefs granted to Edmund Crouchback himself or connected with the family of his first wife. While the Richmond title was held by an absentee, that of

Hereford and Essex was one of the major fiefs, and Humphrey appears to have been prominent at the court.

The titles are given in alphabetical order, with the family names given parenthetically.

ARUNDEL (FitzAlan): *Gules a lion rampant Or.* Richard, earl of Arundel (1267–1302), was very active in the Welsh, Gascon, and Scottish wars of Edward I between 1288 and 1301.

CORNWALL: As above. The arms were tricked by Charles and would probably refer to Edmund "of Almain," earl of Cornwall, son of Earl Richard, who died in 1300. After 1337, the title was always part of the fiefs for the heir apparent.

DERBY (Ferrers): *Vairy Or and Gules.* Robert III, earl of Derby, forfeited his fiefs in 1266, and these were granted to Edmund Crouchback in 1267.

DEVON (Reviers): *Or a lion rampant Azure.* Baldwin, the last earl, died in 1262, and his sister and heir, Isabel, was the mother of Edmund's first wife, Aveline, by William (de Forz), count of Aumale.

GLOUCESTER (Clare): *Or three chevrons Gules.* Gilbert, earl of Gloucester (1242–95), in 1290, married Joan of Acre, daughter of Edward I. Her second marriage was to Ralph de Monthermer, in 1297, who was styled earl of Gloucester from 1297–1307, in the right of his wife. The arms were tricked by Charles.

LANCASTER: As above. The arms were tricked by Charles and used by both Edmund and his eldest son Thomas.

LEICESTER: *Gules a pierced cinquefoil Ermine.* Tricked by Charles but with the tinctures *Azure and Or,* which is not what is at present painted on the south side of the tomb. The lands of Simon (de Montfort), earl of Leicester, were forfeited in 1265, and granted to Edmund Crouchback the next year. He is not known to have made use of this coat, and it seems to have been connected with an earlier line.

The banners prefixed to the Great Coucher Book of the duchy of Lancaster circa 1399–1413 include the arms.[32] A cinquefoil or sexfoil is found on two seals at the beginning of the thirteenth century for Margaret, sister and coheir of Robert, earl of Leicester, and her second son Roger (de Quincy), earl of Winchester (d. 1264). Her sister Amice had married Simon de Montfort's father, who was styled earl of Leicester from 1205.

NORFOLK (Bigod): (1) *Or a cross Gules* (Bigod), or (2) *Party Or and Vert a lion rampant Gules* (Earl Marshal). Both coats appear in the canopy work according to Neale and Brayley, but there is a problem in their interpretation. Roger Bigod (ca. 1245–1306) was the grandson of Hugh, earl of Norfolk (d. 1225), who had married Maud, coheir of William the Marshal, earl of Pembroke. The Bigod arms were the first given here, but in 1270, Roger was admitted to the office of marshal and thereafter the second coat, perhaps borne for that office, was usually given for him. It is used on his seal affixed to the Barons' Letter.[33] The coat with the cross was also used by the de Burgh earls of Ulster at the same period.

OXFORD (de Vere): *Quarterly Gules and Or, in the first quarter a molet Argent.* Robert, earl of Oxford (d. 1296), may have served as chamberlain at Edward I's coronation in 1274, and was in Wales at the same time as Edmund in 1277 and 1282–83.

SURREY (Warenne): *Checky Or and Azure.* John, earl of Surrey (1231–1304), married Henry III's half sister, daughter of Hugh, count of La Marche (d. 1256). In 1257, he was in Germany with the earl of Cornwall and took part, with his wife's kinsman, William de Valence, and Prince Edward, in the Barons' War of 1265. The arms were tricked by Charles.

ULSTER: See under Norfolk.

WARWICK (Beauchamp): *Gules a fess between six crosses crosslet Or.* William Beauchamp (d. 1298) became earl of Warwick in 1268, as nephew and heir to William Mauduit, whose sister married his father, William Beauchamp of Elmley. The arms were tricked by Charles.

WINCHESTER (Quincy): *Gules seven mascles conjoined Or.* The arms were adopted by Roger, second and last earl of Winchester who died in 1264. The lands were divided among coheirs including Margaret, wife of William (de Ferrers), earl of Derby (d. 1254), whose son Robert was involved with the rebellion of Simon de Montfort in 1265, and forfeited both his earldom and many of his lands in 1266. The lands were granted to Edmund, and the Derby title was granted to his descendents in 1337.

As suggested above, the intention seems to have been to include most, if not all, of the earls, but several could also have been included because they were among the deceased's kindred.

Group III: Barons and Knights

This is the largest group represented in the heraldry on the canopy and the most difficult to explain. There is no surviving inquisition postmortem for Edmund, and few of these barons and knights seem to have been his tenants. Writs of summons for military service show that some were in Wales in his contin-

gent or during the same campaigns. Lists of the Lancastrian retinues at the Dunstable Tournament in 1308 or at Boroughbridge have also been used to show the connection of given families with the House of Lancaster. Only a few are given in both Charles and Neale and Brayley, and four appear only in Charles's tricks.

BASSET: *Barry wavy Or and Gules.* Sir Philip Basset was Henry III's Justiciar, who helped the king and Edmund Crouchback carry the relics of Saint Edward the Confessor to the new shrine. His arms are given in Glover's roll (no. 93) and in other thirteenth-century rolls.

BEAUCHAMP OF ALCESTER: *Gules a fess between six martlets Or.* Sir Walter Beauchamp died in 1303, having served in Wales in 1277, with his kinsman the earl of Warwick. He was steward of the household in 1292, and was appointed paymaster in Gascony in 1295, shortly before Edmund was expected to arrive as lieutenant.

BEAUCHAMP OF ELMLEY: *Gules a fess Or.* James Beauchamp served in Wales, in 1277, for his brother, the earl of Warwick.

BERKELEY: *Gules a chevron between ten crosses formy Argent.* Thomas Lord Berkeley served under Edmund in Wales in 1277, and two members of the family were with Thomas, earl of Lancaster, at Boroughbridge in 1322.

BISHOPSTONE (?): *Bendy Or and Sable.* William de Bishopstone bore this coat, but with bendy of ten pieces, in both St. George's and Charles's rolls (nos. 400 and 357, respectively); and his son John (ca. 1284–1340) bore the same, with a canton Ermine, in the Parliamentary roll (p. 72). He was captured at Boroughbridge. At this date, the precise number of pieces could vary from roll to roll or seal to seal, but there is no other candidate with a Lancastrian connection.

BLOUNT: *Barry wavy Or and Sable.* Sir William le Blount of Warwickshire was with Edward I on his crusade in 1270, and his son John (d. 1337) was a retainer of Henry of Lancaster in 1322.

BOHUN OF MIDHURST: *Azure a cross Or.* The arms are given for Sir John Bohun in Segar's roll (no. 110). He was the first of his family to use the coat. He served in Wales in 1277 and died in 1284.

DEINCOURT: *Gules billetty a dance Or.* The coat is given for Sir Ralph Deincourt, of whom little is known, in Charles's roll (no. 214).

DESPENSER: *Quarterly Argent and Gules fretty Or, a bendlet Sable.* Hugh le Despenser (1261–1326) married the heiress of Sir Philip Basset and was created earl of Winchester in 1322, but was executed in 1326. The arms were tricked by Charles, but with the first and fourth quarters as *Or.*

FAUCONBERG: *Or a fess Azure, in chief three pales Gules.* So given for Sir Walter Fauconberg in St. George's roll (no. 159). He served in Wales in 1277, and died in 1304.

FITZALAN OF BEDALE: *Barry Or and Gules.* The arms were tricked by Charles and appear in the rolls and on seals with varying numbers of bars, but the effigy of Brian Fitzalan at Bedale shows the same as here.[34] He was in Wales in 1277, and on later campaigns between 1282 and 1294. Some of his lands were held of Count Peter of Savoy. He died without surviving male issue in 1306.

FITZWALTER: *Or a fess between two chevrons Gules.* Descended from the House of Clare and the leader of the barons against King John, Robert III, Lord FitzWalter came of age in 1268, and married, as his second wife, Eleanor, daughter of Robert, earl of Derby. He died in 1326. He held some of his lands of the earls of Cornwall in 1285, and was in Gascony in 1296–97. The arms occur in several of the rolls and on his seals.

FITZWARINE: *Quarterly per fess indented Argent and Gules.* Fulk FitzWarine is recorded in several rolls with these arms, and in 1318, his son Fulk (d. 1336) was pardoned for having been with Thomas, earl of Lancaster, against Gaveston. Another member of the family was with the earl at Boroughbridge in 1322.

FURNIVAL: *Argent a bend between six martlets Gules.* Thomas de Furnival married Joan, daughter of Hugh le Despenser, and died in 1332, having served in Wales in 1277 and 1282–83. The arms are given on his seal and in the Caerlaverock roll.

GAUNT: *Barry Or and Azure, a bend Gules.* Sir Gilbert de Gaunt served in Wales in 1277, 1287, and 1294, and died in 1298. The arms are recorded for his grandfather.[35]

HASTINGS: *Or a maunch Gules.* John Hastings (1262–1313) is recorded with these arms in several rolls and on his seal. His first wife was Isabel, daughter of William de Valence, and he was closely connected with Edward I's court, attending his daughter Margaret, duchess of Brabant, in 1297.

KYME: *Gules a chevron and eight crosses crosslet Or.* The arms seem to have been adopted by William III de Kyme (d. 1259), and often appear with ten crosslets. His son Philip (d. 1323) was in Gascony in 1294–95. The arms were tricked by Charles.

MAULEY: *Or a bend Sable.* Peter Mauley (1249–1308) is given this coat in Segar's roll (no. 137) and was in Wales in 1277. He married Nichole, one of the coheirs in her issue to Gilbert de Gaunt.

MORTIMER: *Barry the chief paly and the corners gyronny Azure and Or, an escutcheon Argent.* Edmund de Mortimer of Wigmore died in 1304, and his wife, Margaret, daughter of Sir William de Fenles (or Fiennes), is said to have been a cousin of

Queen Eleanor of Castile. His son escaped capture after Boroughbridge and was instrumental in the overthrow of Edward II in 1327. The arms were tricked by Charles.

MUCEGROS (?): *Or a lion rampant Gules.* Robert Mucegros (d. 1280) served in Wales in 1277, and is in Camden's roll with these arms (no. 178).

PEROT: *Quarterly per fess indented Or and Azure.* Known only from Charles's trick. Ralph Perot of Bedfordshire is in the parliamentary roll with these arms. One of this name had served in Wales in 1277 and in 1282, and in Gascony in 1294.

ST. AMAND: *Or fretty and on a chief Sable three bezants.* Amauri de St. Amand (1269–1310) is given this coat in St. George's roll (n.165). His great grandfather had been godfather to Edward I in 1239, and he was captured while serving in Gascony in 1294.

STAFFORD: *Or a chevron Gules.* Nicholas Stafford (d. 1282) was in Wales in 1277, but his son Edmund did not come of age until 1294.

SUDELEY: *Or two bends Gules.* Presumably for John de Sudeley (d. 1336), who succeeded in 1280, and was chamberlain of Edward I's household in 1306.

TATESHAL: *Checky Or and Gules a chief Ermine.* Robert IV de Tateshal (d. 1298), whose father is in Glover's roll with this coat, served in Wales in 1277, and in the other campaigns to 1294–95.

WAKE: *Or two bars and in chief three roundels Gules.* Probably for Baldwin IV de Wake (d. 1282), whose arms are in Glover's roll and who was in Wales in 1277, with the earl of Gloucester. His second wife was Hawise, one of the coheirs of the last Quincy earl of Winchester. Their grandson Thomas Wake (d. 1349) married Blanche of Lancaster.

WILLOUGHBY: *Or fretty Azure.* Only given in Charles's tricks. These are the old arms of Willoughby, last borne by Robert de Willoughby (d. 1317) at Caerlaverock in 1300. His mother was coheir of the Beke family and, after her death in 1311, he adopted the arms of that family. He was in Wales in 1277, and also associated with Thomas, earl of Lancaster, against Gaveston in 1313.

Notes

1. London, Brit. Lib., Ms. Lansdowne 874, fol. 135v.

2. London, Westminster Abbey, Dean and Chapter Library. See Figure 37.

3. See above, pages 72–73.

4. Neale and Brayley 1818–23, 2, 276–77.

5. See Adhémar 1974.

6. Although Charles tricked Savoy at N5a, the traces of a cross in situ do not appear to extend to the edges of the shield, but this could be due to irregular breakage.

7. *Rolls of Arms. Henry III,* 14, no. 19.

8. Ibid., 29–30, no. 77.

9. London, Public Record Office, Calendar of Liberate rolls, 3, 113.

10. *Rolls of Arms. Henry III,* 51, no. 72.

11. *Age of Chivalry,* 361–66.

12. *Rolls of Arms. Henry III,* 134, no. 101.

13. Ibid., 20, no. 38; 37, no. 3; PRO P 655.

14. *Rolls of Arms. Henry III,* 167–68, nos. 1 and 8.

15. Three points (A, no. 2); five points (E, no. 66).

16. *Rolls of Arms. Henry III,* 118, no. 23; PRO P 820.

17. Five points for Edmund: E, no. 5; BMS 12665; three points for Thomas: H, no. 51; Howard de Walden, *Some Feudal Lords and Their Seals,* London, 1904, 5–6.

18. *Rolls of Arms. Henry III,* 174, no. 31; *Armorial Wijnbergen,* ed. P. Adam-Even and L. Jéquier, (*Archives héraldiques suisses,* 1951–54), no. 760.

19. *Rolls of Arms. Henry III,* 34, no. 94.

20. With a bendlet: Caerlaverock Roll (Howard de Walden 1904, 29–30); with a label: PRO P 1530.

21. *Rolls of Arms. Henry III,* 116, no. 9.

22. PRO P 1637.

23. *Rolls of Arms. Henry III,* 33, no. 90; Marks and Payne 1978, no. 1, illus. p. 10.

24. C. L. Kingsford, "Sir Otho de Grandison 1238?–1328," *Transactions of the Royal Historical Society,* 3 ser., 3, 1909, 125–26.

25. CP, 6, 60. For his arms, see W. R. Lethaby, "Medieval Paintings at Westminster," *Proceedings of the British Academy,* 13, 1927, 142–43.

26. London, Brit. Lib., Ms. Lansdowne 874, fol. 135v.

27. Neale and Brayley 1818–23, 2, 277.

28. The precise significance of one of Charles's alterations to his original trick is not clear.

29. All except the earl of Lincoln and England were tricked by Charles.

30. *Armorial Wijnbergen,* no. 1.

31. E. Boudeau, *Monnaies françaises provinciales,* n.d., nos. 2357–61.

32. London, Public Record Office, Duchy of Lancaster, 42, no. 6.

33. Howard de Walden 1904, 15.

34. H. Lawrence, *Heraldry from Military Monuments before 1350,* London, 1946, 17.

35. *Rolls of Arms. Henry III,* 68, no. 49.

The Program of the Tomb of Aymer de Valence, Earl of Pembroke (d. 1324)

F OR THE SAKE of clarity, only my analyses of the heraldry still in situ and of Charles's drawing are indicated below. A summary of how these relate to the record left by Blore, Gough, Powell, and the Inventory of the Royal Commission on Historical Monuments is included at the end of the appendix.

Arms in Situ	Arms According to Charles	Identification of Arms	Identification of Figure and Relation to the Earl
		THE NORTH SIDE	
N0 *Or 3 escutcheons barry, Vair and Gu.* (dexter side only)	The same	Munchensy[1]	
N1 *Paly of 6, Or and Sa. dimid. Az. 3 cinquefoils Or*	*Or 3 pales Sa. dimid. Az. 3 cinquefoils Or*	Atholl dimid. Bardolf (?)	A lady married to a member of the House of Atholl[2]
N2 *Or a maunch Gu.*	The same	Hastings	John Hastings (d. 1325),[3] nephew, or his son Laurence (d. 1348),[4] great-nephew
N3 *Az. semy of lis Or, a label impal. checky Or and Az., a border Gu., a canton with traces of Ermine*	The same, with the dexter side having *a label of 3 pts. Gu., each charged with 3 castles Or*	Artois impal. Brittany of the House of Dreux[5]	Blanche de Bretagne, wife of Philippe d'Artois (d. 1328),[6] aunt by marriage
N4 *Az. semy of lis Or, a label of 4* (?) *pts.*	The same, but with *a label of 3 pts. Gu., each charged with 3 castles Or*	Artois	Robert d'Artois (d. 1343),[7] cousin by marriage

N5	*Or a lion Sa., a riband Gu. dimid. (?)*	*Or a lion Sa., a riband Gu. dimid. Gu. 3 pales Vair, a chief Or with a label Az. of 4 pts.*	Flanders differenced dimid. Châtillon Saint-Pol	Béatrice de Saint-Pol, lady of Termonde and Crèvecoeur (liv. 1350),[8] sister-in-law
N6	*Or a lion Sa., a riband Gu.*	The same	Flanders differenced	Jean de Flandre, lord of Termonde and Crèvecoeur (k. 1325),[9] brother-in-law
N7	*Barully Arg. (?) and Az., traces of an orle of martlets Gu. dimid. Gu. 3 pales Vair, a chief Or, a label Az. of 4 pts.*	*Barully Arg. and Az., an orle of martlets Gu. dimid. Gu. 3 pales Vair, a chief Or, a label Az. of 4 pts.*	Valence dimid. Châtillon Saint-Pol	Marie de Saint-Pol, countess of Pembroke (d. 1377),[10] wife
N8	*Checky Or and Az., a border Gu. (sinister side only)*		Brittany of the House of Dreux	Jean II (d. 1305) or Arthur II (d. 1312), dukes of Brittany,[11] grandfather and uncle by marriage

THE SOUTH SIDE

S0	*Barully (?) and Az. (?) (sinister side only)*	*Barully Arg. and Az., an orle of marlets Gu.*	Valence	
S1	*Gu. 3 pales Vair, a chief Or, a label of 4 pts. dimid. checky Or and Az. (?), a border Gu., a canton Ermine*	*Gu. 3 pales Vair, a chief Or, a label Az. of 4 pts. dimid. checky Or and Az., a border Gu., a canton Ermine.*	Châtillon Saint-Pol[12] dimid. Brittany of the House of Dreux	Marie de Bretagne, countess of Saint-Pol (d. 1339), mother-in-law
S2	*Gu. charged Or, a label*	*Gu. 3 leopards Or, a label Az. of 3 pts., each charged with 3 fleurs-de-lys*	Lancaster	Henry, earl of Lancaster (d. 1345),[13] cousin
S3	Traces of *barry of 6, Vair and Gu. dimid. Gu. 3 pales Vair, a chief Or, a label of 4 pts.*	*Barry of 6, Vair and Gu. dimid. Gu. 3 pales Vair, a chief Or, a label Az. of 4 pts.*	Coucy dimid. Châtillon Saint-Pol	Isabelle de Saint-Pol, lady of Coucy (liv. 1367),[14] sister-in-law
S4	*Barry of 6, Vair and Gu.*	The same	Coucy	Guillaume, sire of Coucy (d. 1336),[15] brother-in-law
S5	*(?) dimid. Gu. 3 pales Vair, a chief Or, a label of 4 pts.*	*Az. semy of lis Or, a border Gu. dimid. 3 pales Vair, a chief, a label of 4 pts.*	Valois dimid. Châtillon Saint-Pol	Mahaut de Saint-Pol, countess of Valois (d. 1358),[16] sister-in-law

S6	*Az. semy of lis Or, a border Gu.*	The same	Valois	Charles de France, count of Valois (d. 1325),[17] brother-in-law
S7	*Barully (?) and Az. (?), traces of an orle of martlets Gu. dimid. Gu. 3 pales Vair, a chief Or, a label of 4 pts.*	*Barully Arg. and Az., an orle of martlets Gu. dimid. 3 pales Vair, a chief Or, a label Az. of 4 pts.*	Valence dimid. Châtillon Saint-Pol	Marie de Saint-Pol, countess of Pembroke (d. 1377), wife
S8	*Gu. 3 pales Vair, a chief Or, a label of 4 pts.* (dexter side only)	*Gu. 3 pales Vair, a chief Or, a label Az. of 4 pts.*	Châtillon Saint-Pol	Guy (d. 1317) or Jean (d. 1342) de Châtillon, counts of Saint-Pol,[18] father-in-law and brother-in-law

Edward Blore's description of the arms (*The Monumental Remains of Noble and Eminent Persons, comprising the Sepulchral Antiquities of Great Britain.* London, 1826, 10–12) corresponds to that of Charles (London, Brit. Lib., Ms. Lansdowne 874, fol. 135v) and Powell (London, Brit. Lib., Ms. Add. 17694, fols. 61–64v) for shields N0, N2, and N5–8 and S0–4, S7, and S8, except that, as Powell pointed out, he describes the marshaled shields N5 and N7 and S3 and S7 as impaled rather than dimidiated and generally associates the dimidiated shields with lords rather than ladies. My identification of the figures corresponds to his for Figures N3, N7, N8, and S2. Gough's description of the arms (1786, 1, 85–86), limited to the north side, corresponds to that of Charles and Powell for shields N0, N2, N6 (except for the tincture of the bendlet, which he gave as azure), and N8.[19] The Inventory of the Royal Commission[20] corresponds to Charles's and Powell's analysis of the arms for N0, N2–4, N7, and N8 and the entire south side. My identifications of the figures are consistent with the Royal Commission's identifications for N2, N7, N8, S1, and S3–8.

Notes

1. For Joan de Munchensy, daughter of Warin de Munchensy and the defunct's mother (*Rolls of Arms. Henry III,* 119, no. 25; 185, no. 87).

2. A member of the family of Joan Comyn (d. 1326), coheir of Aymer de Valence by right of her mother, seems to be represented in this niche, the first on the most visible side of the tomb chest. Joan Comyn was married to David de Strathbogie, earl of Atholl. The Atholl arms appear to be represented on the dexter side of the shield (*Rolls of Arms. Henry III,* 181, no. 62). The arms impaled by Atholl normally signify Bardolf in England in this period (Ibid., 128, no. 70), but no marriage joining these two families is known from this period.

3. N 21.

4. Laurence first bore the plain coat of Hastings (AS 57). The earliest seal to show his arms as Valence quartering Hastings was used in 1340 (BMS 6098), and was presumably adopted when he was recognized as the earl of Pembroke on October 13, 1339 (CP, 10, 389).

5. *Rolls of Arms. Henry III,* 172, no. 24.

6. As seen on her seal of 1310 (Demay 1873, 1, 14, no. 76).

7. His arms, as seen on a seal of 1325, were *Artois with a label of five points, each charged with three castles Or* (Douet d'Arcq 1863–68, 1, 411, no. 917).

8. As seen on her seal of 1329, with the legend BEATRICIS.DE.SCO.PAVLO (Beatricis de Sancto Paulo) (Demay 1873, 1, 45–46, no. 290). Although Anselme (4, 106), Le Chevalier de Courcelles (*Généalogie de la maison de Chastillon-sur-Marne,* Paris, 1830, 112–16), and La Chenaye-Desbois (1868–76, 5, 467) indicated that Béatrice de Saint-Pol, like her sister Isabelle (S3), was the daughter of Guy III de Châtillon, count of Saint-Pol, and thus was Marie de Saint-Pol's sister, André Du Chesne (*Histoire de la Maison de Chastillon sur Marne,* Paris, 1621, 305–10), followed by Isenburg and Schwennicke (1984, 2, Table 18), took her and her sister Isabelle for the

daughters of his brother, Jacques de Châtillon, lord of Leuze, who differenced the Châtillon arms with a fleur-de-lis sable coupée. Charles's copy of a blazon that can no longer be read on the tomb is verified by the seal.

9. Jean de Flandre, lord of Crevecoeur and Alleux, succeeded his brother, Guillaume II (d. 1320), as lord of Termonde circa 1320, according to Anselme (2, 743–44; see also Isenburg and Schwennicke, 1980–, 2, Table 8). In the *Armorial Wijnbergen* (1265–85), their father's arms are given as *Or, a lion Sable, a rib- and Gules* (ed. Adam-Even and Jéquier, 1951–54, 73, no. 1235). According to the evidence furnished by this tomb, and the seal of his wife of 1329 (see previous note), Jean bore his father's arms after he succeeded his older brother.

10. See Jenkinson 1915, Pl. XXXI, Fig. 5, for the lady's seal with the Valence and Châtillon Saint-Pol arms.

11. *Rolls of Arms. Henry III*, 172, no. 24.

12. Ibid., 173, no. 27.

13. Henry assumed his father's arms on becoming earl of Lancaster in 1326 (CP, 7, 398).

14. As seen on her seal of 1367, with the legend "YSABEL.DE SAINT . . . DAME DE COVCI" (Demay 1873, 1, 46, no. 291).

15. Douet d'Arcq 1863–68, 1, 550, no. 1909.

16. As seen on her seal of 1324 (Demay, *Inventaire des sceaux de la Collection Clairambault à la Bibliothèque Nationale* [Collection de Documents inédits sur l'Histoire de France, 3e sér. Archéologie], Paris, 1885–86, 2, 279, no. 9209).

17. As represented on his tomb in the Jacobins, Paris (Adhémar 1974, 121, no. 657), and on a number of seals (Douet d'Arcq 1863–68, 1, 430, nos. 1033–35).

18. *Rolls of Arms. Henry III*, 173, no. 27.

19. Although he erroneously says that the arms described were found on the south side, they correspond exactly to those represented on his Plate XXXII, which he designates there as being the north side.

20. RCHM, 24.

The Program of the Tomb of Philippa of Hainault, Queen of England (d. 1369)

NO ONE SOURCE gives a complete list of the figures represented on the chest of Philippa of Hainault's tomb, nor of the coats of arms that identified them. Figure 59 was constructed by comparing five early sources and checking them with the figures and shields that remain on the tomb. The sources are Charles, ca. 1590 (London, Brit. Lib., Ms. Lansdowne 874, fols. 135–36); Camden 1606; Sandford 1683; Dart 1723, 2; and Stow (1618, 1633, 1733–35, and 1754 editions). Stow's *Survey of London* was published under various titles in numerous editions, which are not consistent. Two versions were used: (1) the edition of 1618 (corrected and enlarged by Anthony Munday), which was enlarged by Munday, Henry Dyson, and others in 1633, and by John Strype in 1754, but with no significant changes in the text regarding this tomb; and (2) the edition of 1733–35 revised by John Motley, which was reissued in 1754.

Further checking included the record of the tomb in Keepe 1681; Gough 1786–96, 1; Powell 1795 (London, Brit. Lib., Ms. Add. 17694); Scott 1863; and RCHM, 1924.

Both Camden (1606) and Stow (1618) say that they took their identifications for the figures from an old manuscript, and this is confirmed by the fact that they both list ten figures on the north side of the chest, where only eight were visible after the fifteenth century. Charles must have relied on a different source, since his drawing of the shields is in a different order from their identifications, but his inclusion of nine shields suggests that he too relied at least in part on previous sources rather than on the monument itself.

The West End

The sources concur in their description of the shields on the west side of the chest, or in their identity of the persons identified by the arms represented.

Arms in Situ	Arms According to Charles	Stow's Identification of Figure	Identification of Figure and Relation to the Queen
W1	*Qtrly.: 1, 4, semy of lis; 2, 3, 3 leopards Or, a label of 3 pts. Arg.*	Edward, Prince of Wales	Edward, Prince of Wales (b. 1330, d. 1376), son
W2	*Or a 2-headed eagle displayed Sa.*	Lewis, the emperor	Louis IV of Bavaria, Holy Roman Emperor (d. 1347), brother-in-law
W3	*Qtrly.: 1, 4, semy of lis; 2, 3, 3 leopards Or*	King Edward III	Edward III, king of England (d. 1377), husband
W4	*Semy of lis*	John, king of France	John II (d. 1364) or Charles V (d. 1380), kings of France, cousins
W5	*Qtrly.: 1, 4, Or a lion Sa.; 2, 3, Or a lion Gu.*	William, earl of Heinault	William I, count of Hainault and Holland (d. 1337), father[1]

The South Side

The most complete record of the heraldry on the south side of the chest is the drawing of nine of the original eleven shields by Charles. Sandford's engraving (Fig. 58), which shows blank shields under niches S6 and S7, suggests that the shields omitted by Charles were already missing when he made his drawing. Fortunately this gap is filled by Dart's identification of all eleven persons originally found on this side (followed by Motley's edition of Stow, in 1733–35). According to his list, the figures in S6 and S7 represented the queen's uncle, John of Bavaria [*sic*], count of Hainault, and her daughter, Mary, duchess of Brittany. Camden's identifications correspond to Stow's, although he lists Margaret of Hainault ("Imperatrix") before her brother, William II.

Arms in Situ	Arms According to Charles	Stow's Identification of Figure	Identification of Figure and Relation to the Queen
S1	*Qtrly.: 1, 4, Or a lion Sa.; 2, 3, Or a lion Gu. impal. Az. semy of lis Or, a border Gu.*	Joan, countess of Heinault	Joan of Valois, countess of Hainault (d. 1342),[2] mother

S2		*Qtrly: 1, 4, Or a lion Sa.; 2, 3, Or a lion Gu.*	William, earl of Heinault	William II, count of Hainault (k. 1345),[3] brother
S3		*Or a double-headed eagle displayed Sa. impal. qtrly.: 1, 4, Or a lion Sa.; 2, 3, Or a lion Gu.*	Margaret, empress of Germany	Margaret of Hainault, Holy Roman Empress (d. 1356),[4] sister
S4		*Az. a lion double-queued crowned Or*	Reginald, duke of Geldres	Reginald II, duke of Guelders (d. 1343), brother-in-law[5]
S5		*Az. a lion double-queued crowned Or impal. Gu. 3 leopards*	Eleanor, duchess of Geldres	Eleanor of England, duchess of Guelders (d. 1355), sister-in-law
S6			John of Bavaria, earl of Heinault	John II, count of Hainault (d. 1304) (?) grandfather[6]
S7			Mary, duchess of Britain	Mary of England, duchess of Brittany (b. 1344, d. 1362), daughter
S8		*Qtrly: 1, 4, paly-bendy Arg. and Az.; 2, 3, qtrly: 1, 4, Or a lion Sa.; 2, 3, Or a lion Gu.*	Lewis, duke of Bavaria	William III, count of Hainault and Holland (d. 1388),[7] nephew
S9	*Qtrly: 1, 4, a maunch; 2, 3, 6 martlets imp. qtrly: 1, 4, semy of lis; 2, 3, 3 leopards*[8]	*Qtrly.: 1, 4, Or a maunch Gu.; 2, 3, burely Arg. and Az., an orle of martlets Gu. impal. qtrly.: 1, 4, semy of lis; 2, 3, 3 leopards*	Margaret, countess of Pembroke	Margaret of England, countess of Pembroke (b. 1346, d. 1361), daughter
S10		*Az. semy of lis Or, a border Gu.*	Charles of Valois	Charles, count of Valois (d. 1325),[9] grandfather
S11	*Qtrly.: a lion in each impal. qtrly: a lion in each*	*Qtrly.: 1, 4, Or a lion Sa.; 2, 3, Or a lion Gu. impal qtrly.: 1, 4, Sa. a lion Or; 2, 3, Arg. a lion double-queued Gu.*	John, duke of Brabant	Joanna, duchess of Brabant (d. 1406),[10] sister-in-law

The North Side

The encroachment of the Chapel of Henry VII on the north side of the tomb saved three figures and their shields from destruction. Sir Gilbert Scott's incisions into the masonry of the chapel in the nineteenth century made the three last niches on the north side and their shields

at least partially visible to the modern investigator armed with a flashlight.[11] Thus the arms of Philippa's daughter-in-law, Blanche of Lancaster, have long been identified under the lady at N9.[12] Although the figure at N10 was stolen in the course of Scott's work, its shield can still be read as quarterly France and England, with a label of three points, and the shield in the last niche, N11, as quarterly France and England impaling Hainault. These shields still in situ furnish a point of reference for checking the sources. The list of only ten of the eleven personages furnished by Camden (1606) and Stow (1618 and 1633 editions), which they both say was taken from an old manuscript, corresponds in its order with the shield at N9. A different order is followed in Charles's record, where he tricks only nine of the shields, although the shields recorded correspond to nine of Stow's identifications. Two factors argue for accepting Camden and Stow's arrangement, rather than Charles's. In the first place, it is in accord with one of the shields in situ, that of Blanche of Lancaster. In the second place, it suggests court protocol by placing the eldest relatives nearest the head of the tomb, with the sons placed in order of birth when read from head to foot. Thus on our chart, Charles's record of the shields has been made to conform to Camden and Stow's order.

Arms in Situ	Arms According to Charles	Stow's Identification of Figure	Identification of Figure and Relation to the Queen
N1	*A lion within a tressure fleury counter-fleury impal. Gu. 3 leopards*	Jone, queen of Scotland	Joan of England, queen of Scotland (d. 1362), sister-in-law
N2	*3 leopards, a border Az. semy of lis Or*	John of Eltham, earl of Cornwall	John of Eltham, earl of Cornwall (k. 1336), brother-in-law
N3	*Qtrly.: 1, 4, semy of lis; 2, 3, 3 leopards, a label of 3 pts. impal. Gu. 3 leopards Or, a border Arg.*	Jone, princess of Wales	Joan of Kent, princess of Wales (d. 1385), daughter-in-law
N4	*Qtrly.: 1, 4, semy of lis; 2, 3, 3 leopards Or, a label of 3 pts. Arg., a canton Gu.*	Lionel, duke of Clarence	Lionel of Antwerp, duke of Clarence (b. 1338, d. 1368), son
N5	*Barry of 6, Vair and Gu. impal. qtrly.: 1, 4, semy of lis; 2, 3, 3 leopards*	Isabel, countess of Bedford	Isabel of England, countess of Bedford (b. 1332, d. 1379), daughter
N6	*Qtrly.: 1, 4, semy of lis; 2, 3, 3 leopards, a label of 3 pts. Ermine*	John, duke of Lancaster	John of Gaunt, duke of Lancaster (b. 1340, d. 1399), son

	Arms in Situ	Arms According to Charles	Stow's Identification of Figure	Identification of Figure and Relation to the Queen
N7		*Qtrly.: 1, 4, semy of lis; 2, 3, 3 leopards, a label of 3 pts., a canton impal. Or, a cross Gu.*	Jone, dutchess of Clarence	Elizabeth de Burgh, duchess of Clarence (d. 1363), daughter-in-law
N8		*Qtrly.: 1, 4, semy of lis; 2, 3, 3 leopards, a label Arg. of 3 pts., each with 3 torteaux*	Edmund, earl of Cambridge	Edmund of Langley, duke of York (b. 1341, d. 1402), son
N9	*Qtrly.: 1, 4, semy of lis; 2, 3, 3 leopards, a label of 3 pts. impal. 3 leopards, a label of 3 pts.*[13]		Jone, dutchess of Lancaster	Blanche, duchess of Lancaster (d. 1369), daughter-in-law
N10	*Qtrly.: 1, 4, semy of lis; 2, 3, 3 leopards, a label of 3 pts.*	*Qtrly.: 1, 4, semy of lis; 2, 3, 3 leopards, a border Arg.*[14]	Thomas, earl of Buckingham	Thomas of Woodstock (?), duke of Gloucester (b. 1355, d. 1397), son
N11	*Qtrly.: 1, 4, semy of lis; 2, 3, traces of 3 leopards impal. qtrly.: a lion in each*			Philippa of Hainault, queen of England (d. 1369), herself

The East End

The sources concur in their description of the shields on the east side of the chest, or in their identity of the persons identified by the arms represented. However, there is a discrepancy between the coat of arms represented on the shield in Niche E4 and that recorded by the sources. The relief of four rampant lions at E4 is at variance with the identification of the arms of Bohemia here by the sources. In 1924, the Royal Commission Inventory recorded the arms of Hainault at the east end, and the four rampant lions seen on the shield at E4 do in fact suggest the Hainault arms. Apparently Scott misplaced this shield when he restored the tomb. It would have been placed originally either under the figure of the queen's father at the west end (W5), or that of her brother on the south side (S2).

	Arms in Situ	Arms According to Charles	Stow's Identification of Figure	Identification of Figure and Relation to the Queen
E1		*Qtrly.: 1, 4, Gu. a castle Or; 2, 3, Arg. a lion Pur.*	King of Spain	Pedro I, king of Castile (k. 1369)[15]

E2		*Az., semy of lis Or, a label Gu. of 5 pts.*	King of Sicily	Robert I, king of Naples, (d. 1343),[16] great-uncle
E3		*A lion within a tressure fleury counter-fleury*	King of Scotland	David II, king of Scotland (d. 1371),[17] brother-in-law
E4	*Qtrly.: a lion in each*[18]	*Gu. a lion Arg. crowned Or*	King of Bohemia	Charles IV, king of Bohemia and Holy Roman Emperor (d. 1378) (?) uncle by marriage
E5	*An escarbuncle*	*Gu. an escarbuncle Or*	King of Navarre	Charles II, king of Navarre (d. 1387)?,[19] cousin by marriage

Notes

1. As seen on his seals of 1316 and 1323 (Demay 1873, 1, 33, no. 202; Raadt 1898, 2, 15), and in *L'armorial universel du héraut Gelre (1370–1395)*, ed. P. Adam-Even (*Archives héraldiques suisses,* 1971), 108, no. 1746.

2. As seen on her seal of 1320 (Demay 1873, 1, 33, no. 205).

3. As seen on his seal of 1341 (Douet d'Arcq 1863–68, 1, 367, no. 655).

4. Her seals of 1346 and 1353 show an eagle (for the empire) carrying a shield with the four lions of Hainault (Demay 1873, 1, 5, no. 26; Douet d'Arcq 1863–1868, no. 656).

5. Raadt 1897, 1, 522, a seal of 1339.

6. There was no John of Bavaria, count of Hainault, and since either William or Albert of Bavaria was represented in S8, this seems most likely to have been John II d'Avesnes, count of Hainault, Philippa's grandfather.

7. The arms recorded by Charles correspond to those given for the duke of Holland in *L'Armorial universel*, 72, no. 1010, implying the duke of Bavaria who, after 1356, was also count of Hainault and Holland. Stow's identification of this figure as Louis, duke of Bavaria, is questionable. Louis, duke of Bavaria, was emperor of the Holy Roman Empire and was represented according to all sources, including Stow himself, at the head of the tomb (W2). The figure represented in this niche was more likely his elder son, William of Bavaria, who became count of Hainault and Holland in 1356, although his younger brother Albert succeeded him as regent in 1358. See page 98.

8. RCHM, Pl. 26.

9. As seen on his seals of 1292, 1301, and 1319 (Douet d'Arcq 1863–68, 1, 430, nos. 1033–35).

10. Stow, Keepe, Sandford, Dart, and Gough identify the figure as a duke of Brabant. But the shield, which is intact, displays four lions arranged as if in quarters impaling the same (see RCHM, Pl. 26). The impalement suggests that the figure represented was a lady, as does the alternation of men and women on this side of the chest. The tinctures indicated by Charles suggest that the shield represented Hainault impaling Brabant/Limburg. For the latter, see *L'Armorial universal*, 61, no. 805. These would have been the arms of Joanna of Brabant during her first marriage to Philippa's brother, William II of Hainault, and so it would seem that she was the person intended in this niche, as first suggested by Powell. After Joanna's marriage to Wenceslas of Luxembourg in 1347, she impaled her arms with his, as seen on a seal of 1355 (Raadt 1901, 4, 406, illustrated in 3, Pl. CLXXII), but on this tomb for her sister-in-law by her first marriage, her earlier arms were apparently considered appropriate.

11. See Scott 1863, 64–65, and London, Victoria and Albert Museum, *Victorian Church Art*, London, 56, for an account of Scott's investigations.

12. Pradel 1954, 241.

13. The blazon is described in RCHM, 30, as *France with a label impaling England with a label*, a description that misled Noppen (1931, 117) to identify the figure as Joan, Princess of Wales. This error was corrected by Pradel (1954, 241).

14. Comparing the shields tricked by Charles and the identifications of figures by Camden and Stow with the shields in situ leaves one unresolved problem: the arms indicated by Charles for Thomas of Woodstock, *Quarterly France and England, a border Argent*, do not match the shield at N10. It should be borne in mind that Charles could not have seen the shield in question, which was concealed by the fifteenth-century encroachment.

15. As seen in *L'Armorial universal*, 50, no. 635. Philippa's daughter Joan was betrothed to him but died before the marriage took place.

16. *Rolls of Arms. Henry III*, 167, no. 5.

17. As seen in *L'Armorial universal*, 50, no. 635.

18. This shield was apparently misplaced during Scott's restoration of the tomb, as all earlier sources indicate a shield blazoned Bohemia (*Gules a lion Argent crowned Or*) in this place. In 1924, the Royal Commission Inventory (RCHM) recorded the arms of Hainault at this end of the tomb, and the four rampant lions do suggest the arms of Hainault. The shield must have originally been placed at the west end of the tomb under the figure representing Philippa's father (W5), or on the south side under the figure representing her brother (S2).

19. The last king of Navarre to use the escarbuncle alone appears to have been Henri I (d. 1274), as seen on his seal of 1271 (Douet d'Arcq 1863–68, 3, 463, no. 11379). Charles II, or the Bad, Philippa's cousin, normally used the arms of Navarre quartered with Evreux, as seen on a number of seals (Douet d'Arcq 1863–68, 3, 464, nos. 11387–89; Demay 1886, 2, 6, nos. 6666–67), and in *L'Armorial universal*, 56, no. 733. But since the English rolls ignored most of the later marshalings for the kings of Navarre (John A. Goodall, "Rolls of Arms of Kings: Some Recent Discoveries in the British Library," *The Antiquaries Journal*, 70, Part 1, 1990, 88, no. 76), it seems most likely that Charles II was intended here. The arms of Old Navarre appearing in English rolls after they were no longer used by the kings of Navarre include the Ashmolean Roll (ca. 1334), Grimaldi's Roll (ca. 1350), and Fenwick's Roll (fifteenth century).

The Program of the Tomb
of Henry Burghersh,
Bishop of Lincoln (d. 1340)

WITH JOHN A. GOODALL, FSA, FRNS

THE NORTH SIDE of the tomb chest is decorated with an arcade that houses five pairs of clerks seated at lecterns as if engaged in chanting the prayers established by the Burghershes. Above them in the spandrels of the arches are shields that have been repainted, but which can be read in general by the charges carved in relief. One of these corresponds to the arms borne by a person mentioned in the chantry established by the bishop in 1332 (1a, Edward III); five others correspond to those mentioned in the amplification of the chantry by his brother in 1345 (1b, Edward, Prince of Wales; 2a, 2b, 3a, the rest of the royal children; 5b, Gilbert de Clare).

	Arms in Situ	Identification of Arms	Identification of Person Suggested by Arms and Relation to the Bishop
1a	*Qtrly.: 1, 4, semy of lis; 2, 3, 3 leopards*	England after 1340 (Old France qtring. England)[1]	Edward III, king of England (d. 1377), sovereign
1b	*Qtrly.: 1, 4, semy of lis; 2, 3, 3 leopards, a label of five*	England, with a label	Edward, Prince of Wales and Aquitaine, the Black Prince (b. 1330, d. 1376), first son of sovereign[2]
2a	*Qtrly.: 1, 4, semy of lis; 2, 3, 3 leopards, a label of five*[3]	England, with a label	Lionel of Antwerp, duke of Clarence (?) (b. 1338, d. 1368), third son of sovereign[4]
2b	*Qtrly.: 1, 4, semy of lis; 2, 3, 3 leopards, a label of five*[5]	England, with a label	John of Gaunt, duke of Lancaster (b. 1340, d. 1399), fourth son of sovereign[6]
3a	*Qtrly.: 1, 4, semy of lis; 2, 3, 3 leopards , a label of five*[7]	England, with a label	Edmund of Langley, duke of York (?) (b. 1341?, d. 1402), fifth son of sovereign

3b	*3 leopards, a label of five*	Lancaster[8]	Henry, earl of Lancaster (d. 1345), associate
4a	*A cross between 4 lions, tail forked*	Burghersh differenced[9]	Nicholas de Burghersh (?), relationship unknown
4b	*Qtrly.: 1, 4, a maunch; 2, 3, burely, an orle of martlets*	Hastings, earl of Pembroke[10]	Laurence Hastings, earl of Pembroke (d. 1348), associate[11]
5a	*A bend cotised between 6 lions*	Bohun, earl of Hereford[12]	Humphrey de Bohun, earl of Hereford and Essex, constable of England (k. 1322), associate[13]
5b	*3 chevrons*	Clare[14]	Gilbert de Clare, earl of Gloucester (k. 1314)[15]

Notes

1. BMS 182 (1340), etc; *Quarterly: 1 and 4 Azure semy of lis Or, 2 and 3 Gules 3 leopards Or* (PO 1).

2. The arms would have been used from circa 1330 or 1333, when he was created earl of Chester, until June 8, 1376, when he died; in PO 3, he has a label of three.

3. BM, fol. 98, indicates each file of the label was charged with a cross, but Gough (1786–96, 1, 96–97) indicated each file was charged with a canton, the difference employed by Lionel of Antwerp, which is more likely.

4. The second son, William of Hatfield, died in infancy, in 1337.

5. Both BM, fol. 98, and Gough (1786–96, 1, 96–97) indicated that the label was Ermine.

6. BMS 12691 (1363), etc.

7. BM, fol. 98, indicated a label of five counter-gobony; Gough's description of the label (1786–96, 1, 96–97), *"each file cheque Or charged with 3 roundells,"* suggests the three torteaux later employed by Edmund of Langley.

8. The label should have the fleurs-de-lis, a label of France, which appears on seals and in the rolls (BMS 12675, dated ca. 1345–51, AS 23). Fleurs-de-lis are probably intended by the little figures on the label in BM, fol. 98.

9. *Gules a cross Argent between 4 lions tail forked Or* (WJ 253, for Nicholas de Burghersh, who has not been identified). In the seventeenth century, John Withie, the herald painter, identified this as the coat for Bishop Henry himself (W. K. R. Bedford, *Blazon of Episcopacy*, 1897, 71), but the bishop's seal has only two lozenges of Badlesmere and Burghersh (BMS 1734, 5, n.d., and 1334; Birch read the lozenges as shields).

10. BMS 10537 (1345); *Quarterly: 1 and 4 Or a maunch Gules; 2 and 3 burely Argent and Azure, an orle of martlets Gules* (AN 19).

11. Laurence Hastings (1320–48) in 1328, married Agnes, daughter of Roger Mortimer, who died 1368.

12. BMS 7531 (1300) and 7537 (1337); *Azure a bend Argent cotised and between 6 lions Or* (AS 30, PO 7).

13. Humphrey de Bohun was killed at the Battle of Boroughbridge. He was one of the leaders of the Welsh Marcher arm of the rebellion against Edward II (CP, 2, 598).

14. *Rolls of Arms. Henry III*, 64, no. 29.

15. He is mentioned in the chantry ordinance of 1345, as the late Gilbert de Clare (Foster and Thompson 1922, 211).

The Program of the Tomb of Sir Robert Burghersh (d. 1306)

WITH JOHN A. GOODALL, FSA, FRNS

THE NORTH SIDE of the tomb chest is decorated with an arcade that houses five standing couples that are identified by shields in the spandrels between the arches. Although the shields have been repainted, and thus may not reflect the originals accurately, a reading of the charges only, carved in relief, suggests that the statuettes represent the surviving descendants of Sir Robert's brother-in-law, Bartholomew Badlesmere (k. 1322), and their husbands, or in one case, a son.[1] None of these persons are mentioned specifically in the chantry ordinances.

	Arms in Situ	Identity of Arms	Identity of Person and Relation to Sir Robert
1a	*On a bend cotised between 6 lions, 3 molets of 6 points*	Bohun, earl of Northampton[2]	William de Bohun, earl of Northampton (d. 1360), nephew by marriage[3]
1b	*Qtrly., in the first qtr., a molet, impal. a fess double cotised*	Vere impal. Badlesmere[4]	Maud Badlesmere (d. 1366), niece, m. before 1338 John de Vere, 7th earl of Oxford
2a	*On a chief a pale between 2 gyrons, an escutcheon, a border gobony [sic]*	Mortimer of Wigmore[5]	Roger de Mortimer, earl of March (d. 1360), great-nephew[6]
2b	*On a bend cotised between 6 lions, 3 molets of 6 points impal. a fess double cotised*	Bohun of Northampton impal. Badlesmere[7]	Elizabeth Badlesmere (d. 1356), niece, m. (1) Edmund de Mortimer, and, before 1338, (2) William de Bohun, earl of Northampton
3a	*Qtrly., in the first qtr., a molet*	Vere, earl of Oxford[8]	John de Vere, 7th earl of Oxford (d. 1360), nephew by marriage[9]
3b	*3 bougets impal. a fess double cotised*	Ros of Helmsley impal. Badlesmere[10]	Margery Badlesmere (d. 1363), niece, m., before 1338, Sir William Ros of Helmsley
4a	*A lion, tail forked*	Welles[11]	Sir John Welles (d. 1361), great-nephew by marriage[12]
4b	*3 bougets impal. a lion, tail forked [sic][13]*	Ros impal. Welles[14]	Maud Ros (d. 1388), great-niece, m. 1344–45 Sir John Welles

5a	*3 bougets*	Ros[15]	William Ros of Helmsley (d. 1343), nephew by marriage[16]
5b	*A saltire engrailed impal. a fesse double cotised*	Tybotot impal. Badlesmere[17]	Margaret Badlesmere (d. 1344–47), niece, m., before 1338, Sir John Tybotot

Notes

1. For the pertinent Badlesmere genealogy, see CP, 1, 372.

2. BMS 7558 (n.d. ca. 1337–52); *Azure on a bend Argent cotised and between 6 lions Or 3 molets Gules* (PO 8 omits the molets [*sic*], CKO 184).

3. William de Bohun married, before 1338, Elizabeth Badlesmere, Sir Robert's niece.

4. For Vere, see below, note 8. For Badlesmere, see Appendix IX, note 11.

5. *Rolls of Arms. Henry III,* 21, no. 32, as borne by Roger de Mortimer of Wigmore (d. 1282). The carving is a very odd interpretation of the arms.

6. Edmund de Mortimer was the first husband of Elizabeth Badlesmere, Sir Robert's niece; Roger de Mortimer was their son.

7. For Bohun of Northampton, see note 2 above; for Badlesmere, see Appendix IX, note 11.

8. BMS 14135 (1313, for Robert, earl of Oxford 1296–1331); *Quarterly Gules and Or, in 1 a molet Argent* (AS 32, PO 15, AN 21).

9. John de Vere married, before 1338, Maud Badlesmere, Sir Robert's niece.

10. For Ros, see below, note 15; for Badlesmere, see Appendix IX, note 11.

11. BMS 14335 (1301, for Adam de Welle(s); *Or a lion tail forked Sable* (AS 52, AN 204).

12. According to CP, 12, Part 2, 441, Sir John Welles married Maud, probably the daughter of William de Ros by Margery, sister and coheir of Giles Badlesmere, in 1344–45. The heraldry identifying the couple in this niche confirms this hypothesis.

13. The impalement appears to be reversed.

14. For Ros, see note 15 below; for Welles, see note 11 above.

15. *Gules 3 bougets Argent* (AS 36, PO 21, AN 97).

16. William Ros married, before 1338, Margery Badlesmere, Sir Robert's niece.

17. For Tybotot, see Appendix IX, note 16; for Badlesmere, see Appendix IX, note 11.

The Program of the Tomb of Sir Bartholomew Burghersh (d. 1355)

WITH JOHN A. GOODALL, FSA, FRNS

THE TOMB CHEST is set within a triple-arched canopy that is decorated along its upper edge with shields displaying the same arms that appear in Niches 1 through 3 of Bishop Henry's tomb chest, which refer to Edward III and his family. The chest itself is decorated with an arcade that housed six pairs of statuettes that have disappeared, but of which the bases can still be seen. They probably all represented lords, since the shields above them in the spandrels between the arches display no impaling. The heraldry is all intact, except for the shield at 3b on the chest. This shield was recorded, with the rest of the heraldry, by Dugdale in 1641 (London, Brit. Lib., Ms. Add. 71474). Unlike the other Burghersh tombs at Lincoln, the shields have not been repainted. Only one of the persons represented by the shields is mentioned specifically in the chantry ordinances (4b, Bartholomew or Giles Badlesmere, both mentioned in the ordinance of 1332).

	Arms in Situ	Identification of Arms	Identification of Person and Relation to Sir Bartholomew
1a	*A cross between 4 lions, tails forked*	Burghersh differenced[1]	Nicholas de Burghersh (?), relationship unknown
1b	*On a bend cotised between 6 lions, 3 molets of 6 points*	Bohun, earl of Northampton	William de Bohun, earl of Northampton (d. 1360), cousin by marriage[2]
2a	*Qtrly.: 1, 4, a maunch; 2, 3, burely, an orle of martlets*	Hastings, earl of Pembroke	Laurence Hastings, earl of Pembroke (d. 1348),[3] associate
2b	*A fess between 6 crosses crosslet*	Beauchamp, earl of Warwick[4]	Thomas Beauchamp, earl of Warwick (d. 1369), comrade in arms[5]
3a	*Barry, on a chief two pales betw. 2 gyrons, on an escutcheon a lion*	Mortimer of Wigmore	Roger Mortimer, earl of March (ex. 1330) (?), associate[6]
3b	Destroyed[7]	Vere[8]	John de Vere, 7th earl of Oxford (d. 1360), cousin by marriage

4a	*A chevron*	Stafford[9]	Ralph Stafford (d. 1372), comrade in arms[10]
4b	*A fess double cotised*	Badlesmere[11]	Bartholomew Badlesmere (ex. 1322), uncle, or his son Giles Badlesmere (d. 1338), cousin
5a	*Fretty*	Verdun[12]	Theobald de Verdun (d. 1316), father-in-law
5b	*3 bougets*	Ros[13]	William Ros of Helmsley (d. 1343) or his sons William (d. 1352) or Thomas (d. 1384), cousins
6a	*On a chevron, 3 estoiles*	Cobham of Sterborough[14]	Reginald Cobham (d. 1361), comrade in arms[15]
6	*A saltire engrailed*	Tybotot[16]	John Tybotot (d. 1367), cousin by marriage[17]

Notes

1. See Appendix VII, note 9.
2. See Appendix VIII, notes 2 and 3.
3. See Appendix VII, note 11.
4. BMS 7260 (1340, Thomas, earl of Warwirk); *Gules a fess between 6 crosses crosslet Or* (AS 29, PO 10, AN 4).
5. Thomas Beauchamp was joint commander, with the Black Prince, of Sir Bartholomew's division at Crécy.
6. *Barry Or and Azure, on a chief Azure 2 pales between 2 gyrons, on an escutcheon Argent a lion Purpure* (L 171 for Roger Mortimer), which was not his usual coat. The arms on the escutcheon could be those of Dene (N 835) and Fitzroger (A 164, etc.) As active members of Queen Isabella's party, the Burghershes were associated with Roger Mortimer in the events that led to the downfall and eventual murder of Edward II.
7. BM, fol. 98, indicated *Quartered, in the first quarter a molet.*
8. See Appendix VIII, note 8.

9. BMS 13641 (1331, Ralph Stafford, later earl of Stafford [1351–72]); *Or a chevron Gules* (PO 23, AN 7 as earl).
10. Ralph Stafford was in the Black Prince's division at Crécy with Sir Bartholomew. See DNB, 18, 865.
11. At the tournament at Dunstable in 1308, Sir Bartholomew Badlesmere bore *Argent a fess double cotised Gules* (as published by C. E. Long in CTG, 4, 1837, 66). In AS 70 and PO 341 this coat designates Giles Badlesmere.
12. *Or fretty Gules* (AN 1102).
13. For Ros, see Appendix VIII, note 15.
14. PRO P 1210 (1335); *Gules on a chevron Or 3 estoiles Sable* (PO 25, AN 38).
15. Reginald Cobham fought with Sir Bartholomew in the Black Prince's division at Crécy (Jean Froissart, *Chroniques*, ed. S. Luce, G. Raynaud, L. Mirot, and A. Mirot, Paris, 1869–1931, 3, 169).
16. *Argent a saltire engrailed Gules* (AS 72, PO 43, AN 67).
17. John Tybotot married Margaret Badlesmere before 1338.

The Program of the Tomb
of Richard Beauchamp,
Earl of Warwick (d. 1439)

THE SHIELDS identifying the figures are still in place, although some of the originals have been replaced by newer ones.[1] These have been studied and compared with the record and identifications proposed by the English antiquarians Dugdale,[2] Edmondson,[3] Carter,[4] Gough,[5] Stothard,[6] and more recently Chatwin.[7] The identifications of the figures given below follow those of Dugdale, the great antiquarian authority on this monument, to whom the later authors mentioned above are indebted. They follow his identifications exactly except for Gough and Carter, both of whom reversed the order of the identifications on the north side. Gough's illustrations of the shields are also not entirely accurate.

The blazons of all the families represented on the shields are given at the end of the appendix.

Arms in Situ	Identification of Figures and Relation to the Earl

THE WEST END

1. Qterly.: 1, Beauchamp, 2, Clare, 3, Old Warwick, 4, Despenser impal. qterly.: 1, 4, Montacute qtering. Monthermer;[8] 2, 3, Neville with a label of 3 pts. gobony Arg. and Az.	W1. Cecily Neville, duchess of Warwick (d. 1450), daughter-in-law
2. Qterly.: 1, Beauchamp, 2, Clare, 3, Old Warwick, 4, Despenser	W2. Henry Beauchamp, duke of Warwick (d. 1445), son (second marriage)

THE SOUTH SIDE

1. Qterly.: 1, 4, Montacute qtering. Monthermer; 2, 3, Neville with a label of 3 pts. gobony Arg. and Az.	S1. Richard Neville, earl of Salisbury (d. 1460), friend
2. Beaufort, duke of Somerset	S2. Edmund Beaufort, duke of Somerset (k. 1455), son-in-law

3. Qterly.: 1, Woodstock, 2 and 3, Bohun of Hereford, 4, Stafford
4. Qterly.: 1, Belisme, 2, Talbot, 3, Le Strange, 4, Furnivall
5. Neville with a label of 3 pts. gobony Arg. and Az.

S3. Humphrey Stafford, duke of Buckingham (d. 1460), friend
S4. John Talbot, earl of Shrewsbury (d. 1453), son-in-law[9]
S5. Richard Neville, earl of Warwick (k. 1471), son-in-law

THE NORTH SIDE

1. Qterly.: 1, 4, Montacute qtering. Monthermer; 2, 3, Neville with a label of 3 pts. gobony Arg. and Az.
2. Beaufort, D. of Somerset impal. Beauchamp qtering. Old Warwick
3. Qterly.: 1, Woodstock, 2 and 3, Bohun of Hereford, 4, Stafford impal. Neville
4. Qterly.: 1, Belisme, 2, Talbot, 3, Le Strange, 4, Furnivall impal. Beauchamp qtering. Old Warwick
5. Qterly.: 1, Beauchamp impal. Old Warwick, 2, Montacute impal. Monthermer, 3, Neville with a label of 3 pts. gobony Arg. and Az., 4, Clare impal. Despenser

N1. Alice Montacute, countess of Salisbury (d. 1462), friend's wife
N2. Eleanor Beauchamp, duchess of Somerset (d. 1467), daughter (first marriage)
N3. Anne Neville, duchess of Buckingham, friend's wife
N4. Margaret Beauchamp, countess of Shrewsbury (d. 1467), daughter (first marriage)
N5. Anne Beauchamp, countess of Warwick (d. 1492), daughter (second marriage)[10]

THE EAST END

1. Latimer qtering. Neville with a double annulet Sa.
2. Latimer qtering. Neville with a double annulet Sa. impal. Beauchamp qtering. Old Warwick

E1. George Neville, Lord Latimer (d. 1469), son-in-law
E2. Elizabeth Beauchamp, Lady Latimer (d. 1480), daughter (first marriage)

Blazons of Families Represented on the Shields

BEAUCHAMP: *Gules a fess between 6 crosses crosslet Or.*

BEAUFORT, DUKE OF SOMERSET: *Quarterly: 1, 4, Azure 3 lis Or; 2, 3, Gules 3 leopards Or, a border gobony Or and Azure.* The blues are blackened and the gold on the order appears silver on the shields in situ.

BELISME: *Azure a lion Or, a border of the same.*

BOHUN OF HEREFORD: *Azure a bend Argent cottized and between 6 lions Or.*[11]

CLARE: *Or 3 chevronels Gules.*

DESPENSER: *Quarterly: Argent and Gules fretty Or, a bend Sable overall.*[12]

FURNIVALL: *Argent a bend between 6 martlets Gules.*[13]

LATIMER: *Gules a cross fleurie Or.*

LE STRANGE: *Argent 2 lions passant in pale Gules.*

MONTACUTE: *Or, 3 lozenges conjoined in fess Gules.*

MONTHERMER: *Or an eagle displayed Vert.*

NEVILLE: *Gules a saltire Argent.*[14] The silver is worn away on the shields at E1 and E2; the saltire is therefore gold.

OLD WARWICK: *Checky Azure and Or, a chevron Ermine* (Beaumont, former earls of Warwick).[15]

STAFFORD: *Or a chevron Gules.*

TALBOT: *Gules a lion Or, a border engrailed of the last.* These are the bardic arms of Rhys, Prince of S. Wales.[16]

WOODSTOCK: *Quarterly: 1, 4, Azure 3 lis Or; 2, 3, Gules 3 leopards Or, a border of the last.*

Notes

1. See above, page 135.
2. Dugdale 1730, 1, 410.
3. Joseph Edmondson, *An Historical and Genealogical Account of the Noble Family of Greville . . . including the History and Succession of the several Earls of Warwick since the Norman Conquest,* London, 1766, 48–49.
4. John Carter, Drawings at the London Society of Antiquaries, 1785.
5. Richard Gough, *Description of the Beauchamp Chapel adjoining to the Church of St. Mary, at Warwick; and the Monuments of the Earls of Warwick, in the said church and elsewhere,* London, 1809, 13–16.
6. Stothard 1832, 94.
7. Chatwin 1924, 64.
8. The colors of Monthermer have disappeared here.
9. For other examples of this version of John, Lord Talbot's arms, see John A. Goodall, "A Fifteenth-century Anglo-French-Burgundian Heraldic Collection (ET)," *The Antiquaries Journal,* 70, 1990, Part 2, 432, no. 48.
10. This shield represents an eccentric marshaling of Anne Beauchamp's arms, quartering her paternal arms in the first and fourth quarters with those of her husband in the second and third. These are the quarters that she was represented wearing in the chapel windows, commissioned in 1447, but there they were marshaled differently. She wore a gown displaying Beauchamp quartering Old Warwick with a shield of pretense Despenser, a mantel with three quarters: Neville with a label, Monthermer, and Montacute (BM, fol. 34v, and Dugdale 1956, n.p.).
11. See Appendix VII, note 12.
12. *Rolls of Arms. Henry III,* 48.
13. *Rolls of Arms. Henry III,* 45.
14. *Rolls of Arms. Henry III,* 126.
15. CP, 12, pt. 2, 386, n. c.
16. CP, 12, 609, n. b.

The Program of the Tomb of
Louis de Mâle, Count of Flanders (d. 1384),
Marguerite de Brabant, Countess of
Flanders (d. 1380), and Marguerite de Flandre,
Countess of Flanders and Duchess
of Burgundy (d. 1405)

M ILLIN recorded the inscriptions identifying the small figures that decorated the tomb chest, as well as publishing the engraving reproduced as Figure 98.[1] He numbered the figures consecutively, beginning at the head of the chest and reading continuously from left to right. His numbers have been transposed into the medieval system, and his identifications brought up-to-date in terms of birth and death dates. The family relationship of each person represented is described in relation to Louis de Mâle and his wife, Marguerite de Brabant.

Millin's Numbers and Copy of Inscriptions	Identification of Figures and Relation to the Deceased

THE WEST END

Millin's Numbers and Copy of Inscriptions	Identification of Figures and Relation to the Deceased
1. JEAN duc de Lotriche de Brabant, de Limbourch, comte d'Aynau, de Holl. de Zeel., filz d'Antoine duc de Brabant	W1. Jean IV, duke of Brabant and Limburg, (b. 1403, d. 1427), great grandson
2. ANTHOINE, duc de Lottriche de Brabant et de Limbourch, fils desditz duc Phelippe de Bourg gne, et de Marguerite de Flandres	W2. Antoine, duke of Brabant and Limburg (b. 1384, d. 1415), grandson
3. JEHAN, duc de Bourg gne, fils de Phelippe, fils du roy de France, duc de Bourg gne, et de Marguerite de Flandres	W3. Jean sans Peur, duke of Burgundy (b. 1371, k. 1419), grandson
4. PHELIPPE duc de Bourg gne, de Lottriche de Brabant et de Limbourch, comte de Flandres d'Artois et de Bourg gne filz de Jehan duc de Bourg gne, etc.	W4. Philippe le Bon, duke of Burgundy (b. 1396, d. 1467), great grandson
5. CHARLES, comte de Charolois, filz de Phelippe, duc de Bourgogne et de Brabant, et d'Ysabel fille du roi de Portugal	W5. Charles, count of Charolais (b. 1433, k. 1477), great (2) grandson

THE SOUTH SIDE

6. MARGUERITE ducess de Guienne, fille de Jehan duc, de Bourgg^{ne}

S1. Marguerite, duchess of Guienne, countess of Gien (d. 1441), great granddaughter

7. MARIE ducesse de Cleves, fille de Jehan, duc de Bourgg^{ne}.

S2. Marie, duchess of Cleves and La Marck (d. 1463), great granddaughter

8. JEHAN, duc de Cleves, filz de Marie ducesse de Cleves

S3. Jean, duke of Cleves (b. 1419, d. 1481), great (2) grandson

9. ISABELLE, contesse de Ponteure, fille de Jean duc de Boourg^{gne}

S4. Isabelle, countess of Penthièvre (d. 1412), great granddaughter

10. KATHERINE, fiancée au roi de Cicile par procureur, fille de Jehan, duc de Bourgogne

S5. Catherine (b. ca. 1392, d. 1414), great granddaughter

11. ANNE, ducesse de Betford, fille de Jehan, duc de Bourgogne

S6. Anne, duchess of Bedford (b. 1404, d. 1432), great granddaughter

12. AGNÈS, ducesse de Bourbon, fille de Jehan, duc de Bourgogne

S7. Agnès, duchess of Bourbon and Auvergne (b. 1407, d. 1476), great granddaughter

THE NORTH SIDE

24. PHELIPPE duc de Lottriche de Brabant de Limbourg comte de Ligney et de Saint Pol fils d'Anthoine duc de Brabant il mourut sans enfans en 1430 a 25 ans

N1. Philippe, duke of Brabant and Limburg (b. 1404, d. 1430), great grandson

23. PHELIPPE conte de Nevers fils des dits Phelippe duc de Bourgogne et Marguerite de Flandres

N2. Philippe, count of Nevers and Rethel (b. 1389, d. 1415), grandson

22. CHARLES conte de Nevers fils de Phelippe conte de Nevers

N3. Charles, count of Nevers and Rethel (b. 1414, d. 1464), great grandson

21. JEHAN conte d'Estampes filz dudit Phelippe conte de Nevers

N4. Jean, count of Nevers and Rethel (b. 1415, d. 1491), great grandson

20. CATHERINE ducesse d'Ostriche fille de Phelippe duc de Bourgogne et de Marguerite de Flandre

N5. Catherine, duchess of Austria (b. 1378, d. 1425), granddaughter

19. MARGUERITE Ducesse de Baviere comtesse de Haynnau del dits Phelippe et Marguerite de Flandre

N6. Marguerite, countess of Hainault and Holland (b. 1374, d. 1441), granddaughter

18. JACQUEL, ducess de Touraine et depuis dalfine, fille de Marguerite ducesse de Baviere

N7. Jacqueline de Bavière, countess of Hainault, Holland, and Zeeland (b. 1401, d. 1436), great granddaughter

THE EAST END

13. PHELIPPE, conte de Genève, fils de la ducesse de Savoye

E1. Philippe de Savoie, count of Geneva (b. 1416, d. 1452), great grandson

14. royne de Cicile, fille de la ducesse de Savoie

E2. Marguerite de Savoie, queen of Sicily (b. 1420/ 21, d. 1479), great granddaughter

15. ducesse de Savoie, fille de Phelippe, duc de Bourgogne et de Marguerite de Flandres

E3. Marie, duchess of Savoy (b. 1386, d. 1422), granddaughter

16. LOYS, duc de Savoye, fils de la ducesse de Savoye

E4. Louis, duke of Savoy (b. 1413, d. 1465), great grandson

17. ducesse de Milan, fille de la ducesse de Savoie

E5. Marie de Savoie, duchess of Milan (b. 1411, d. 1458), great granddaughter

Notes

1. Millin 1790–99, 5, 61–69.

Notes

Introduction

1. *The Cartulary of the Monastery of St. Frideswide at Oxford*, ed. S. R. Wigram (Oxford, Historical Society, 31), Oxford, 1896, 8–10. "Dicent insuper dicti Sacerdotes . . . commendacionem . . . in dicta Capella, & . . . in eadem placebo & dirige pro animabus superius enumeratis specialiter, & pro omnibus alijs fidelium defunctorum, secundum vsum Sar', ad tumulum viz. dicte domine si & cum eam ibidem contigerit sepeliri, captatis ad hoc horis congruis atque certis, prout eis videbitur commodius faciendum, in vna semper oracione animam dicte domine in specie nominando." In the fourteenth century, Oxford was within the diocese of Lincoln. The priests who served the chantry were to be presented to the bishop of Lincoln by Lady Montacute, and after her death, by the prior and canons. See further, K. L. Wood-Legh, *Perpetual Chantries in Britain*, Cambridge, 1965, 139–40.

2. "ordinamus diem annuum . . . domini W. de M. A. . . . & alium eiusdem domine, cum migraverit ad Dominum . . . solemniter celebrari. Et vt nostri Can. ac Fratres ad huiusmodi officia reddantur promciores, pro quolibet die huiusmodi annuo, nomine vnius pietancie, xs. ipsi Can. in communi recipient. . . . In vita tamen prefate domine singulis annis, dum vixerit, celebrabunt ijdem Canonici in festo S. (Botulphi), pro statu salubri predicte domine, de B. Virgine ad summum altare solemniter unam Missam . . . "*Cartulary of St. Frideswide*, 12–13.

3. For the displacement of the tomb and the evidence for its original location, see John Blair, ed., *Saint Frideswide's Monastery at Oxford: Archaeological and Architectural Studies*, Gloucester and Wolfeboro Falls (N.H.), 1990, 251–52.

4. For the vicissitudes of the institution after the suppression of the priory at the behest of Cardinal Wolsey in 1524, see S. A. Warner, *Oxford Cathedral*, London, 1924, 221–43.

5. See Denise Jalabert, "Le tombeau gothique," *Revue de l'art*, 64, 1933, 145–66; 65, 1934, 11–30, for an essay on the sources of the elements of a Gothic tomb that is still valid for the most part in spite of considerable recent research. Erwin Panofsky's contention (in *Tomb Sculpture*, New York and London, 1964, 53) that medieval tomb chests are derived from the Late Antique *tumba* (a solid mound of earth raised above a grave), though usually correct conceptually by the fourteenth century, is inadequate visually. In fact, sometimes the chest still contains the body, as in Lady Montacute's case (Warner 1924, 56). Even when it does not, it usually looks like a sarcophagus. Earlier writers (Eugène Viollet-le-Duc, *Dictionnaire raisonné de l'architecture française du XIe au XVIe siècle*, Paris, 1858–68, 1967, repr., 9, 23–25; Jalabert 1933, 147–53) had related the form of the Gothic tomb chest directly to antique sarcophagi, and Panofsky himself recognized the visual relationship when he described the tombs of Louis de France from Royaumont and those of the landgraves of Hesse at Marburg as pseudomorphous (62).

6. See Matthew H. Bloxham, "Sepulchral Monuments in Oxford Cathedral," *Memoirs illustrative of the History and Antiquities of the County and City of Oxford* (Annual Meeting of the Royal Archaeological Institute of Great Britain and Ireland, 6, . . . 1850), London, 1854, 223; Warner 1924, 57–58; and E. G. W. Bill, "Lady Montacute and St. Frideswide's Priory," *Friends of Christ Church Cathedral Report*, 1960, 10. For a list of the Montacute children, see *Cartulary of St. Frideswide*, 9, and CP, 11, 385–88. The ends of the chest are decorated with devotional reliefs, the Virgin and Child with symbols of Matthew and John at the west, and a maiden saint with symbols of Luke and Mark at the east. Though virtually concealed from view now, this decoration suggests that the tomb was originally freestanding.

7. Lawrence Stone's statement that "the *weepers* are lords and ladies and prelates of the church who can be identified with the relatives and friends of Lady Elizabeth for whose souls she specifically ordered the two chantry priests to pray" is symptomatic of the general confusion over the function of the family members represented on the Montacute tomb (*Sculpture in Britain: The Middle Ages* [Pelican History of Art], Harmondsworth, 1955, 181).

8. The heads and hands of all figures have been destroyed, but some evidence of the gestures is furnished by the breakage. While the majority appear to have merely stood composed, one daughter (N2) joined her hands in prayer. The eighteenth-century drawing of the tomb in the collection of Horace Walpole (London, Brit. Mus., Ms. Add. 27349, fol. 10)

leaves much to be desired in accuracy in the representation of the family members. Richard Gough's engraving of the tomb (*Sepulchral Monuments in Great Britain*, 1786–96, 1, Pl. XXVIII) is obviously based on this drawing.

9. *Cartulary of St. Frideswide*, 9; CP, 9, 82–83.

10. See page 108 for a discussion of the date of the tomb. For the importance of motherhood in the Middle Ages and of maternal affection, see Claudia Opitz, "Contraintes et libertés (1250–1500)," in *Histoire des femmes en occident*, dir. Georges Duby and Michelle Perrot, 2. *Le Moyen Age*, Paris, 1991, 296–97, 299–300.

11. One of the first examples of masses founded for the restoration of the soul *(in remedium animae)* is in the foundation charter of the Monastery of Saint-Julien in Auxerre, dated 635, for King Dagobert and his noble house, past and future (cited in Cyrille Vogel, "Une mutation cultuelle inexpliquée: le passage de l'Eucharistie communautaire à la messe privée," *Revue des sciences religieuses*, 54, 1980, 242). For a discussion of the development of prayers for the living and the dead in the Carolingian liturgy, and numerous examples from the ninth and tenth centuries, see Arnold Angenendt, "Theologie und Liturgie der mittelalterliche Toten-Memoria," *Memoria*, 180–84, 189–90. See also Angenendt, "Missa specialis. Zugleich ein Beitrag zur Entstehung der Privatmessen," *Frühmittelalterliche Studien*, 17, 1983, esp. 169–75, 179–81, 189–215. For the eventual separation of the prayers for the living and the dead in the canon of the mass, see Joseph A. Jungmann, *The Mass of the Roman Rite: Its Origins and Development*, trans. Francis A. Brummer, replica of the 2d ed., Westminster (Md.), 1986, 2, 159–69, 237–47. For the important link between almsgiving and the celebration of mass in memory of the dead, see Joachim Wollasch, "Gemeinschaftsbewusstsein und soziale Leistung im Mittelalter," *Frühmittelalterliche Studien*, 9, 1975, 268–86.

12. Megan McLaughlin, *Consorting with Saints: Prayer for the Dead in Early Medieval France*, Ithaca and London, 1994, 166. On the question of the theological basis of prayers for the dead, and the early medieval laity's probable understanding of it, see 178–234, esp. 199.

13. Ibid., 138–53, for a discussion of the nature of exchanges between the laity and monastic houses in the gift economy of the early Middle Ages. For the complex nature of such transactions, and the family's involvement in them in eleventh- and twelfth-century France, see Stephen D. White, *Custom, Kinship, and Gifts to Saints: The "Laudatio Parentum" in Western France, 1050–1150*, Chapel Hill and London, 1988, esp. 25–39, 153–63.

14. For the successive official decrees regarding burial rights and a variety of practices, see the definitive article of Philipp Hofmeister, "Das Gotteshaus als Begräbnisstätte," *Archiv für Katholisches Kirchenrecht*, 3, 1931, 450–87, esp. 454–55, 460, 467–68, 470, regarding the burial of founders in the sanctuary. For more recent discussions, see Bernhard Kötting, "Die Tradition der Grabkirche," in *Memoria*, 69–78, and Christine Sauer, *Fundatio und Memoria. Stifter und Klostergründer im Bild. 1100 bis 1350*. (Veröffentlichungen des Max-Planck-Instituts für Geschichte, 109), Göttingen, 1993, 110–15, 154–60. For the nobility seeking burial in monastic churches in France by the late tenth century, see McLaughlin 1994, 125–32. On the relation of families to burial churches in England, see Susan Wood, *English Monasteries and their Patrons in the Thirteenth Century*, London, 1955, 3, 129–31, and Joel T. Rosenthal, *The Purchase of Paradise: Gift Giving and the Aristocracy, 1307–1485*, London and Toronto, 1972, Chaps. 4 and 5.

15. "Die räumliche Nähe und damit die dauernde Gegenwart der Verstorbenen verpflichtet die Lebenden. Sie bindet das Geschlecht zusammen." Karl Schmid, "Zur Problematik von Familie, Sippe und Geschlecht. Haus und Dynastie beim mittelalterlichen Adel . . . "*Zeitschrift für die Geschichte des Oberrheins*, 105, NF 66, 1957, 47; repr. in *Gebetsgedenken und adliges Selbstverständnis im Mittelalter*, Sigmaringen, 1983, 229. See further, Cinzio Violante, "Quelques caractéristiques des structures familiales en Lombardie, Emilie et Toscane au XIe et XIIe siècles," in *Famille et parenté dans l'Occident médiéval* (Actes du Colloque de Paris, 6–8 juin 1974), ed. Georges Duby and Jacques Le Goff (Collection de l'Ecole Française de Rome, 30), Rome, 1977, 93.

16. For an excellent short history of the relation between the French monarchy and Saint-Denis, see Gabrielle M. Spiegel, *The Chronicle Tradition at Saint-Denis: A Survey*, Brookline (Mass.) and Leyden, 1978, esp. 11–37. For the royal tombs, see Alain Erlande-Brandenburg, *Le Roi est mort* (Bibliothèque de la Société française d'archéologie, 7), Paris, 1975, 68–86, esp. 84–86, and Elizabeth A. R. Brown, "Burying and Unburying the Kings of France," in *Persons in Groups: Behavior as Identity Formation in Medieval and Renaissance Europe* (Papers of the 16th Annual Conference of the Center for Medieval and Early Renaissance Studies), Binghamton, 1985, 241–66.

17. Paul Binski, *Westminster Abbey and the Plantagenets: Kingship and the Representation of Power 1200–1400*, New Haven and London, 1995, 91–93, treats the evolutionary process whereby Westminster Abbey became the royal burial church. Barbara Harvey, *Westminster Abbey and Its estates in the*

Middle Ages, Oxford, 1977, 26–43, surveys the relationship between burial and liturgical commemoration and endowment at the abbey. Eva-Maria Wendebourg, *Westminster Abbey als Königliche Grablege zwischen 1250 und 1400,* Worms, 1986, focuses on the royal tombs.

18. See Wood 1955, Chap. 7, esp. 123–31, for the mutual support between monasteries and their founders' families, and a demonstration of how the monastery became a repository of family tradition; McLaughlin 1994, 158–77, for evidence of how the association of lay benefactors was manifested in the monastic communities of the early Middle Ages; and McLaughlin 1985, 349, for evidence of the continuation of this kind of bond even into the late Middle Ages.

19. See Oexle's major article, "Memoria und Memorialbild," in *Memoria,* 384–440, and Sauer 1993, 19–21, for a succinct summary of his work of the past twenty years on the liturgical memorial of the dead.

20. Otto Gerhard Oexle, "Die Gegenwart der Lebenden und der Toten. Gedanken über Memoria," in *Gedächnis, das Gemeinschaft stiftet,* ed. Karl Schmid, Munich and Zürich, 1985, 81.

21. Karl Schmid, "Das liturgische Gebetsgedenken in seiner historischen Relevanz am Beispiel der Verbruderbewegung des früheren Mittelalters," *Jahresversammlung des Kirchengeschichtlichen Vereins für des Erzbistum Freiburg,* 1979, 36; repr. in *Gebetsgedenken und adliges Selbstverständnis im Mittelalter,* Sigmaringen, 1983, 636, with reference to the eighth-century *Liber vitae* of Salzburg. See the article as a whole for an overview of liturgical *memoria* in the early Middle Ages.

22. As described in the proem of the *Liber vitae* from New Minster Abbey (London, Brit. Mus., Ms. Stowe 944) compiled in the early eleventh century, edited by Walter de Gray Birch, *Liber vitae: Register and Martyrology of New Minster and Hyde Abbey Winchester,* London and Winchester, 1892, and quoted by Edmund Bishop, *Liturgica Historica: Papers on the Liturgy and Religious Life of the Western Church,* Oxford, 1962, 352. For a discussion of the book's illustration in relation to liturgical commemoration, see Oexle, in *Memoria,* 391–94, with further bibliography.

23. McLaughlin 1994, 93, 96–97, 161–63, for solemn anniversaries celebrated for extraordinary benefactors in the twelfth century. See Erlande-Brandenburg 1975, 97–105, for foundations of royal anniversaries in France, beginning under the reign of the emperor, Charles the Bald. From the tenth century, more and more necrologies are preserved with the names of individuals entered on a calendar devised to record their anniversaries (Karl Schmid

and Joachim Wollasch, "Societas et Fraternitas. Begründung eines kommentierten Quellenwerkes zur Erforschung der Personen und Personengruppen des Mittelalters," *Frühmittelalterliche Studien,* 19, 1975, 10–11). See Sauer 1993, 149–52, for a discussion of twelfth-century anniversary celebrations for founders and benefactors, and Wood 1955, 131–33, for endowments of anniversaries in the thirteenth century in England.

The celebration of anniversaries may be a survival of an Early Christian practice. Both Wood-Legh 1965, 2, and Jacques Le Goff, *The Birth of Purgatory,* trans. Arthur Goldhammer, Chicago, 1984, 47, cite Tertullian (d. after 220) for evidence of the offering of oblations for the deceased on the anniversary of their deaths. Tertullian says that this was based on tradition (*De corona militis* 3.2–3).

24. Jean-Loup Lemaître, "Liber Capituli. Le Livre du chapître, des origines au XVIᵉ siècle. L'exemple français," in *Memoria,* 628–37. The Martyrology of Usuard, compiled for the Abbey of Saint-Germain-des-Prés in Paris after 858, is the first "chapter book" preserved (Paris, Bibl. Nat., Ms. lat. 13745). Its text establishes that by the mid-ninth century, kings and queens of France, bishops of Paris, and a certain number of counts of Paris were commemorated in the daily office of the monastic chapter. The necrology of the manuscript was last edited by Auguste Molinier, *Obituaires de la province de Sens et de Paris* (Recueil des Historiens de la France. Obituaires 1, Parts 1 and 2), Paris, 1902, 1, 240–44, 246–80. For a succinct summary of how the chapter book was used, see Sauer 1993, 51–52.

25. McLaughlin 1994, 69–75.

26. Jungmann 1986, 1, 129–32, 217–19; Cyrille Vogel, "La multiplication des messes solitaires au moyen age. Essai de statistique," *Revue des sciences religieuses,* 55, 1981, 206–13; and Jacques Chiffoleau, "Sur l'usage obsessionnel de la messe pour les morts à la fin du moyen âge," in *Faire croire: modalités de la diffusion et de la réception des messages religieux du XIIᵉ au XVᵉ siècle* (Collection de l'Ecole Française de Rome, 51), Rome, 1981, 235–56. For the church's ensuing struggle both with simony and with failed obligations, see G. G. Coulton, *Five Centuries of Religion,* Cambridge, 1929–50, 3, Chap. 5, and pp. 620–22.

27. Molly Megan McLaughlin, "Consorting with Saints: Prayer for the Dead in Early Medieval French Society," 2 vols., Stanford University, Ph.D. dissertation, 1985, 329–465.

28. Ibid., 287–309. See 386–401, for the various factors contributing to this development.

29. Ibid., 334–40, 370–77.

30. Ibid., 427–63. For the concept of Purgatory in the twelfth century and beyond, see Le Goff 1984,

130–333. For a review of the controversy aroused by his book, see McLaughlin 1994, 17–19.

31. *Cartulary of St. Frideswide,* 6–7, 15–16. See Wood-Legh 1965, 130–36, for the "substantial minority" of perpetual chantries served by religious in England.

32. On the development of the chantry, especially in England, see Wood-Legh 1965, 1–5. Her study is the basic work on English chantries, but see also Rosenthal 1972, Chap. 3. For a tenth-century antecedent to the French chantry or *chapellenie,* and its royal espousal in France beginning with Philip Augustus, see Erlande-Brandenburg 1975, 90, 100–101. For a good explanation of all that a perpetual chantry endowment usually entailed, see G. H. Cook, *Medieval Chantries and Chantry Chapels,* London, 1963, 12–13.

33. See Rosenthal 1972, 15–27, for statistics regarding the commendations in England.

34. Renate Kroos, "Grabbräuche-Grabbilder," in *Memoria,* 287, has remarked how seldom the evidence in the charters from her survey of German and English documents can be exactly matched with an existing monument, but she is able to relate many elements of funerary art, such as the representation of praying clergy, grave covers, candles, censers, and sprinklers, to coeval documentation concerning funerals and anniversary celebrations. See H. Wischermann, *Grabmal, Grabdenkmale und Memoria im Mittelalter* (Berichte und Forschungen zur Kunstgeschichte, 5), Freiburg in Breisgau, 1980, 10, 18, for evidence of prayer obligations and requests in tombstone inscriptions, and McLaughlin 1985, 382–83, for evidence of the tomb as the center of anniversary celebrations in the twelfth century.

35. These tombs are personalized versions of monuments for which the tomb chest was decorated with heraldic shields that usually identify the family of the deceased, but may also refer to family lineage or alliances. See Adelin De Valkeneer, "Iconographie des dalles à gisants de pierre en relief en Belgique: moyen âge roman et gothique," *Revue des archéologues et historiens d'art de Louvain,* 5, 1972, 50.

36. The charts that illustrate the text have been designed accordingly, so that the reader may follow the order of the programs by reading down, from head to foot. Figures are numbered according to the side of the tomb chest on which they appear (north, south, east, and west) and according to place on a given side. The head and the foot of the tomb chest were generally designed around the central figure on that side, but for the sake of uniformity, these figures are numbered consecutively from left to right. For the head sides, this results in a reversal of the numbers on the charts if read from left to right.

37. For the most recent and thoughtful typology of the formal and iconographic elements of the Gothic tomb, see Gerhardt Schmidt, "Typen und Bildmotive des Spätmittelalterlichen Monumentalgrabes," in *Skulptur und Grabmal des Spätmittelalters in Rom und Italien* (Publikationen des Historischen Instituts beim Osterreichischen Kulturinstitut in Rom, 1, 10), Vienna, 1990, 13–82, whose essay includes an extensive discussion of the previous literature.

38. In a work of this geographic scope, some onomastic inconsistencies are inevitable unless all names are rendered in one language, a standardization that seemed artificial in this case. Therefore, names of persons in francophone lands are in French, except when there are common English equivalents. Otherwise names are in English, except for persons, like Aymer de Valence and Robert d'Artois, who were known at the English court by their French names.

39. Although Pierre Pradel, "Les tombiers français en Angleterre au XIVᵉ siècle," *Mémoires de la Société nationale des antiquaires de France,* 9ᵉ sér., 3, 1954, 240, was mistaken in stating that the kinship tomb, with full heraldic apparatus, did not occur in France, his assumption that the representation of family members on tomb chests was much less frequent in France than in England is also suggested by my research. The French monuments are largely known from drawings, engravings, and descriptions. Since heraldry was used on many of them to identify family members, they were natural targets for the systematic destruction of all signs of feudalism decreed by the conventions of 1792 and 1793, although provision was made to save monuments of artistic and historic importance. For the destruction of monuments with heraldic decoration during the Reign of Terror, see F. Cadet de Gassicourt and B. du Roure de Paulin, "L'héraldique impérial français," *Heraldica,* 1, 1911, 11–15; Rémi Mathieu, *Le système héraldique français,* Paris, 1946, 143–46; and Michel Pastoureau, *Traité d'Héraldique,* Paris, 1979, 76–77.

40. See L. Génicot, *Les Généologies* (Typologie des sources du moyen âge, 15), Turnhout, 1975, 22.

41. Schmid 1957, 14–15, repr. in Schmid 1983, 196–97.

42. Georges Duby, *Hommes and structures du moyen âge,* Paris and The Hague, 1973, 266–67.

43. Otto Gerhard Oexle, "Welfische und staufische Hausüberlieferung in der Handschrift Fulda D11 aus Weingarten," in *Von der Klosterbibliothek zur Landesbibliothek. Beiträge zum 200-jährigen Bestehen der Hessischen Landesbibliothek Fulda,* ed. A. Brall (Bibliothek des Buchwesens, 6), Stuttgart, 1978, 224–29. For genealogical references on tombs, see his article in *Memoria,* 416–17.

44. Michel Bur, "Les Comtes de Champagne et la 'Normanitas': Sémiologie d'un tombeau," *Proceed-*

ings of the Battle Conference on Anglo-Norman Studies, 3, 1980, 22–32, and "L'image de la parenté chez les comtes de Champagne," *Annales,* 38, 1983, 1016–39. See also "Une célébration sélective de la parentèle. Le tombeau de Marie de Dreux à Saint-Yved de Braine (XIIIᵉ siècle)," *Comptes rendus de l'Académie d'Inscriptions,* 1991, 301–18.

45. See pages 40 and 210 n. 38 for clarification of the civil status of one of the sons of King Thibaud I of Navarre on the tomb of Marie de Bourbon, and page 176 for the record of the sisters of Marie de Saint-Pol on the tomb of Aymer de Valence.

46. Kroos, in *Memoria,* 300, has noted the similarity between the funeral and the anniversary rites, and the difficulty of distinguishing which is represented on some tombs.

47. Emile Mâle, *L'Art religieux de la fin du moyen âge en France. Etude sur l'iconographie du moyen age et sur ses sources d'inspiration,* Paris, 1908, 415–16.

48. Dijon, Musée des Beaux-Arts, *Les pleurants dans l'art du moyen âge en Europe,* by Pierre Quarré, Dijon, 1971, 18–19. Quarré also included in his discussion of the pleurant theme three other kinship tombs and did not realize that the majority of the tombs in England and Belgium cited in his repertoire are actually tombs of kinship.

49. Panofsky 1964, 62.

50. Henriette s'Jacob, *Idealism and Realism: A Study of Sepulchral Symbolism,* Leiden, 1954, 86–87.

51. L. Pillion, "Un tombeau français du 13ᵉ siècle et l'apologue de Barlaam sur la vie humaine," *Revue de l'art ancien et moderne,* 28, 1910, 324–25, in relation to the tomb at Joigny to be discussed in Chapter 1. In spite of her perception, Gerhardt Schmidt continued to characterize the figures on the tomb chest as mourners as recently as 1990 (26–28).

52. Guisepe Gerola, "Appunti di iconografia Angioina," *Atti del Reale Istituto Veneto di Scienze lettere ed Arti,* 91, 1931–32, 265

53. Paris, Galeries nationales du Grand Palais, *Les Fastes du Gothique: le siècle de Charles V,* dir. Françoise Baron, Paris, 1981, 51; hereafter cited as *Fastes du Gothique.*

54. Bur 1980, 22–32; 1983, 1016–39.

55. Bur 1991.

56. Philippe Plagnieux, "La fondation funéraire de Philippe de Morvilliers, premier président du parlement: art, politique et société à Paris sous la régence du duc de Bedford," *Bulletin monumental,* 151, 1993, 357–81. See Chapter 8 of this volume.

57. De Valkeneer 1972, 48–56.

58. Gough 1786–96, 2, ccxxxii*; W. Burges in George Gilbert Scott, *Gleanings from Westminster Abbey,* 2d ed., Oxford and London, 1863, 159; Ed-

ward S. Prior and Arthur Gardner, *An Account of Medieval Figure-Sculpture in England,* Cambridge, 1912, 377; Arthur Gardner, *English Medieval Sculpture,* 2d ed., Cambridge, 1951, 314.

59. Prior and Gardner 1912, 375–77, 446; F. H. Crossley, *English Church Monuments A. D. 1150–1550: An Introduction to the Study of Tombs and Effigies of the Mediaeval Period,* New York, 1921, 128; Stone 1955, 146; Peter Brieger, *English Art 1216–1307,* Oxford, 1957, 204. See also Paul Binski's works, "The Coronation of the Virgin on the Hastings Brass at Elsing, Norfolk," *Church Monuments,* 1, 1985, 1, and "The Stylistic Sequence of London Figure Brasses," in *The Earliest English Brasses: Patronage, Style, and Workshops 1270–1350,* ed. John Coales, London, 1987, 104, in which his discussion of the brass of Bishop Louis de Beaumont in Durham Cathedral compounds the notion of weepers with the lineage expressed by the figures and with French ceremonial tombs. Even Brian Kemp, *English Church Monuments,* London, 1980, whose summary of the English tombs is unusually careful in this respect, fails to distinguish between the tomb with family members, which appears to have been prevalent in England, and the ceremonial tombs of Lord Harrington (d. 1347) at Cartmel Priory (Cumbria) and of Thomas Fitzalan, earl of Arundel (d. 1415) and Beatrice of Portugal (d. 1439) at Arundel (Sussex), where canons say the last rites.

60. I first noted this in a short research report, "The Genealogical Tomb: Thirteenth to Fifteenth Century," *Center 3: Research Reports and Records of Activities, June 1982–May 1983,* Washington (D.C.), National Gallery of Art, Center for Advanced Study in the Visual Arts, 1983, 65–66.

61. Andrew Martindale, "Patrons and Minders: The Intrusion of the Secular into Sacred Spaces in the Late Middle Ages," in *The Church and the Arts* (Studies in Church History, 28), ed. Diana Wood, Oxford and Cambridge (Mass.), 1992, 143–78. Binski 1995, 80, 113–15, and 198, apparently follows Martindale in identifying the statuettes on the tomb chest of three of the monuments—for William de Valence, Aveline de Forz, and Edmund Crouchback, Earl of Lancaster—to be discussed below, as a "composed courtly entourage of relatives and allies," while emphasizing the dynastic emphasis of the tomb of Edward III.

62. For a discussion of the *chapelle ardente,* see Colette Beaune, "Mourir noblement à la fin du moyen âge," in *La Mort au moyen âge,* Colloque de l'Association des Historiens médiévistes français . . . Strasbourg, 1975. (Publications de la Société savante d'Alsace et des régions de l'est, Coll. "Recherches et Documents," 25), Strasbourg, 1977, 136, and Elizabeth A. R. Brown, "The Ceremonial of Royal Succession in Capetian France: The Funeral of Philip V,"

Speculum, 55, 1980, 280. For illustrations, see Millard Meiss, *French Painting in the Time of Jean de Berry: The Boucicaut Master*, London and New York, 1968, Figs. 135–36 and 145.

63. For the latter two developments, see Beaune 1977, 138–40.

64. See Max Prinet, "La décoration héraldique du tombeau de Philippe Pot," *Bulletin de la Société nationale des antiquaires de France*, 1929, 161–70; 1932, 168–71.

One
Genesis

1. For the fundamental study of this tomb and its political implications, see Bur 1980, 1983. Bur's suggestion that the tomb of Count Thibaud might have been inspired by the Salian monument in the choir of Speyer Cathedral is unconvincing (1980, 24). At Speyer, an essentially retrospective monument was erected over the burial of six members of the Salian House after the death and burial of the last Salian emperor, Henry V, in 1125. This monument, on which inscriptions indicated the family relationship of the six individuals as well as their death dates, was phenomenally and typologically different from the tomb of Count Thibaud, a monument for a single person decorated with a series of family members, although the religious incentive for the monuments must have been essentially the same. For the record of the Salian monument, see Hans-Erich Kubach and Walter Haas, *Der Dom zu Speyer* (Die Kunstdenkmäler von Rheinland-Pfalz, 5), Munich, 1972, 1, 777–78, 892–94, 901–3, and Fig. 1390; for its liturgical and social function, see Karl Schmid, "Die Sorge der Salier um ihre Memoria: Zeugnisse, Erwägungen und Fragen," in *Memoria*, 672–706.

On the other hand, in his Scottish chronicle, Iohannes de Fordun mentions the tomb of a daughter, Maria, of Malcolm III at Bermondsey Abbey, with images of kings and queens displaying her lineage (Otto Lehmann-Brockhaus, *Lateinische Schriftquellen zur Kunst in England, Wales und Schottland vom Jahre 901 bis zum Jahre 1307* [Veröffentlichungen des Zentralinstituts für Kunstgeschichte in München, 1], Munich, 1955–60, 1, 82, no. 304; cited by Kroos, in *Memoria*, 353). The lady died in 1115, but it is impossible to know whether this was a very early example of a kinship tomb or a retrospective monument erected long after her death.

2. I owe my first acquaintance with the elaborate foundation of Henry the Liberal to Walter Cahn, who presented a paper, "Troyes as an Artistic Capital in the Twelfth Century," at the symposium, *The Civi-

lization of Champagne and Burgundy*, held at Tufts University in October 1984. Professor Cahn subsequently allowed me to review his work by making a copy of his paper available. For a brief account of the palace, see, most recently, Jean Mesqui, Marcel Bellot, and Pierre Garrigou-Grandchamp, "Le Palais des Comtes de Champagne à Provins (XIIᵉ–XIIIᵉ siècles)," *Bulletin monumental*, 151, 1993, 351–53; and for the two tombs in the context of medieval French enamels, with further bibliography, see Paris, Musée du Louvre, and New York, The Metropolitan Museum of Art, *Enamels of Limoges, 1100–1350*, New York, 1996, 443; hereafter cited as *Enamels of Limoges.*

3. Bur 1983, 1018.

4. Both tombs were destroyed in 1793, after having been moved from Saint-Etienne to the Cathedral of Troyes. The description of the tomb of Henry the Liberal is reproduced by l'Abbé Coffinet, "Trésor de Saint-Etienne de Troyes," *Annales archéologiques*, 20, 1860, 91–97, and Henri d'Arbois de Jubainville, *Histoire des ducs et des comtes de Champagne*, Paris, 1859–66, 3, 311–17. The first engraving was published by A.-F. Arnaud in 1837 (*Voyage archéologique et pittoresque dans le département de l'Aube et dans l'ancien diocèse de Troyes*, Troyes, 1837, 2, Pl. 14). Arnaud's engraving was reworked for the *Annales archéologiques* by Léon Gaucherel and published by Coffinet in 1860 (Coffinet 1860, opposite p. 80). The Gaucherel engraving has also been reproduced by R. de Lasteyrie, *L'Architecture religieuse en France à l'Epoque gothique*, Paris, 1926–27, 2, Fig. 1164, and Kurt Bauch, *Das mittelalterliche Grabbild*, Berlin and New York, 1976, Fig. 35. Bauch's skepticism regarding its accuracy is probably unjustified except in regard to decorative details, which were made much more graphic in Gaucherel's rendition. The account of the sources of the engraving by Coffinet 1860, 86, n. 3, suggests that the basic form and detail of the tomb depicted in the drawing were respected by the engraver, and its architectural design is confirmed by Canon Hugot's description.

5. For the Requiem Prayer and its sources, see Damien Sicard, *La Liturgie de la mort dans l'église latine des origines à la réforme carolingienne* (Liturgiewissenschaftliche Quellen und Forschungen, 63), Münster, 1978, 72–74, 76–78. On the recumbent suppliant as characteristic of French effigies from the early thirteenth century until the end of the Middle Ages and beyond, see Schmidt 1990, 62–65.

6. "Le dedans du cadre (frame of the chest cover) se trouve divisé en cinq portions par une manière de croix ... au milieu de laquelle est une grande rose qui porte un petit cadre d'argent, sur lequel est en émail la figure du prophète Isaïe et sa prophétie représentée

par un arbre qui pousse une fleur, sur laquelle est le Saint-Esprit, pour indiquer qu'il prédit la venue de Notre-Seigneur, dont on voit le portrait au bas de la croix, sortant d'un nuage, ayant un livre scellé à la main, . . . et comme donnant sa bénédiction entre le soleil, la lune et les étoiles. . . .

. . . Au-dessus de la figure de Notre-Seigneur sont deux anges, l'un à droite, l'autre à gauche . . . Au-dessus des anges . . . on voit la figure du comte Henri . . . tenant en ses mains la représentation d'une église . . . qu'il paraît offrir à St. Estienne, qui est auprès" (Coffinet 1860, 90).

My brief translation of Canon Hugot's description of the chest cover does not differ significantly from that of Walter Cahn in the paper cited in note 2. See Alfred Weckwerth, "Der Ursprung des Bildepitaphs," *Zeitschrift für Kunstgeschichte*, 1957, 166, for many examples of founders' tombs in the empire in which a church model or an inscription refers to the foundation.

7. Coffinet 1860, 89.

8. Mars was originally a chthonian deity, hence a god of death and hence of war (*Oxford Classical Dictionary*, 651). Henry the Liberal died on March 16, 1181, or 1180 according to the Julian calendar reflected in the epitaph (Arbois de Jubainville 1859–67, 3, 111).

9. Coffinet 1860, 89.

10. The count returned from the Holy Land in February 1181, the year of his death (Arbois de Jubainville 1859–67, 3, 109).

11. As discussed by Arbois de Jubainville (1859–67, 3, 311), the tomb was violated in 1583, and subsequently restored, probably resulting in some losses. He added six lines culled from other sources to Canon Hugot's record of the tomb inscriptions (318), including two lines that unequivocally give Marie credit for the erection of the tomb: "Principis egregios actus Maria revelat, / Dum sponsi cineres tali velamine velat" (Camuzat, *Promptuarium*, fol. 330).

12. Coffinet 1860, 87.

13. For Count Henry's Champagne, see John Benton, "The Court of Champagne under Henry the Liberal and Countess Marie," Princeton, Ph.D. dissertation, 1959, and "The Court of Champagne as a literary center," *Speculum*, 36, 1961, 551–91. See also Arbois de Jubainville 1859–67, vol. 3.

14. Karl Schmid, "Der Stifter und sein Gedenken: Die Vita Bennonis als Memorialzeugnis," in *Tradition als Historische Kraft*, ed. Norbert Kamp and Joachim Wollasch, Berlin, 1982, 297–322, esp. 312–13; Sauer 1993, 116–29, 327–34.

15. For Henry of Champagne's election and subsequent fate, see S. Runciman, *A History of the Crusades*, Cambridge, 1951–54, 3, 65–93.

16. On the contest between Blanche de Navarre and Philippa and Erard de Brienne, see Arbois de Jubainville 1859–67, 4, Part 1, 101–88.

17. Coffinet 1860, 91–97; Arbois de Jubainville 1859–67, 4, Part 1, 90–98.

18. In reversing the order of the inscriptions as published by Coffinet 1860, 91–92, 94–95, I am following Bur 1983, 1019, because the inscription giving the date of death is normally placed on the border framing the effigy. Moreover, this inscription refers to the effigy and would seem to have logically been placed in proximity to it.

19. Coffinet 1860, 91–92.

20. The text of the inscription suggests that the attribute held by the count referred to his vow to go on crusade. Canon Hugot described the attribute as a pilgrim's staff ("tient à la main un bâton de pèlerin pour marque du voeu . . . d'aller en la Terre-Sainte"), apparently held in both hands, for he also says that his hands were joined ("a les mains jointes") (Coffinet 1860, 96).

21. Count Thibaud died in the second year of the new century, on May 24, 1201. See Arbois de Jubainville 1859–67, 4, Part 1, 91, for a discussion of the inscription in relation to the date of death.

22. See above, note 20.

23. Coffinet 1860, 94–95.

24. The counts of Champagne had held first rank in the palace of the kings of France since the eleventh century (Michel Bur, *La formation du comté de Champagne, v. 950–v. 1150* [Mémoires des Annales de l'Est, 54], Nancy, 1977, 200, 230).

25. Coffinet (1860) transcribed "flores et," while Arbois de Jubainville's transcription (1859–67, 4, Part 1, 96), corrected from other manuscripts, gives "florentis," which makes more sense.

26. Coffinet 1860, 95.

27. According to Arbois de Jubainville (1859–67, 4, Part 1, 86), rather than ransoming the Jews in order to provide for needy Christians, Thibaud raised considerable sums for his crusade by these questionable means.

28. Coffinet 1860, 93.

29. Ibid., 91.

30. Ibid., 94.

31. Bur 1983, 1024–25.

32. See Bur 1983, 1031, citing the bishop of Laon, Adalbéron, in the eleventh century, "What did it mean to be noble, if not to be of the blood of kings?"

33. Bur 1980, 24–25. Although Bur assigned the king of France the place of honor at the head of the tomb in 1980, he corrected this error in 1983, recognizing that this honor, if so construed, would have fallen to the king of England.

34. In *The Cultural Patronage of Medieval*

Women, ed. June Hall McCash, Athens (Ga.) and London, 1996, 42–43, n. 73.

35. Jean-Charles Courtalon-Delaistre, *Topographie historique de la ville et du diocèse de Troyes*, Troyes, 1783–84, 2, 139–40; cited by Arbois de Jubainville 1859–67, 3, 319–20, and Bur 1983, 1017.

36. Schmidt 1990, 25, 42, 52; Sauer 1993, 184–94, 330. See also Binski 1995, 103–4, for the design of the tomb of Henry III in Westminster for potential veneration.

37. Bauch 1976, 35, compared the tomb with the thirteenth-century shrine of St. Stephen, the founder of the Cistercian monastery at Aubazine.

38. On the equivalence of images and relics in the early church, see Hans Belting, *Likeness and Presence: A History of the Image before the Era of Art*, trans. Edmund Jephcott, Chicago and London, 1994, 59–60; for the reliquary, especially the Western figural reliquary, as proof of the physical presence of the saint, and thus the focus of the cult, see 299, 301–2.

39. A particularly striking parallel is furnished by the eleventh-century portable altar of Countess Gertrude of Brunswick in Cleveland from the Guelf Treasure. See Patrick M. de Winter, *The Sacral Treasure of the Guelphs* (Special issue of the *Bulletin of the Cleveland Museum of Art*), 1985, 36–41, Pls. V–IX and Figs. 38–39, for this and examples of similar portable altars; Patrick Corbet, "L'autel portatif de la comtesse Gertrude de Brunswick (vers 1040): Tradition royale de Bourgogne et conscience aristocratique dans l'Empire des Saliens," *Cahiers de civilisation médiévale*, 34, 1991, 97–120, for a cogent analysis of the iconography of the altar of Countess Gertrude, which demonstrates that she ingenuously inserted dynastic saints into the context of the veneration of the cross on one side of the altar, thus furnishing an example of the political piety from which the earliest tombs of kinship no doubt emerged.

40. The date of the Trier reliquary can be no earlier than the abbacy of James of Lorraine (1212–56), who appears on the back (Stuttgart, Würtembergisches Landesmuseum, *Die Zeit der Staufer. Geschichte—Kunst—Kultur. Katalog der Ausstellung*, Stuttgart, 1977, 1, 432–34, n. 566). While the date 1230–35 is suggested by the entry in the Stuttgart catalogue, the reliquary is usually dated circa 1220 (Sauer 1993, 301).

41. For a full discussion of the reliquary, and a closely related one from Mettlach, see Sauer 1993, 301–11.

42. Bur 1983, 1019, dates the tomb between 1208 and 1215, on the basis of Thibaud IV's being described as a boy in the epitaph and the wish expressed in the inscription above the children that a "springtime of peace" might continue in Champagne. In 1215, Erard de Brienne returned to Champagne with Philippa to pursue her claim with force. Strife between them and Blanche continued until 1221, when Philippa and Erard renounced their pretension to the county (Arbois de Jubainville 1859–67, 4, Part 1, 187).

43. For a succinct review of Count Guillaume's life, see Edouard de Saint-Phalle, "La première dynastie des comtes de Joigny (1055–1338)," in *Autour du Comté de Joigny XIᵉ–XVIIIᵉ siècles* (Actes du colloque de Joigny 9–10 juin 1990), Joigny, 1991, 66–67.

44. Jean-Luc Dauphin, *Notre-Dame de Dilo: Une Abbaye au coeur du pays d'Othe*, Villeneuve-sur-Yonne, 1992, 4–5.

45. Ibid., 5–6.

46. *Cartulaire général de l'Yonne*, ed. Maximilien Quantin, Auxerre, 1854–60, 2, 168–69; Dauphin 1992, 9.

47. *Cart. gén. de l'Yonne*, 1854–60, 2, 236.

48. "canonici Deiloci concesserunt mihi, pro hac re fraternitatem suam y omni tempore missam [i]n ecclesia celebrandam pro me et pro meis. . . . (Bibl. mun. de Joigny, Ms. 1815, no. 6; *Cart. gén. de l'Yonne*, 1854–60, 2, 303).

49. Ibid. Quantin (as in note 46) read "*Aalatt*" as "*Aalaet*," while it is "*Aalitz*" in the transcription of the document in the *Gallia Christiana*, 12, 56. According to W. M. Newman, *Les Seigneurs de Nesle en Picardie: XIIᵉ–XIIIᵉ siècle*, Paris, 1971, 335–36, n. 3, the lady was Adèle de Courtenay, who was separated from Guillaume because of their too close kinship and who had married Adémar I, count of Angoulême, by 1191.

50. "Concessi etiam eis corpus meum in ecclesia deiloci sepeliendum" (Bibl. mun. de Joigny, Ms. 1815, no. 6; *Cart. gén. de l'Yonne*, 1854–60, 2, 303).

51. "quod laudante Matre mea Adelide, concessi Deo, et Ecclesiae deiloci, in elemosinam, clausum meum de joviniaco, ad illuminandam unam Lampadam perpetuo, ante majus Altare, consecratum in honore beatae Virginis; et ad faciendam [*sic*] anniversarium meum, et meorum singulis annis; quod videlicet clausum Mater mea tenebit, quoad vixerit, et voluerit; et post ejus decessum, ad praefatam Ecclesiam revertetur" (A. D. Yonne, H 598).

52. The charter of 1195, in which the countess ceded the vineyard to the abbey is preserved in two eighteenth-century copies, where she is only indicated as "A . . . Comittisa joviniaci" (A. D. Yonne, H 598). This led one of the copyists to suggest that the gift was from "Alix," Guillaume's first wife, but they were separated before 1191, and Guillaume's second wife was named Béatrix (Newman [as in note 49], 334, 336). This is the last document in which Adélais is mentioned. Dauphin's statement (1992, 9) that she died in 1187, at the convent at Fossemore, a protectorate of Dilo, is based on a seventeenth-century chronicle published by C. Demay, "Une Chronique inédite des comtes de Joigny par Philippe Delon," *Bulletin de*

la Société des Sciences historiques and naturelles de l'Yonne, 34, 1880, 213, which says that Adélais died in 1187, and Dauphin's confusion of the countess with Elisabeth de Rigny-le-Ferron (helisabeth de Regniaco) who, in a charter of 1186 (A. D. Yonne, H 631), ceded her rights in the forest of Rigny to Dilo in order to enter the convent at Fossemore. The seventeenth-century chronicle published by Demay is the only source I know that indicates where the countess was buried.

53. Victor Petit, "Notes pour servir à la description de quelques églises du département de l'Yonne," *Bulletin monumental,* 1847, 261–68. The lithograph reproduced as Figure 6 was first published by Petit, and later by Arcis de Caumont, *Abécédaire ou Rudiment d'Archéologie,* Paris, Caen, and Rouen, 1850, 279. Another, more polished, lithograph of the tomb in situ and two elevations of the church at Dilo were recently published by Dauphin (1992, 10, 12, 14).

54. Marcel Aubert, *La Bourgogne: La Sculpture,* Paris, 1930, 3, Pls. 108–9 (after plaster casts at the Trocadero), and *La sculpture française au moyen-age,* 1946, 297–98; Willibald Sauerländer, *Gotische Skulptur in Frankreich 1140–1270,* Munich, 1970, 185–86; Bauch 1976, 99; Schmidt 1990, 26.

55. The foot of the chest has been restored and any decoration that it might have had has been lost. Petit's print shows this area already damaged, suggesting that this side was lost before the tomb was transferred.

56. Pillion 1910, 324. Saint-Phalle 1991, 64–66, for the family record.

57. Both the falcon and the lure, a bird's leg, are damaged but can be read. The fragment of a claw remains below the wrist of the lord's right arm and the claws, tail feather, and one wing of the hawk, which was held on a cord, remain above his left hand. For the use of a bird's leg in taming the falcon, see Frederick II of Hohenstaufen, *The Art of Falconry being the De Arte Venandi cum avibus of Frederick II of Hohenstaufen,* trans. C. A. Wood and F. Marjorie Fyle, Stanford (Calif.) and Oxford, 1943, 174.

58. Pillion 1910, 325–28. For a brief summary of the Byzantine manuscripts, see *The Oxford Dictionary of Byzantium,* New York and Oxford, 1993, 1, 256–57; for the Latin and vernacular translations, see Jean Sonet, *Le Roman de Barlaam et Josaphat.* I. *Recherches sur la tradition inscrite latine et française,* Namur and Paris, 1949, 63–65, 71–190; Wolfgang Stammler, *Wort und Bild: Studien zu den Wechselbeziehungen zwischen Schrifttum und Bildkunst im Mittelalter,* Berlin, 1962, 94–96; and Salvatore Calomino, *From Verse to Prose: The Barlaam and Josaphat Legend in Fifteenth-Century Germany* (Scripta Humanistica, 63), Potomac (Md.), 1990, 4–6.

59. Sonet 1949, 63–65; Calomino 1990, 5.

60. Stammler 1962, 94, cites the epic poem written circa 1220, by Rudolf von Ems at the bidding of the Cistercian convent of Kappel (Switzerland), which had a considerable dissemination.

61. Paris, Bibl. Nat., Ms. fr. 1038, fol. 128r–128v (fourteenth-century copy). For the Champagne recension of *Barlaam and Josaphat,* see Sonet 1949, 136–47. The prologue of the work warns the countess of the lies of rhymed fiction, for instance, *Cligès* and *Perceval,* and other *"romanz de vanité,"* as indicated by June Hall McCash, in *The Cultural Patronage of Medieval Women,* Athens (Ga.) and London, 1996, 24–25. The text of another manuscript in the Champagne group, Bibl. Apost. Vat., Ms. reg. lat. 660, was published by Leonard R. Mills (*L'histoire de Barlaam et Josaphat,* Geneva, 1973). I am grateful to Marie-Madeleine Stey for bringing it to my attention.

62. Pillion 1910, 332–33.

63. Paris, Bibl. Nat., Ms. nouv. acq. fr. 1330, "Mémoires pour l'histoire de la ville et comté de Joigny," par le sieur Davier, avocat, 1723, 103; Saint-Phalle 1991, 62.

64. "Canonici remiserunt monachis actionem quam contra eos pro predicti comitis corpore Intendebant. Et monachi remiserunt predictis canonicis. duos solidos et quatuor sextarios et Unam minem bladi quos eis debebant annuatim pro molendino Saneveriarum Ita quod non soluent canonici decetero monachis. nisi unum sextarium frumenti laudabilis . . . Et Canonici quitaverunt monachis decem solidos quos percipiebant annuatim in hala draperiorum Jovigniaci et quicquid habebant in hala predicta" (A. D. Yonne, H 595).

Pillion's source for this charter, Ambroise Challe ("Histoire de la ville et du comté de Joigny," *Bulletin de la Société des Sciences historiques et naturels de l'Yonne,* 3e sér., 36, 1882, 17–18), misread the document to the effect that the monks relinquished the body of the count in exchange for the reduction in a tax that they paid to the canons on the mill at Sanevières, whereas in fact the document says that the *canons* gave up their claim to the count's body in exchange for a significant reduction in the tax that *they* paid on the mill, and in return ceded to the monks the quitrent that they collected in the wool market at Joigny, plus whatever else they possessed in that market. For an accurate transcription of the entire document and the correct reading, see Maximilien Quantin, ed., *Recueil de Pièces pour faire suite au Cartulaire Général de l'Yonne: XIIIe siècle,* Auxerre, 1873, 133.

65. On retrospective tombs for important founders erected by monastic communities, see Willibald Sauerländer and Joachim Wollasch, "Stifter-gedenken und Stifterfiguren in Naumburg," in *Memoria,* 372–73. For various examples in the empire from the

twelfth to the fourteenth centuries, and further bibliography, see Sauer 1993, 89, 103–9, 129–46.

66. To my knowledge, only Andrea Teuscher has suggested that the tomb dates earlier than midcentury, in a master's thesis that I have not had the chance to read. See Andrea Teuscher, *Das Prämonstratenskloster Saint-Yved in Braine als Grablege der Grafen von Dreux: Zu Stifterverhalten und Grabmalgestaltung im Frankreich des 13. Jahrhunderts* (Bamburger studien zur Kunstgeschichte und Denkmalpflege, 7), Bamburg, 1990, 164–65.

67. Sauerländer 1970, 186.

68. Musée national du Moyen Age-Thermes de Cluny, Inv. C1. 18643 a. See A. Erlande-Brandenburg, *Les sculptures de Notre Dame de Paris au musée de Cluny*, Paris, 1982, no. 33.

69. See Dieter Kimpel and Robert Suckale, *Die gotische architektur in Frankreich 1130–1270*, Munich, 1985, 275, 515–16, for an early thirteenth-century date for the eastern end of the church and the relation to Paris. Analogous arches with somewhat more slender proportions are found in the triforium of the nave of Saint-Pierre at Chartres, dated roughly 1225–40, by P. Héliot and G. Jouven, "L'Eglise Saint-Pierre de Chartres et l'architecture du moyen âge," *Bulletin archéologique du comité des travaux historiques et scientifiques*, 6, 1970, 161.

70. For the cathedral dado, see Stephen Murray, "Looking for Robert de Luzarches: The Early work at Amiens Cathedral," *Gesta*, 29, 1990, 115–16; for the tomb of the bishop, see Sauerländer 1970, Fig. 88. Paul Williamson suggested a date as late as ca. 1240 for the tomb of Bishop Evrard, in *Gothic Sculpture 1140–1300* (Pelican History of Art), New Haven and London, 1995, 278, n.l.

71. Denise Jalabert, "La flore gothique, ses origines, son évolution du XII^e au XV^e siècle," *Bulletin monumental*, 91, 1932, 206–10; *La Flore sculptée des monuments du moyen âge en France*, Paris, 1965, 96–103.

72. See Willibald Sauerländer, "Die Kunstgeschichtliche Stellung der Westportale von Notre-Dame in Paris," *Marburger Jahrbuch für Kunstwissenschaft*, 17, 1959, 41 and 43, n. 110; and 1970, 137–38. Following Wolfgang Medding, *Die Westportale der Kathedrale von Amiens und ihre Meister*, Augsburg, 1930, 72–78, Sauerländer grouped the fragment in the Musée de Cluny with the Christ of the Last Judgment and the angel to his right in the tympanum and endorsed Viollet-le-Duc's conclusion that the style represented by the Last Judgment Christ was the most advanced seen on the portals of the west facade of Notre-Dame. This view is now generally accepted.

73. A. Erlande-Brandenburg, "Les remaniements du portail central à Notre-Dame de Paris," *Bulletin monumental*, 1971, 143–246, and "Nouvelles remarques sur le portail central de Notre-Dame de Paris," *Bulletin monumental*, 132, 1974, 287–94.

74. Jean Taralon, "Observations sur le portail central et sur la facade occidentale de Notre-Dame de Paris," *Bulletin monumental*, 149, 1991, 341–432, esp. 361–71.

75. Sauerländer 1970, Pl. 175.

76. Ibid., Pl. 185. Williamson (1995, 51–52) endorsed Sauerländer's chronology, and suggested that the sculptors at Saint-Germain-des-Prés and at the Sainte-Chapelle would have found their stylistic impetus at Notre-Dame.

77. The further implications of the association of the Joigny tomb with the Notre-Dame lodge will be addressed by the writer on a later occasion.

78. F. Cristophre Butkens's location of the tomb "au choeur . . . au costé droict entre deux pilliers" does not allow for a more precise location in the choir (*Trophées tant sacrés que prophanes du Duché de Brabant*, La Haye, 1724, 1, 237). But Alphonse Wauters gave evidence for its placement on the north side by citing the gift of two hundred pounds that the duke left for the celebration of mass at the altar of the Evangelists, before which his tomb was erected (*L'Ancienne Abbaye de Villers: Histoire de l'abbaye et description de ses ruines*, Brussels, 1868, 90). The altar of the Evangelists must have been in the chapel flanking the choir on the north. See J. T. Vos, *Notice historique et descriptive sur l'Abbaye de Villers*, Louvain, 1867, 91–98, for the duke's gifts to the monastery.

79. According to the chronicle, the monks left Clairvaux after the Easter octave of 1146, that is, April 7 (Edouard de Moreau, *L'Abbaye de Villers-en-Brabant aux XII^e et XIII^e siècles*, Brussels, 1909, 3–4; *Monasticon Belge*, 4, 2, *Province de Brabant*, Liège, 1968, 363). They were mentioned at Villers in a charter of October/November 1146, and Saint Bernard himself visited the new community in the winter of 1147, during his journey to the Low Countries and the Rhineland to preach the Second Crusade (Ibid., 363–65).

80. Moreau 1909, 17–26, 66–73.

81. Vos 1867, 53.

82. Moreau 1909, 35, 55, 66–73.

83. Ibid., 91–93.

84. For Acquensis (Aachen). I am grateful to Mme. C. Van den Bergen-Pantens, conservateur in the Bibliothèque royale in Brussels, for checking the manuscript cited in note 85, which is the earliest copy of the epitaph and the source for the later printed versions.

85. Antonius Sanderus, *Grand théâtre sacré du Brabant*, The Hague, 1734, 2, 14. The epitaph, recorded in Brussels, Bibl. roy., Ms. Goethals 1621, was also published by L. Galesloot, "Les tombeaux

d'Henri II et de Jean III, Ducs de Brabant, à l'abbaye de Villers," *Messager des Sciences historiques,* 1882, 25, no. 6, and other authors.

86. Daelhem Castle was taken by the duke in 1239, during his conflict with the archbishop of Cologne, and remained in his hands after peace was restored. The count of Jülich was the duke's ally, and although the archbishop devastated the province in 1239, he failed to take Jülich Castle. The bourgeoisie of Aachen supported the duke in his siege of Lechenich during the same conflict (DNB, 9, 128–30).

87. Georges Despy, "La fondation de l'abbaye de Villers (1146)," *Archives, Bibliothèques et Musées de Belgique,* 28, 1957, 5–15.

88. Ibid., 13.

89. Hofmeister 1931, 466; Marcel Aubert and La Marquise de Maillé, *L'Architecture cistercienne en France,* Paris, 1, 329–31.

90. *Institutiones Cap. gen.* 1240–56, cited by Aubert and Maillé, ibid.

91. Brussels, Bibl. roy., Ms. 7781, fol. 135.

92. Brussels, Bibl. roy., Ms. 22483, fol. 60v–61. The engraving of the tomb, first published by Butkens in 1641, is based on Riedwijck's drawing. See C. G. Dallemagne, "Le Manuscrit de l'écuyer Charles van Riedwijck," *Annales de la Société royale d'archéologie de Bruxelles: Mémoires, rapports et documents,* 46, 1942–43, 88.

93. Evidence of a restoration circa 1620 is furnished by the correspondence of the Archduke Albert and his herald, Adrien de Riebeke, published by Galesloot (1882, 17–20).

94. The important Gothic canopy sheltering the head of the effigy in the earlier drawing is substituted by a simple trefoil arch in Riedwijck's. The tomb chest arcade rests on slender Gothic columns in the earlier drawing. They have been substituted by thickened versions of obvious Baroque design on the long side of the chest in Riedwijck's drawing, and eliminated entirely at the head and the foot. In the earlier drawing, the arcade spandrels are filled with a relief simulating a crenellated city or castle wall on both the long and short sides, but in Riedwijck's drawing, this relief has disappeared on the short sides, along with the columns. A less radical change, but one that implies structural reinforcement, is suggested by the depictions of the corners of the tomb chest. A tessellated relief is shown in both drawings, but it is framed by a wide plain molding in Riedwijck's drawing, which suggests that these reliefs may have been reset.

95. According to Anselme de Saint-Marie, *Histoire généalogique et chronologique de la Maison Royale de France, des Pairs, Grands Officiers de la Couronne et de la Maison du Roy: et des anciens Barons du Royaume,* 3d ed., Paris, 1726–33, 2, 792, the effigy was in marble, which probably means touchstone

(carboniferous limestone). See Ann M. Roberts, "The Chronology and Political Significance of the Tomb of Mary of Burgundy," *The Art Bulletin,* 71, 1989, 381, n. 24.

96. The ducal herald Adrien de Riebeke apparently mistook one of the angels for the duke's second wife, Sophia of Thuringia, in a letter of 1620 requesting a restoration (Galesloot 1882, 17–18). Although a commemorative inscription on parchment hanging from a pier adjacent to the tomb in the seventeenth century stated that she was buried beside her husband in the monastery, Alphonse Wauters (as in note 78, p. 90) stated categorically that she was never represented on the tomb, which seems likely.

97. The child is more easily read in the earlier drawing than in Riedwijck's, but even there, the image is unclear. Since all Cistercian monasteries were dedicated to the Virgin (Louis J. Lekai, *The Cistercians: Ideals and Reality,* Kent [Oh.], 1977, 26), this seems the most probable identification.

98. Sicard 1978, 56–58, cited in McLaughlin 1994, 37. See Kroos 1984, 343–44, and Schmidt 1990, 29, for further examples of the representation of this theme on tombs.

99. For a transcription of the legend, see Dallemagne 1942–43, 76.

100. Ibid.

101. Duby 1973, 333–34.

102. Adolph Goldschmidt and Kurt Weitzmann, *Die Byzantinischen Elfenbeinskulpturen des X.–XIII. Jahrhunderts,* 2d ed., Berlin, 1979, 2, Pl. XIII.

103. Moreau 1909, 30.

104. The best-known monument in a monastic setting that can be associated with the evangelical promotion of the Crusades is the portal representing the Mission of the Apostles at Vezelay. As first discussed by Adolph Katzenellenbogen ("The Central Tympanum at Vézelay: Its Encyclopedic Meaning and its Relation to the First Crusade," *The Art Bulletin,* 26, 1944, 148–51), this began with the preaching of the First Crusade and manifested itself in the linkage by contemporaries between the capture of Jerusalem on July 15, 1099, and the dispersal of the apostles on the same day, with the crusaders even being called the sons of the apostles by Raymond d'Aguilers. A consciousness of their evangelical mission and a specific dialogue with the apostles is reflected intermittently in the account of the First Crusade by the anonymous author of the *Gesta Francorum* (ed. and trans. Rosalind Hill, London and New York, 1962, esp. 59–60, 66, 77). The specific association of the crusaders with the monastic profession was a post–First Crusade development, as discussed by Jonathan Riley-Smith, *The First Crusade and the Idea of Crusading,* London, 1986, 135–52.

105. For a historical treatment of the transmission

of the *vita apostolica* from the first apostolic community in Jerusalem to Western monasticism, see M.-H. Vicaire, O.P., *L'Imitation des apotres: Moines, chanoines, mendiants (IVᵉ–XIIIᵉ siècles)*, Paris, 1963, 9–37. For a brief but magisterial essay on the reforming ideal of the *vita apostolica* and its changing interpretations in the course of the twelfth century, see M. D. Chenu, *Nature, Man, and Society in the Twelfth Century*, trans. Jerome Taylor and Lester K. Little, Chicago and London, 1968. For the Cistercian interpretation of the apostolic life, see Lekai 1977, 7, 25–26.

106. Ibid., 52–62.

107. For Henry I's expedition to the Holy Land in 1197, see BNB, 9, 110; for his role while there, see Runciman 1955, 3, 91–98. For the future Henry II's activities in Friesland, see BNB, 9, 117.

108. For an example of a tomb decorated only with an effigy and a series of shields, see below, Figure 31.

Two
The Genealogical Tomb

1. Georgia Sommers Wright, "A Royal Tomb Program in the Reign of St. Louis," *The Art Bulletin*, 56, 1974, 238, based on her 1966 dissertation at Columbia University. See A. Erlande-Brandenburg, "Le tombeau de saint Louis," *Bulletin de la Société nationale des Antiquaires de France*, 1970, 223–24, and 1975, 82–83; and Wright 1974, Fig. 24, for the disposition of the royal tombs in the time of Saint Louis. For the disruption of the tombs at the Revolution, the removal of the royal effigies from Saint-Denis, and their subsequent peregrinations, see, most recently, Elizabeth A. R. Brown, *The Oxford Collection of the Drawings of Roger de Gaignières and the Royal Tombs of Saint-Denis* (Transactions of the American Philosophical Society, 78, Part 5), Philadelphia, 1988, esp. 7–52.

2. Caroline Astrid Bruzelius, *The 13th-Century Church at St-Denis*, New Haven and London, 1985, 11–12.

3. Elizabeth A. R. Brown, "Burying and Unburying the Kings of France," *Persons in Groups: Behavior as Identity Formation in Medieval and Renaissance Europe* (Papers of the 16th Annual Conference of the Center for Medieval and Early Renaissance Studies), Binghamton, 1985, 244–46. With the marriage of Louis IX's grandfather, Philip Augustus, the seventh Capetian, to the Carolingian princess, Isabelle de Hainaut, and the ascension of their son Louis VIII to the throne, the Carolingians could be said to have reentered the royal line.

4. See Anne D. Hedeman, *The Royal Image: Illustrations of the Grandes Chroniques de France,* *1274–1422*, Berkeley, Los Angeles, and Oxford, 1991, 30–35, for parallels in the subsequent illumination of the *Grandes Chroniques de France.*

5. J. Cuvelier, *La formation de la ville de Louvain des origines à la fin du XIVᵉ siécle* (Mémoires de l'Académie Royale, Classe des lettres et des sciences morales et politiques, 2ᵉ sér., 10, 1934–35), Brussels, 1935, 150, 157–59, 178.

6. Antonius Sanderus, *Grand théâtre sacré du Brabant*, 4 vols., The Hague, 1734, 1, 113. Sanderus's version of the epitaph corresponds to that in Butkens 1724, 1, 269, except for a few details.

7. Sanderus 1734, 1, 113.

8. Adelin De Valkeneer, "Inventaire des tombeaux et dalles à gisants en relief en Belgique: Epoques romane et gothique," *Bulletin de la Commission Royale des Monuments et des Sites*, 14, 1963, 180.

9. Ibid., 178–86, for a careful report on the actual state of the monument and further bibliography; Brussels, Bibl. roy., Ms. 22483, fol. 65, for the watercolor.

10. The head was probably placed against one of the piers that separated the choir from the ducal chapel to the north. De Valkeneer (1963, 180) says the tomb was on the south side of the choir, but Butkens 1724, 1, 267, who saw it in place, located it on the side between the choir and the ducal chapel to the north, as did P. F. X. de Ram, *Recherches sur les sépultures des ducs de Brabant à Louvain*, Brussels, 1845, 22. De Valkeneer (1963, 184) mistook the Man of Sorrows for Abraham.

11. See Antoine de Succa, *Les Mémoriaux d'Antoine de Succa*, ed. Micheline Comblen-Sonkes and Christiane Van den Bergen-Pantens (Les Primitifs Flamands. III. Contributions à l'étude des Primitifs flamands, 7), 2 vols, Brussels, Bibliothèque royale Albert Ier, 1977, 1, 208; 2, fol. 68v, a critical edition of Succa's manuscript (Brussels, Bibl. roy., Ms. II 1862), and Appendix I of this book. Succa does not say where this epitaph was found, but it is unusually long and differs in content from the one transcribed by Sanderus, which he says was on the tomb, and which gives the information regarding the identity of the deceased, their titles and dates of death, that is normal for epitaphs at the time. Succa's epitaph was certainly written after the duchess's death in 1273, for in it the couple's daughter Marie is qualified as queen of France, a title that she assumed with her marriage in 1274.

12. De Valkeneer 1963, 180; Alexandre Pinchart, *Archives des Arts, Sciences et Lettres: Documents Inédits*, Ghent, 1865, 2, 137.

13. Paris, Musée national du Moyen Age-Thermes de Cluny, Cl 11655, on loan to the Louvre; and Paris, Musée du Louvre, Inv. R. F. 522–23. See Prague and

Bratislava, *Chefs-d'oeuvre de l'art français du Moyen-Age*, 1978–79, no. 42, for a summary of the fragments from the tomb, which was displaced during the Revolution and subsequently restored. See also Paris, Musée National du Louvre, *Description raisonnée des sculptures du moyen âge, de la renaissance, et des temps moderns. I. Moyen Age*, Notices by M. Aubert and M. Beaulieu, Paris, 1950, 91, no. 111.

14. The tomb of Louis de France, which was reconstructed at Saint-Denis in the nineteenth century, has been considerably restored, but of those architectural elements to be discussed here, only the foot of the tomb is modern. That it follows the original design except in a few details can be seen by comparing our Figure 16 with the drawing in the Clairambault Collection, which was made before the Revolution (Fig. 17). For the details of the restoration of the tomb, see Erlande-Brandenburg 1975, 167–68.

15. Paris, Salle des Gens d'Armes du Palais, *La France de Saint Louis*, 1970–71, 35.

16. Sauerländer 1970, 141.

17. The simple cusped arches of the chest, supported by columns and surmounted by gables that consist of a plain projecting molding, find their closest parallels in the niches of the nave buttresses at Chartres Cathedral, datable to circa 1194–1210, although the gables at Chartres are generic, rather than applied. See Jean Bony, *French Gothic Architecture of the 12th and 13th Centuries*, Berkeley, Los Angeles and London, 1983, Fig. 211.

18. Sauerländer 1970, 141.

19. See Duby 1973, 330–40.

20. See G. Boland, "Le testament d'Henri III, duc de Brabant; 26 février 1261," *Revue d'histoire écclésiastique*, 38, 1942, 59–96, for the will; 86–87, for the impression that death took the duke by surprise.

21. Butkens 1724, 1, 267.

22. BNB, 9, 201–2. The genealogy illustrated on the tomb confirms that it was finished before John assumed power, for as we shall see, the program was limited to the House of Brabant and Henry's illustrious ancestors and kinsmen on his mother's side. After assuming the title, John commissioned two written genealogies, the first before the end of the year 1271 (*Monumenta Germaniae Historica, Scriptores*, 25, ed. Joh. Heller, Hannova, Deutsches Institut für Erforschung des Mittelalters, 1880, 385–99). Both these genealogies stress the descent of the dukes of Brabant from Charlemagne, thus asserting their claim to the *French* throne. Had John been responsible for erecting his father's tomb, it seems likely that Charlemagne would have figured there also.

23. See Georges Duby, *Medieval Marriage: Two Models from Twelfth-Century France*, trans. Elborg Forster (The Johns Hopkins Symposia in Comparative History, 11), Baltimore and London, 1978, 25–27, for a genealogical memory of six generations employed by Bishop Ivo of Chartres circa 1110.

24. Duby 1973, 152; Georges Duby, *The Chivalrous Society*, trans. Cynthia Postan, Berkeley and Los Angeles, 1977, 73–75, and *The Knight, the Lady, and the Priest*, trans. Barbara Bray, New York, 1983, 92–99.

25. Schmid 1957, 22–25 (repr. 1983, 204–7); Karl Schmid, "Heirat, Familienfolge, Geschlechterbewusstsein," in *Il Matrimonio nella società altomedievale* (Settimane di studio del Centro italiano di studi sull'alto medioevo, 24), Spoleto, 1977, 115–17, 130–37 (repr. 1983, 400–402, 415–22); Karl Ferdinand Werner, "Liens de Parenté et noms de personne," in *Famille et parenté dans l'Occident médiéval* (Actes du Colloque de Paris, 6–8 juin 1974), ed. Georges Duby and Jacques Le Goff (Collection de l'Ecole française de Rome, 30), Rome, 1977, 27; Duby 1978, 11.

26. See Karl Schmid, "Uber die struktur des Adels im früheren Mittelalter," *Jahrbuch für fränkische Landesforschung*, 19, 1959, 15 (repr. 1983, 259), for this as a normal attitude of the nobility of the Middle Ages.

27. Cinzio Violante, "Quelques caractéristiques des structures familiales en Lombardie, Emilie et Toscane au XIᵉ et XIIᵉ siècles," in *Famille et parenté dans l'Occident médiéval* (Actes du Colloque de Paris, 6–8 juin, 1974), ed. Georges Duby and Jacques Le Goff (Collection de l'Ecole française de Rome, 30), Rome, 1977, 108–9.

28. Succa, 2, fol. 68.

29. Both men died on Cyprus, where the king spent the winter of 1248–49 with his army before beginning his campaign in Egypt. Anselme (1726–33, 1, 427) mistakenly gives the date of Jean I's death as 1241, although he indicates in vol. 3, 1060, that Marie was left a widow in 1248; he gives Archambaud's death date as 1249 (3, 160). Gaston Sirjean, *Encyclopédie généalogique des maisons souveraines du monde*, 1966, 1, 2. Cah. 4, *Les Dreux*, gives the date of death of Jean I of Dreux as 1248.

30. Teuscher (1990) sets the tomb within the context of the burials of the Dreux family at Saint-Yved, while Bur (1991) concentrates on the tomb's family program. I am gratified to see that his analysis of the program and my own, both derived from the Gaignières drawings, though done independently of one another, correspond in all important respects. See also *Enamels of Limoges*, 441.

31. Oxford, Bodleian Library, Ms. Gough Drgs.-Gaignières 1, fols. 78r, 79r. Most of the Gaignières drawings are in the Bibliothèque Nationale in Paris. For an overall view of them, including tracings of those at Oxford, see Jean Adhémar, "Les tombeaux

de la Collection Gaignières: Dessins d'archéologie du XVIIᵉ siècle," *Gazette des Beaux-Arts*, VIᵉ pér., 74, 1974, 3–192; 88, 1976, 3–128.

32. For thirteenth-century tombs that display shields rather than figures identified by shields, see our Figure 31 and Adhémar 1974, nos. 265, 277, and 446; and *Enamels of Limoges*, 410–13, no. 149; 435, no. 5.

33. But see Bur's citation of the eighteenth-century account of the tomb by Jardel, who described it as "rare et des plus belles" (Bur 1991, 305).

34. For the casket of Saint Louis, see Hervé Pinoteau, "La date de la cassette de Saint Louis: été 1236?" *Cahiers d'Heraldique*, 4, 1983, 97–130, and *Enamels of Limoges*, 360–63, no. 123; for the tomb-plates of Jean and Blanche de France (d. 1247 and 1243), see Erlande-Brandenburg 1975, 123, and *Enamels of Limoges*, 402–5, no. 146; for the tomb of Blanche de Castille, see Erlande-Brandenburg 1975, 165, and *Enamels of Limoges*, 442, for the suggestion that the material was actually bronze.

35. See Teuscher 1990, 126, 131, 145, for a discussion of the location of the tomb. According to the legend on the Gaignières drawing, it was "posé par moitié en dedans du choeur, moitié en dehors."

36. The arms of Marie's family, the first sires of Bourbon, were *Or, a rampant lion Gules, with an orle of escallops Azur* (Jean-Bernard de Vaivre, "Les tombeaux des Sires de Bourbon [XIIIᵉ et première partie du XIVᵉ siècles]," *Bulletin monumental*, 138, 1980, 369). Those of her husband, Jean of Dreux, were *checky Or and Azur, a border Gules* (Sirjean 1966, 4, 241–49).

37. By the mid-eighteenth century, according to Jardel, only a few statuettes remained (Bur 1991, 307).

38. His presence here would seem sufficient to establish his legitimacy, for although listed by Anselme (2, 844) among Thibaud I's bastards on the basis of hearsay and the inconclusive evidence furnished by a letter of 1260, the inscription on the tomb identified him as son of the king *and queen* of Navarre. The letter, published by Arnaldo Oihenarto, *Notitia utriusque Vasconiae, tum Ibericae tum Aquitanicae*, Paris, 1638, 335, refers to him as "Dominus Guillelmus," brother of the king of Navarre.

39. See Duby 1973, 294, for the shift, already in the twelfth century, of the writing of genealogies from the monasteries to princely households.

40. Bur 1991, 311.

41. For example, on the south side of the tomb, Thibaud II, king of Navarre (S2) is described as the son of the king and queen of Navarre mentioned above, who were placed in positions S1 and W5, just previous to him, when the tomb is read from head to foot. The same situation can be observed again in the inscriptions recorded at S4, S7, S9–S13, N2–N4, N6, N8, and N10.

42. See Joachim Bumke, *Courtly Culture: Literature and Society in the High Middle Ages*, trans. Thomas Dunlap, Berkeley, Los Angeles, and Oxford, 1991, 187, 214, for courtly dining and processions in thirteenth-century literature, where the guests were seated as couples or rode in pairs "in a beautifully arranged train."

43. See Bur 1991, 311–13, for observations on the preeminence given the royal Houses of Navarre and Sicily, and for some notable absences.

44. Bur 1991, 314.

45. See Roland Carron, *Enfant and Parenté dans la France médiévale Xᵉ–XIIIᵉ siècles*, Genève, 1989, 6–10, for the relationship between noble youths and their, usually maternal, uncles, which often included their being raised and educated in their uncles' households.

46. Teuscher 1990, 126; Bur 1991, 21.

47. Teuscher 1990, 197–98.

48. Bur (1991, 311) assumes that the countess planned the program herself.

49. For the engraving, see Samuel Guichenon, *Histoire généalogique de la royale maison de Savoie*, Lyon, 1660, 1, 264; for the countess's foundation, see Francisque Viard, *Béatrice de Savoye*, Lyon, 1942, 131–32, 142.

50. He mentions only one of these by name, François Ranchin's edition of Pierre d'Avity's *Description Générale de L'Europe*, which was published in Paris in 1637. Avity's text must have been written before 1600, since he speaks of the tomb as still in existence, stating that it is in marble, one of the most beautiful in Europe, and that the relatives were represented by very well-executed statues (Pierre d'Avity, *Description Generale de l'Europe*, cont. by François Ranchin, Paris, 1637, 2, 427).

51. London, Brit. Lib., Ms. Lansdowne 874, fol. 135v, and Paris, Bibl. Nat., Ms. fr. 24020.

52. Max Prinet, "Armoiries couronnées figurées sur des sceaux français de la fin du XIIIᵉ et du commencement du XIVᵉ siècle," *Revue archéologique*, 4ᵉ sér., 2, 1909, 370–79.

53. For advice on the heraldry represented on the engraving and the form of the shields, I am indebted to Baron H. Pinoteau and to Cecil Humphery Smith, FSA, and for useful observations concerning the form of the tomb, to Michel Popoff.

54. Viard 1942, 133, 142. That the only grandchildren represented on the tomb were either from the House of France or of England argues strongly for the involvement of these two queens in planning the tomb's program.

55. For the tombs of the Angevins in Naples, most of which were designed by Tino di Camaino, see now Lorenz Enderlein, *Die Grablegen des Hauses Anjou*

in Unteritalien. Totenkult und Monumente 1266–1343, Worms, 1997, who also discusses briefly the tomb of Béatrice de Savoie (31, n. 32). Gerola (1931–32, 265–67) made the conceptual connection between the Angevin tombs in Naples and the tomb of Béatrice de Savoie, but posed the problem of which came first. Aside from the evidence cited in note 54, the engraving suggests that the form of the Provençal tomb was northern, and it would provide a logical link between the art of the French court and Naples.

56. Brussels, Bibl. roy., Ms. II 1862, fols. 15r, 15v, 16r.

57. Brussels, Bibl. roy., Ms. Goethals 1507, fol. 16v.

58. "en bas le Roy de France, La Roine, le Roy de Cecile La Roine, Enc. le Roy de Frane et la Roine" (Brussels, Bibl. roy., Ms. Goethals 1507, fol. 16v).

59. According to the antiquarian record, the genealogy of Queen Blanche de Navarre (d. 1398) and her daughter Jeanne de France (d. 1371) was displayed on their joint tomb at Saint-Denis, and that of Isabelle de Bourbon (d. 1465), first wife of Charles the Bold, duke of Burgundy, was decorated with statuettes of her ancestors. For the tomb of Blanche de Navarre and Jeanne de France, see, most recently, Erlande-Brandenburg et al. 1975, 24. The tomb program is given in Gilles Corrozet, *Les antiquitez, chroniques, singularitez de Paris, ville capitale du roy de France, avec les fondations et bastimens des lieux; les sepulchres & epitaphes des princes, princesses & autres personnes illustres*, 2d ed., Paris, 1561, 34–35. For the tomb of Isabelle of Bourbon, see below, pages 146–48.

60. Comblen-Sonkes and Bergen-Panthens (Succa, 1, 114) place the monument in the late thirteenth or early fourteenth century on the basis of costume.

61. Anselme, 2, 735. For the will itself, see *Cartulaire de l'Abbaye de Flines*, ed., L'Abbé E. Hautcoeur, Lille, Paris, and Brussels, 1873, 1, 177–80. Wilhelm Karl Prinz von Isenburg and Detlev Schwennicke, *Europaische Stammtafeln*, 2d ed., Marburg, 1984, 2, Table 8, take the will to indicate the time of her death.

62. For the will of Robert de Béthune, see *Cartulaire Flines*, 1, 378. See further, l'Abbé E. Hautcoeur, *Histoire de l'Abbaye de Flines*, 2d ed., Lille, 1909, 89, 439.

63. For the main developments in the revolt of the Dampierres against the Crown, see H. Pirenne, *Histoire de Belgique*, Brussels, 1900, 1, 352–97, and David Nicholas, *Medieval Flanders*, New York, 1992, 180–97.

64. Moulins, Musée Anne de Beaujeu, Inv. 1051, h. 0.46 m.

65. The statuette was first mentioned in Moulins, Musée municipal et départemental, *Catalogue*, by M. de l'Estoille, 1885, no. 43. Most recently it figured in the exhibitions *Huit siècles de sculpture française*, Paris, Musée du Louvre, 1964, no. 30, and Dijon, Musée des Beaux-Arts, *Les pleurants dans l'art du moyen âge en Europe*, by Pierre Quarré, Dijon 1971, no. 4.

66. In the earliest memorial books, written in the prime of the Carolingian period, secular women are listed separately from their male counterparts. See Schmid 1957, 55, repr. 1983, 237.

Three
The Tomb of Kinship in the Low Countries

1. Baudouin's consort, Marie de Champagne, died in the same year as he and was buried in the Church of Hagia Sophia in Constantinople (Anselme, 2, 726).

2. For the historical events outlined above, see Pirenne 1900, 1, 196–205, and Nicholas 1992, 74–76. For a brief history of the Fourth Crusade and the Latin Empire of Constantinople, see E. H. McNeal and R. L. Wolff, in Kenneth M. Setton, ed., *A History of the Crusades*, 2d ed., Madison, 1969, 2, 153–233.

3. The definitive history of the quarrel of the Avesnes and Dampierres is Charles Duvivier, *La Querelle des d'Avesnes et des Dampierres jusqu'à la mort de Jean d'Avesnes (1257)*, 2 vols, Brussels, 1894. For a brief account, see BNB, 13, 612–29; for its implications, see Pirenne 1900, 1, 230–38, 361–2.

4. For the early history of the Convent of L'Honneur-Notre-Dame and its transfer to Flines, see Hautcoeur 1909, 15–39.

5. "pro remedio anime nostre ac domini Willelmi de Dampetra, quondam mariti nostri, necnon et omnium antecessorum successorumque nostrorum" (*Cartulaire Flines*, 1, 94). According to Henri d'Outreman, *Histoire de la ville et comté de Valentiennes*. Douai, 1639, 549, Flines was the largest and most majestic convent in the Low Countries. Initially founded for one hundred choir nuns, eighteen lay brothers or sisters, a chaplain, and a confessor, in time it exceeded that number (see Hautcoeur 1909, 46–48).

6. *Cartulaire Flines*, 1, 156.

7. Ibid., 194–206; Hautcoeur 1909, 71–72.

8. Guy de Dampierre founded a daily mass in the convent at Flines in 1263, for himself, his ancestors, and his descendants, for which he adjusted the source of income in 1279 (*Cartulaire Flines*, 1, 158–59, 233–35; Hautcoeur 1909, 438).

9. Mahaut de Béthune established a chantry at Flines in 1262, which was augmented by her son, Robert de Béthune in 1265 (*Cartulaire Flines*, 1, 154–55, 161; Hautcoeur 1909, 438). In her will of 1269,

Blanche de Sicile established prayers at Flines on her anniversary (*Cartulaire Flines*, 1, 178).

10. Already by March 18, 1262, Urban IV had accorded indulgences to the faithful who would attend the consecration of the church and spend the following week there in prayer and devotion (*Cartulaire Flines*, 1, 154). Hautcoeur (1909, 67) pointed out that this suggests that construction was already advanced by this date.

11. These are the "Mémoriaux" of Antoine de Succa, the "Recerches" of the seventeenth-century antiquarian Jean Lalou, and the "Monumens sépulchral de Flinne" by Jean d'Assignies, chaplain and confessor at Flines circa 1600 (see above, page 47 and notes 56 and 57). For Jean d'Assignies, see Hautcoeur 1909, 215–19.

12. According to Hautcoeur (1909, 122), the entire nave of the church formed the nuns' choir.

13. Brussels, Bibl. roy., Ms. Goethals 1507, fol. 16. Succa (2, fol. 13) sketched only the torso and head of the countess's effigy, depicting a lady heavily veiled, with her hands joined in prayer.

14. "Au bas sont au chief dieu a dextre u empereur et sa feme. a ses 3 femes et Religieuses La quatriesme (est) Au pies une dae a gaushe & personnaige destruis desrompus gatte etc" (Brussels, Bibl. roy., Ms. Goethels 1507, fol.16). Lalou's reference to members of both sexes is confirmed by Succa (2, fol. 3), who mentioned a diversity of figures around the tomb, among which the women were intact, while the men had their heads broken.

15. "de mesme haulteur, longeur et façon que le precedent. . . . il est aussi au milieu du mesme coeur un peu plus bas" (Brussels, Bibl. roy., Ms. Goethals 1509, fol. 3). There is no antecedent to Marie's tomb in the manuscript at present, but we can deduce from Lalou (fol. 16) that Marguerite's tomb was that other tomb in the middle of the choir to which this passage refers.

16. Hautcoeur (1909, 122) named these chapels. See also the eighteenth-century plan of the abbey reproduced before his frontispiece, which shows the church to have had a Cistercian plan, with five chapels radiating from an ambulatory, a chancel consisting of an apse and straight bay, a short transept, and a long nave, both with side aisles.

17. Hautcoeur (1909, 433) argued for assigning the tomb to the first Guillaume de Dampierre, followed by Robert Mullie, "Sépultures et Monuments funéraires. Les comtes de Flandres. Les comtes de Louvain et les ducs de Brabant. Les ducs de Bourgogne," Woluwe-Saint-Lambert (typescript), 1955–56, 13–14.

18. Succa reported the seventeenth-century local tradition, according to which the first Guillaume was buried in the cloister at Flines (1, 102, 113, no. 42; 2, fol. 4v).

19. Brussels, Bibl. roy., Ms. Goethals 1509, fol. 18; Goethals 1507, fol. 17.

20. Ibid.; Hautcoeur 1909, 433; L'Abbé T. Leuridan, *Epigraphie du Nord. Recueil des inscriptions du Département du Nord ou du Diocèse de Cambrai*, Lille, 1927, 6, 438.

21. Brussels, Bibl. roy., Ms. Goethals 1507, fol. 17; Succa, 2, fol. 14; Brussels, Bibl. roy., Ms. Goethals 1509, fol. 18. This discrepancy and a difference in headgear between the figures drawn by Succa and d'Assignies led Comblen-Sonkes and Bergen-Pantens (Succa, 1, 112) to suggest that there were two representations of the defunct on the tomb, one recumbent and one standing, but errors in d'Assignies's drawing seems a more likely explanation.

22. See Olivarius Vredius, *Sigilla comitum Flandriae*, Bruges, 1639, 37–38, for Guillaume's arms; G. Demay, *Inventaire des sceaux de la Flandre*, Paris, 1873, 1, 26, no. 147, for those of Jean I; and J.-T. de Raadt, *Sceaux, armoiries des Pays-Bas et des pays avoisinants, recueil historique et héraldique*, Brussels, 1897–1901, 1, 368, for those of Jean II.

23. *Cartulaire Flines*, 1, 261–63. Leuridan (1927, 6, 424) and Hautcoeur himself (1909, 438) are in error in stating that this chaplaincy was founded for Guillaume de Dampierre, husband of Marguerite de Constantinople.

24. "Au bas Lepereur de constantinoble, margherite sa fille, ung Mper et Jane, puis 3 hoes le i fladres et nevers Le 2e de flandres, Le 3e demy chapaigne et demie flandres" (Brussels, Bibl. roy., Ms. Goethals 1507, fol. 17). Succa's sketch of three of the statuettes (2, fol. 14) and his note that there were seven, including three kings, two counts, and two women, confirm Lalou's text.

25. Demay 1873, 1, 26, no. 150. After his father became count in 1305, Louis bore Flanders with a label, as seen on seals of 1308 and 1315 (M. Douet d'Arcq, *Collection de Sceaux*, Paris, 1863–68 [Munich, Kraus repr., 1980], 1, 404, nos. 875 and 876).

26. See above, page 50.

27. Ibid., 2, 731; Hautcoeur 1909, 89; and Succa, 1, 101.

28. *Cartulaire Flines*, 2, 534; Hautcoeur 1909, 89.

29. Pirenne 1922, 2, 191.

30. Simon Le Boucq, *Histoire ecclesiastique de la ville et comte de Valentienne* (1650), ed. A. Prignet and A. Dinaux, Valenciennes, 1844, 113–18, 162–66. Of the tombs described by Le Boucq, eight had statuettes carrying shields emblazoned with the arms of members of the family, or were painted in armorial dress. Fragments of the figures of yet another tomb described by Le Boucq are preserved and will be discussed below, while those of the two counts of Hainault, Jean II and Guillaume I, although not specifically mentioned with statuettes, most probably included them, as will be seen in our discussion of

these tombs. Le Boucq says that the statuary of all the tombs had been destroyed by the iconoclasts in 1566, but we may infer from Outreman (1639, 445–50) that although the damage had been extensive, the arms identifying statuettes were often left intact and in some cases, the statuettes as well. Le Boucq's record is considerably amplified by Leuridan (1932–48, 9–12), an extensive compilation of the antiquarian sources for Valenciennes. Leuridan's work allows us to add one more tomb to those recorded by Le Boucq, and it gives a more complete program of a number of those recorded by him. In addition to those pages cited below in relation to monuments discussed in detail, see his volume 9, 303–5, 362–67, 370–74, 376–77, 379–84, and volume 12, 760, 784, 833. For Le Boucq himself, see Valenciennes, Musée des Beaux-Arts, *Richesses des Anciennes Eglises de Valenciennes,* 1987–88, 88–89.

31. We should recall that Jeanne was apparently instrumental in separating Marguerite from Bouchard d'Avesnes, while Marguerite herself was ultimately estranged from her two sons by him, Jean and Baudouin.

32. The church was dedicated in 1233. See Louis Serbat, "L'Eglise des Frères Mineurs à Valenciennes," *Revue d'histoire franciscaine,* 2, 1925, 141–55, for an account of the brothers' initial aversion to the site offered by the countess, which they esteemed both pretentious and unhealthy. But she persisted, and, aided by the pope, eventually overcame their antipathy. See Valenciennes (1987–88) for Jacques de Guise's (d. 1395) account of the laying of the first stone by Countess Jeanne (84–85), and for a brief description of the church (28).

33. Outreman (1639, 452–53) says that according to some sources, Jeanne was responsible for the building, while others say Marguerite. Outreman thought it probable that work was begun under Jeanne and completed under Marguerite. He says the monastery and church were completed in 1272, but consecrated only in 1317. For a brief description of the church, see Valenciennes 1987–88, 28.

34. I am grateful to Philippe Beaussart, who heads the Musée des Beaux-Arts' archeological section, for informing me of the work underway in Valenciennes in 1989–90. For the implications of this work for the history of Gothic sculpture in northern France, see the catalogue of the 1987–88 exhibition in the Musée des Beaux-Arts de Valenciennes, *Richesses des Anciennes Eglises de Valenciennes,* and the article therein on medieval funerary sculpture by Ludovic Nys (31–38); the account of the excavations in Valenciennes, Musée des Beaux-Arts, *Les collections d'archéologie régionale du Musée des Beaux-Arts de Valenciennes,* Valenciennes, 1993, 30–32; and Françoise Baron and Ludovic Nys, "La sculpture valenciennoise aux XIVᵉ et XVᵉ siècles," in *Valenciennes*

aux XIVᵉ et XVᵉ siècles. Art et Histoire, dir. Ludovic Nys and Alain Salamagne, Valenciennes, 1996, 130–36.

35. An effigy in carboniferous limestone found in the 1989 excavation in the Dominicans' choir is thought to be that of Alix de Hollande (Valenciennes 1993, 30–31, 100–101). Outreman (1639, 456) located the tomb in the center of the choir; Leuridan (1938, 10, 200–201) described it as an elevated tomb in marble. See also Leuridan 1948, 12, 759.

36. Leuridan 1938, 10, 303; 1948, 12, 760. The heads of an effigy and two smaller figures in carboniferous limestone found in the excavation of 1990, on the north side of the Dominicans' choir, have been associated with this tomb (Valenciennes 1993, 106–7).

37. Important fragments of the tomb of Jean, lord of Beaumont (d. 1279), were discovered in the choir of the Dominicans in 1989, confirming that the tomb chest in carboniferous limestone displayed knights identified by shields and by inscriptions in the arcade sheltering them (Valenciennes 1993, 102–5).

38. Outreman 1639, 445. The tomb's material is indicated in the executor's accounts cited in note 39, but as pointed out by Ann Roberts, "marble" usually meant carboniferous limestone at this time.

39. Le Chanoine Dehaisnes, *Documents et extraits divers concernant l'histoire de l'art dans la Flandre, l'Artois et le Hainaut avant le XVᵉ siècle,* Lille, 1886, 1, 195–98; discussed by the same author in his *Histoire de l'art dans la Flandre, l'Artois et la Hainaut avant le XVᵉ siècle,* Lille, 1886, 455.

40. Le Boucq 1650 (pub. 1844), 113; Leuridan 1938, 10, 358–59, and 1947, 11, 781. Outreman (1639, 445–46) implies that this tomb, like that of Guillaume I of Hainault, discussed below, was comparable to the other tombs of the counts of Hainault in the church. Le Boucq mentions statuettes with the shields in most of these.

41. See Appendix III for the rationale for the chart.

42. Philippine's relatives were two cousins, the count of Bar and the duke of Guelders; her niece, Marguerite de Brabant, Holy Roman Empress; and her nephew, the count of Namur, who was also a half cousin of her husband.

43. Guillaume I's tomb must have been in the works by July 23, 1339, when his successor, Guillaume II, ordered that thirty livres tournois be applied each month to the expenses of his father's tomb and the chapel of his chateau in Valenciennes until their completion. See Dehaisnes, *Documents,* 1886, 1, 333–34, for the document.

44. Le Boucq 1650 (pub. 1844), 113–14; Leuridan 1938, 10, 362–66.

45. Brussels, Bibl. roy., Ms. Goethals 1509, fol. 34; Clément Monnier, "Histoire de l'Abbaye de Cambron" *Annales du Cercle archéologique de Mons,* 17,

1880–82 (pub. 1884), 27–31; De Valkeneer 1972, 50. The same arrangement was employed at Cambron for the fifteenth-century tomb of Englebert d'Enghien (d. 1403) and Marie de Lalaing (d. 1416) (De Valkeneer 1963, 129–30; 1972, 50; Monnier 1880–82, 35–36).

46. William Durandus, *Rationale divinorum officiorum*, Chap. 1, Sect. 46 (trans. John Mason Neale and Benjamin Webb, Leeds, 1843; repr. AMS Press Inc., New York, 1973); Friedrich Möbius, "Basilikale Raumstruktur im Feudalisierungsprozess: Anmerkungen zu einer Ikonologie der Seitenschiffe," *Kritische Berichte: Mitteilungsorgan des Ulmer Vereins Verband für Kunst- und Kulturwissenschaften*, 7, 1979, 7–10. I am grateful to Thomas Matthews for calling my attention to Durandus's text.

47. In Valenciennes 1996, 130–36. They pointed out that all the comital tombs known from the church of the Dominicans and that of Jean d'Avesnes, lord of Beaumont (d. 1356), at the Franciscans, were executed in carboniferous limestone, and therefore probably represent imported tombs from Tournai.

48. See Lille, Musée des Beaux-Arts, *Sculptures romanes et gothiques du Nord de la France*, dir. Hervé Oursel, 1978–79, no. 57, 129, and more recently, André Hardy and Philippe Beaussart, "Peintures et Sculptures gothiques du Couvent des Dames de Beaumont à Valenciennes," *Revue du Nord*, 57, 1980, 911; Valenciennes 1987–88, 40; Valenciennes 1993, 118–19; and Baron and Nys 1996, 136.

49. Besides the fragments illustrated, two others were found of the bases of four niches. Two of the fragments allow us to establish the width of the niches (21.4 cm.) and of the piers that separated them (8.3 cm).

50. Le Boucq 1650 (pub. 1844), 162.

51. Ibid., 163.

52. Ibid., 163, 165. He mentioned only one other tomb in the church with statuettes, that of Isabeau de Kievrain (d. 1337), which he said was in marble. Nys (Valenciennes 1987–88, 40) suggested that the fragments were from the tomb of another daughter of the foundress, Marguerite de Luxembourg (d. 1324), who, according to Leuridan (1938, 10, 456), had an *enfeu* tomb next to the choir, but Leuridan's sources apparently did not mention figures in relation to the fifteen shields that he associates with this tomb. Neither Le Boucq nor Outreman mentions it. Earlier in the same work, Nys (33) had alluded to the tomb fragments as possibly belonging to the tomb of Béatrice d'Avesnes herself, and in his recent article in collaboration with Françoise Baron (Valenciennes 1996, 136), he seems to favor assigning the fragments to the tomb of the foundress.

53. Lille 1978–79, no. 57, 129; A. Erlande-Brandenburg, Review of Hervé Oursel, *Sculptures ro-manes et gothiques du nord de la France*, Lille, Musée des Beaux-Arts, 1978–79, in *Bulletin monumental*, 137, 1979, 271; Hardy and Beaussart 1980, 911. See also Baron and Nys 1996, 136.

54. The first contract, preserved in the Archives départementales du Nord at Lille, was published by Pinchart 1882, 566–71, and by Dehaisnes, *Documents*, 1886, 1, 330–33; the second, known from two copies, one formerly in the Archives of Tournai and the other in the Archives of Mons, was published by Hocquet 1921, 267–69. The document in Lille has not been located recently. Those in Tournai and Mons were destroyed in 1940.

55. "pourtraitures de chevaliers u de dames menans duel u d'autres contenances, u se il plaist apostles" (Pinchart 1882, 568; Dehaisnes, *Documents*, 1886, 1, 331). Tradition in Brabant died hard.

56. "les XX ymaginettes des espondes . . . seront de boine blanke piere de Louch . . . les XX ymaiginettes des espondes de boin fin or . . . et de boines couleurs à ole" (Hocquet 1921, 268).

57. "ara ymaiginettes d'esleveure dou lignage menant duel . . . "(Ibid).

58. De Valkeneer (1972, 53–54) seems somewhat confused by the document, although he rightly insists that the theme is different from that of a funeral procession such as we find in Burgundy.

Four
The First Tombs of Kinship in England

1. For a recent review of Henry III's building campaign at Westminster, see Binski 1995, 13–33; for the royal accounts, see H. M., Colvin, ed., *The History of the King's Works*. I. *The Middle Ages*, London, 1963, 130–51; for the formation of the royal necropolis, see Wendebourg 1986, 23–35, 60–62, and Binski 1995, 91–110.

2. See W. R. Lethaby, *Westminster Abbey Reexamined*, London, 1925, 279–80, for evidence of a probable displacement of the tomb. He thought that it was probably originally erected in the royal chapel.

3. For the foregoing, see Bernard Burke, *Dormant and Extinct Peerages of the British Empire*, London, 1883, repr. 1978, 545, and CP, 10, 377–81.

4. There are spaces for twelve niches on each long side, three at the head and four at the foot. Some of the statuettes were still in place in the early seventeenth century when they were mentioned by William Camden, *Reges, Reginae, Nobiles et alij in Ecclesia Collegiata B. Petri Westmonasterij sepulti*, London, 1606. They are referred to subsequently by Henry Keepe, *Monumenta Westmonasteriensia*, London, 1681; John Dart, *Westmonasterium or the History and Antiquities of the Abbey Church of St. Peters*

Westminster, London, 1723, 1, 119; John Stow, *The Survey of London*, London, 1733–35, 2, 521; 1754, 2, 521; Gough 1786–96, 1, 75–77; and C. A. Stothard, *Monumental Effigies of Great Britain*, ed. A. J. Kempe, London, 1817–32, Pls. 44 and 45. However, only W. Burges (in Scott 1863, 158) got the number of niches right.

5. The exact date of the marriage is unknown, but it had taken place by October 18, 1295 (J. R. S. Phillips, *Aymer de Valence Earl of Pembroke 1307–1324: Baronial Politics in the Reign of Edward II*, Oxford, 1972, 5). M.-M. Gauthier (*Emaux du moyen âge occidentel*, Fribourg, 1972, 377) mistakenly assigned the tomb to William II de Valence, who predeceased his father, an error that is perpetuated in *Enamels of Limoges*, 399, but correctly identified on p. 437, no. 16. But the presence of the arms of Clermont Neslé (*Gules semé with trefoils Or with two bars of the same*) on the base of the tomb undermines this hypothesis by referring to Aymer's wife.

6. Burges, in Scott 1863, 155–58; H. A. Tummers, *Early Secular Effigies in England: The Thirteenth Century*, Leiden, 1980, 100. See Gauthier 1972, 376–77, for a careful analysis of the material.

7. CP, 10, 379.

8. *Barruly Argent and Azure, 6 lions Gules, 3, 2 and 1*, identified as the arms of William's brother, Hugh XI, sire of Lusignan, count of La Marche and Angoulême, by F. A. A. de La Chenaye-Desbois, *Dictionnaire de la Noblesse*, 3d ed., Paris, 1868–76, 12, 563. The coat is reproduced by Stothard (1832, 76). The description of these arms in RCHM, 43, as *barry Argent and Azure, 6 scutcheons Or each charged with a lion Gules* is inaccurate.

9. London, Brit. Lib., Ms. Lansdowne 874, fol. 136.

10. All reproduced by Stothard (1832, Pl. 45). The arms of Châtillon cited by Gauthier (1972, 377) do not appear on the tomb. Marie de Châtillon Saint-Pol was not the wife of William but of Aymer de Valence. See below, page 73.

11. CP, 5, 707.

12. Ibid., 564.

13. Ibid., 563.

14. Burke 1883, 311.

15. Burges, in Scott 1863, 155–517.

16. See *Enamels of Limoges*, 436, no. 8, for a date in the third quarter of the thirteenth century for the tomb of Juhel de Mayenne.

17. See Phillips 1972, 2, Table 1, and Le Boucq 1650 (pub. 1844), 84, for the epitaph of Jean d'Avesnes (d. 1279), which mentions his marriage to Agnès de Valence, daughter of William de Valence.

18. See *Enamels of Limoges*, 38–39, and Sect. 6, 398–419, 435–41, for a survey of the Limoges tombs by Béatrice de Chancel-Bardelot.

19. For a careful record of the original polychromy still present on all three tombs, see Wendebourg 1986, 97–98, 143–44, 163–64.

20. CP, 7, 386.

21. Ayloffe (in *Vetusta Monumenta*, 2, 6), Gough (1786–96, 1, 67–68), and Dart (1723, 2, 10) thought the tomb was at one time open to the ambulatory, but Burges (in Scott 1863, 161–62) pointed out that a careful examination of the masonry rules this out.

22. L. L. Gee, "'Ciborium' Tombs in England 1290–1330," *Journal of the British Archaeological Society*, 132, 1979, 29–32; Adhémar 1974, 115–118, 275, 322, 328–30, 344.

23. Most scholars have dated Aveline's tomb to the 1290s (Crossley 1921, 128; Gee 1979, 33; Christopher Wilson, "The Origins of the Perpendicular Style and Its Development to Circa 1360," University of London, Ph.D. dissertation, 1980, 80; Wendebourg 1986, 101; Binski 1995, 114; Williamson 1995, 218), while both Judith W. Hurtig (*The Armored Gisant Before 1400*, New York and London, 1979, 139–40) and Wilson (1980, 80–81) stressed the difference in architectural conception and detail between Aveline's tomb and Edmund's. Wilson explained these differences by comparing the tomb chest of Aveline with the chest of Eleanor of Castile's tomb in the royal chapel at Westminster, designed by the royal mason, Richard Crundale, in 1291–92. Accordingly, he attributed Aveline's tomb to Crundale, who died in 1293 (Wilson 1980, 81).

24. These tombs are more likely continental prototypes for the monument than the ceremonial tombs at Royaumont cited by Binski (1995, 115).

25. The coats identified by Ayloffe (*Vetusta Monumenta*, 5) seem to represent a garbled selection of shields from the neighboring Valence and Crouchback tombs, and they bear no direct relation to Aveline's family. The engraving of the monument by Hollar, dated 1666, and published in Francis Sandford, *A genealogical history of the Kings of England and Monarchs of Great Britain from the Conquest, Anno 1066 to the Year 1677*, London, 1683, 104, shows the shields blank, as does the later one by Basire (in *Vetusta Monumenta*, 2, Pl. XXIX). No other antiquarian consulted by the writer (Gough, Dart, Stothard, Stow) mentions coats on the shields.

26. Previous examples of near or equal monumentality in France are known only from the Gagnières drawings; for example, the tombs of the Capetians at Royaumont (Adhémar 1974, nos. 104, 308) or the Montmirel tombs at Longpont (ibid., nos. 64, 327). For a discussion of early tombs with canopies in France and England, see Marion E. Roberts, "The Tomb of Giles de Bridport in Salisbury Cathedral," *The Art Bulletin*, 65, 1983, 562.

27. Astutely observed by Gee (1979, 35–36). Binski

(1995, 116), following Wilson (1980, 85), has aptly compared the tomb's architectural composition to a later derivative of the Notre-Dame portals at Rouen Cathedral, the Portal of the Libraires.

28. John H. Harvey, "St. Stephen's Chapel and the Origin of the Perpendicular Style," *The Burlington Magazine*, 88, 1946, 196. The attribution has been most recently argued by Wilson (1980, 80–87) and endorsed by Phillip Lindley, "The Tomb of Bishop William de Luda: An Architectural Model at Ely Cathedral," *Proceedings of the Cambridge Antiquarian Society*, 73, 1984, 75 (repr. in Phillip Lindley, *Gothic to Renaissance: Essays on Sculpture in England*, Stamford, 1995, 85); and Binski (1995, 116).

29. As signaled by Schmidt (1990, 68), the crossed legs of the typical English knight are here combined with the folded hands usual on French tombs. This hybrid pose would find echoes at Westminster in the tombs of Aymer de Valence and John of Eltham.

30. The angels are detectable in the sixteenth-century obituary roll of Abbot Islip (Binski 1995, 118), and in Sandford's engraving of the tomb (1683, 106). See Binski 1995, 116–17, for a consideration of the tomb's polychromy and metallic insets in relation to the probable placement of the Westminster retable on the high altar.

31. The analogy with seals is Gardner's (1951, repr. 1973, 187). See Hurtig 1979, 143–45, for further discussion of this image, and Binski 1995, 118, for its association with the now-destroyed rood, and by implication, with penance.

32. First suggested by Wendebourg (1986, 138). The heads of two (S4 and S7) are gone, and the attribute of one (S3) is unclear. In many cases damage does not allow us to determine whether a rod or scepter was originally represented. Given their attributes, Binski's suggestion that the statuettes represent the earl's adherents is untenable (1995, 118).

33. The stylistic analogies of the sculpture with contemporary continental work have been pointed out by Georgia Wright ("A Tomb Program at Fécamp," *Zeitschrift für Kunstgeschichte*, 47, 1984, 190–91).

34. London, Brit. Lib., Ms. Lansdowne 874, fol. 135v; Sandford 1683, 106. The engraving in Sandford is a mirror image of the ambulatory side of the tomb. See Appendix IV for an analysis by John A. Goodall of the coats, based on remaining traces and Charles's manuscript.

35. Gough 1786–96, 1, 75; RCHM, 22–24.

36. The only comparable series in which two shields per figure sometimes appear, besides the tomb of Aveline de Forz, is the fourteenth-century tomb of Archbishop Pierre de La Jugie in Narbonne Cathedral, where the arms of the archbishop and those of his cathedral chapter were repeated above each niche, to judge from the blazons that remain. Although the blazons on the shields in situ at Narbonne have been completely razed, they remain intact on the arcade from the choir side of the chest now preserved in the Musée des Augustins in Toulouse, where they all carry the same arms. See Michèle Pradelier-Schlumberger, "Le tombeau du cardinal Pierre de La Jugie à Narbonne," *Actes du Congrès de la fédération historique du Languedoc méditerranéen et du Roussillon*, 1973, 279, Figs. 10 and 11, and *Fastes du Gothique*, no. 58.

37. On ladies' seals, two shields often refer to their marriages, with their fathers' arms appearing on one side, their husbands' on the other. According to the survey of women's seals in France and Flanders by L. Bouly de Lesdain ("Les armoiries des femmes d'après les sceaux," *Etudes héraldiques*, 1978–81, 47–75), these seals were the most popular in the period from 1275 to 1350, with, generally, the husband's arms on the right of an image of the titular, the father's, on her left. See Raadt 1897–1901, 1, 95–98, for examples.

38. A seal of Margaret of France, second wife of Edward I, employed two shields to demonstrate her lineage, with her father's arms on one side, her mother's on the other (BMS, 1, 100, no. 798).

39. The early thirteenth-century seal matrix of Robert Fitzwalter shows Fitzwalter bearing his own arms on his shield and horse trapper, while a shield of his comrade, Saher de Quincy, appears in the field in front of him. Illustrated in Richard Marks and Ann Payne, *British Heraldry from Its Origins to c. 1800*, London, 1978, 16, no. 5.

40. In Niche N4, the arms of Cornwall and Provence must refer to the marriage of Richard of Cornwall, king of the Romans, and Sanchia of Provence in 1243, so the lady in the niche would represent Sanchia of Provence; in Niche S3, England and Provence could refer to the marriage of Henry III and Eleanor of Provence in 1236, with the lord depicted below possibly representing the king; and in S7, Cornwall and the empire refer to Richard, earl of Cornwall, suggesting that the lord in the niche represents him.

41. See Appendix IV, pages 167–74.

42. See Maurice Keen, *Chivalry*, New Haven and London, 1984, 133, for the practice of painting the blazons of the kingdom's nobles in their halls and chambers.

43. Westminster Abbey Library. I am grateful to Christine Reynolds of the abbey library for bringing this drawing to my attention. Carter published an engraving after the drawing in his *Ancient Sculpture and Painting*.

44. Carter represented the knight wearing a surcoat blazoned Savoy (*Gules a cross Argent*) but identified him as Roger Bigod, earl of Norfolk, or Sir William de Forz. The most likely identification is Peter,

count of Savoy and earl of Richmond (d. 1268), whom Henry III knighted in 1241 (*Rolls of Arms. Henry III, The Matthew Paris Shields*, c. 1244–59, ed. T. D. Tremlett, *Glover's Roll*, c. 1253–58, and *Walford's Roll*, c. 1273, ed. H. S. London [Harleian Society Publication 113–14: *Aspilogia* 2], Oxford, 1967, 195).

45. To judge from the surcoat, which is blazoned *Azur, a lion Or, differenced with a ribaud* (*Rolls of Arms. Henry III*, 195).

46. Roger de Clifford (d. 1285) bore *Checky Or and Azur, a fess Gules* (*Rolls of Arms. Henry III*, 121). He was a prominent knight during the reigns of Henry III and Edward I. He accompanied the latter on crusade with Earl Edmund in 1270, and was one of the executors of the will made by the prince at Acre in 1272 (DNB, 4, 528–29). Although Carter says that some of the checks appeared blue and others red, he identified the knight as Roger de Clifford, and his notes seem to indicate that the paint was in a poor state of preservation. The band that he depicts around the knight's waist could be read as a fess.

47. This seems more likely than that the company represented knights who accompanied the earl on crusade, as suggested by J. P. Neale and E. W. Brayley, *The History and Antiquities of the Abbey Church of St. Peter, Westminster*, London, 1818–23, 2, 278.

48. Lindley 1984, 76, repr. in Lindley 1995, 88; but see Walter E. Rhodes, "Edmund, Earl of Lancaster, Part II," *English Historical Review*, 10, 1895, 234.

49. see Appendix IV, page 171.

50. CP, 7, 395.

51. For the tomb of Bishop de Luda at Ely, which was most likely by the same shop, see Lindley 1984 and 1995, 85–96. For the tomb of Henry de Lacey, earl of Lincoln (d. 1310), which to judge from an old engraving depended on the Crouchback monument for its tomb chest and effigy, see William Dugdale, *The History of St. Paul's Cathedral in London*, London, 1716, 84.

52. For the most recent examination of the earl's career, see Phillips 1972.

53. In London, Royal Academy of Arts, *Age of Chivalry: Art in Plantagenet England 1200–1400*, ed. Jonathan Alexander and Paul Binski, London, 1987, 45, hereafter cited as *Age of Chivalry*.

54. Hilary Jenkinson ("Mary de Sancto Paulo, Foundress of Pembroke College, Cambridge," *Archaeologia*, 66, 1914–15, 402) reckoned that Marie was born about 1304, and that Aymer would have been over fifty at the time of the marriage. He pointed out that Aymer was her grandmother's first cousin!

55. Phillips 1972, 239.

56. See Appendix V for an analysis of the heraldry based on the shields in situ and a seventeenth-century drawing by Nicolas Charles (London, Brit. Lib., Ms. Lansdowne 874, fol. 135v). Charles's drawing has

been checked against the shields in situ and the more elaborate critical record made by Powell in 1795 (London, Brit. Lib., Ms. Add. 17694, fol. 61–64v). This has allowed the identifications suggested by Blore, Gough, Powell himself, and the Inventory of the Royal Commission on Historical Monuments to be corrected and amplified.

57. For this reason, they are numbered zero in Appendix V.

58. See Appendix V, note 4. The earliest seal to show his arms as Valence quartering Hastings was used in 1340 (BMS 6098).

59. Jenkinson 1914–15, 409.

60. Hurtig 1979, 147: 1330; Wendebourg 1986: the late 1320s; Binski 1995: 1325–30.

61. CP, 7, 398. The Lancaster title and lands had forfeited to the Crown in 1322, after Henry's older brother Thomas revolted against the king (Ibid., 395, and May McKisack, *The Fourteenth Century 1307–1399*, Oxford, 1959, 61–67).

62. Jenkinson 1914–15, 432–35, for a transcription of the will, and 433, for the clause in question. See also Harvey 1977, 396.

63. Corporation of London, Records Office, Letter Book F, fol. 152v; *Calendar of Letterbooks preserved among the archives of the Corporation of the City of London at the Guildhall*, ed. R. R. Sharpe, London, 1899–1912, Letter-book F, 180.

64. Phillips 1972, 234–38.

65. Jenkinson 1914–15.

66. See Anne Echols and Marty Williams, *An Annotated Index of Medieval Women*, New York, Princeton, and Oxford, 1992, 339, for further bibliographic references on the countess.

67. Robert Somerville, *History of the Duchy of Lancaster*, 1, 1265–1603, London, 1953, 15.

68. Ibid.

69. However, Wilson (1980, 86) pointed out that Edward I paid for his brother's obsequies, and Wendebourg (1986, 146) suggested that the king would have been the most probable patron of the tomb, while Williamson (1995, 218) assumed that only the king could have been responsible for it.

70. Scott 1863, 63; Paul Biver, "Les tombes de l'école de Londres au début du XIVe siècle," *Bulletin monumental*, 73, 1909, 254. Wilson (1980, 124–25) traced the details of its architectural design to French Rayonnant micro-architecture but attributed the tomb to the royal mason, Thomas of Canterbury.

Five
The Royal English Tomb

1. For the civil war of 1321–22 and its aftermath, see McKisack 1959, 66–81; and Natalie Fryde, *The*

Tyranny and Fall of Edward II. 1321–1326, Cambridge, 1979, 37–86.

2. McKisack 1959, 437–41; CP, 8, 436–37; Fryde 1979, 146–48, 180–81.

3. CP, 8, 437–41; McKisack 1959, 81–95; W. M. Ormrod, *The Reign of Edward III: Crown and Political Society in England 1327–1377,* New Haven and London, 1990, 3–7. For an alternate account of the fate of Edward II, see G. P. Cuttino and Thomas Lyman, "Where Is Edward II?" *Speculum,* 53, 1978, 522–44; and Fryde 1979, 200–206. For a recent review of Edward II's fate and a strong argument for this having stimulated the first use of an effigy in English royal funerals, see Lindley 1995, 97–107 and 110–12.

4. McKisack 1959, 100–101; CP, 8, 440–41; Fryde 1979, 207–27.

5. This opinion is reflected in Stone 1955, 160–61, and David Verey and David Welander, *Gloucester Cathedral,* Gloucester, 1981, 19–21. The tradition was challenged by Cuttino and Lyman, who suggested that the tomb was erected by the abbot and convent of Gloucester (as in note 3, above, 525), and W. M. Ormrod ("The Personal Religion of Edward III," *Speculum,* 64, 1989, 870), who attributed the royal funeral to the shrewdness of Queen Isabella and the tomb to the "relic-hungry monks of Gloucester."

6. Stone 1955, 160–61; Arthur Gardner 1951, repr. 1973, 325; Joan Evans, *English Art 1307–1461,* Oxford, 1949, 164; Nikolaus Pevsner and P. Metcalf, *The Cathedrals of England: Midland, Eastern, and Northern England,* Harmondsworth, 1985, 1, 152.

7. Stone 1955, 160–61.

8. Wilson 1980, 117–21. For the accounts bearing on the funeral, see S. A. Moore, "Documents Relating to the Death and Burial of Edward II," *Archaeologia,* 50, Part 1, 1887, 221–22, and W. H. St. John Hope, "On the Funeral Effigies of the Kings and Queens of England, with Special Reference to Those in the Abbey Church of Westminster," *Archaeologia,* 60, 1907, 531. For a more recent discussion, see Wolfgang Brückner, *Bildnis und Brauch. Studien zur Bildnisfunktion der Effigies,* Berlin, 1966, 68–72.

9. Stone 1955, 161.

10. Percy Ernst Schramm, *Sphaira Globus Reichsapfel,* Stuttgart, 1958, 116–18.

11. The early Plantagenets, Henry II (d. 1189) and Richard the Lionhearted (d. 1199), in effigy at Fontevrault, clasp a long scepter with both hands, while a sword is laid on the bier at their sides (Sauerländer 1970, 130–31, Fig. 142), no doubt reflecting the funeral ceremony of Henry II, as recounted by Benedict of Peterborough and Matthew Paris, who reported that the corpse held the scepter and was girded with the sword (Hope 1907, 523). The effigy of King John (d. 1216) at Worcester carries the scepter in his right hand and grasps the handle of his sword with his left

(Binski 1995, 110), while that of Henry III (d. 1272) at Westminster Abbey apparently had the sword replaced by the rod with a dove, for although the attributes are missing, the position of the hands is indicative (Ibid.). The effigy of Edward II's successor, Edward III, holds two short handles, suggesting two scepters (see Fig. 74 of this book). Binski (1995, 201) is obviously mistaken in stating that the orb surmounted by a cross placed between the effigy of Richard II (d. 1400) and his consort, Anne of Bohemia, on their tomb at Westminster was the first use of the orb with a royal effigy.

12. Percy Ernst Schramm, *A History of the English Coronation,* Oxford, 1937, 19–21. Beginning with the Coronation Order of St. Dunstan (960–73), the Anglo-Saxon kings were crowned with a golden helmet as well as anointed and invested with a short scepter and a long rod. With the Order of Edgar (973), a sword and ring were added to the regalia and the helmet was replaced by a crown. According to the description of the coronation of Richard II in 1377, he held a scepter issuing from an orb, which must have resembled the one on his famous portrait at Westminster, but according to Schramm, an orb as such is never mentioned in the coronation orders or in the inventories of the regalia (1958, 119–20).

The use of the scepter and the orb surmounted by a crucifix in the order for a king's funeral in the fourteenth century, *De exequiis regalibus,* probably followed the precedent set at Gloucester. See Ralph E. Giesey, *The Royal Funeral Ceremony in Renaissance France,* Geneva, 1960, 82–84, for a discerning discussion of the chronological problems posed by this order, which all authorities consider subsequent to Edward II's funeral.

13. Percy Ernst Schramm, *Herrschaftszeichen und Staatssymbolik: Beitrage zu ihrer Geschichte vom dritten bis zum sechzehnten Jahrhundert* (Schriften der Monumenta Germaniae Historica, 13), Stuttgart, 1954–56, 1, 17–20; 1958, 58–60, 96.

14. Ibid., 63.

15. Ibid., 62, 65–66.

16. Schramm (1958, 65–67) cites English examples from the eleventh to the fourteenth century. See O. Elfrida Saunders, *Englishe Buchmalerei,* Florence and Munich, 1927, 2, Pls. 104, 106, and 111; Nigel Morgan, *Early Gothic Manuscripts 1190–1285* (A Survey of Manuscripts Illuminated in the British Isles, 4, ed. J. J. G. Alexander), London 1988, 2, 402, 406; and Lucy Freeman Sandler, *Gothic Manuscripts 1285–1385* (A Survey of Manuscripts Illuminated in the British Isles, 5, ed. J. J. G. Alexander), London, 1986, 1, Figs. 169, 187, and 194, for examples in English manuscripts; *Age of Chivalry,* 465–66, nos. 593–94, for examples in ivories; and Paul Binski, "What Was the Westminster Retable?" *Journal of the*

British Archaeological Association, 1987, 159–65, for a discussion of the meaning of the orb held by the Christ in the Westminster Retable.

17. Schramm 1937, 7, 118.

18. Ibid., 9; Schramm 1958, 68. For the Order of Edgar, see Schramm 1937, 20–21.

19. *"Sanctus enim et Christus Domini est"* (cited in Marc Bloch, *Les Rois thaumaturges. Etude sur le caractère surnaturel attribué à la puissance royale particulièrement en France et en Angleterre,* Paris, 1961, 41).

20. Schramm 1937, 129.

21. Ibid., 131–34. See 117–31, for a discussion of the controversy over the relative positions of the king and the bishops in the preceding centuries.

22. John Britton, in *Cathedral Antiquities,* London, 1828, 5, 71, says that it was repaired in 1737, 1789, and 1798. Evans (1949, 164) mentions a restoration of 1876.

23. As pointed out by Wilson 1980, 119. For shrine bases provided with "squeezing places," see Nicola Coldstream, "English Decorated Shrine Bases," *Journal of the British Archaeological Association,* 3d ser., 129, 1976, 16, and *The Decorated Style: Architecture and Ornament 1240–1360,* Toronto, 1994, 90–91. For a thirteenth-century illustration of pilgrims at a healing site, see Binski 1995, Fig. 77.

24. See the engraving by Gravelot and C. Du Bosc published in the 1743 edition of Paul Rapin de Thoyras, *The History of England,* 3d ed., trans. N. Tindal, London, 1743, 1, opposite 414; that by H. Ansted and J. Le Keux, in Britton 1828, 5; and that by Willis, Skelton, and Widler, published by Skelton in 1830. I have had access to the latter two prints in the Graphics Collection of the London Society of Antiquaries. Gough (1786–96, 1, 92) mentions the shields.

25. F. H. Fairweather, "Colne Priory, Essex, and the Burials of the Earls of Oxford," *Archaeologia,* 87, 1937, 275–95. I am indebted to the proprietor of the Chapel of St. Stephen, Colonel Geoffrey Probert, for the opportunity to study and photograph the monuments at Bures. Wilson (1980, 118) cited the architectural similarity of the tomb chests but did not treat their iconographical relationship. Colonel Probert himself has since published a detailed account of the fate of the monuments at Colne Priory after the Dissolution, and compared the tomb chest in question with that of Edward II at Gloucester, and the effigy with those of Edmund Crouchback, Aymer de Valence, and John of Eltham at Westminster (Geoffrey Probert, "The Riddles of Bures Unravelled," *Essex Archaeology and History (Transactions of the Essex Society for Archaeology and History),* 3d ser., 16, 1986, 55–59).

26. Prior and Gardner 1912, 652. Although the tomb chest has usually been ascribed to a later tomb (RCHM Ex, 1916–23, 3, 88; Fairweather 1937, 287; J.

Enoch Powell, "The Riddles of Bures," *Essex Archaeology and History,* 3d ser., 14, 1974, 90), the only part of it that may not be commensurate with the date suggested by the style of the effigy is the battlemented chest cover, perhaps a later accretion; however, Colonel Probert (1986, 55–59) has brought important evidence, both heraldic and stylistic, that the assembly of effigy, slab, and tomb chest is original. In terms of style, a date in the 1320s or early 1330s seems feasible for both effigy and chest. As already noted, the style of the effigy corresponds to that of the effigies on the tombs of Crouchback and Aymer de Valence at Westminster. The figures in relief on the chest exhibit a grace and movement that is closer to the statuettes at the latter tomb. The bold use of the ogee arch to frame the large niches and the attenuated proportions of the smaller niches both seem more developed than the arch on the Valence tomb, which dates after 1324.

27. The drawing is a copy of an original by Daniel King from 1653 (London, Brit. Lib., Ms. Add. 27348, fol. 29). For problems with the drawing and specifically the tomb chest's pedimental prou, see Probert 1986, 59. The inventory of the tombs at Earl's Colne published by the Royal Commission in 1922 (RCHM Ex, 3, 88) mentions four niches with figures (outer niches) and three others (inner niches) from the destroyed sides of the tomb, which were still preserved in a house near the parish church. Two of the inner niches can be seen on the plate opposite page 87.

28. See Probert (1986, 57) for the most recent discussion of the heraldry. The figures apparently painted on the walls of the recessed niches are problematic. Whereas King's obviously inaccurate perspective shows only two figures per niche, a more accurate drawing by the Rev. David Powell of ca. 1806 (Probert 1986, Pl. II) shows faint traces of one figure on the center panel of each niche. The function of these deep niches on the tomb of a knight is unclear, although one finds them again on the later tomb of Sir Humphrey Littlebury (d. after 1346) at Holbeach (Lincolnshire).

29. The remaining statuettes are barefoot and wear tunics and cloaks, one carrying a book and a staff (?) while two are bearded.

30. See above, pages 29–31. An analogous coeval tomb program at Durham suggests that representations of Edward's forebears were represented in the recessed niches at Gloucester. As recently discussed by Paul Binski (1987, 204–6, Fig. 98), the elaborate brass tomb plate of Louis de Beaumont, bishop of Durham (d. 1333), formerly in the pavement of the cathedral sanctuary, displayed an apposition of the twelve apostles with Beaumont's royal French ancestors in the architectural framework that surrounded the effigy. Here, as at Gloucester and Bures, a hierarchy was suggested by the arrangement of the figures. Whereas

the apostles stood in niches that graced the shafts supporting a crowning two-tiered canopy and also in the canopy itself, representations of the bishop's ancestors filled the niches of two flanking towers linked to the inner structure by flyers.

31. Bloch 1961, 17–20.

32. Ibid., 31–46, 78–84, 129–34, 223–24.

33. Ibid., 102–3, 159–61, 172–74.

34. For a discussion of the rumor, see Moore 1887, 215–20.

35. Ibid., 221, 226 ("iij.magnis lignis de quercu aptis ad sarrandis ad barras factis pro claustura circa corpus Regis ad resistendam oppressionem populi irruentis").

36. *Historia et Cartularium monasterii Sancti Petri Gloucestriae*, ed. W. H. Hart, London, 1863–67, 1, lxi, 46–47.

37. For the chronology of the Gloucester choir remodeling, see Christopher Wilson, *Age of Chivalry*, 417; for the great window, see Jill Kerr, "The East Window of Gloucester Cathedral," *British Archaeological Association Conference Transactions*, 7, 1981, 120–22. Kerr's objection to the traditional identification of a Coronation of the Virgin in the figures of Christ and the Virgin on the fourth level is unconvincing. The Coronation is often flanked by the apostles, for example, on a fifteenth-century stone retable at Fressin (Pas-de-Calais) and at Saint-Vaast, Arras (J. Lestocquoy, "Le rôle des artistes tournaisiens à Arras au XVe siècle," *Revue belge d'archéologie et d'histoire de l'art*, 7, 1937, 211–16), and most notably on tombs for members of the Avignon curia in the fourteenth century (Françoise Baron, "Collèges apostoliques et Couronnement de la Vierge dans la sculpture avignonnaise des XIVe et XVe siècles," *Revue du Louvre et des Musées de France*, 1979, 3, 173–85). Understood as a metaphor of Christ and his church, the place of the coronation in a hierarchy of authority is completely orthodox.

38. Ormrod 1989, 868, no. 109.

39. Lethaby (1925, 281); Stone's interpretation of the situation (1955, 162) was followed by Binski (1995, 177). The letter is preserved in the Westminster Abbey Library, Doc. 6300*. Written to the abbot and convent of Westminster, the full text of the document is transcribed in Ormrod 1989, 868, no. 109. The clause regarding the transfer of the body reads as follows: "Nous vous prioms cherment que selonc la eslection & le devis de nostre treschere dame & mere Isabel Reine Dengleterre vueilletz ordiner & suffrir que le corps de nostre trescher frere Jehan iadis Counte de Cornewaille peusse estre remuez & translatez du lieu ou il gist iusques a autre plus covenable place entre les Roials."

40. Leslie Southwick, "The Armoured Effigy of Prince John of Eltham in Westminster Abbey and Some Closely Related Military Monuments," *Journal of the Church Monuments Society*, 2, 1987, 12–20, also interprets the document so, and relates the particular fashion of the effigy's armor to monuments of the late 1330s to early 1350s.

41. "Ffaisant toutes foitz reserver & garder les places plus honourables illueques por le gisir & la sepulture de nous & de noz heirs" (London, Westminster Abbey Library, Doc. 6300*).

42. See Binski 1995, 178, for important corroborative evidence for Queen Isabella's involvement.

43. Gough 1786–96, 1, 94; Scott 1863, 65–66, 168.

44. For an analysis of its architectural style and an attribution to the royal architect, William Ramsey, see Wilson 1980, 245–47.

45. See Wendebourg 1986, 171–72, for a careful description of the prince's outfit.

46. Stone (1955, 161, 164) has characterized the "Master of the Effigy of John of Eltham" as the most important court artist of the period between 1325 and 1340, and attributed the effigy of Edward II to him as well. Wendebourg (1986, 175) also suggested the same workshop.

47. Gough's engravings of the tomb (1786–96, 1, Pls. XXXI and XXXII) enable us to ascertain the attributes of several figures that have disappeared since: N6, a queen with crown and scepter; S2, a queen crowned; S4, a queen with crown and scepter (Gough represents the last as a king, but the shape of the figure that remains and the length of the gown prove that a lady was represented); S5 a bearded king with crown and scepter.

48. Keepe (1681, 66) already noted that the blazoning had been completely worn away.

49. *Age of Chivalry*, 416.

50. The monument for the queen was apparently made immediately following her death in 1271; that for the king was begun before 1298 and installed in 1307 (Erlande-Brandenburg et al. 1975, 168–72).

51. Ibid., Figs. 152–55 and 157–59, for reproductions of both.

52. This trend was led, as was to be expected, by commissions for tombs of the kings and queens, as can be seen in those for the last Capetians in the 1320s. See Erlande-Brandenburg et al. 1975, 18–20, with further bibliography, and Adhémar 1974, 104, no. 558; 109, no. 589; 111, no. 600; 118, no. 639; and 123, no. 671, for drawings of the tombs. That other members of the family were quick to follow suit is suggested by the tombs for Robert d'Artois (d. 1317), finished by the sculptor Jean Pépin de Huy in 1320 (Françoise Baron, "Un Artiste du XIVe siècle, Jean Pépin de Huy. Problèmes d'attributions," *Bulletin de la Société de l'histoire de l'Art français*, 1960, 89); for Louis de France (d. 1319) and Marguerite d'Artois (d. 1311) (Erlande-Brandenburg et al. 1975, 17–18); and

for the heart of Charles, count of Anjou, king of Sicily (d. 1285), commissioned by his great granddaughter, Clémence de Hongrie in 1326 (Ibid., 20–21, and Gerhard Schmidt, "Drei pariser Marmorbildhauer des 14. Jahrhunderts," *Wiener Jahrbuch für Kunstgeschichte*, 24, 1971, 169).

53. Jean de Liège received partial payment of the two hundred marks due for making the tomb on January 20, 1367. See W. Burges, in Scott 1863, 170, and J. G. Noppen, "A Tomb and Effigy by Hennequin of Liège," *Burlington Magazine*, 59, 1931, 114. The text of the account is transcribed by Pradel (1954, 127). A terminus ad quem of 1371 is suggested by the inclusion in the tomb's program of Blanche of Lancaster, first wife of John of Gaunt. He married his second, Constance of Castile, in 1371, and by 1372, had assumed the title of king of Castile and Léon, by right of his wife, and had impaled his arms with hers. See *Age of Chivalry*, 538, for an example of these later arms in stained glass.

54. The fragments of the chest decoration that are intact are attributable to the restoration of Sir George Gilbert Scott. See Scott 1863, 64, and London, Victoria and Albert Museum, *Victorian Church Art*, London, 1971–72, no. F1, 56.

55. The inscription in Roman majuscule below the tomb on the ledge of the chapel platform in Sandford's engraving, "REGINA PHILIPPA * CONIVNX EDWARDI IACET HIC REGINA PHILIPPA * DISCE VIVERE," was probably contemporary with the epitaph on a tablet near the tomb recorded by Camden 1600; Stow 1633, 505; 1754, 598; and Sandford 1683, 172, which, to judge by its humanistic language, was postmedieval. I am indebted to Lisa Kiser for this observation.

56. The rationale for the chart is given in Appendix VI. Pradel's assertion (1954, 241–42) that only dead family members were represented on the tomb chest is counter to the antiquarian record of the tomb and to the evidence furnished by the shields still in situ. Martindale's summary of the program, based on Dart 1723, is inexact (1992, 157).

57. Martindale's statement (1992, 157) that the queen's relations were ranged down the south side of the tomb, and her husband Edward's down the north, oversimplifies the program.

58. This is reflected in Figure 59 by the divisions between niches.

59. See E. Perroy, *La guerre de Cent Ans*, 6th ed, Paris, 1945, 73, 78, 124, 130–31.

60. See Pirenne 3d ed., 1922, 2, 179–83, and M. Huberty, A. Giraud, and F. and B. Magdelaine, *L'Allemagne dynastique*, 4. *Wittelsbach*, Le Perreux-sur-Marne, 1985, 58, no. 86, for the foregoing.

61. For the latter observation, I am indebted to Nanci Alexander.

62. The crown can be seen in Sandford's engraving,

and two small holes in the band over which it would have been fitted can still be seen above the queen's forehead.

63. Scott (1863, 64–65) says that he made a cast of the head of the figure, which had been broken off in the process of opening up this end of the tomb. The original head was subsequently stolen, but the cast remains in the library at Westminster Abbey.

64. RCHM, 30. I have verified that this reading is indeed correct.

65. Gerhard Schmidt, "Beitrage zu Stil und Oeuvre des Jean de Liège," *Metropolitan Museum of Art Journal*, 4, 1971, 94–95. Pradel (1954, 242) had also dismissed the possibility that Jean de Liège had been responsible for the statuettes, reasoning that all of the figures represented were deceased, and that since Blanche of Lancaster died only in 1369, the statuette would have been executed, along with the others, after the sculptor had left England. His reasoning is disproved by my analysis of the program of the tomb chest.

66 Wendebourg 1986, 193.

67. For a reproduction of the effigy of Queen Jeanne d'Evreux and the effigy of Charles IV that accompanied it on the tomb at Maubuisson, see Schmidt, as in note 52 above, Fig. 11, and *Fastes du Gothique*, 122. Schmidt has rehabilitated these effigies and attributed them to Jean de Liège himself, rather than to his atelier, to which they had generally been consigned in the previous literature. His assessment has been followed by Françoise Baron (in *Fastes du Gothique*, no. 70) and Wendebourg (1986, 196).

68. Wendebourg's comparison of the head of the queen with the head of Bonne de France (1986, 194–95), first attributed to Jean de Liège by Gerhard Schmidt (1971, 98), and identified as the second daughter of Charles V by Françoise Baron (in *Fastes du Gothique*, 116–17, no. 65), is even more applicable to the plaster cast of the statuette of the queen (Fig. 61).

69. These two coppersmiths of London also furnished the effigy of Richard II, accoutrements for the two effigies, twelve images of saints, eight angels, and shields charged with coats of arms in gilt copper for the tomb, according to a contract drawn up in April 1395. See Colvin 1963, 487–88; Wendebourg 1986, 223–25; *Age of Chivalry*, 393–94, no. 446; and Binski 1995, 201. See Wendebourg 1986, Fig. 35, for a reproduction of the effigy of Anne of Bohemia.

70. The chest for the tomb of Richard II and Anne of Bohemia was due to the master mason Henry Yevele and to Stephen Lote according to a contract of April 1, 1395, which stipulated that it should be the same height as that of Edward III in the adjacent bay of the royal chapel (Colvin 1963, 487). Its resemblance to that tomb chest suggests that the chest for Edward's

tomb, ordered a decade earlier, was also due to Yevele, as suggested in Nigel Ramsay's discussion of the tomb of Richard II and Anne of Bohemia (*Age of Chivalry*, 393–94). For a discussion of the documentation concerning King Edward's tomb, see Colvin 1963, 487, and below, pages 121–25.

Six
The English Baron's Tomb
in the Fourteenth Century

1. William Dugdale, *Durham Monuments* (1666), ed. C. H. Hunter Blair, Newcastle upon Tyne, 1925, 55.

2. For the rebuilding of St. Mary's church initiated by Thomas Beauchamp, see Philip B. Chatwin, "The Rebuilding of St. Mary's Church, Warwick," *Transactions of the Birmingham Archaeological Society*, 65, 1943–44 (pub. 1949), 1. For the Calveley tomb, see Claude Blair, "The Effigy and Tomb of Sir Hugh Calveley," *The Bunbury Papers*, 4, 1951. The effigy was engraved by Stothard (1817–32, Pls. 98 and 99).

3. For the reassignment of the Kerdiston tomb, which was long thought to belong to Sir William's father, Sir Roger de Kerdiston, see M. J. Sayer, *Reepham's Three Churches*, Dercham, 1972, 19, and Wilson 1980, 248–49. Wilson has argued persuasively that the Ingham tomb, which he attributes to the London court architect, William Ramsey, was erected shortly after Sir Oliver's death in 1344. This furnishes a good indication of the source of the monument at Reepham, since Ramsey's daughter carried on his shop after his death in 1349 (see Wilson, in *Age of Chivalry*, 248–49). The differences between the monuments at Ingham and Reepham may reflect a change in the atelier at William Ramsey's death, but it is notable that the figures on the tomb chest at Reepham are superior in quality to those on the Ingham monument, and their relation to their counterparts on the tomb of Aymer de Valence, briefly noted in Chapter 4, suggests an earlier date for the Kerdiston tomb than after the 1361 death of Sir William.

4. For the tomb of Sir John, see *A Short History of the Parish Church of St. Mary and St. Eanswythe*, Folkestone, 1956, 4; for the tomb of Lady Clinton, see Samuel Hilton, *The Story of Haversham and Its Historical Associations*, Aylesbury (Bucks.), 1937, 51–54.

5. See K. B. McFarlane, *The Nobility of Later Medieval England*, Oxford, 1973, 34–38, for the war profits.

6. CP, 9, 499–503; DNB, 14, 271–73.

7. DNB, 3, 334–38.

8. CP, 12, Part 2, 372–74.

9. Phillips 1972, 131.

10. Juliet Vale, *Edward III and Chivalry: Chivalric Society and Its Context 1270–1350*, Woodbridge (Suffolk), 1982, 62, 69; Ormrod 1990, 12, 107.

11. DNB, 3, 714–15; J. C. Bridge, "Two Cheshire Soldiers of Fortune in the XIV Century: Sir Hugh Calveley and Sir Robert Knolles," *Journal of the Chester and Northern Wales Archaeological Society*, n.s., 14, 1908, 112–231.

12. DNB, 10, 435; CP, 7, 58–60.

13. CP, 7, 191–192; Sayer (as in note 3, above), 1972, 19.

14. Ormrod (1990, 102–5) treats the common cause between the nobility and the king created by the war. For the gentry in arms, see his pages 149–51.

15. This point has been admirably made by Albert Hartshorne, "On the Brass of Sir Hugh Hastings in Elsing Church, Norfolk," *Archaeologia*, 9, Part 1, 1906, 25–42, with illustrations in detail of the brass. See further, Paul Binski 1985, and in Coales 1987, 119–24, for a review of the iconography of the tomb plate and a thorough stylistic analysis that argues for its origin in a London shop with international links.

16. CP, 6, 352–53.

17. Hartshorne (1906, 35) identified this figure, which disappeared before 1782, as Edward le Despenser (d. 1375), cousin of Sir Hugh, but a case could also be made for identifying him as Edward's uncle, Sir Hugh le Despenser (d. 1349), who was Sir Hugh's contemporary and fought at Sluys and Crécy.

18. CP, 6, 154. The latter figure had previously been identified as Sir Roger Grey (d. 1353), but see Claude Blair, *Age of Chivalry*, 498, for the suggestion that the figure represents his eldest son John, since his arms are charged with a label.

19. CP, 4, 271–74, for Sir Hugh le Despenser; 6, 154, for Grey; 6, 352–53, for Hastings; 7, 396–401, for Lancaster; 10, 388–91, for Pembroke; 11, 298–99, for St. Amand; 12, Part 1, 174–77, for Stafford; and 12, Part 2, 372–74, for Warwick.

20. Martindale's statement (1992, 165) that none of the figures represented had any obvious family connection with Sir Hugh is in error.

21. For the tomb chests at Abergavenny and Sparsholt, see Claude Blair, "The Wooden Knight at Abergavenny," *Church Monuments. Journal of the Church Monuments Society*, 9, 1994, 43–47; for formal brotherhood bonds, see Maurice Keen, "Brotherhood in Arms," *History*, 47, 1962, 1–17; for the kinship established by knighting, Keen 1984, 68–69; and for how service to a great lord might even be reflected in the heraldic arms borne by a subordinate, Keen 1984, 166. The idea of brothers-in-arms seems to be expressed on the fourteenth-century double tomb of Thietmar, margrave of Anhalt, and his son at Nienburg a. d. Saale, where small warriors in armor recline beside

the effigies on the tomb slab. See Bauch 1976, 133, Fig. 213.

22. For the record of the controversy, which Sir Edward lost, see Charles George Young, ed., *An Account of the Controversy between Reginale Lord Grey of Ruthyn and Sir Edward Hastings in the Court of Chivalry in the Reign of King Henry IV*, London, 1841, and Anthony Richard Wagner, "A Fifteenth-Century Description of the Brass of Sir Hugh Hastings at Elsing, Norfolk," *The Antiquaries Journal*, 29, 1939, 421–28.

23. The blazons on these shields are no longer preserved, but an engraving in William Dugdale, *Antiquities of Warwickshire*, 2d ed., London, 1730, 1, 398, displays blazons on the shields on the south side of the chest, suggesting that an elaborate genealogy was represented by the figures.

24. Blair 1951, n.p. It is interesting to note, however, that the college founded by Sir Hugh at Bunbury was charged to say daily prayers for his soul, that of the king, and those of their *respective ancestors*.

25. Biver's initial remarks (1909, 252–58) were considerably developed by Stone (1955, 141–50, 155, 159–68), who added a number of examples to his list and placed the discussion in a richer historical framework.

26. See Warner 1924, 57–58, and Bill 1960, 10. For a list of the Montacute children, see *Cartulary of St. Frideswide*, 9, and CP, 11, 385–88.

27. Warner 1924, 57–58; Bill 1960, 10.

28. CP, 1, 373.

29. Lincoln, Lincolnshire Arch., Bishop's Reg. 4, fol. 39–40v; the former is translated in C. W. Foster and A. Hamilton Thompson, "The Chantry Certificates for Lincoln and Lincolnshire, returned in 1548 under the Act of Parliament of Edward VI," *Lincolnshire Architectural and Archaeological Society, Reports and Papers*, 36, 1922, 207–10.

30. The admission of Sir Bartholomew into brotherhood with the dean and chapter, recorded in the chapter martyrology, was transcribed by Gough (1786–96, 1, 109–10).

31. "domini Roberti de Burghersch patris dictorum dominorum Henrici et Bartholomei ad pedes dicti domini Henrici in capella beate Katerine predicte tumulati . . . set missa in dicta capella sancte Katerine iuxcta funus suum cantabitur pro anima sua" (Lincoln, Lincolnshire Arch., Bishop's Reg. 6, fols. 147–147v; Foster and Thompson 1922, 213).

Since the date of this document is instructive in dating the tombs, it is important to note that it is dated April 28, 1345, following the appearance of Sir Bartholomew before the cathedral chapter on the Feast of Saint George (April 23) (Lincoln, Lincolnshire Arch., Bishop's Reg. 6, fols. 145, 148), rather than on the Feast of Saint Gregory (March 12), as read by Fos-

ter and Thompson (1922, 210), which would place the document one year later. I am grateful to Dr. G. A. Knight, principal archivist of the Lincolnshire Archives, for discussing this passage with me.

32. Lincoln, Lincolnshire Arch., Bishop's Reg. 6, fol. 145; Foster and Thompson 1922, 211.

33. Lincoln, Lincolnshire Arch., Bishop's Reg. 6, fol. 147; Foster and Thompson 1922, 212–13.

34. The chapel is now devoted to the cult of Saint Gilbert. Cook (1963, 135, Fig. 13) gives a useful plan, indicating the location of the chapel and the Burghersh tombs, but his account of the Burghersh chantry is inexact.

35. The outer sides of the tombs of Bishop Henry and Sir Robert were probably initially left undecorated, as was their counterpart on the opposite side of the choir. The tomb of Nicolas de Cantilupe (d. 1355), which is decorated with shields of Cantilupe on the south side of the chest, facing the Cantilupe chapel, remains plain on the side facing the center aisle of the choir. Probably later in the fourteenth century the present facings, visible on the right side of Fig. 68, were added to the Burghersh chests on the outer sides. Their design is different from that found on the north. Instead of arcades housing statuettes, each chest is decorated with four large shields set within barbed quatrefoil frames and surmounted by a relatively flat cornice studded with alternating lions' faces and rosettes, instead of the richer version of the same cornice studded with human heads and finials on the north side of the chests and on the shrine base. The shields themselves suggest a later campaign for the decoration of the outer sides of the chests. Aside from the Burghersh and Tybotot arms, those arms that have been identified (Percy, Clifford, Scrope, and Cantilupe) refer to families that bear only a tangential relationship to the Burghershes.

36. Coldstream 1976, 19.

37. See below and Appendix VII.

38. The marriage was of Maud Ros to John Welles. According to CP, 12, Part 2, 441, John Lord Welles married Maud, probably the daughter of William de Ros by Margery, sister and coheir of Giles Badlesmere, in 1344–45. The heraldry on this tomb confirms this hypothesis.

39. The document of 1345 proves that Sir Bartholomew's burial in the chapel had already been arranged: "in dicta capella ubi corpus suum disposuit tumulari" (Lincoln, Lincolnshire Arch., Bishop's Reg. 6, fol. 147v). (Foster and Thompson's reading of this passage as referring to the accomplished, rather than the projected, burial of Sir Bartholomew is obviously in error.) Sir Bartholomew's son and heir, also named Bartholomew, confirmed in 1358 certain alterations to the chantry made by his father before his death that affected the chaplains (Foster and Thompson 1922,

215–16). He must have attended to the erection of his father's tomb as well if this had not already been done.

40. They seem to be the secular counterparts of the monks seated around the bier and hearse in the illustration of the Office of the Dead in the *Très Belles Heures de Notre-Dame* (Paris, Bibl. Nat., Ms. nouv. acq. lat. 3093, fol. 104), illuminated for Jean de Berry circa 1384 (Millard Meiss, *French Painting in the Time of Jean de Berry: The Late XIV Century and the Patronage of the Duke*, 2d ed., London 1969, 2, Pl. 14). See also the funeral of a king in the English Coronation Order circa 1380–90 (Pamplona, Archivo General de Navarra, Ms. 197, fol. 22v), reproduced in Lucy Freeman Sandler, *Gothic Manuscripts 1285–1385*, London 1986, 1, Fig. 418; 2, 179–80. Bishop Henry had ordered that the clerks participate daily in the celebration of the mass, vested in their habits, especially helping with the singing (Lincoln, Lincolnshire Arch., Bishop's Reg. 4, fol. 40; Foster and Thompson 1922, 109).

41. See Anne M. Morganstern, "The Bishop, the Lion and the Two-headed Dragon: The Burghersh Memorial in Lincoln Cathedral," *Memory and Oblivion: Acts of the 29th International Congress of the History of Art*, Dordrecht, 1998, for a detailed discussion of the political nuances suggested by the tomb programs.

42. Mary J. Carruthers, *The Book of Memory: A Study of Memory in Medieval Culture*, Cambridge, 1990, 62–63, 122–29, 271.

43. Ibid., 70.

44. H. A. Oberman, *Archbishop Thomas Bradwardine: A Fourteenth Century Augustinian*, Utrecht, 1957, 12–17.

45. DNB, 2, 1097.

46. For a discussion of Bradwardine's treatise, see Carruthers 1990, 130–33; for a translation of the text, 281–88.

Seven
The Tomb of Edward III and New Developments in England

1. Stone 1955, 192–93; Wendebourg 1986, 207; Binski 1995, 196.

2. Burges, in Scott 1863, 173.

3. Binski 1995, 198–99.

4. It is notable that the family portrayed on the east wall of St. Stephen's chapel, destroyed circa 1800, included only the children who lived beyond infancy (John Page-Phillips, *Children on Brasses*, London, 1970, Fig. 3; *Age of Chivalry*, 499–500, no. 681).

5. John Nichols, *A Collection of all the Wills, now known to be extant, of the Kings and Queens of England, Princes and Princesses of Wales, and every*

Branch of the Blood Royal, repr. of 1780 ed., New York, 1969, 60–61.

6. London, Brit. Lib., Ms. Lansdowne 874, fol. 135v. The same order is given in Stow 1618, 857; Keepe 1681, 151; Sandford 1683, 176; Dart 1723, 2, 42; Gough 1786–96, 1, 139; and Powell, in London, Brit. Lib., Ms. Add. 17694 (pub. 1795), fol. 81.

7. "monsigneur, je vous pri que vous ne voelliés eslire aultre sepulture que de jesir dalés moy, ou clostre de Wesmoustier, quant Diex fera sa volenté de vous" (Jean Froissart, *Chroniques*, ed. S. Luce, G. Raynaud, L. Mirot, and A. Mirot, Paris, 1869–1931, 7, 182).

8. Stow (1754, 2, 547) and Dart (1723, 2, 42) say that Edward's body lies in the same grave with Philippa's, as she requested on her deathbed.

9. Colvin 1963, 1, 487; J. W. Blair and N. L. Ramsay, eds., *English Medieval Industries: Craftsmen, Techniques, Products*, London, 1991, 43; Binski 1995, 196.

10. Wendebourg 1986, 206–7; Binski 1995, 196. See Chapter 8, pages 133–35, for the relative progression of work for the various parts of the similar tomb of Richard Beauchamp, earl of Warwick.

11. Gardner 1951, repr. 1973, 291; Stone 1955, 192–93; Phillip Lindley, "'Una grande opera al mio re': Gilt-bronze effigies in England from the Middle Ages to the Renaissance," *Journal of the British Archaeological Association*, 143, 1990, 122, with a question mark. Stone accepted a long tradition according to which the bronze effigy is based on a death mask that would also have served as the model for the wooden effigy of the king used in the funeral ceremony, which is now preserved in the Westminster Museum. But this tradition is questionable. See R. P. Howgrave-Graham, "The Earlier Royal Funeral Effigies: New Light on Portraiture in Westminster Abbey," *Archaeologia*, 98, 1961, 160–62, for an account of the restoration of the wooden effigy after World War II, and the conclusion that its face is the actual death mask that recorded the final paralysis of the king caused by a stroke. If the bronze effigy had been made during the lifetime of the king, it would presumably resemble the record of his features preserved in a death mask, but with a difference in nature. And there are significant differences between the wooden effigy and the bronze. The distorted mouth of the wooden effigy is not apparent in the bronze. The treatment of the eyes, so vividly modeled in the bronze effigy, are without the prominent expressive ridge of the brow in the wooden effigy. Overall, the wooden effigy looks rather helpless and decayed, without the compelling intensity of the metal image of the king.

12. Stone 1955, 192. Wendebourg (1986, 208) and Binski (1995, 197) later came to the same conclusion.

13. The portrait qualities of the effigy of Edward III

were already recognized by W. R. Lethaby (*Westminster Abbey and the Kings' Craftsmen: A Study of Mediaeval Building*, London, 1906, repr. 1971, 189) and Gardner (1951, repr. 1973, 291), and they have been reiterated most recently by Paul Williamson (in *Age of Chivalry*, 104), who still assumes that the bronze effigy was based on the death mask made for the funeral of the king.

14. Paris, Bibl. Nat., Mss. fr. 167 and fr. 1586. See François Avril, *Manuscript Painting at the Court of France: The Fourteenth Century*, trans. Ursule Molinaro, New York, 1978, 77–78, 84–88, and Pls. 19, 20, 23–25, and *Fastes du Gothique*, nos. 271 and 272, for further illustrations.

15. Stella Mary Newton, *Fashion in the Age of the Black Prince: A Study of the Years 1340–1365*, Woodbridge and Totowa (N.J.), 1980, 30, 54. See also the kneeling effigy of Edward, Lord Despenser, dated by Stone previous to his death in 1375 (Stone 1955, 184, and Pl. 137).

16. Avril 1978, Pl. 24.

17. See above, page 108. In fact, the costume of Lady Montecute's daughters is already to be seen on the tomb of Sir Robert Burghersh (Fig. 71), which was erected in the 1340s.

18. Jean Favier, *La Guerre de Cent Ans*, Paris, 1980, 225–26, 269–86.

19. Although the Yorkshire tombs are undated, they have been recognized as the workmanship of a single shop (Pevsner and Metcalf 1985, 96). The death of Thomas de Ingilby circa 1369 furnishes a general terminus a quo for the Ingilby monument; Lord Neville's impeachment and disappearance from the court, in 1376, seems relevant to the relatively provincial character of his (Christopher Wilson, "The Neville Screen," in *Medieval Art and Architecture at Durham Cathedral* [British Archaeological Association Conference Transactions 3, 1977], 1980, 98; Pevsner and Metcalf 1985, 96).

20. Ormrod (1990, 44–45) has emphasized Edward's consciousness of his image.

21. For the effigy of Jeanne d'Evreux for Saint-Denis, which was apparently stored for many years in the treasury, see Stephen K. Scher, "The Sculpture of André Beauneveu," Yale University, Ph.D. dissertation, 1966, 63–64, and Schmidt 1971, 99–100, and Fig. 10. For the three tombs of Charles V, all initiated before his death, see *Fastes du Gothique*, 1981, 119, 129–30, nos. 67, 74–75, with further bibliography. For the tomb of Louis de Mâle, see below, page 140. For the tomb of Philippe le Hardi, see most recently, Kathleen Morand, *Claus Sluter: Artist at the Court of Burgundy*, London, 1991, 360–64.

22. Martindale (1992, 163) has also made this observation but cited only two examples.

23. For the program of the Ingilby tomb, see *A Short History of the Parish Church of All Saints' Ripley*, Harrogate, n.d., 3; for the Elrington tomb, see London, Brit. Lib., Mss. Lansdowne 874, fol. 66, and Add. 27348, fol. 94–97. For the Fitzherbert tombs, see L. J. Bowyer, *The Ancient Parish of Norbury*, Ashbourne (Derbyshire), 1953, 83–86.

24. Hans Peter Hilger, *Kreis Kleve* (Die Denkmaler des Rheinlandes, 4), Dusseldorf, 1967, 64–69; Cologne, Schnütgen-Museums in der Kunsthalle, *Die Parler und der Schöne Stil 1350–1400, Europäische Kunst unter den Luxemburgers*, Cologne, Museen der Stadt, 1978, 1, 114–15.

25. Anselme, (6, 410) lists four surviving children of the Morvilliers: Pierre de Morvilliers, councilor in Parliament in 1436; a second Pierre, knight and chancellor of France (probably the same as the first; see Plagnieux 1993, 366); and two married daughters, Marie and Philippa. The chrisom children represented on the tomb chest were interpreted by s'Jacob (1954, 52) as deceased relatives joining the procession of mourners or personifications of the decay of the flesh, but they must represent children who died in "ye cradle, or swathes" by analogy with a contract of 1582, published by Crossley (1921, 32). See further, F. A. Greenhill, *Incised Effigial Slabs: A Study of Engraved Stone Memorials in Latin Christendom, c. 1100 to c. 1700*, London, 1976, 1, 288–89.

26. Bowyer 1953, 83–86.

27. See, moreover, the evidence of the importance of the nuclear family among the English nobility of the fourteenth and fifteenth centuries cited by Jennifer Ward, *English Noblewomen in the Later Middle Ages*, London and New York, 1992, 97–103.

28. Crossley 1921, 30–31.

29. Williamson, in *Age of Chivalry*, 106.

30. The assignment of the effigy at Barthomley to Sir Thomas Foulshurst (d. 1404), rather than to his father, Robert, was suggested to me by Mr. A. J. Bostock, who is conducting a survey of the medieval monuments in Cheshire. The tomb chest is no doubt from a later tomb, as already recognized by Arthur Gardner, *Alabaster Tombs of the Pre-Reformation Period in England*, Cambridge, 1940, 88, and Nikolaus Pevsner and E. Hubbbard, *Cheshire* (The Buildings of England, 42), London, 1971, repr. 1977, 72.

31. In their translation of the first book of Durandus's *Rationale Divinorum Officiorum*, published in 1843, Neale and Webb noted that men and women still sat apart in church in some parts of England, a practice that they strongly endorsed (Durandus 1973, 36, no. 67).

32. Blanket obtained a royal license in 1371, to found a chantry in the church formerly on the site of the present one. See C. F. Pilkington, ed., *Bristol City Parish Church: St. Stephen with St. Nicholas and St. Leonard*, Bristol and Bridgwater, 1977, 16, and Niko-

laus Pevsner, *North Somerset and Bristol* (*The Buildings of England*, 13), London, 19, repr. 1979, 409.

33. Since De Valkeneer's publication of this monument (1963, 203–4, Fig. 44), it has been disassembled. The effigy, carved on a tomb slab with the epitaph, is stored at the Hôtel de Croix in Namur, while a fragment of the chest, with two of the original three praying statuettes, is exhibited at the Musée archéologique of Namur. I am indebted to M. Danzin of the Musée archologique for facilitating my study of the tomb. For a photograph of the entire monument before the disassembly, see Robert Didier, *La Sculpture Mosane du XIV^e Siècle*, Namur 1993, Fig. 66.

34. The tombstone of Dame Havise at Tournan-en-Brie cited by Mâle (1908, 412) and dated circa 1230 by the Abbé Lebeuf, who saw it in the eighteenth century, has since disappeared, and the date could not be verified.

35. For tombstones of the middle class from the thirteenth century, see Adhémar 1974, nos. 168, 234, 257, 284, 320, 367, 368, 405, 412, 415, 431, 441, 457.

36. Dehaisnes 1886 (*Documents*), 2, 597.

37. M. de Beaurepaire, "Pierres tombales: Conventions," *Bulletin de la Commission des Antiquités de la Seine-Inférieure*, 3, 1874, 215.

38. Greenhill 1976, 2, Pl. 66.

39. Page-Phillips 1970, Figs. 7, 9–15, 19–21, 23–24.

40. Ibid., Figs. 6 and 8.

41. This point has been cogently made by Stone (1955, 177–81) in a succinct treatment of the social and economic factors affecting sculpture in England in the second half of the fourteenth century.

42. Plagnieux 1993.

43. Ibid., 364.

Eight
The Great Lord's Tomb of Kinship

1. The chapel was consecrated as late as 1475, according to William Dugdale (*Antiquities of Warwickshire*, 2d ed., London, 1730, 1, 447), but he says that it was begun in 1442–43, and finished in 1463–64 (445). In fact, however, the chapel must have been nearing completion in June 1447, when a contract was drawn up for the window glass (446).

2. The bear and griffin were the emblems of Warwick and his second wife, Isabel le Despenser. See Philip B. Chatwin, "Monumental Effigies in the County of Warwick," *Birmingham Archaeological Transactions*, 47, 1924, 60–64, for a more detailed description of the monument.

3. The Archer notes are preserved today in the Oakley Park Library. Two copies of them are also known: one by R. B. Wheler (London, Brit. Lib., Ms. Add. 28564, fols. 252v–68); the other by James Saunders (Shakespeare Birthplace Trust Archives, ER 1/99, fols. 50–61v). I have had the opportunity to examine only the Wheler and Saunders copies, but Phillip Lindley, who has studied the Archer transcript, kindly checked my deductions against his notes. I am also grateful to Mr. Robert Bearman, archivist at the Shakespeare Birthplace Trust, for informing me of the whereabouts of the Archer notes and the copies, and for furnishing a photocopy of the Saunders transcript.

4. Saunders, 61–61v. See Lindley 1990, 120–22, for a discussion of the production of the effigy; and 1995, 62–66 and 68–69, for a discussion of the roles of the various craftsmen. A contract of May 23, 1449, involved not only the founder, William Austen, but also Roger Webbe, barber; John Massingham, carver; and Lambespring in its production (Wheler, fol. 26; Saunders, fol. 59–60v; Chatwin 1924, 62).

5. Wheler, fol. 263; Saunders, 55–55v.

6. The term "morner" used in a contract for an alabaster tomb in 1421 anticipates the term, but it is interesting that both occurrences are relatively late. See Stone 1955, 197–98, for the contract in which "morner" appears.

7. Wheler, fol. 263–64; Saunders, fol. 56–57.

8. Stone 1955, 208, and n. 47.

9. Wheler, fol. 257; Saunders, fol. 52. The entry is always the same: "Johni Bord, Marbelor, in prestu."

10. Wheler, fol. 255; Saunders, fol. 51.

11. Wheler, fol. 166; Saunders, fol. 58–59v.

12. Wheler, fol. 262; Saunders, fol. 54–55v. Prior and Gardner (1912, 412) suggested that John Essex, who had a workshop in St. Paul's Yard, London, designed the tomb, since he was later called in with Stevens to advise Henry VII about his tomb projected for Westminster. In fact, although Essex only appears at Warwick in the contract of 1454, he is qualified there as a marbler, and since this contract concerns a brass plate to cover the chest executed by John Bourde "according to a portraiture delivered him" (Wheler, fol. 263–64; Saunders, fol. 56–57), it is quite conceivable that John Essex designed the chest and was accordingly involved in designing the brass plate to cover it.

13. Wheler, fol. 258; Saunders, fol. 52v.

14. The watercolor is in a manuscript compiled by Sir William Dugdale known as the "Book of Monuments" (London, Brit. Lib., Ms. Add. 71474), abbreviated here as BM. The plate is reproduced in color in a volume by Dugdale's descendant, Sir William Dugdale (*The Restoration of the Beauchamp Chapel at St. Mary's Collegiate Church Warwick 1674–1742*, Oxford, 1956, Pl. VI).

15. The documentation of the restoration has been systematically examined by Dugdale (1956, 15–55). See especially the bill of charges (42–43).

16. The 1972 conservation campaign included a careful cleaning of the metalwork and the tomb chest and some consolidation of the latter. I am very grate-

ful to Ruth Guilding of the Council for the Care of Churches for giving me access to the conservation report of 1972.

17. CP, 12, Part 2, 383–85.

18. Ibid., 384–92.

19. See above, page 103 and Figure 63. Only fifteen of the present figures are original, but their placement suggests that the tomb originally displayed an alternation of lords and ladies. This is confirmed by the drawing of the monument published by Dugdale (1730, 1, 398).

20. The epitaph, which is transcribed both by Dugdale (1730, 1, 410) and Richard Gough (*Description of the Beauchamp chapel adjoining to the Church of St. Mary, at Warwick; and the Monuments of the Earls of Warwick, in the said church and elsewhere*, London, 1809, 16), gives, besides the usual eulogy and titles of the earl, the details of his last sickness and burial according to the instructions in his will, an obvious concern of his executors, who must have devised the epitaph, or at least had a part in it.

21. Stone 1955, 209.

22. Jaap Leeuwenberg, "De tien bronzen 'Plorannen' in het Rijksmuseum te Amsterdam, hun herkomst en de voorbeelden waaraan zij zijn ontleend," *Gentse Bijdragen tot de Kunstgeschiedenis*, 13, 1951, 32–33, cites the tombs of King Edward III and Richard Beauchamp as forerunners of the tombs discussed below.

23. Anselme, 2, 716.

24. Marguerite Devigne ("Un nouveau document pour servir à l'histoire des statuettes de Jacques de Gérines," *La Revue d'Art*, 23, 1922, 90, 93) first suggested that the tomb of Joanna de Brabant was a copy of the Lille tomb. This is further supported in the discussion by Leeuwenberg (1951, 14–18) and D. Roggen ("Prae-Sluteriaanse, Sluteriaanse, Post-Sluteriaanse Nederlandse Sculptuur," *Gentse Bijdragen tot de Kunstgeschiedenis*, 16, 1955–56, 175–78). The monument is known from two drawings: one by Charles van Riedwijck, the other by Antoine de Succa. See Dallemagne 1942–43, 84–86, and Succa, 1, 220, and 2, fol. 74. Riedwijck's drawing was the source for an engraving by Butkens (1724, 1, 526).

25. Alexandre Pinchart, "Jacques de Gerines, batteur de cuivre du XVe siècle, et ses oeuvres," *Bulletin des commissions royales d'art et d'archéologie*, 5, 1866, 120–22.

26. Lille, Arch. Nord, B 3775–113513. The contract was first published by A. Le Glaye et al., *Inventaire sommaire des archives départementales du Nord*, Sér. B, Lille, 1863–1906, 7, 364–65, and in English translation in Richard Vaughan, *Philip the Good*, London, 1970, 154.

27. Pinchart 1866, 125–26.

28. A.-L. Millin, *Antiquités nationales*, Paris, 1790–99, 5, 58. For an inventory of the considerable

visual record of the tomb of Louis de Mâle, see Leeuwenberg 1951, 14–15, 37. The most useful of the sources cited by him are the engravings of the monument in Millin; a complete set of drawings of its statuary by Succa (1, 166–73; 2, fols. 55–58v); and fifteenth-century silverpoint drawings of four of the statuettes. Only two of the silverpoint drawings are still preserved, in Rotterdam, Museum Boymans-van Beuningen, nos. MB 1950/T20 and MB 1950/T21. For reproductions of all four, see Max J. Friedländer, *Early Netherlandish Painting*, I. *The Van Eycks-Petrus Christus*, trans. Heinz Norden, New York, 1967, Pls. 100–101. A drawing of the south side of the tomb in the Bibliothèque Nationale in Paris (Ms. Coll. Bourgogne 16, fol. 5) may be added to Leeuwenberg's inventory.

29. The inscriptions were transcribed by Millin (1790–99, 5, Sect. 54, 61–69). His system for numbering the statuettes, reflected both in his list of the inscriptions and in his depictions of the figures (5, Sect. 54, Pls. 6 and 7) began at the head of the tomb chest at the left niche (W1 on Fig. 100) and read continuously from left to right completely around the tomb. A glance at our Figures 99 and 101 demonstrates that this reading is anachronistic, for the arrangement of the figures corresponded to the genealogy if read from the head to the foot of the tomb. See Appendix XI for a transposition of Millin's numbers into the system suggested by the genealogy.

30. See C. M. A. A. Lindeman, "De dateering, herkomst en identificatie der 'Gravenbeeldjes' van Jacques de Gérines," *Oud Holland*, 58, 1941, 161–68, 193–200; Leeuwenberg 1951, 28–29; and Succa, 2, 167.

31. See above, note 28. Critical opinion of the drawings has generally shifted from the initial attribution to Jan van Eyck and the assumption that they were preparatory drawings for the Lille figures (L. Baldass, *Jan van Eyck*, London, 1952, 80–81, 181–283, and others cited by him) to their attribution to a member of the circle of Rogier van der Weyden (Erwin Panofsky, *Early Netherlandish Painting*, Cambridge [Mass.], 291, n. 4) or another court artist (M. Comblen-Sonkes, *Dessins du XVe Siècle: Groupe van der Weyden*, [Les Primitifs flamands, 3; Contributions à l'étude des primitifs flamands, 7], Brussels, 1969, 242–48), which implies that they were either copied from the tomb figures (Leeuwenberg 1951, 24–25; Comblen-Sonkes 1969, 242–48) or derived from a common source (Lindeman 1941, 165).

32. Lindeman 1941, 99; Leeuwenberg 1951, 30–31; D. Roggen, "Prae-Sluteriaanse, Sluteriaanse, Post-Sluteriaanse Nederlandse Sculptuur," *Gentse Bijdragen tot de Kunstgeschiedenis*, 16, 1955–56, 178.

33. For the tomb of Isabelle de Bourbon, see Leeuwenberg 1951, 16, 18–24; Detroit, Institute of Arts, *Flanders in the Fifteenth Century: Art and Civiliza-*

tion, Detroit and Brussels, The Detroit Institute of Arts and the Centre National de Recherches Primitifs Flamands, 1960, 264–67; and Amsterdam, Rijksmuseum, *Beeldhouwkunst in het Rijksmuseum*, Catalogue by Jaap Leeuwenberg and Willy Halsema-Kubes, Amsterdam, 1973, 40–45. For a recent discussion of the statuettes, see John W. Steyaert (*Late Gothic Sculpture: The Burgundian Netherlands*, Ghent, 1994, 138–41), who emphasizes the influence of the sculptor, Jean Delemer, carver of wooden models for the tomb of Joanna of Brabant, who was therefore possibly also involved in the conception of the tomb in Lille.

34. Amsterdam, Rijksmuseum, Am. 33-a.-j. Confirmation of the material, which has been described as both brass and bronze in the literature, was recently established by a material analysis of the statuettes. I am grateful to Mme. W. Halsema-Kubes, curator of sculpture at the Rijksmuseum, for informing me of the results.

35. Lindeman 1941, 97–105; Leeuwenberg 1951, 13–14, 21–23. This can be appreciated in comparing our Figure 102, representing John IV of Brabant, with Figure 104, a lord from the tomb of Isabelle de Bourbon.

36. Theodor Müller (*Sculpture in the Netherlands, Germany, France, and Spain 1400 to 1500* [Pelican History of Art], Harmondsworth and Baltimore, 1966, 62) attributes this reduplication partly to the common practice in the founders' workshops of using earlier models.

37. On the tomb of Marie de Bourgogne, see the very interesting study by Ann M. Roberts ("The Chronology and Political Significance of the Tomb of Mary of Burgundy," *The Art Bulletin*, 71, 1989, 376–400), who correctly invoked the political implications of the genealogy represented on the tomb without realizing the long history of the type. For the tomb of Charles le Téméraire, initiated considerably later by the emperor Charles V, see Suzanne Collon-Gevaert, *Histoire des arts du métal en Belgique*, Brussels, 1951, 1, 281–84.

38. And not, as Gert von der Osten, and Horst Vey (*Painting and Sculpture in Germany and the Netherlands 1500 to 1600* [The Pelican History of Art], Harmondsworth and Baltimore, 1969, 44) state, completely new in its inclusion of ancestors in the "procession." Collon-Gevaert (1951, 1, 280–81, no. 3) and Panofsky (1964, 62) associated the Innsbruck monument with the Burgundian tombs in the Netherlands long ago. For the very complicated history of the realization of Maximilian's tomb, see Karl Oettinger, "Die Grabmalkonzeption Kaiser Maximilians," *Zeitschrift des Deutschen Vereins für Kunstwissenschaft*, 19, 1965, 170–84; and Jeffrey Chipps Smith, *German Sculpture of the Later Renaissance c. 1520–*

1580: Art in an Age of Uncertainty, Princeton, 1994, 185–92. For good photographs of the statues and a convincing assessment of their meaning, see Erich Egg, *Die Hofkirche in Innsbruck. Das Grabdenkmal Kaiser Maximilians I. und die Silberne Kapelle*, Innsbruck, 1974, who stresses the political intention of the program and its essential difference from the Burgundian tombs in France; and finally and above all, Schmid, in *Memoria*, 750–86, for Maximilian's initial plans for the tomb, and its intended liturgical setting, where, in the midst of representations of his predecessors, he would attain immortality through the *memoria* realized by perpetual prayers and masses, safeguarded by the Order of Saint George.

Conclusion

1. *Memoria*, 413–18.

2. Wood 1955, 8–21; Schmid 1957, 42–44, repr. 1983, 224–26.

3. See Walter Ullmann, *The Individual and Society in the Middle Ages*, Baltimore, 1966, 46–47, for the relation between the priesthood and the laity as analogous to that between the soul and the body.

4. For the Guelph family tree, see Oexle 1978, 207–19, 221, 226–28. For other examples, see Violante 1977, 92; Oexle 1978, 207–10, 224–26; and Nora Gädeke, *Zeugnisse Bildlicher Darstellung der Nachkommenschaft Heinrichs I*, Berlin and New York, 1992, 1–3, 25–29, 253–62. For England, see Wood 1955, 122–25. For a late example, see the fourteenth-century pictorial chart of the kings of France in the royal copy of Ivo de Saint-Denis's *Vita et Passio Sancti Dionysii* (Paris, Bibl. Nat., Ms. lat. 13836, fol. 78), discussed and illustrated in Hedeman 1991, 35, and Fig. 21.

5. For the close relationship between clerics and their lay brothers and sisters in the early Middle Ages, see Karl Schmid, "Religiöses und sippengebundenes Gemeinschaftsbewusstsein in frühmittelalterlichen Gedenkbucheinträgen," *Deutsches Archiv für Erforschung des Mittelalters*, 21, 1965, 59–63, repr. in *Gebetsgedenken und adliges Selbstverständnis im Mittelalter*, Sigmaringen, 1983, 575–79.

6. Sauer 1993, 327–34.

7. See Wood 1955, 131, for sentiments similar to those expressed by Abbot David of St. Augustine's, Bristol, in the thirteenth century.

8. For the contents of several memorial books, see Oexle, in *Memoria*, 392–95; for the cartulary/chronicle of Echternach, see Sauer 1993, 247–67.

9. Lorne Campbell, *Renaissance Portraits: European Portrait-Painting in the Fourteenth, Fifteenth, and Sixteenth Centuries*, London, 1990, 42–43. The panels are now in the Groot Seminarie in Bruges. For

a description of all of them, see B. Janssens de Bisthoven, *De Abdij van de Duinen te Brugge,* Bruges, 1963, 24–35.

10. As pointed out by Campbell (1990, 42). In the panel reproduced here, the ladies at the upper right and lower left and right are mirror images of Millin's numbers 9, 15, and 11.

11. See, moreover, the evidence for the placement of the founder's tomb and her family presented by Teuscher (1990, esp. 141–45).

12. McLaughlin 1985, 102, 368. See also pages 376 and 379–85 for her evidence on the twelfth-century tomb as status symbol.

13. See Wood-Legh 1965, 65–92, for the considerable anxiety felt by many founders of chantries over the long-term security of their foundations, and for their efforts to ensure them, thereby, in their minds, assisting their eventual entry into heaven. See also her conclusions on page 305.

14. See Chapter 3, pages 61–62.

15. Duby 1973, 343.

16. Ibid., 344–48.

17. Robert Boutruche, *Seigneurie et Féodalité,* 2d ed., Paris, 1968–70, 2, 231–32; Duby 1973, 152; 1977, 71–75, 117; 1983, 92–99. For the durability of the patrilineal model of inheritance into the fifteenth century, see Henri Bresc, "L'Europe des Villes et des Campagnes (XIIIe–XVe siècle)," in *Histoire de la Famille,* ed. André Burguière et al., Paris, 1986, 1, 385–419.

18. Génicot 1975 (*Généologies*), 18–22; Duby 1977, 151–52, 268, 289.

19. For the new laws governing taxation in France, see Duby 1977, 108–9; for the situation in Flanders, where the kinship tomb was to flourish in the late thirteenth and fourteenth centuries, see E. Warlop, *The Flemish Nobility before 1300,* trans. J. B. Ross and H. Vandermoere, Courtrai, 1975, 1, 276–98, 322–31; for the emphasis on lineage in the chivalric world of the later Middle Ages, see Keen 1984, 143–48. I am pleased that Andrea Teuscher (1990) agrees with my assessment of the social factors that prompted the appearance of the kinship tomb in her recent dissertation on the tombs of the House of Dreux at Braine.

20. McFarlane 1973, 122–25.

21. For the proliferation of written genealogies in France after 1160, see Duby 1977, 151–52. For the appearance of vernacular histories in the context of the altered social status of the aristocracy at the beginning of the thirteenth century, see Gabrielle Spiegel, "Pseudo-Turpin, the Crisis of the Aristocracy and the Beginnings of Vernacular Historiography in France," *Journal of Medieval History,* 12, 1986, 207–23, and "Social Change and Literary Language: The Texturalization of the Past in Thirteenth-Century Old French Historiography," *Journal of Medieval and Renaissance Studies,* 17, 1987, 129–48; for the close associa-

tion between the coat of arms, pride of lineage, and esteem for martial achievement, see Keen 1984, 132.

22. Erlande-Brandenburg 1975, 106. See further, Spiegel 1978, 61–62, 103–5.

23. "[M]oult de gent et meismement li haut homme et li noble qui souvent viennent en l'église monsignour Saint Dyonix de France, ou grant partie de vaillans roys de France gisent en sepouture, desirent cognoistre et savoer la naissance et la descendue de lour très-haute généracion et les merveillous faiz qui sunt raconté et publié par maintes terres des devant diz rois de France" (quoted from Erlande-Brandenburg 1975, 106).

24. See Teuscher 1990, 190.

25. See above, page 107.

26. For the relation between written genealogies and political exigency, see Duby 1973, 291.

27. See, however, Patrick Corbet, *Les saints ottoniens. Sainteté dynastique, sainteté royale et sainteté féminine autour de l'an Mil,* Sigmaringen, 1986, 263–65; 1991, 102; Ward 1992, 34–35; and Miriam Shadis, "Piety, Politics, and Power: The Patronage of Leonor of England and Her Daughters Berenguela of Léon and Blanche of Castile," in *The Cultural Patronage of Medieval Women,* ed. June Hall McCash, Athens (Ga.) and London, 1996, 211.

For medieval noblewomen as tomb patrons, Mahaut, countess of Artois, immediately comes to mind. For the contract for the tomb of her husband (Otton, count of Burgundy) with the Parisian artist Jean Pépin de Huy, see Dehaisnes 1886 (*Documents*), 1, 202–3, published in English translation by Theresa G. Frisch, *Gothic Art 1140–c. 1450* (Sources and Documents in the History of Art Series, ed. H. W. Janson), Englewood Cliffs (N. J.), 1971, 113–14. See further Pierre Pradel, "Les ateliers des sculpteurs parisiens au début du XIVe siècle," *Comptes rendus de l'académie des inscriptions et belles-lettres,* 1957, 67–74, and Françoise Baron, "Un artiste du XIVe siècle: Jean Pépin de Huy. Problèmes d'attribution," *Bulletin de la Société de l'histoire de l'art français,* 1960, 89; "Le gisant de Jean de Bourgogne, fils de Mahaut, oeuvre de Jean Pépin de Huy," *Bulletin de la Société des Antiquaires de France,* 1985, 161–63; and "Au Musée des Beaux-Arts et d'Archéologie de Besançon: Le gisant de Jean de Bourgogne, fils de Mahaut d'Artois, oeuvre de Pépin de Huy (1315)," *Revue du Louvre et des Musées de France,* 44, 1995, 13.

28. Carla Casagrande "La femme gardée," in *Histoire des femmes en Occident,* dir. Georges Duby and Michelle Perrot, 2. *Le Moyen Age,* Paris, 1991, 87–92.

29. Janet L. Nelson, "Perceptions du pouvoir chez les historiennes du haut moyen age," in *La Femme au moyen-âge,* ed. Michel Rouche and Jean Heuclin, Maubeuge, 1990, 75–76; Henri Platelle, "L'Epouse 'gardienne aimante de la vie et de l'ame de son marie'

quelques exemples du haut Moyen Age," also in *La Femme au moyen-âge*, 171–79; and Silvana Vecchio, "La bonne épouse," in *Histoire des femmes*, 201. See further, Lois L. Huneycutt, "'*Proclaiming her dignity abroad*': The Literary and Artistic Network of Matilda of Scotland, Queen of England 1100–1118," in *Cultural Patronage*, 1996, 155–74, and John Carmi Parsons, "Of Queen, Court, and Books: Reflections on the Literary Patronage of Thirteenth-century Plantagenet Queens," also in *Cultural Patronage*, 175–201, esp. 185–86, for the role of queens in literary patronage promoting ancestral cults.

30. These are the tombs of Henry the Liberal, count of Champagne (d. 1181), whose tomb was commissioned by his widow (see above, p. 12); his son, Thibaud III, count of Champagne (d. 1201), also commissioned by his widow (p. 15); the last three sires of Louvain, commissioned by the sister of the youngest (pp. 61–62); and Aymer de Valence, earl of Pembroke (d. 1324), commissioned by his widow (p. 73).

31. Circumstances suggest a role for Adelaide of Burgundy, widow of Henry III, duke of Brabant (d. 1261), in planning the tomb that she shared with him in the Church of the Dominicans in Louvain (see above, p. 36); the same is true of Philippine de Luxembourg in regard to the tomb for Jean II, count of Hainault (d. 1304) and herself (see above, p. 59). I have suggested that Isabella de France, queen of England and the widow of Edward II, had a primary role in planning the king's tomb at Gloucester (p. 83), and there is documentary evidence that she was involved in the burial of their son John of Eltham (k. 1336) at Westminster Abbey (p. 91). Isabelle de Portugal, duchess of Burgundy, negotiated the contract for the tomb of Louis de Mâle, Marguerite de Brabant, and Marguerite de Flandre with the coppersmith, Jacques de Gérines, in 1453 (p. 140). And the daughters of Béatrice de Savoie, countess of Provence, were probably responsible for the memorial for their mother at Les Echelles (p. 47).

32. Schmid 1957, esp. 47–57, repr. 1983, 229–39; Schmid 1967, 225–49, repr. 1983, 363–87; Duby, in *Famille et parenté*, 1977, 58; Keen 1984, 160; Robert Fossier, "L'ère féodale (XIᵉ–XIIIᵉ siècle)," in *Histoire de la Famille*, ed. André Burguière et al., Paris, 1986, 1, 375. Moreover, R. Howard Bloch ("Genealogy as a Medieval Mental Structure and Textual Form," in *Grundriss der Romanischen Literaturen des Mittelalters*, Heidelberg, 1986, 11, 1, 135–56) has recognized genealogy as a medieval mental structure, reflected in historical writing, the language arts, and to some degree, theology.

33. Schmid 1967, 235, repr. 1983, 373. In this context, it should be noted, however, that many Early Christian senators and nobles had their lineage indicated on their tombstones, and that many prelates and Early Christian saints traced their lineage to the Roman nobility or to royal forebears (Speyer, in *Reallexikon für Antike und Christentum*, dir. Theodor Klauser, Stuttgart, 1950–, 9, 1260–63).

34. For the first medieval monumental tombs in the empire and in France, see Bauch 1976, 11–44; for the lack of interest in monumental tombs for the French kings at Saint-Denis in the twelfth century, see Brown 1985, 241–42.

35. See Ullmann 1966, 53–151, for the gradual emergence of political individualism in the thirteenth and fourteenth centuries; however, Colin Morris has argued convincingly that individualism in the current sense of self-discovery, social relationships, and inner intention developed earlier (*The Discovery of the Individual 1050–1200*, Toronto, Buffalo, and London, 1972 [Medieval Academy Reprints for Teaching, 19, 1995]). See also Keen 1984, 18–27, 131–33, and 250, for the chivalric emphasis on prowess and individual feats of arms as early manifestations of self-importance. H. Wischermann (*Grabmal, Grabdenkmal und Memoria im Mittelalter* [Berichte und Forschungen zur Kunstgeschichte, 5], Freiburg im Breisgau, 1980, 9–10) sees the origin of the medieval monumental tomb in the twelfth-century anxiety over the redemption of the soul, with the resulting increase in liturgical *memoria*, and McLaughlin (1985, 414–19) observes a relationship between the shift in liturgical practices in the high and late Middle Ages, and an emerging individualism in the twelfth century. Wood-Legh (1965, 154) viewed chantries as "the most important manifestation of a movement of individual self-expression in religion in which both seculars and regulars were involved."

36. See Philippe Ariès, *The Hour of Our Death*, trans. H. Weaver, New York, 1981, 215–30, for a discussion of the reemergence of the epitaph on tombs, beginning in the tenth century. There is a great record of epitaphs in the antiquarian literature, of which W. R. Lethaby (*Westminster Abbey and the Kings' Craftsman: A Study of Medieval Building*, London, 1906 [repr. 1971], 332–38) gives a useful summary from the medieval tombs at Westminster. Emile Rauni (*Epitaphier du Vieux Paris*, 4 vols., Paris, 1890–1974) has an invaluable collection taken from the Parisian antiquarian material, and the Gaignières Collection of tomb drawings also records the epitaphs.

37. This definition of a portrait excludes those twelfth- and thirteenth-century representations of individuals cited by Morris (as in note 35), 89–95

38. Quoted in Keen 1984, 160. See further, Opitz 1991, 281.

39. Duby 1973, 283.

Select Bibliography

Abbreviations

A — Dering roll, ca. 1270 (Anthony R. Wagner, Richmond Herald, College of Arms, London).

AN — Antiquaries' roll, ca. 1360 (London, Society of Antiquaries, Ms. 136, Part 1).

Anselme — Anselme de Saint-Marie, *Histoire généalogique et chronologique de la Maison Royale de France, des Pairs, Grands Officiers de la Couronne et de la Maison du Roy: et des anciens Barons du Royaume*, 3rd ed. 9 vols. Paris, 1726–33.

AS — Ashmolean roll, ca. 1334 (Oxford, Bodleian Library, Ms. Ashmole 15A).

BM — Dugdale, William. Book of Monuments (London, Brit. Lib., Ms. Add. 71474).

BMS — Birch, W. de G. *Catalogue of Seals in the Department of Manuscripts in the British Museum*. 6 vols. London, 1887–1900.

BNB — *Biographie Nationale de Belgique*. 44 vols. Brussels, 1866–1986.

CKO — Cooke's ordinary, ca. 1340 (Anthony R. Wagner, Richmond Herald, College of Arms, London).

CP — Cokayne, G. E. *The complete peerage of England, Scotland, Ireland, Great Britain, and the United Kingdom*, rev. ed., ed. the Hon. Vicary Gibbs, 13 vols. London, 1910–59.

CTG — Society of Antiquaries, *Collectanea Topographica et Genealogica*. 4 vols. London, 1835–37.

D — Camden roll, ca. 1280 (London, Brit. Lib., Ms. Cotton Roll XV.8).

DACL — *Dictionnaire d'archéologie chrétienne et de liturgie*, ed. Dom F. Cabrol and Dom H. Le Clercq. 15 vols. Paris, 1924–53.

DNB — *Dictionary of National Biography from the earliest times to 1900*. 22 vols. London, 1950.

E — St. George's roll, ca. 1285 (Copy in London, College of Arms, Ms. Vincent 164, fols. 1–21v).

FW — Fitzwilliam version of Heralds' roll, ca. 1270–80 (Cambridge, Fitzwilliam Museum, Ms. 297).

H — Falkirk roll, 1298 (17th-century copy in London, Brit. Lib., Ms. Harl. 6589, fols. 9–9v).

L — First Dunstable tournament roll, 1308 (London, College of Arms, Ms. Vincent 165, fols. 37–44b).

Memoria — *Memoria: Der geschichtliche Zeugniswert des liturgische Gedenkens im Mittelalter*, ed. Karl Schmid and Joachim Wollasch (Münstersche Mittelalter-Schriften, 48). Munich, 1984.

N — Parliamentary roll, ca. 1312 (London, Brit. Lib., Ms. Cotton, Caligula A. XVIII, fols. 3–21b).

PO — Powell's roll, ca. 1350 (Oxford, Bodleian Library, Ms. Ashmole 804.IV).

PRO P — Ellis, R. H. *Catalogue of Seals in the Public Record office: Personal Seals*. 2 vols. London, 1978–81.

RCHM — Royal Commission on Historical Monuments, *An Inventory of the Historical Monuments in London*. I. *Westminster Abbey*. London, 1924.

RCHM Ex — Royal Commission on Historical Monuments, *An Inventory of the Historical Monuments in Essex*. 4 vols. London, 1916–23.

Succa — Succa, Antoine de, *Les Mémoriaux d'Antoine de Succa*, ed. Micheline Comblen-Sonkes and Christiane van den Bergen-Pantens (Les Primitifs Flamands. III. Contributions à l'étude des Primitifs flamands, 7). 2 vols. Brussels, Bibliothèque royale Albert Ier, 1977.

WJ — William Jenyns's ordinary, ca. 1380 (London, College of Arms, Ms. "Jenyns' Ordinary").

Primary Sources

Auxerre, Arch. départ. de l'Yonne, H 595, Abbaye de Dilo, Chartes; H 598, Copies de diverses chartes tirées du cartulaire de l'abbaye de Dilo et des originaux, 18th C.; H 631, Rigny-le-Ferron, Chartes.

Brussels, Bibl. roy. Albert Ier, Ms. Goethels 1507. Jean Lalou, Recerches. 17th C.

Brussels, Bibl. roy. Albert Ier, Ms. Goethels 1509. Jean d'Assignies, Monumens sépulchral de Flinne. ca. 1600.

Brussels, Bibl. roy. Albert Ier, Ms. Goethals 1640. Elisium illustrium hoeroum. Cimmetiere des illustres personnes. 17th C.

Brussels, Bibl. roy. Albert Ier, Ms. 7781. De Monasterio Villariensi ordinis Cisterciensis. 17th C.

Brussels, Bibl. roy. Albert Ier, Ms. 22483. Charles van Riedwijck, Sigillographica Belgica. 17th C.

Joigny, Bibl. mun., Ms. 1815. Chartes de 1142 à 1484 provenant de l'Abbaye de Dilo.

Lille, Archives départementales du Nord, B 3775–113513.

Lincoln, Lincolnshire Arch., Bishop's Reg. 4, fol. 39–40v; 6, fol. 145–48.

London, Brit. Lib., Ms. Add. 17694. Powell's Topographical Collections: Westminster Abbey. 1795.

London, Brit. Lib., Ms. Add. 27348. Horace Walpole Papers. 18th C.

London, Brit. Lib., Ms. Add. 28564. R. B. Wheler, Collections for the History of Warwickshire. 19th C.

London, Brit. Lib., Ms. Lansdowne 874. 17th C.

London, Corporation of London, Records Office, Letter Book F.

London, Public Record Office, Calendar of Liberate rolls, 3.

London, Public Record Office, Duchy of Lancaster, 42.

London, Society of Antiquaries Library, Drawings of John Carter. 1785.

London, Westminster Abbey Library, Doc. 6300*.

Oxford, Bodleian Library, Ms. Gough Drgs.-Gaignières l, 14, 18. 17th C.

Paris, Bibl. Nat. de France, Est., Drgs. Gaignières, Pe 11, Pe 11a.

Paris, Bibl. Nat. de France, Ms. Coll. Bourgogne, l6.

Paris, Bibl. Nat. de France, Ms. Fr. 1038. "Vie des Pères." 14th C.

Paris, Bibl. Nat. de France, Ms. Fr. 24020. Recueil d'épitaphes relevées dans differents églises de Flandres. 16th C.

Paris, Bibl. Nat. de France, Ms. nouv. acq. fr. 1330. "Mémoires pour l'histoire de la ville et comté de Joigny," par le sieur Davier, avocat. 1723.

Stratford-upon-Avon, Shakespeare Birthplace Trust Archives, ER 1/99, fols. 50–61v. James Saunders, Copy of the Archer Transcript of the Beauchamp Chapel Accounts. 19th C.

Printed Primary Sources

L'armorial universel du héraut Gelre (1370–1395), ed. P. Adam-Even (Archives héraldiques suisses, 1971).

Armorial Wijnbergen, ed. P. Adam-Even and L. Jéquier (Archives héraldiques suisses, 1951–54).

Calendar of Letterbooks preserved among the archives of the Corporation of the City of London at the Guildhall, ed. R. R. Sharpe. London, 1899–1912.

Cartulaire de l'Abbaye de Flines, ed., L'Abbé E. Hautcoeur. 2 vols. Lille, Paris, and Brussels, 1873.

Cartulaire général de l'Yonne, ed. Maximilien Quantin. 2 vols. Auxerre, 1854–60.

The Cartulary of the Monastery of St. Frideswide at Oxford, ed. S. R. Wigram (Oxford, Historical Society, 31). Oxford, 1896.

Dehaisnes, C. Documents et extraits divers concernant l'histoire de l'art dans la Flandre, l'Artois et le Hainaut avant le XVᵉ siècle. 2 vols. Lille, 1886.

Demay, G. Inventaire des sceaux de la Flandre. 2 vols. Paris, 1873.

———. Inventaire des sceaux de la Collection Clairambault à la Bibliothèque Nationale. 2 vols. (Collection de Documents inédits sur l'Histoire de France, 3ᵉ sér. Archéologie). Paris, 1885–86.

Douet d'Arcq, M. Collection de Sceaux. 3 vols. Paris, 1863–68. Munich, Kraus Repr., 1980.

Durandus, William. Rationale Divinorum Officiorum, trans. John Mason Neale and Benjamin Webb. Leeds, 1843. Repr. AMS Press Inc., New York, 1973.

Foster, C. W., and A. H. Thompson. "The Chantry Certificates for Lincoln and Lincolnshire, Returned in 1548 under the Act of Parliament of I Edward VI," Lincolnshire Architectural and Archaeological Society, Reports and Papers, 36, 1922, 207–17.

L'Histoire de Barlaam et Josaphat. Version champenoise d'après le ms. Reg. Lat. 660 et la Bibliothèque Apostolique Vaticane, ed. Leonard R. Mills. Geneva, 1973.

Historia et Cartularium monasterii Sancti Petri Gloucestriae, ed. W. H. Hart. 3 vols. London, 1863–67.

Leuridan, L'Abbé T. Epigraphie du Nord. Recueil des inscriptions du Département du Nord ou du Diocèse de Cambrai. 5–8: Douai. 9–12: Valenciennes (Mémoires de la Société d'Etudes de la Province de Cambrai, vols. 21–28). Lille, 1914–48.

Molinier, Auguste. Obituaires de la province de Sens et de Paris. 2 vols. (Recueil des Historiens de la France. Obituaires I, Parts 1 and 2). Paris, 1902.

Monumenta Germaniae Historica, Scriptores, 25, ed. Joh. Heller. Hannover, Deutsches Institut für Erforschung des Mittelalters, 1880.

Pinchart, Alexandre. Archives des Arts, Sciences et Lettres. Documents inédits. 3 vols. Ghent, 1860–81.

Quantin, Maximilien, ed. *Recueil de Pièces pour faire suite au Cartulaire Général de l'Yonne. XIII^e siècle.* Auxerre, 1873.

Raadt, J.-T. de. *Sceaux, armoiries des Pays-Bas et des pays avoisinants, recueil historique et héraldique.* 4 vols. Brussels, 1897–1901.

Raunié, Emile. *Epitaphier du Vieux Paris.* 4 vols. Paris, 1890–1974.

Rolls of Arms. Henry III. The Matthew Paris Shields. ca. 1244–59, ed. T. D. Tremlett. Glover's Roll, ca. 1253–58, and Walford's Roll, ca. 1273, ed. H. S. London (Harleian Society Publication, 113–114: *Aspilogia*, 2). Oxford, 1967.

Vredius, Olivarius, *Sigilla comitum Flandriae.* Bruges, 1639.

Wagner, Anthony Richard. *A Catalogue of English Medieval Rolls of Arms* (Harleian Society Publications, 100). Oxford, 1950.

Secondary Sources

Adhémar, Jean. "Les tombeaux de la Collection Gaignières: Dessins d'archéologie du XVII^e siècle," *Gazette des Beaux-Arts*, VI^e pér., 74, 1974, 3–192; 88, 1976, 3–128.

Arbois de Jubainville, Henri d', *Histoire des ducs et des comtes de Champagne.* 6 vols. Paris, 1859–66.

L'Art de vérifier les dates. 41 vols. Paris, 1818–44.

Avril, François. *Manuscript Painting at the Court of France: The Fourteenth Century*, trans. Ursule Molinaro. New York, 1978.

Baron, Françoise, and Ludovic Nys. "La sculpture valenciennoise aux XIV^e et XV^e siècles," in *Valenciennes aux XIV^e et XV^e siècles. Art et Histoire*, dir. Ludovic Nys and Alain Salamagne. Valenciennes, 1996, 127–45.

Bauch, Kurt. *Das mittelalterliche Grabbild.* Berlin and New York, 1976.

Beaune, Colette. "Mourir noblement à la fin du moyen âge," in *La Mort au moyen âge*, Colloque de l'Association des Historiens médiévistes français . . . Strasbourg, 1975 (Publications de la Société savante d'Alsace et des régions de l'est, Coll. "Recherches et Documents," 25). Strasbourg, 1977.

Bill, E. G. W. "Lady Montacute and St. Frideswide's Priory," *Friends of Christ Church Cathedral Report*, 1960, 8–13.

Binski, Paul. "The Coronation of the Virgin on the Hastings Brass at Elsing, Norfolk," *Church Monuments*, 1, 1985, 1–9.

———. "The Stylistic Sequence of London Figure Brasses," in *The Earliest English Brasses: Patronage, Style and Workshops 1270–1350*, ed. John Coales. London, 1987, 69–131.

———. *Westminster Abbey and the Plantagenets: Kingship and the Representation of Power 1200–1400.* New Haven and London, 1995.

Biver, Paul. "Les tombes de l'école de Londres au début du XIV siècle," *Bulletin monumental*, 73, 1909, 243–58.

Blair, Claude. "The Effigy and Tomb of Sir Hugh Calveley," *The Bunbury Papers*, 4, 195l.

Blair, John, ed. *Saint Frideswide's Monastery at Oxford: Archaeological and Architectural Studies.* Gloucester and Wolfeboro Falls (N.H.), 1990.

Bloch, Marc. *Les Rois thaumaturges. Etude sur le caractère surnaturel attribué à la puissance royale particulièrement en France et en Angleterre.* Paris, 1961.

Bowyer, L. J. *The Ancient Parish of Norbury.* Ashbourne (Derbyshire), 1953.

Britton, John. *Cathedral Antiquities.* 5 vols. London, 1828.

Brown, Elizabeth A. R. "Burying and Unburying the Kings of France," *Persons in Groups: Behavior as Identity Formation in Medieval and Renaissance Europe* (Papers of the 16th Annual Conference of the Center for Medieval and Early Renaissance Studies). Binghamton, 1985, 241–66.

Bur, Michel. "Les Comtes de Champagne et la 'Normanitas': Sémiologie d'un tombeau," *Proceedings of the Battle Conference on Anglo-Norman Studies*, 3, 1980, 22–32.

———. "L'image de la parenté chez les comtes de Champagne," *Annales*, 38, 1983, 1016–39.

———. "Une célébration sélective de la parentèle. Le tombeau de Marie de Dreux à Saint-Yved de Braine (XIII^e siècle)," *Comptes rendus de l'Académie d'Inscriptions*, 1991, 301–18.

Burguière, A., Christiane Klapisch-Zuber, Martine Segalen, and Françoise Zonabend, eds. *Histoire de la Famille.* 2 vols. Paris, 1986.

Burke, Bernard. *Dormant and Extinct Peerages of the British Empire.* Repr. 1978. London, 1883.

Butkens, F. Cristophre. *Trophées tant sacrés que prophanes du Duché de Brabant.* 2 vols. The Hague, 1724.

Calomino, Salvatore. *From Verse to Prose: The Barlaam and Josaphat Legend in Fifteenth-Century Germany* (Scripta Humanistica, 63). Potomac (Md.), 1990.

Campbell, Lorne. *Renaissance Portraits: European Portrait-Painting in the Fourteenth, Fifteenth, and Sixteenth Centuries.* London, 1990.

Carruthers, Mary J. *The Book of Memory: A Study of Memory in Medieval Culture.* Cambridge, 1990.

Chatwin, Philip B. "Monumental Effigies in the County of Warwick," *Birmingham Archaeological Transactions*, 47, 1924, 35–88.

Coffinet, l'Abbé. "Trésor de Saint-Etienne de

Troyes," *Annales archéologiques*, 20, 1860, 80–97.

Coldstream, Nicola. "English Decorated Shrine Bases," *Journal of the British Archaeological Association*, 3rd. ser., 129, 1976, 15–34.

Collon-Gevaert, Suzanne. *Histoire des arts du métal en Belgique*. 2 vols. Brussels, 1951.

Colvin, H. M., ed. *The History of the King's Works*. I. *The Middle Ages*. London, 1963.

Cook, G. H. *Medieval Chantries and Chantry Chapels*. London, 1963.

Corbet, Patrick. "L'autel portatif de la comtesse Gertrude de Brunswick (vers 1040): Tradition royale de Bourgogne et conscience aristocratique dans l'Empire des Saliens," *Cahiers de civilisation médiévale*, 34, 1991, 97–120.

Crossley, F. H. *English Church Monuments A. D. 1150–1550; An Introduction to the Study of Tombs and Effigies of the Mediaeval Period*. New York, 1921.

The Cultural Patronage of Medieval Women, ed. June Hall McCash. Athens (Ga.) and London, 1996.

Dallemagne, C. G. "Le Manuscrit de l'écuyer Charles van Riedwijck," *Annales de la Société royale d'archéologie de Bruxelles. Mémoires, rapports et documents*, 46, 1942–43, 27–98.

Dart, John. *Westmonasterium or the History and Antiquities of the Abbey Church of St. Peters Westminster*. 2 vols. London, 1723.

Dauphin, Jean-Luc. *Notre-Dame de Dilo. Une Abbaye au coeur du pays d'Othe*. Villeneuve-sur-Yonne, 1992.

Dehaisnes, Le Chanoine. *Histoire de l'art dans la Flandre, l'Artois et le Hainaut avant le XVe siècle*. Lille, 1886.

De Valkeneer, Adelin. "Inventaire des tombeaux et dalles à gisants en relief en Belgique: Epoques romane et gothique," *Bulletin de la Commission Royale des Monuments et des Sites*, 14, 1963, 91–256.

————. "Iconographie des dalles à gisants de pierre en relief en Belgique: moyen âge roman et gothique," *Revue des archéologues et historiens d'art de Louvain*, 5, 1972, 33–58.

Dijon, Musée des Beaux-Arts, *Les pleurants dans l'art du moyen âge en Europe*, by Pierre Quarré. 1971.

Duby, Georges. *Hommes and structures du moyen âge*. Paris and The Hague, 1973.

————. *The Chivalrous Society*, trans. Cynthia Postan. Berkeley and Los Angeles, 1977.

————. *Medieval Marriage: Two Models from Twelfth-Century France*, trans. Elborg Forster (The Johns Hopkins Symposia in Comparative History, 11). Baltimore and London, 1978.

————. *The Knight, the Lady, and the Priest*, trans. Barbara Bray. New York, 1983.

Duby, Georges, and Jacques Le Goff, eds., *Famille et parenté dans l'Occident médiéval* (Actes du Colloque de Paris, 6–8 juin 1974, Collection de l'Ecole française de Rome, 30). Rome, 1977.

Dugdale, William. *Antiquities of Warwickshire*, 2d ed. 2 vols. London, 1730.

Dugdale, Sir William. *The Restoration of the Beauchamp Chapel at St. Mary's Collegiate Church Warwick 1674–1742*. Oxford, 1956.

Duvivier, Charles. *La Querelle des d'Avesnes et des Dampierres jusqu'à la mort de Jean d'Avesnes (1257)*. 2 vols. Brussels, 1894.

Erlande-Brandenburg, Alain. *Le Roi est mort* (Bibliothèque de la Société française d'archéologie, 7). Paris, 1975.

Erlande-Brandenburg, A., J.-P. Babelon, F. Jenn, and J.-M. Jenn. *Le roi, la sculpture et la mort. Gisants et tombeaux de la basilique de Saint-Denis*. Paris, Archives départementales de la Seine-Saint-Denis, 1975.

Evans, Joan. *English Art 1307–1461*. Oxford, 1949.

Fairweather, F. H. "Colne Priory, Essex, and the Burials of the Earls of Oxford," *Archaeologia*, 87, 1937, 275–95.

Favier, Jean. *La Guerre de Cent Ans*. Paris, 1980.

Fryde, Natalie. *The Tyranny and Fall of Edward II, 1321–1326*. Cambridge, 1979.

Galesloot, L. "Les tombeaux d'Henri II et de Jean III, Ducs de Brabant, à l'abbaye de Villers," *Messager des Sciences historiques*, 1882, 15–36.

Gardner, Arthur. *English Medieval Sculpture*, 2d ed. Cambridge, 1951. Repr. New York 1973.

Gauthier, M.-M. *Emaux du moyen âge occidentel*. Fribourg, 1972.

Gee, L. L. "'Ciborium' Tombs in England 1290–1330," *Journal of the British Archaeological Society*, 132, 1979, 29–41.

Génicot, L. *Les Généologies* (Typologie des sources du moyen âge, 15). Turnhout, 1975.

Gerola, Guiseppe. "Appunti di iconografia Angioina," *Atti del Reale Istituto Veneto di Scienze lettere ed Arti*, 91, 1931–32, 257–73.

Gough, Richard. *Sepulchral Monuments in Great Britain*. 2 vols. London, 1786–96.

Greenhill, F. A. *Incised Effigial Slabs: A Study of Engraved Stone Memorials in Latin Christendom, c. 1100 to c. 1700*. 2 vols. London, 1976.

Hardy, André, and Philippe Beaussart, "Peintures et Sculptures gothiques du Couvent des Dames de Beaumont à Valenciennes," *Revue du Nord*, 62, 1980, 903–14.

Hartshorne, Albert. "On the Brass of Sir Hugh Hastings in Elsing Church, Norfolk," *Archaeologia*, 9, Part 1, 1906, 25–42.

Harvey, Barbara. *Westminster Abbey and its estates in the Middle Ages.* Oxford, 1977.

Hautcoeur, L'Abbe E. *Histoire de l'Abbaye de Flines,* 2d. ed. Lille, 1909.

Hedeman, Anne D. *The Royal Image: Illustrations of the* Grandes Chroniques de France, *1274–1422.* Berkeley, Los Angeles, and Oxford, 1991.

Histoire des femmes en Occident, dir. Georges Duby and Michelle Perrot, 2. *Le Moyen Age.* Paris, 1991.

Hofmeister, Philipp. "Das Gotteshaus als Begräbnisstätte," *Archiv für Katholisches Kirchenrecht,* 3, 1931, 450–87.

Hope, W. H. St. John. "On the funeral effigies of the kings and queens of England, with special reference to those in the abbey church of Westminster," *Archaeologia,* 60, 1907, 517–70.

Howard de Walden. *Some Feudal Lords and their Seals.* London, 1904.

Hurtig, Judith W. *The Armored Gisant Before 1400.* New York and London, 1979.

Isenburg, Wilhelm Karl Prinz von, and Detlev Schwennicke. *Europaische Stammtafeln,* 2d ed. 11 vols. Marburg, 1980–.

Knetsch, Karl Gustav Philipp. *Das Haus Brabant: Genealogie der Herzoge von Brabant und der Landgrafen von Hessen.* Darmstadt, 1931.

Jacob, Henriette s'. *Idealism and Realism: A Study of Sepulchral Symbolism.* Leiden, 1954.

Jalabert, Denise. "Le tombeau gothique," *Revue de l'art,* 64, 1933, 145–66; 65, 1934, 11–30.

Jenkinson, Hilary. "Mary de Sancto Paulo, Foundress of Pembroke College, Cambridge," *Archaeologia,* 66, 1914–15, 401–46.

Jungmann, Joseph A. *The Mass of the Roman Rite: Its Origins and Development,* trans. Francis A. Brummer, replica of the 2d ed. 2 vols. Westminster (Md.), 1986.

Keen, Maurice. *Chivalry.* New Haven and London, 1984.

Keepe, Henry. *Monumenta Westmonasteriensia.* London, 1681.

Kroos, Renate. "Grabbräuche-Grabbilder," in *Memoria,* ed. Karl Schmid and Joachim Wollasch. Munich, 1984, 285–353.

La Chenaye-Desbois, F. A. A. de. *Dictionnaire de la Noblesse,* 3d ed. 19 vols. Paris, 1868–76.

Le Boucq, Simon. *Histoire ecclesiastique de la ville et comte de Valentienne* (1650), ed. A. Prignet and A. Dinaux. Valenciennes, 1844.

Leeuwenberg, Jaap. "De tien bronzen 'Plorannen' in het Rijksmuseum te Amsterdam, hun herkomst en de voorbeelden waaraan zij zijn ontleend," *Gentse Bijdragen tot de Kunstgeschiedenis,* 13, 1951, 13–59.

Le Goff, Jacques. *The Birth of Purgatory,* trans. Arthur Goldhammer. Chicago, 1984.

Lekai, Louis J. *The Cistercians: Ideals and Reality.* Kent (Oh.), 1977.

Lethaby, W. R. *Westminster Abbey Re-examined.* London, 1925.

Lille, Musée des Beaux-Arts, *Sculptures romanes et gothiques du Nord de la France,* dir. Hervé Oursel. 1978–79.

Lindeman, C. M. A. A. "De dateering, herkomst en identificatie der 'Gravenbeeldjes' van Jacques de Gérines," *Oud Holland,* 58, 1941, 49–58, 97–105, 161–68, 193–219.

Lindley, Phillip. "The Tomb of Bishop William de Luda: An Architectural Model at Ely Cathedral," *Proceedings of the Cambridge Antiquarian Society,* 73, 1984, 75–87.

———. "'Una grande opera al mio re': Gilt-bronze effigies in England from the Middle Ages to the Renaissance," *Journal of the British Archeaological Association,* 143, 1990, 112–30.

———. *Gothic to Renaissance: Essays on Sculpture in England.* Stamford, 1995.

London, Royal Academy of Arts, *Age of Chivalry: Art in Plantagenet England 1200–1400,* ed. Jonathan Alexander and Paul Binski. London, 1987.

Mâle, Emile. *L'Art religieux de la fin du moyen âge en France. Etude sur l'iconographie du moyen âge et sur ses sources d'inspiration.* Paris, 1908.

Marks, Richard, and Ann Payne. *British Heraldry from its origins to c. 1800.* London, 1978.

Martindale, Andrew. "Patrons and Minders: The Intrusion of the Secular into Sacred Spaces in the Late Middle Ages," in *The Church and the Arts,* ed. Diana Wood (Studies in Church History, 28). Oxford and Cambridge (Mass.), 1992, 143–78.

McFarlane, K. B. *The Nobility of Later Medieval England.* Oxford, 1973.

McKisack, May. *The Fourteenth Century 1307–1399.* Oxford, 1959.

McLaughlin, Megan. *Consorting with Saints: Prayer for the Dead in Early Medieval France.* Ithaca and London, 1994.

McLaughlin, Molly Megan. "Consorting with Saints: Prayer for the Dead in Early Medieval French Society." 2 vols. Stanford University, Ph.D. dissertation, 1985.

Millin, A.-L. *Antiquités nationales.* 5 vols. Paris, 1790–99.

Moore, S. A. "Documents relating to the death and burial of Edward II," *Archaeologia,* 50, Part 1, 1887, 215–26.

Moreau, Edouard de. *L'Abbaye de Villers-en-Brabant aux XIIe et XIIIe siècles.* Brussels, 1909.

Neale, J. P., and E. W. Brayley. *The History and Antiquities of the Abbey Church of St. Peter, Westminster.* 2 vols. London, 1818–23.

Newton, Stella Mary. *Fashion in the Age of the Black*

Prince: A Study of the Years 1340–1365. Woodbridge and Totowa (N.J.), 1980.

Nicholas, David. *Medieval Flanders.* New York, 1992.

Noppen, J. G. "A Tomb and Effigy by Hennequin of Liège," *Burlington Magazine,* 59, 1931, 114–17.

Oexle, Otto Gerhard. "Welfische und staufische Hausüberlieferung in der Handschrift Fulda D11 aus Weingarten," in *Von der Klosterbibliothek zur Landesbibliothek. Beiträge zum 200-jährigen Bestehen der Hessischen Landesbibliothek Fulda,* ed. A. Brall (Bibliothek des Buchwesens, 6). Stuttgart, 1978, 203–31.

———. "Memoria und Memorialbild," in *Memoria,* ed. Karl Schmid and Joachim Wollasch. Munich, 1984, 384–440.

Opitz, Claudia. "Contraintes et libertés (1250–1500)," in *Histoire des femmes en occident,* dir. Georges Duby and Michelle Perrot, 2. *Le Moyen Age.* Paris, 1991, 277–335.

Ormrod, W. M. "The Personal Religion of Edward III," *Speculum,* 64, 1989, 849–77.

———. *The Reign of Edward III: Crown and Political Society in England 1327–1377.* New Haven and London, 1990.

Outreman, Henri d'. *Histoire de la ville et comté de Valentiennes.* Douai, 1639.

Page-Phillips, John. *Children on Brasses.* London, 1970.

Panofsky, Erwin. *Tomb Sculpture.* New York and London, 1964.

Paris, Galeries nationales du Grand Palais, *Les Fastes du Gothique: le siècle de Charles V,* dir. Françoise Baron. Paris, 1981.

Paris, Musée du Louvre and New York, The Metropolitan Museum of Art, *Enamels of Limoges, 1100–1350.* New York, 1996.

Pevsner, Nikolaus, ed. *The Buildings of England.* 46 vols. Harmondsworth, 1954– .

Pevsner, Nikolaus, and Metcalf, P. *The Cathedrals of England: Midland, Eastern, and Northern England.* 2 vols. Harmondsworth, 1985.

Phillips, J. R. S. *Aymer de Valence Earl of Pembroke 1307–1324: Baronial Politics in the Reign of Edward II.* Oxford, 1972.

Pillion, L. "Un tombeau français du 13e siècle et l'apologue de Barlaam sur la vie humaine," *Revue de l'art ancien et moderne,* 28, 1910, 321–34.

Pinchart, Alexandre. "Jacques de Gerines, batteur de cuivre du XVe siècle, et ses oeuvres," *Bulletin des commissions royales d'art et d'archéologie,* 5, 1866, 112–36.

Pirenne, H. *Histoire de Belgique.* Vol. 1. Brussels, 1900. Vol. 2, 3d. ed. Brussels, 1922.

Plagnieux, Philippe. "La fondation funéraire de Philippe de Morvilliers, premier président du parlement: art, politique et société à Paris sous la régence du duc de Bedford," *Bulletin monumental,* 151, 1993, 357–81.

Powell, J. Enoch. "The Riddles of Bures," *Essex Archaeology and History,* 3d ser., 14, 1974, 90–98.

Pradel, Pierre. "Les tombiers français en Angleterre au XIVe siècle," *Mémoires de la Société nationale des antiquaires de France,* 9e sér., 3, 1954, 235–43.

Prior, Edward S., and Arthur Gardner. *An Account of Medieval Figure-Sculpture in England.* Cambridge, 1912.

Prioux, Stanislas. *Monographie de Saint-Yved de Braine.* Paris, 1859.

Probert, Geoffrey. "The Riddles of Bures Unravelled," *Essex Archaeology and History. Transactions of the Essex Society for Archaeology and History,* 3d ser., 16, 1986, 55–64.

Rosenthal, Joel T. *The Purchase of Paradise: Gift Giving and the Aristocracy, 1307–1485.* London and Toronto, 1972.

Runciman, S. *A History of the Crusades.* 3 vols. Cambridge, 1951–54.

Saint-Phalle, Edouard de. "La première dynastie des comtes de Joigny (1055–1338)," in *Autour du Comté de Joigny XIe–XVIIIe siècles* (Actes du colloque de Joigny 9–10 juin 1990). Joigny, 1991.

Sanderus, Antonius. *Grand théâtre sacré du Brabant.* 4 vols. The Hague, 1734.

Sandford, Francis. *A genealogical history of the Kings of England and Monarchs of Great Britain from the Conquest, Anno 1066 to the Year 1677.* London, 1683.

Sauer, Christine. *Fundatio und Memoria. Stifter und Klostergründer im Bild. 1100 bis 1350* (Veröffentlichungen des Max-Planck-Instituts für Geschichte, 109). Göttingen, 1993.

Sauerländer, Willibald. *Gotische Skulptur in Frankreich 1140–1270.* Munich, 1970.

Sayer, M. J. *Reepham's Three Churches.* Dercham, 1972.

Schmid, Karl. "Zur Problematik von Familie, Sippe und Geschlecht. Haus und Dynastie beim mittelalterlichen Adel . . . "*Zeitschrift für die Geschichte des Oberrheins,* 105, NF 66, 1957, 1–62. Repr. in *Gebetsgedenken und adliges Selbstverständnis im Mittelalter.* Sigmaringen, 1983, 183–244.

———. "Uber die struktur des Adels im früheren Mittelalter," *Jahrbuch für fränkische Landesforschung,* 19, 1959, 1–23. Repr. in *Gebetsgedenken und adliges Selbstverständnis im Mittelalter.* Sigmaringen, 1983, 245–67.

———. "Uber das Verhältnis von Person und Gemeinschaft im frühen Mittelalter," *Frühmittel-*

alter Studien, 1, 1967, 225–49. Repr. in *Gebets-gedenken und adliges Selbstverständnis im Mittel-alter*. Sigmaringen, 1983, 363–87.

———. "'Andacht und Stift.' Zur Grabmalplanung Kaiser Maximilians I," in *Memoria*, ed. Karl Schmid and Joachim Wollasch. Munich, 1984, 750–86.

Schmidt, Gerhard, "Beitrage zu Stil und Oeuvre des Jean de Liège," *Metropolitan Museum of Art Journal*, 4, 1971, 81–107.

———. "Typen und Bildmotive des Spätmittel-alterlichen Monumentalgrabes," in *Skulptur und Grabmal des Spätmittelalters in Rom und Italien* (Publikationen des Historischen Instituts beim Osterreichischen Kulturinstitut in Rom, 1, 10). Vienna, 1990, 13–82.

Schramm, Percy Ernst, *A History of the English Coronation*. Oxford, 1937.

———. *Sphaira Globus Reichsapfel*. Stuttgart, 1958.

Scott, George Gilbert. *Gleanings from Westminster Abbey*, 2d ed. Oxford and London, 1863.

Sicard, Damien. *La Liturgie de la mort dans l'église latine des origines à la réforme carolingienne* (Liturgiewissenschaftliche Quellen und Forschungen, 63). Münster, 1978.

Sirjean, Gaston, *Encyclopédie généalogique des maisons souveraines du monde*, 1. Paris, 1959–.

Sonet, Jean. *Le Roman de Barlaam et Josaphat*. I. *Recherches sur la tradition inscrite latine et française*. Namur and Paris, 1949.

Spiegel, Gabrielle M. *The Chronicle Tradition of Saint-Denis: A Survey*. Brookline (Mass.) and Leyden, 1978.

Stammler, Wolfgang. *Wort und Bild. Studien zu den Wechselbeziehungen zwischen Schrifttum und Bildkunst im Mittelalter*. Berlin, 1962.

Stone, Lawrence. *Sculpture in Britain: The Middle Ages* (Pelican History of Art). Harmondsworth, 1955.

Stothard, C. A. *Monumental Effigies of Great Britain*, ed. A. J. Kempe. London, 1817–32.

Stow, John. *The Survey of London*. London, 1618, 1633, 1733–35, and 1754 editions.

Teuscher, Andrea. *Das Prämonstratenskloster Saint-Yved in Braine als Grablege der Grafen von Dreux. Zu Stifterverhalten und Grabmalgestaltung im Frankreich des 13. Jahrhunderts* (Bamburger studien zur Kunstgeschichte und Denkmalflege, 7). Bamburg, 1990.

Ullmann, Walter. *The Individual and Society in the Middle Ages*. Baltimore, 1966.

Valenciennes, Musée des Beaux-Arts, *Richesses des Anciennes Eglises de Valenciennes*. 1987–88.

———. *Les collections d'archéologie du Musée des Beaux-Arts de Valenciennes*. 1993.

Vetusta Monumenta, 2. London, Society of Antiquaries, 1789.

Viard, Francisque. *Béatrice de Savoye*. Lyon, 1942.

Violante, Cinzio. "Quelques caractéristiques des structures familiales en Lombardie, Emilie et Toscane au XIe et XIIe siècles," in *Famille et parenté dans l'Occident médiéval*, ed. Georges Duby and Jacques Le Goff (Actes du Colloque de Paris, 6–8 juin 1974, Collection de l'Ecole française de Rome, 30). Rome, 1977.

Vos, J. T. *Notice historique et descriptive sur l'Abbaye de Villers*. Louvain, 1867.

Ward, Jennifer C. *English Noblewomen in the Later Middle Ages*. London and New York, 1992.

Warner, S. A. *Oxford Cathedral*. London, 1924.

Wendebourg, Eva-Andrea. *Westminster Abbey als Königliche Grablege zwischen 1250 und 1400*. Worms, 1986.

Williamson, Paul. *Gothic Sculpture 1140–1300* (Pelican History of Art). New Haven and London, 1995.

Wilson, Christopher. "The Origins of the Perpendicular Style and Its Development to circa 1360." University of London, Ph.D. dissertation, 1980.

Wood, Susan. *English Monasteries and their Patrons in the Thirteenth Century*. London, 1955.

Wood-Legh, K. L. *Perpetual Chantries in Britain*. Cambridge, 1965.

Index